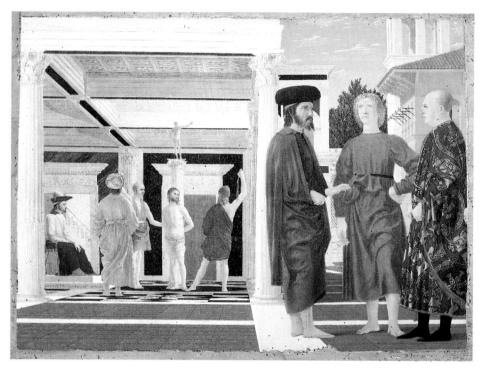

Piero della Francesca, Flagellation of Christ. Urbino, Galleria Nazionale delle Marche.

The Enigma of Piero

Piero della Francesca

New Edition with Appendices

CARLO GINZBURG

Translated by Martin Ryle and Kate Soper

With an Introduction by Peter Burke

This edition first published by Verso 2000 © Verso 2000 Translation © Martin Ryle and Kate Soper 2000 First published as *Indagini su Piero* (nuova edizione) © Giulio Einaudi editore s.p.a., Torino, 1994

All rights reserved

The moral rights of the author and the translators have been asserted

Verso

UK: 6 Meard Street, London W1V 3HR USA: 180 Varick Street, New York, NY 10014–4606

Verso is the imprint of New Left Books

ISBN 1-85984-731-5

British Library Cataloguing in Publication Data A catalogue record for this book is available from the British Library

US Library of Congress Cataloging-in-Publication Data A catalog record for this book is available from the Library of Congress

Typeset in Bembo by SetSystems, Saffron Walden, Essex Printed by in Great Britain by the Bath Press

Contents

List of Plates		vii	
Introduction by Peter Burke		xiii	
Preface		xix	
Preface to the New Edition		xxxi	
THE ENIGMA OF PIERO			
I	The Baptism of Christ	5	
II	The Arezzo Cycle	15	
III	The Flagellation of Christ	48	
IV	Further Thoughts on the Flagellation	60	
Conclusion		102	
AP	PENDICES		
Ι	Giovanni di Francesco, Piero della Francesca and the Date of the Arezzo Cycle	107	
II	The Flagellation: Conjectures and Refutations	116	
III	Berenson, Longhi, and the Rediscovery of Piero della Francesca	129	
IV	Absolute and Relative Dating: on the Method of Roberto Longhi	138	
Index		153	

List of Plates

- front. Piero della Francesca, Flagellation of Christ. Urbino, Galleria Nazionale delle Marche. (Archivio Electa, Milan.)
 - 1. Piero della Francesca, *Victory of Constantine* (detail). Arezzo, San Francesco. (Archivio Electa, Milan.)
 - Piero della Francesca, Baptism of Christ. London, National Gallery. (Archivio Electa, Milan.)
 - 3. Piero della Francesca, *Baptism of Christ* (detail). London, National Gallery. (Archivio Electa, Milan.)
 - 4. Andrea Mantegna, Cardinal Ludovico. Berlin, Staatliche Museen.
 - Piero della Francesca, Death of Adam. Arezzo, San Francesco. (Archivio Electa, Milan.)
 - 6. Piero della Francesca, Raising of the Wood. Arezzo, San Francesco. (Archivio Electa, Milan.)
 - 7. Piero della Francesca, Queen of Sheba and her Retinue. Solomon Receiving the Queen of Sheba. Arezzo, San Francesco. (Archivio Electa, Milan.)
 - 8. Piero della Francesca, *Annunciation*. Arezzo, San Francesco. (Archivio Electa, Milan.)
 - 9. Piero della Francesca, *Dream of Constantine*. Arezzo, San Francesco. (Archivio Electa, Milan.)
 - 10. Piero della Francesca, *Victory of Constantine*. Arezzo, San Francesco. (Archivio Electa, Milan.)
 - 11. Piero della Francesca, *Torture of the Jew*. Arezzo, San Francesco. (Archivio Electa, Milan.)
 - 12. Piero della Francesca, *Discovery and Proof of the Cross*. Arezzo, San Francesco. (Archivio Electa, Milan.)
 - 13. Piero della Francesca, *Defeat of Chosroes*. Arezzo, San Francesco. (Archivio Electa, Milan.)
 - 14. Piero della Francesca, Exaltation of the Cross. Arezzo, San Francesco. (Archivio Electa, Milan.)

- 15. Piero della Francesca, *St Luke the Evangelist*. Rome, Santa Maria Maggiore. (Archivio Scala, Florence.)
- 16. Agnolo Gaddi, *Death of Adam*. Florence, Santa Croce. (Alinari, Florence.)
- 17. Agnolo Gaddi, Queen of Sheba Kneeling before the Wood of the Cross. Solomon Burying the Wood. Florence, Santa Croce. (Alinari, Florence.)
- 18. Agnolo Gaddi, *Making of the Cross*. Florence, Santa Croce. (Alinari, Florence.)
- 19. Agnolo Gaddi, Empress Helena Making Proof of the Three Crosses. Florence, Santa Croce. (Alinari, Florence.)
- 20. Agnolo Gaddi, *Empress Helena Taking the Cross to Jerusalem*. Florence, Santa Croce. (Alinari, Florence.)
- 21. Agnolo Gaddi, Chosroes Removing the Cross from Jerusalem. Florence, Santa Croce. (Alinari, Florence.)
- 22. Agnolo Gaddi, Chosroes Worshipped by his Subjects. Dream of Heraclius. Florence, Santa Croce. (Alinari, Florence.)
- 23. Agnolo Gaddi, Beheading of Chosroes. Heraclius Returning the Cross to Jerusalem. Florence, Santa Croce. (Alinari, Florence.)
- Florentine wedding-chest painting. Solomon and the Queen of Sheba (detail).
 London, Crawford Collection.
- Lorenzo Ghiberti, Solomon and the Queen of Sheba. Florence, Baptistry. (Brogi, Florence.)
- 26. Lorenzo Ghiberti, Solomon and the Queen of Sheba (detail). Florence, Baptistry. (Alinari, Florence.)
- 27. Piero della Francesca, Solomon Receiving the Queen of Sheba (detail). Arezzo, San Francesco. (Archivio Electa, Milan.)
- 28. Casket, once the property of Cardinal Bessarion. Venice, Gallerie dell'Accademia. (Photograph courtesy of the Istituto centrale per il catalogo e la documentazione, Rome.)
- 29. Bessarion's Casket (closed). Venice, Gallerie dell'Accademia. (Böhm, Venice.)
- 30. Bessarion's Casket (open). Venice, Gallerie dell'Accademia. (Böhm, Venice.)
- 31. Pisanello, Medal of John VIII Palaeologus. Florence, Bargello. (Alinari, Florence.)
- 32. Anthem-book given by Bessarion, no. 2 in series (detail). Cesena, Biblioteca Malatestiana.
- 33. Medal of Constantine (face). Vienna, Kunsthistorisches Museum.
- 34. Medal of Heraclius (reverse side). Vienna, Kunsthistorisches Museum.
- 35. Piero della Francesca, *Queen of Sheba and her Retinue* (detail). Arezzo, San Francesco. (Archivio Scala, Florence.)

- 36. Giovanni di Piamonte, *Madonna Enthroned and Saints*. Città di Castello, Santa Maria delle Grazie. (Alinari, Florence.)
- 37. Pietro Lorenzetti, *Flagellation of Christ*. Assisi, San Francesco, Basilica inferiore di San Francesco. (Alinari, Florence.)
- 38. Maestro dell'Osservanza, Flagellation of Christ. Rome, Vatican Gallery.
- 39. Alejo Fernandez (?), Flagellation of Christ. Madrid, Prado.
- 40. Piero della Francesca, *Flagellation of Christ* (detail). Urbino, Galleria Nazionale delle Marche. (Archivio Electa, Milan.)
- 41. Piero della Francesca, *Flagellation of Christ* (detail). Urbino, Galleria Nazionale delle Marche. (Archivio Electa, Milan.)
- 42. Piero della Francesca, *Flagellation of Christ* (detail). Urbino, Galleria Nazionale delle Marche. (Archivio Electa, Milan.)
- 43. Piero della Francesca, *Flagellation of Christ* (detail). Urbino, Galleria Nazionale delle Marche. (Archivio Electa, Milan.)
- 44. Piero della Francesca, *Madonna of the Misericordia* (detail). San Sepolcro, Museum. (Archivio Electa, Milan.)
- 45. Piero della Francesca, *Madonna of the Misericordia* (detail). San Sepolcro, Museum. (Archivio Electa, Milan.)
- 46. Piero della Francesca, *Flagellation of Christ* (detail). Urbino, Galleria Nazionale delle Marche. (Archivio Electa, Milan.)
- 47. Piero della Francesca, *Defeat of Chosroes* (detail). Arezzo, San Francesco. (Archivio Scala, Florence.)
- 48. Piero della Francesca, Solomon Receiving the Queen of Sheba (detail). Arezzo, San Francesco. (Archivio Electa, Milan.)
- 49. Piero della Francesca, *Defeat of Chosroes* (detail). Arezzo, San Francesco. (Archivio Scala, Florence.)
- 50. Piero della Francesca, *Defeat of Chosroes* (detail). Arezzo, San Francesco. (Archivio Scala, Florence.)
- 51. Benozzo Gozzoli, *St Francis Stripping Himself of his Possessions*. Montefalco, Museo di San Francesco. (Alinari, Florence.)
- 52. Giotto, *Dream of Innocent III*. Assisi, Basilica superiore di San Francesco. (Alinari, Florence.)
- 53. Benozzo Gozzoli, *Dream of Innocent III* and *The Approval of the Franciscan Rule*. Montefalco, Museo di San Francesco. (Anderson, Florence.)
- 54. Lorenzo Lotto, Brother Gregorio Belo of Vicenza. New York, Metropolitan Museum.
- 55. Taddeo di Bartolo (?), Flagellation of Christ (from Articles of the Credo). Siena, Museo dell'Opera del Duomo. (Photograph courtesy of the Soprintendenza alle Gallerie, Siena.)

- 56. Beato Angelico, *Flagellation of Christ*. Florence, Museo di San Marco. (Alinari, Florence.)
- 57. Filippino Lippi, Triumph of St Thomas (detail). Rome, Santa Maria sopra Minerva.
- 58. Marten van Heemskerck, View of the Lateran. Berlin, Kupferstichkabinett.
- 59. Giovanni Marcanova, *Antiquitates*: view of the Lateran. Modena, Biblioteca Estense. (Roncaglia, Modena.)
- 60. Head of Constantine. Rome, Musei Capitolini. (B. Malter, Rome.)
- 61. Hand of Constantine. Rome, Musei Capitolini. (B. Malter, Rome.)
- 62. Sphere, formerly part of the statue of Constantine. Rome, Musei Capitolini. (B. Malter, Rome.)
- 63. Plan of the Lateran (from Severano's *Memorie Sacre*). Bologna, Biblioteca Comunale.
- 64. "Pilate's doorways", near the Scala Santa, Rome.
- 65. Stone and column with "mensura Christi", from the cloister of St John Lateran, Rome.
- 66. "Pilate's Column", from the cloister of St John Lateran, Rome.
- 67. Another "Pilate's Column", from the cloister of St John Lateran, Rome.
- 68. Column with "mensura Christi", from the cloister of St John Lateran, Rome.
- 69. Column with "mensura Christi", from the cloister of St John Lateran, Rome (detail).
- 70. Doorway in the Palazzo Venezia, Rome.
- 71. Anthem-book given by Bessarion, no. 2 in series, frontispiece. Cesena, Biblioteca Malatestiana.
- 72. Anthem-book given by Bessarion, no. 2 in series, frontispiece (detail). Cesena, Biblioteca Malatestiana.
- 73. Graziano the Minorite, Summa de casibus conscientiae, frontispiece (detail). Paris, Bibliothèque Nationale, nouv. acq. lat. 10002. (Photograph: Bibliothèque Nationale.)
- 74. Medal of Bessarion (face). Weimar, Nationale Forschungs- und Gedenkstätte.
- 75. Paolo Romano (completed by a follower of Andrea Bregno), funeral monument of Pius II: the gift of the relic of St Andrew's head. Rome, Sant'Andrea della Valle. (Anderson, Florence.)
- 76. Guillaume Fichet, Rhetorica, frontispiece. Venice, Biblioteca Marciana, membr. 53.
- 77. Bessarion, *Epistolae et Orationes*, frontispiece. Rome, Biblioteca Apostolica Vaticana, vat. lat. 3586. (Photograph courtesy Biblioteca Apostolica Vaticana.)
- Andrea Contrario, Obiurgatio in Platonis Calumniatorem (detail). Paris, Bibliothèque Nationale, lat. 12947, f. 11r. (Photograph courtesy Bibliothèque Nationale.)

- 79. Bessarion, *Adversus calumniatorem Platonis* (detail). Paris, Bibliothèque Nationale, lat. 12946, f. 29r. (Photograph courtesy Bibliothèque Nationale.)
- 80. Gentile Bellini, Bessarion Kneeling before the Casket Given to the Scuola Grande della Carità. Vienna, Kunsthistorisches Museum.
- 81. Pedro Berruguete (?), Bessarion. Paris, Louvre.
- 82. Sixteenth-century anonymous painter (after Gentile Bellini?), *Bessarion*. Venice, Gallerie dell'Accademia. (Böhm, Venice.)
- 83. Diptych of Bessarion. Venice, Biblioteca Marciana (after Kyros).
- 84. Cristoforo Altissimo, *Bessarion*. Florence, Galleria degli Uffizi. (Photograph courtesy Gabinetto Fotografico Soprintendenza Beni artistici e storici di Firenze.)
- 85. Bessarion (from Giovio's *Elogium virorum literis illustrium*). Rome, Biblioteca Herziana.
- 86. Guillaume Fichet, *Rhetorica*, frontispiece (detail). Venice, Biblioteca Marciana, membr. 53.
- 87. Paolo Romano (completed by a follower of Andrea Bregno), funeral monument of Pius II: the gift of the relic of St Andrew's head (detail). Rome, Sant'Andrea del Valle. (Anderson, Florence.)
- 88. Illuminated initial with portrait of Bessarion (from *Ludovici Bentivoli virtutis, et nobilitatis insignia*). Bologna, Biblioteca Universitaria.
- 89. Piero della Francesca, *Flagellation of Christ* (detail). Urbino, Galleria Nazionale delle Marche. (Archivio Electa, Milan.)
- 90. Vittore Carpaccio, Vision of St Augustine. Venice, Scuola di San Giorgio degli Schiavoni. (Alinari, Florence.)
- 91. Vittore Carpaccio, drawing, London, British Museum.
- 92. Vittore Carpaccio, drawing, Moscow, Pushkin Museum.
- 93. Vittore Carpaccio, drawing (verso of previous folio), Moscow, Pushkin Museum.
- 94. Piero della Francesca, *Flagellation of Christ* (detail). Urbino, Galleria Nazionale delle Marche. (Archivio Electa, Milan.)
- 95. Piero della Francesca, *Nativity* (detail). London, National Gallery. (Archivio Electa, Milan.)
- 96. Piero della Francesca, Prophet. Arezzo, San Francesco. (Archivio Electa, Milan.)
- 97. Giovanni di Piamonte, Sant'Anna Metterza with SS Michael, Catherine, Mary Magdalen and Francis. Berlin, Staatliche Museen.
- 98. Piero della Francesca, Mother and Child with Four Angels. Williamstown, Clark Art Institute.
- 99. Giovanni di Francesco, predella with *Scenes from the Life of St Nicholas*. Florence, Casa Buonarroti.

- Giovanni di Francesco, God the Father with Angels. Florence, Ospedale degli Innocenti.
- 101. Giovanni di Francesco, Carrand Triptych (Madonna and Child with SS Francis, John the Baptist, Nicholas and Peter). Florence, Bargello.
- 102. Giovanni di Francesco, Crucifix. Brozzi (Florence), Sant'Andrea.
- Giovanni di Francesco, Madonna and Child with St Bridget and St Michael, Los Angeles, Getty Museum.
- 104. Maestro del 1399 (Giovanni di Tano di Fei?), St Bridget Giving the Rule of the Order. Formerly in Milan, Bassi Collection.
- Domenico Veneziano, Altarpiece: Santa Lucia dei Magnoli. Florence, Galleria degli Uffizi.
- 106. Giovanni di Francesco, S. Biagio (altar-frontal). Petriolo (Florence), San Biagio.
- 107. Giovanni di Francesco, Madonna and Child. Contini Bonacossi bequest.
- 108. Francesco del Cossa, Pietà with St Francis. Paris, Musée Jacquemart-André.
- 109. Giovanni di Piamonte, Pietà. Florence, S. Pancrazio, Rucellai Chapel.
- 110. Piero della Francesca, *Flagellation of Christ* (detail). Urbino, Galleria Nazionale delle Marche. (Archivio Electa, Milan.)
- 111. Piero della Francesca, *St Jerome with a Disciple*. Venice, Gallerie dell'Accademia. (Archivio Scala, Florence.)
- 112. Piero della Francesca, Sigismondo Malatesta kneeling before his Patron Saint. Rimini, Tempio Malatestiano.
- 113. Piero della Francesca, St Jerome. Berlin, Staatliche Museen.
- 114. Piero della Francesca, St Jerome with a Disciple (detail). Venice, Gallerie dell'Accademia. (Archivio Scala, Florence.)
- 115. Piero della Francesca, Resurrection. San Sepolcro, Palazzo Comunale.
- 116. G. Tortelli, *De Orthographia*, ms. Urbinate Latino 303, f. 1 (illuminated initial with portrait of the author). Rome, Biblioteca Apostolica Vaticana.
- 117. Carnevale Fra, *Presentation of the Virgin in the Temple*. Boston, Museum of Fine Arts.
- 118. Antonello da Messina, Benson Madonna. Washington, National Gallery of Art.
- 119. Pablo Picasso, *Nude*, Paris, Spring 1910. Formerly in New York, Alfred Stieglitz Collection.
- 120. Umberto Boccioni, The Laugh. New York, Metropolitan Museum.
- 121. Piero della Francesca, *Discovery and Proof of the Cross* (detail). Arezzo, San Francesco. (Archivio Electa, Milan.)
- 122. Paul Cézanne, Gardanne. New York, Brooklyn Museum.
- 123. Umberto Boccioni, *Portrait of Ferruccio Busoni*. Rome, Galleria Nazionale d'Arte Moderna.

Introduction

Carlo Ginzburg, Detective

The purpose of this brief note is not to introduce Carlo Ginzburg to the English-speaking world – a task fortunately made superfluous by the translation of his *Night Battles* and *The Cheese and the Worms* – but to comment on this particular book. Why is the discoverer of the *benandanti* and Menocchio the miller writing about the paintings of Piero della Francesca? What has a "plain" or "general" historian to do with art history?

We should beware of type-casting Ginzburg too easily. If he is best known as a historian of popular culture, it does not follow that he lacks other interests. In 1966, for example, two years after a brief visit to the Warburg Institute in London (to which he later returned for a year), Ginzburg published a perceptive essay on the art historians associated with that institute, notably Aby Warburg (after whom "the Warburg" is named), Fritz Saxl and Sir Ernst Gombrich. The problem he discussed was how – and how not – to use works of art as historical sources, noting in particular the danger of circularity involved in reading paintings as evidence of the painter's state of mind.²

In 1979 Ginzburg published two more essays with the visual arts as a major or minor theme. The first, written in collaboration with the art historian Enrico Castelnuovo, was a discussion of "Centre and Periphery" in the history of Italian art, in other words the problem of the cultural lag between the works produced in a centre of artistic innovation, such as Florence, and the works produced in the provinces. The authors argue that the relation between centre and periphery is both a complex and a variable one. They deny the assumption that all lags are peripheral or that all peripheries lag. They also suggest that provincial imitations of the products of the centre express the "symbolic dominance" of particular cities. This suggestive essay deserves to be better known outside Italy.³

Art is also a central theme in one of Ginzburg's most wide-ranging and controversial pieces, an article with the intriguing title "Clues". Its purpose is to discuss what the author calls a paradigma indiziario, a phrase almost impossible to translate because indiziario refers not only to the phrase prova indiziaria, "circumstantial evidence", but also to the various meanings of indizio, "sign" no less than "indicator" or "clue". The implication, which the article itself teases out, is that there is a sort of art of suspicion, an art which utilizes small pieces of indirect evidence rather than direct or massive proof. Ginzburg begins with a striking comparison between the achievements of three masters of this art at the end of the nineteenth century: Sherlock Holmes, Sigmund Freud and the art historian Giovanni Morelli. All three investigators based important conclusions on apparently trivial pieces of evidence. Holmes attended to the barking of a dog and to other details overlooked by Watson; Freud based diagnoses on apparently trivial slips of the tongue, lapses of memory and so on; while Morelli worked out a system for attributing pictures to particular painters on the basis of such minor details as the shape of the painted ears. As Aby Warburg used to say, "God is in the details" (Der liebe Gott steckt im Detail). Ginzburg goes on to trace the history of this paradigm, which takes him back to the diagnoses of hippocratic medicine, practices of divination and finally to the prehistoric hunter who "read" the tracks of the animal he was pursuing. He has particularly interesting points to make about the seventeenth-century art collector Giulio Mancini. Mancini, himself a physician famous for his diagnoses, told his readers to study the "character" of a painting as they would that of a piece of handwriting, in order to infer its author's identity. This brilliant essay is at once a plea for and an example of historical clue-hunting or divination.4

Problems of historical method have long interested Carlo Ginzburg, as they interested his teacher Delio Cantimori (1904–66), a scholar who was particularly concerned with the history of heresy in Italy, but who also published important essays on the cultural historians Jacob Burckhardt, Johan Huizinga and Lucien Febvre.⁵ Cantimori's two interests came together when he investigated the "Nicodemites", those heretics who conformed to orthodoxy in their outward behaviour (they were named after Nicodemus in the gospels, who came to Christ by night). To track down men like these one needs a historical detective who is exceptionally conscious of problems of method.

Ginzburg too has published a study of "Nicodemism" and the problems of religious simulation and dissimulation in the sixteenth century.⁶ His books on the *benandanti* and on the cosmology of Menocchio the miller, hero of *The Cheese and the Worms*, also reveal his acute awareness of the awkward problems of method involved in the study of popular culture through sources produced by the learned; oral culture through written texts; and the views of the unorthodox via the investigations of the inquisitors who were trying to suppress them.

Problems of method are also raised by Ginzburg's investigation of Piero della Francesca. Piero's major paintings have been the subject of a long debate, particularly since the great Italian art historian Roberto Longhi published his essay on them in 1927. It is not the authorship which is in doubt this time but the dating of the paintings and also their meaning. The specific problems of interpreting the *Flagellation* and other paintings by Piero raise the burning question of the validity of the so-called "iconographical" or "iconological" approach. This approach was worked out from the 1920s onwards by a group of German art historians, notably two members of Aby Warburg's circle, Erwin Panofsky and Edgar Wind.

Panofsky defined iconography as "that branch of the history of art which concerns itself with the subject-matter or meaning of works of art, as opposed to their form". He distinguished between two levels, iconography in the strict sense, which involves identifying a painted figure of a woman, say, as "Venus", "Judith" or "Clio", and iconology, a less precise term. It might be rendered as the art of grasping the meaning of the whole, whether that whole is an individual picture, the "programme" or unifying theme of a pictorial cycle, the oeuvre of a particular artist, or the distinctive quality of the art of a given period. Iconography proper depends very largely on the evidence of texts, but iconology, as Panofsky admitted, requires intuition or — as Ginzburg might say — the art of divination.

Since the publication in 1939 of Panofsky's famous book on the subject, there has been a great wave of studies of this kind. Among the most famous – and controversial – examples are those of Edgar Wind and E. de Jongh. Wind claimed to find references to pagan mystery religions in paintings of the Italian Renaissance, while de Jongh has argued that many seventeenth-century Dutch genre paintings, on the surface depictions of everyday reality, were intended to have a symbolic or emblematic meaning.⁸ Botticelli's so-called *Primavera* and Giorgione's so-called

Tempesta have given rise to a particularly rich literature of interpretation.⁹ The iconographical approach, once unduly neglected, has become something of a fashion and there has inevitably been a backlash against it.

The critique of the iconographical approach to works of art rests on two main arguments. In the first place, it has been suggested that the programme or "deeper meaning" of the work of art did not matter to most patrons (if indeed it mattered to the artists themselves).¹⁰ There is also the argument that even if the artist or his humanist adviser once formulated a programme, and the patron understood this, the art historian may still have little hope of discovering what that programme was. Iconology can rarely meet strict standards of proof.¹¹ The divergence between the scholars who have written about the meaning of Botticelli's *Primavera*, for example, is so great as to remind one of the fable about the wise men and the elephant.

It is in this context that we should read Carlo Ginzburg's investigations into Piero. Like his friend Salvatore Settis, a classical archaeologist who has offered one of the most persuasive readings of Giorgione's *Tempesta*, Ginzburg wants to replace iconographic laxity with a more rigorous method. They both believe in the possibility of successful detective work in this field, provided that the detective follows strict rules. "The first rule", writes Settis, "is that all the pieces should fit together without leaving blank spaces between them. The second is that the whole should make sense." Ginzburg adds a third rule – we might call it "Ginzburg's razor" – to the effect that "other things being equal, the interpretation requiring fewest hypotheses should generally be taken as the most probable".

All the pieces should fit together. As a "plain" historian, Ginzburg's advantage over his art-historian colleagues is that he has more pieces to play with. He has put the problem of Piero into a wider context, notably that of the theological and political conflicts of the time. The major political conflict was of course the one between the Byzantine Empire and the Ottoman Empire which was about to swallow it up. The Byzantines could see what was coming. That was why the emperor John VIII approached Pope Eugenius IV with a plan for a general council which would put an end to the theological disputes between eastern and western Christendom. The council was held at Ferrara and Florence in 1438–39, and the union was signed. However, western aid was ineffective; John VIII came to regret his approach to the pope; and, five years

after his death in 1448, Constantinople fell to the Turks. ¹³ Ginzburg is not the first scholar to have noticed the references in Piero's paintings to John VIII's distinctive hat, any more than he is the first to have noticed the relation between Piero and Bessarion, the Greek archbishop who became a Roman cardinal. All the same, the link between art and politics is central to his study of Piero as it is not in those of his predecessors.

Christopher Hill once wrote of the need to take the history of law away from the lawyers and the history of theology away from the theologians. Ginzburg's essay shows the advantage of taking art history away from the specialist art historians (or to be fairer and more exact, of sharing it with them). For the plain historian has a good deal to say about art patronage. According to Salvatore Settis, for example, Giorgione's Tempesta cannot be understood without studying the intellectual interests of the man who - in all probability - commissioned it, the Venetian patrician Gabriele Vendramin. The meaning of the painting depends upon its context. In a similar way, Ginzburg argues below that it is important to study the humanistic interests of Giovanni Bacci, who was one of the patrons of Piero della Francesca, in order to discover the meaning of the Arezzo frescoes and other works by Piero. Art historians have been aware of Bacci's existence for some time, but it was Ginzburg who identified him with the minor humanist whose letters are preserved in the Archivio di Stato in Florence.

Politics and patronage have taken us a considerable distance away from Giovanni Morelli and his clues, but when Ginzburg attempts to identify the mysterious figures in the foreground of Piero's *Flagellation*, he offers us an analysis which Morelli would have appreciated. In the case of one figure, for example, he focuses on "the very unusual ear, sharply pointed and indented at the top, fleshy at the lobe", and in a second case he concentrates on a nose, "slightly humped, and rounded towards the end". Elsewhere he writes about beards, and about the meaning of certain hand gestures. One of this book's most remarkable features is the range of the sources which it exploits without regard to the frontiers between disciplines and what Aby Warburg used to call the "watchmen" who guard them.

Like earlier essays on Piero della Francesca, Ginzburg's has already provoked considerable controversy. ¹⁴ Such a severe critic of the speculations of others and their excesses of "interpretative zeal", as he puts it, could hardly have expected his own hypotheses to have escaped criticism.

Like Freud and Sherlock Holmes, Ginzburg has an urge to speculate and on occasion he presents these speculations as "fact". Indeed, in one passage he even tells us with great confidence what one figure in the foreground to the *Flagellation* must be saying to the other two. To be fair, he refers, elsewhere in the essay, to his own "chain of conjectures", and to the dangers of circular arguments in a case with so many unknown factors, a jigsaw puzzle in which so many pieces have been lost. His own hypotheses are at once ingenious, economical and plausible. Whether or not readers will agree with the substantive conclusions, it will be hard for them to resist admiring the exemplary way in which the problems have been set out. But it is high time to let Carlo Ginzburg tell his own story.

PETER BURKE

Notes

- C. Ginzburg, The Night Battles (1966; translated by A and J. Tedeschi, London, 1983); The Cheese and the Worms (1975; translated by A. and J. Tedeschi, London, 1980).
- 2. C. Ginzburg, "Da Warburg a Gombrich", Studi Medievali 7 (1966), 1015-65.
- 3. E. Castelnuovo and C. Ginzburg, "Centro e Peripheria", Storia dell'arte italiana 1 (Turin, 1979), 285–352.
- C. Ginzburg, "Clues", in The Sign of Three: Dupin, Holmes, Pierce, ed. U. Eco and T.A. Sebeok (Bloomington, 1983), 81–118.
- 5. D. Cantimori, Storici e storia (Turin, 1971).
- C. Ginzburg, Il nicodemismo: simulazione e dissimulazione religiosa nell'Europa del'500 (Turin, 1970).
- 7. E. Panofsky, Studies in Iconology (New York, 1939), introduction.
- 8. E. Wind, Pagan Mysteries in the Renaissance (Oxford, 1958). E. de Jongh, "Erotica in vogelperspectief", Simiolus 3 (1968), 22–72.
- On the Primavera, Wind, ch. 6; E.H. Gombrich, Symbolic Images (London, 1972), 37f; C. Dempsey, "Mercurius Ver", Journal of the Warburg and Courtauld Institutes 31 (1968), 251–73.
 On the Tempesta, E. Wind, Giorgione's Tempesta (London, 1969); S. Settis, La "Tempesta" interpretata (Turin, 1978).
- C. Hope, "Artists, Patrons and Advisers in the Italian Renaissance", in Patronage in the Renaissance, ed. G.F. Lytle and S. Orgel (Princeton, 1981), 293–343.
- 11. E.H. Gombrich, "Aims and Limits of Iconology" in his Symbolic Images, introduction.
- 12. Settis, 73.
- 13. A good brief account in S. Runciman, The Fall of Constantinople (Cambridge, 1965), ch. 1.
- A. Pinelli, "In margine a 'Indagini su Piero'", Quademi Storici 50 (1982), 692–701, followed by Ginzburg's reply.

Preface

In the following pages I offer an analysis of some of the major works of Piero della Francesca: the *Baptism of Christ*, the *Flagellation* and the Arezzo fresco cycle. My perspective is twofold: I am concerned with their commissioning, and with their iconography. I say nothing of the strictly formal aspects of the paintings, for, being a historian rather than an art historian, I lack the qualifications to do so. This is a serious limitation; it will be asked whether an investigation whose scope is thus confined can arrive at relevant conclusions. I believe that it can, both for reasons pertaining specifically to the nature of the research into Piero's work, and for reasons of a more general kind.

All in all, we have little certain knowledge of Piero's life; very few of his works can be dated. In such conditions, the researcher is in the position of a climber confronted by a particularly severe rock face, smooth and without anything to which a rope-holding peg might be attached. The pegs of fact are few and far between: Piero was in Florence in 1439, working with Domenico Veneziano; in 1445 he received a commission for the Misericordia altarpiece at San Sepolcro; the Rimini fresco, depicting Sigismondo Malatesta, dates from 1451; the record of payments made to him by the Vatican tells us that he was working in Rome in 1458–59. For the rest, we have nothing but conjectures, unreliable or second-hand testimony, and in the best cases *post quem* and *ante quem* dates that leave the intervening decades blank.

In his great book on Piero (first published in 1927 and subsequently enriched, over a period of thirty-five years, by the author's additions and revisions),² Roberto Longhi has shown how an in-depth examination of the paintings themselves may allow us to circumvent the paucity of external evidence. Today, we still have to come to terms with this

XX PREFACE

fundamental reconstruction of Piero's artistic biography. Inevitably, however, given the more than fifty years which have passed since it was first set out, Longhi's treatment now seems doubtful in some respects.

Let us take one example: the dating of the Urbino *Flagellation*.³ Longhi used to hold that this famous picture was painted in or about 1445. He derived this very early date from a particular interpretation of the picture's subject – or rather, of the scene in the foreground. According to this interpretation, which had been developed and gradually modified during the eighteenth and nineteenth centuries in the local tradition of Urbino, and by students of the town's history, the blond youth with bare feet represented Oddantonio da Montefeltro, who was assassinated by conspirators in 1444, standing between two wicked counsellors. Thus Piero's picture was seen as homage to the memory of the Count, who had recently died a tragic death.

Though there is evidence of the young man's mistaken identification as Oddantonio as early as the late sixteenth century (which is already, however, more than a hundred years after the picture was painted), the entire interpretation is certainly quite groundless. While it went unchallenged, Longhi accepted it as the "most probable" account, and held that the dating that followed from it was confirmed by the work's formal qualities: "The style, too, takes us back to a period before the Arezzo frescoes . . . ".4 To the quite justified objections put to him by Toesca, who rejected (even if on the basis of a not entirely satisfactory argument) both the iconographic interpretation and the early relative dating, Longhi replied in 1942. He reiterated his own acceptance of what was then the orthodox thesis: "and since the work was intended for Urbino, so also may well have been its mysterious modern theme [the figures in the foreground]; which in turn lends credence to the local tradition concerning its interpretation – an interpretation quite in keeping with the style of a painting which is connected with the more primitive works, and which is clearly a prevision, rather than a consequence, of the Arezzo frescoes".

Longhi, of course, would never have dreamed of uncritically accepting the attribution of a work to any artist on the basis of a local tradition a hundred, or indeed three hundred, years later than the work in question. In questions of iconography, however, he was altogether less meticulous. Expert though he was, Longhi's eyes were misled, in the case of the *Flagellation*, by pseudo-evidence of an extra-stylistic kind; the result was distortion of a crucial phase in Piero's development as a painter. However,

PREFACE XXI

Longhi did eventually modify his view, writing in 1962 that he was now "inclined to date the work a few years later". The theory that the picture commemorated Oddantonio's death was on the point of collapsing, and the question of its iconography was thus opened once again. Longhi continued at all events to maintain that the painting belonged to "a phase earlier than the Arezzo frescoes".⁵

I shall have more to say later about the dating of the Arezzo cycle and of the *Flagellation* itself. For the moment, I wish simply to make some general comments on the problems raised by Longhi's argument and by his subsequent change of mind.

It is well known that Longhi regarded the dating of a work as a crucially important element in its analysis. His uncanny insight as a connoisseur should not, however, lead us into the mistaken supposition that datings such as "Cremona, 1530" always or only had a stylistic basis. They actually depended upon the interplay and cross-comparison of a range of documentary evidence, concerning style, biography, even the picture's framing – and perhaps, though more rarely, its iconography and other features. Now it is clear that any suggested dating depends on a convergence of stylistic and extra-stylistic inferences: but this convergence, this "agreement" (as Longhi terms it), is a point of arrival, not a point of departure. Which series of data, when we are actually carrying out a piece of research, will weigh most heavily with us, and thus form the basis of any agreement? The answer will, of course, vary from one case to the next. In the present instance, there can be no doubt that most weight was given to extra-stylistic factors, and particularly to data concerning iconography.

It is significant that Longhi, until his change of mind in 1962, always began his discussions of the painting's date by identifying what it represented. And indeed, if one accepted the view that it commemorated Oddantonio's death, then this did provide a fairly exact indication of its date, which could not have been more than a couple of years later than 1444. (Federico da Montefeltro, the painting's likely patron if we accept the theory in question, would surely not have delayed long before honouring his murdered brother's memory.) Longhi's own arguments, meanwhile, always make it clear that stylistic evidence could not offer anything approaching such chronological precision: "earlier than the Arezzo frescoes", "clearly a prevision, rather than a consequence, of the Arezzo frescoes". Complementary to this terminus ante quem, which

xxii Preface

Longhi placed in 1452, was the implicit terminus post quem provided by the oldest parts of the San Sepolcro Misericordia altarpiece, commissioned in 1445 and probably painted in that year or soon afterwards. This means that Longhi, in assigning a date to the Flagellation, faced the choice between a margin of error of two or three years at most (if he went on the basis of iconography), and a margin more than twice as wide (about seven years). For a scholar seeking to establish the date with the smallest possible approximation, the problem was to establish whether the first dating was compatible with the second - compatible, rather than coincident, for we have seen that there was no question of coincidence. Longhi's remark that the interpretation of the picture as representing Oddantonio can be accepted as valid "simply because it is consistent with the formal character of the painting" might encourage the mistaken view that iconographic and stylistic factors were accorded equal weight. On the contrary: in this case, the former were clearly given predominance (where the iconography is markedly stereotypic, the reverse sometimes happens). "Formal" criteria enjoyed a kind of right of veto, should the iconographic hypothesis prove incompatible with stylistic analysis; but only on the basis of its iconography could the painting be precisely dated.

We have seen that it took thirty-five years for the veto derived from stylistic inferences to be lifted, leading Longhi to abandon without comment both the absurd iconographic interpretation linked with Oddantonio, and the dating which this implied. We may legitimately see in this long delay evidence of a disposition widespread among connoisseurs (even of Longhi's stature) towards an acceptance of the precise dating offered by a painting's iconography when it apparently refers to an external historical event. In general (though not in the present case), the caution implicit in this tendency is justified. To say this is not, of course, to belittle the considerable success achieved by stylistic or cultural dating techniques in the domain of art history, and in the historical study of peoples without written culture or with only scanty or indecipherable written remains.8 Even so, it must be remembered that datings based solely on stylistic evidence allow us only to say that x happened before yand after z - to establish, in other words, a relative chronological sequence. Only when stylistic analysis can be coupled with datings derived from external evidence is it possible to turn this "before" and this "after" into absolute chronological landmarks - and sometimes even into precise ad annum dates. Thus when Longhi, in his essay on a youthful Crucifixion

PREFACE XXIII

of Benozzo Gozzoli's, concludes, in a delightful trick of rhetoric, that he "can refrain only with difficulty from adding that it dates 'from Montefalco, in 1450'", he is relying on the date of Benozzo's Montefalco frescoes – a date that is not conjectural but explicit. If, on the other hand, the historian refers to other works which have themselves been dated on stylistic grounds, there is a serious danger of falling into a vicious circle, from which yet more erroneous datings will be inferred.

Longhi's final change of mind about the dating of the Flagellation offers a case in point. Having tacitly rejected the false precision of a date based on a mistaken iconographic interpretation, Longhi simply continued to repeat that the painting predated the beginning of Piero's work on the Arezzo cycle. But in what year did Piero commence work on the Arezzo frescoes? The safest answer is: after 1452, the year in which Bicci di Lorenzo, who had begun the task of decorating the chapel of San Francesco, died (though some scholars argue that Piero may have taken Bicci's place a few years earlier, Bicci being already ill). Now Longhi turns this terminus post quem into an absolute date, basing his argument on the stylistic similarities between the oldest parts of the Arezzo cycle and the Rimini fresco, depicting Sigismondo Malatesta, which dates - one of our "pegs" - from 1451.10 But this absolute date is clearly arrived at in an arbitrary fashion, since we do not know how fast Piero's style was evolving during these years. Turning again to the date of the Flagellation, we can see that the terminus ante quem invoked here - "earlier than the Arezzo cycle" – refers in its turn to a terminus post quem (later than 1452). I shall try later on to show that this date, fragile in itself, has to be corrected both on the plane of relative chronology and on that of absolute or calendar chronology.

All this shows how difficult it is, even for so exceptional an expert as Longhi, to date a work on the basis of style alone in the more or less complete absence of external documentation. Few of Piero's works escape this difficulty (which makes his a case of great methodological significance, quite apart from his artistic excellence). The suggested datings of the *Flagellation* fall anywhere within a margin of fully thirty years; the *Baptism of Christ*, which some scholars regard as a mature work, has been assigned by others to the painter's earliest youth; and so on.¹¹ The datings involved are in many cases absurd; and yet it has been possible to

xxiv Preface

put them forward – possible, that is, without their proposers losing scholarly credibility. On the other hand, anyone who denied that Piero was working in Rimini in 1451, or in Rome in 1458–59, these dates being established respectively by a dated fresco and by the Vatican records, would thereby place themselves beyond the pale of scholarship – unless, as would of course be theoretically possible, they proved that the date was falsified or the records inaccurate. But in that case, the burden of proof would lie with whoever wished to argue for such falsification or inaccuracy.

In the matter of dating, the rope of stylistic interpretation is in fact always tied, with more or less convincing results, to the pegs of available documentary evidence. (This seems to me to imply a tacit acceptance that stylistic data are less trustworthy in the establishment of a precise date.) What is indispensably necessary, in the case of Piero, is a greater number of pegs: that is, to abandon the metaphor, an amplification of the scanty documentary evidence – evidence, in the first place, about the commissioning of his work.

In fact, documentary research into the commissioning of Piero's works came to a halt in the first decades of this century: the last substantial contribution was made by G. Zippel in his essay proving that Piero had worked at Rome in the service of Pius II.¹² Studies such as those of M. Salmi, who had been working a few years earlier on the commissioning of the Arezzo cycle, were never taken any further – not even by scholars such as C. Gilbert, who (as we shall see) was in a position to develop them.¹³ As for the biographical summary that is perhaps the most useful part of E. Battisti's lengthy monograph, while this does supply fresh information on the time Piero spent in Borgo San Sepolcro, it adds nothing about the dating of his works (apart from a request concerning the Misericordia altarpiece).¹⁴

In their reconstructions of the commissioning of Piero's work, scholars have often chosen not to go on the basis of documents in libraries or archives, but to decode the evidence of the works themselves – in particular, of their iconography. Indeed, recent years have seen a large number of iconographic or (to use a term now current) iconological¹⁵ studies of Piero: of these, some have been excellent, others unconvincing or downright bad. This is inevitable – even if, to an outside observer, the

PREFACE XXV

minimum requirements of intellectual rigour seem sometimes to have been disturbingly ignored. To see how, in Battisti's work, one gratuitous iconological hypothesis is followed at random by another, which may well contradict what has gone before, is to wonder whether, in a domain where verification is so hard to come by, any odd conjecture may be permissible.¹⁶

The difficulties of verification are readily stated. When, in their study of Piero's works, the iconologists reveal what are often very complex allusions, they are postulating the existence of specific instructions, conveyed to the artist by the patron of a painting or by some intermediary. Of instructions, however, not a trace remains, perhaps because they were given orally rather than in writing. So far, there is nothing extraordinary about this, for there are in fact very few surviving examples of detailed iconographic instructions dating from before the middle of the sixteenth century. However, there is a very serious risk of constructing circular chains of interpretation, based entirely on conjecture. The chain relies on the reciprocal reinforcement of its various links, and the whole construction is suspended in a vacuum (there is an obvious analogy with the risks involved in dating works on exclusively stylistic grounds). The work itself ends up, as we see in numerous pieces of iconological research, by becoming the pretext for a series of free associations, generally based on some presumed symbolic interpretation.

Similar problems are encountered in other fields of research - for example, in the study of pre-industrial peasant culture, which was largely oral.¹⁷ They cannot be resolved by tacitly doing away with the requirements of documentary verification, but only by developing adequate means of verification. This (let it be clear) does not mean that the interpreter's task is limited to the identification of the explicit meanings attributed to the work by the painter, or the patron. But the interpreter who does not observe these initial precautions risks presenting what are no more than private musings in the guise of a broadening or deepening of Piero's - or, say, Titian's - works. There are plenty of examples, nowadays, of such ridiculous presumption. 18 This underlines the wisdom of Gombrich's suggestion that we should begin by analysing institutions or genres, rather than symbols; then, we might avoid the pitfalls that lie in wait for what we might call "uncontrolled" iconology. 19 But there is one other element of verification that allows us to restrict the range of possible interpretations: research into commissioning. To be sure, if we

xxvi PREFACE

seek to identify a work's patron on the basis of an iconological interpretation, then we land ourselves in yet another vicious circle. The only course is to carry out research simultaneously into commissioning and into iconography, and to bring together the data derived from both sets of investigations. That is what I have tried to do in this book.

In order to demonstrate the limits of a purely stylistic reading of Piero's paintings (and, by extension, of works of art in general), we began with the problem of dating. This, doubtless, can be put down to the habitual vice of the professional historian, whose immediate response to any piece of evidence (pictures included) is to ask, "When?" (and, straight after, "Where?"). Dating, however, is no more than the first step towards a historical reading of a work of art. The body of extra-stylistic data concerning commissioning and iconography, which we propose to examine in order to fill out the results of stylistic research, poses forcibly the question (trite, but terribly real) of the relation between the work of art and the social context in which it was born.

We have chosen to raise the question only now, and in what might be called an indirect way – coming to it, that is, only by way of an elementary but inescapable need (the need to date the work), which is felt by anyone whose relationship with works of art goes beyond a purely aesthetic appreciation. Our reason is this. The relations between a work of art and its context have too often been stated in brutally reductive terms – as, for example, in the recent claim that behind the paintings of Piero della Francesca one can see "agricultural and patriarchal Umbria". Those scholars who are less interested in the social history of artistic expression, or who would even oppose its study on ideological grounds, obviously have no difficulty in dismissing that kind of sterile playing with the metaphor (itself an unfortunate one) of "structure" and "superstructure".

What is much harder to reject in principle (but also much harder and more laborious to achieve) is an analytical reconstruction of the intricate web of minute relations that underlies the production of any work of art, however simple.²¹ Even the preliminary historical task of dating often necessitates, as we have seen, a simultaneous examination of stylistic choices, iconographic forms and relations with patrons. It is only by way of an ever more assiduous analysis of this type that we shall attain the

PREFACE XXVII

infinitely more ambitious goal of writing a social history of artistic expression; we shall never get there by drawing precipitate or far-fetched parallels between the sequence of artistic phenomena and the sequence of socio-economic phenomena.

The most determined steps towards our goal were taken by Aby Warburg, whose essays²² testify to a breadth of vision and a wealth of analytic techniques only in part accountable to the decoding of symbols traditionally regarded as the defining characteristic of the "Warburg method". Nor is it to be overlooked, here, that it was Warburg's attention to the specific social and cultural context that preserved him from the interpretative excesses to which even so great a scholar as Panofsky (not to speak of some of his successors) occasionally succumbed. Rather closer in spirit to Warburg's researches is a work such as M. Baxandall's study of fifteenth-century Italian painting, where the examination of style in relation to concrete social situations and experiences produces highly original results.²³

It is some time now since historians ceased to feel obliged to work only with written evidence. Lucien Febvre has already invited us to take account of weeds, field formations, eclipses of the moon: why not paintings, then – for example, Piero's paintings? After all, they, too, are documents of political or religious history. There has been too much talk, to be sure, of interdisciplinary research (which has not, in most cases, led to much practical result); nevertheless, there is obviously every reason why historians and art historians should collaborate, each deploying their own techniques and their own expertise, in order to arrive together at a deeper understanding of the evidence given by figurative works.²⁴ Nor should anyone object if a scholar working in an overtly historical perspective decides not to venture into the field of stylistic analysis.

The present work, however, has, it seems to me, means and ends that are different, and perhaps more ambitious. I have been obliged to take account of the limits of my training, which have prevented me from fully coming to terms with Piero's paintings; and I have tried neither to hold the disciplines apart, nor to run them into one. I have conducted myself rather like someone making a foray into what is certainly foreign, though by no means definitely hostile, territory. Had I referred to Piero's paintings as evidence of fifteenth-century religious life, or had I

XXVIII PREFACE

contented myself with rediscovering the network of Arezzo patrons, I could no doubt have established peaceful relations with the learned body of art historians. But they will probably take it amiss that I have outlined an image of Piero that differs from the familiar one, and have even disputed the chronology of some of his major works. It will be surprising indeed if nobody advises me to stick to the trade I know best.

As a matter of principle, I believe that forays such as this should become more and more frequent. Because people are unhappy about what are held to be artificial separations between disciplines, there has been a tendency to juxtapose the conclusions of different disciplines (though this, as we have said, has been more in the wish than the deed). Summit meetings of this kind are not much use, and leave everything unchanged; far better to engage with concrete problems – such as the problem dealt with here, concerning the dating and interpretation of individual works. Only in this way will it be possible to reopen real questions about the techniques, the scope and the language of the individual disciplines. Beginning, of course, with historical research.

Notes

I must express grateful thanks to Augusto Campana, whose comments I sought at an early stage in my research; to don Agnoletti, my guide to the Archives of the Curia at San Sepolcro; to Giorgio E. Ferrari, Micaela Guarino Buzzoni, Marité Hirschkoff Grendi, Piero Lucchi, Cristina Mundici, Agostino Paravicini Bagliani, Vittorio Peri and Odile Redon, who helped find the illustrations; and to those students at Bologna with whom I enjoyed useful discussion of the present work, then in course of development, in a seminar of 1979–80. Among friends whom I asked to read my typescript I must mention with especial gratitude Enrico Castelnuovo, Gianni Romano and Salvatore Settis, who drew my attention to mistakes and inexactitudes.

Bologna, March 1981.

- 1. Schlosser's words in this connection are worth recalling: "It is already a matter of exceptional significance for this type of artist one of the purest, in our opinion that empirical biography is of no importance" (J. von Schlosser, *Xenia*: p. 50 of the Italian translation, subtitled *Saggi sulla storia dello stile e del linguaggio nell'arte figurativa*, Bari 1938).
 - 2. R. Longhi, Piero della Francesca, Florence 1963 (Opere Complete, 3).
 - 3. For the present author's views on this, see ch. III.
- 4. Longhi, *Piero*, p. 209; and also p. 25: "Dating to the same period probably shortly after 1444, the year which saw the death of Oddantonio da Montefeltro, to whose wretched fate it most likely alludes is the small painting entitled the *Flagellation of Christ*...". In both cases, as can be seen, the iconographic interpretation (described as "likely" or "most probable") is not just the preface to but the grounds for the proposed dating.

PREFACE XXIX

- 5. Ibid., pp. 196–7 (for the reply to Toesca; for the latter's objections, see below, ch. III). For Longhi's revised opinion of 1962, see ibid., p. 201.
- 6. G. Contini, "Sul metodo di Roberto Longhi", in *Altri Esercizi*, Turin 1972, p. 103. On the "divinatory" implications of the connoisseur's activity, see the present author's "Spie. Radici di un paradigma indiziario", in A. Gargani (ed.), *Crisi della Ragione*, Turin 1979, pp. 57–106 and "Clues", in *Clues, Myths and the Historical Method*, Baltimore 1989, pp. 96–125, 200–14.
 - 7. Longhi, Piero, p. 148.
- 8. G. Kubler, *The Shape of Time. Remarks on the History of Things*, New Haven and London 1973, p. 14.
- 9. R. Longhi, "'Fatti di Masolino e di Masaccio' e altri studi sul Quattrocento", Florence 1975 (Opere Complete, VIII/I), p. 127.
- 10. Longhi, *Piero*, p. 100: "We can assume in all probability that Piero replaced Bicci di Lorenzo almost immediately upon his death in 1452. At that point, the vault of the Chapel of San Francesco di Arezzo, which the Bacci family intended to decorate completely with paintings, was nearly finished. Intuitively one must incline to this view, for had there been any serious break in the work, some other painter of Bicci di Lorenzo's calibre would surely have been found to complete the small unfinished portions of the vault and the entrance arch, and to see to whatever else required attention; whereas in fact Piero himself made good even these tiny omissions. And the same date seems explicitly vouched for by the Rimini fresco which is already, in 1451, on a par with the Arezzo frescoes in breadth, coherence and maturity."
- 11. C. Gilbert has rightly emphasized that this is an unsatisfactory state of affairs: see his Change in Piero della Francesca, Locust Valley, New York 1968.
 - 12. G. Zippel, "Piero della Francesca a Roma", in Rassegna d'Arte, XIX (1919), pp. 81-94.
- 13. M. Salmi, "I Bacci di Arezzo nel sec. XV e la loro cappella nella chiesa di San Francesco", in *Rivista d'Arte*, IX (1916), pp. 224–37. On the line of enquiry which Gilbert opens up, but does not follow, see below, ch. II.
- 14. E. Battisti, *Piero della Francesca*, 2 vols, Milan 1971. The documentary register, compiled by E. Settesoldi, is in the 2nd vol., pp. 213–46. For the request from the *Compagnia della Misericordia*, see vol. 2, p. 221 (but the date of the document, and its interpretation, must be corrected in the light of J. Beck's remarks: see "Una data per Piero della Francesca", in *Prospettiva*, 15 [1978], p. 53).
- 15. On the way in which Panofsky himself came progressively to identify iconology and iconographic analysis, see G. Previtali's introduction to the Italian translation of E. Panofsky, Studi di iconologia. I temi umanistici nell'arte del Rinascimento, Turin 1975.
- 16. See the comments of S. Settis on "indulgent iconologists" in his La "Tempesta" interpretata. Giorgione, i committenti, il soggetto, Turin 1978, pp. 15–16. Settis and myself are described by Battisti as "pathetic victims of a recurrence of neo-Warburgian rigourism" (cf. E. Mucci and P.L. Tazzi [eds], Teoria e pratiche della critica d'arte, Atti del convegno di Montecatini maggio 1978, Milan 1979, p. 241).
- Cf. P. Burke, Cultura popolare nell'Europa moderna, Milan 1980, pp. 77ff., and preface, pp. ix-xi.
- 18. The prize must go (for the time being) to M. Calvesi, "Sistema degli equivalenti ed equivalenza del Sistema in Piero della Francesca", in *Storia dell'arte*, 24–5 (1975), pp. 83–110. For the distinction between explicit and implicit meanings, see G. Previtali's preface to Panofsky, especially pp. xxiv ff. (commenting on Panofsky's discussion with Pächt).
- 19. See E.H. Gombrich, "Aims and Limits of Iconology", in *Symbolic Images. Studies in the Art of the Renaissance*, London 1972, pp. 1–25.
- 20. G. Previtali, "La periodizzazione della storia dell'arte italiana", in *Storia dell'arte italiana*, Turin 1979, vol. 1, p. 46. Calvesi, for his part, discovers by contrast a correspondence between

XXX PREFACE

"the call to centralism to be heard in Piero's work" and "the first moves towards an organized system of exchange (with the advent of the bourgeoisie and the emergence of capitalism)" ("Sistema degli equivalenti", p. 84).

- 21. E. Castelnuovo does not share this positive view of the opportunities offered by this kind of analytical investigation: see his important essay "Per una storia sociale dell'arte" (*Paragone*, 313 [1976], pp. 3–30, 323 [1977], pp. 3–34).
- 22. A. Warburg, *Die Erneuerung der heidnischen Antike*, 2 vols, Leipzig-Berlin 1932. G. Bing is the editor of the Italian volume, *La rinascita del paganesimo antico. Contributi alla storia della cultura* (Florence 1966): this selection includes for the first time the Italian version of an unpublished lecture referring to Piero: see below, ch. II, n. 60.
 - 23. M. Baxandall, Painting and Experience in Fifteenth Century Italy, Oxford 1972.
- 24. On the question of figurative documents as historical sources, the present author has already commented, in a different context (see "From A. Warburg to E.H. Gombrich", in *Clues*, pp. 17–59, 170–94.

Preface to the New Edition

Indagini su Piero came out in 1981, as the first title in a series, "Microstorie", which has now ceased publication. The present new edition, which appeared in Italian more than a decade later (1994) in the series "Saggi" from Einaudi, Turin, differs not only from the original edition but also from the third edition of 1982. The 1982 text, which included a new Introduction, was reprinted several times and a corrected version of this text was translated into English, appearing in 1985 from Verso as *The Enigma of Piero*.¹ The present edition includes a wider range of illustrations. Four Appendices have been added: two of these have previously been published in periodicals, while two appear here for the first time. In the first and second Appendices, I seek to reaffirm or correct my earlier conclusions, in the light of objections made by others and of my own rethinking; the third and fourth offer an analysis of a historiographical crux and of some of its implications.² All four deal in one way or another with the question which was at the root of my original investigations.

I should like to say a few further words about that question here. My impression is that (with one exception, to which I refer below) it has been ignored or misunderstood by commentators on the book, who have generally rejected my conclusions either wholly or in part.

In the opening lines of the original Preface I made it clear that my concern was not with the "strictly formal aspects" of the paintings I was discussing (the *Baptism of Christ*, the Arezzo fresco cycle, and the *Flagellation*), but only with their commissioning and their iconography. One of my critics then claimed that "by his own admission, [Ginzburg] ignores all 'artistic' factors". Another, referring to the information I had presented about those who may have inspired Piero and commissioned work from him, described this, rather superciliously, as "the kind of material that microhistories of art like to deal with". I must beg leave to insist that I was undertaking a somewhat more complicated experiment. My

counterposing – which was purely methodological – of formal aspects (which Lavin miscalls "'artistic' factors") and extra-formal aspects had the ambitious goal of contributing to the chronological ordering of works of art, thereby entering on terrain which had always been claimed as the exclusive preserve of art-historical connoisseurship.

To the best of my knowledge the only scholar to have discussed the implications of this approach has been Giovanni Romano. In the Preface to the second edition of his Studi sul paesaggio (Turin 1991), Romano, making use of my own metaphor, remarked that "the question of 'controls' cuts both ways, and the historical and stylistic 'peg' constituted by Piero della Francesca's work at Rimini in 1451 must take priority over the clues we can garner from our knowledge about patrons, however accurate or plausible this may be". 4 Put in those terms, the question needs no discussion: no clue, obviously, will carry as much weight as an established date. However, by coupling together the epithets "historical and stylistic" Romano conceals the very difficulty which I address in the two writings that he mentions, my original Preface to the present book and the essay "Absolute and Relative Dating: on the Method of Roberto Longhi" which appears here as Appendix IV. Style, to be sure, is a historical phenomenon, and as such is bound up with a temporal context which can in principle be established.⁵ However, the dating of stylistic aspects can be coupled with absolute calendar time only by reference to extra-stylistic facts - for example, the date written on Piero's Rimini fresco. I must repeat that without this date, it would be impossible to take the fresco as a "peg", a reference point which remains indisputable (unless and until its reliability is successfully challenged) as a basis for the absolute chronology of Piero's oeuvre.6 This is not to deny the coherence of art history as a discipline or to suggest that the judgement of connoisseurs is less trustworthy than that of historians.7 Nevertheless, the fact that they can only be relative does set clear limits to the evidential authority of purely stylistic datings. When Luciano Bellosi put forward the date "1459" as a terminus ante quem by which Piero must have finished his Arezzo frescoes, scholars (including, at first, myself) took this to be incontrovertible because it relied on a definitively extra-stylistic datum, namely the death in that year of Giovanni di Francesco, who painted a predella that shows the influence of the frescoes. Here, in Aristotelian terminology, was a tekmerion, a natural and necessary proof, which was intrinsically more reliable than the semeia, the clues and indications, which

historians (including art historians) must normally work with.⁸ Naturally, even necessary proofs may be put to the test of analysis, and I explain in Appendix I why in my view we should place credence neither in the accepted date of Giovanni di Francesco's death nor in the line of argument based upon it. Here too I have tried to emphasize, beyond particular questions of fact, a broader general point: namely that when we discuss artistic phenomena in a historical perspective, we can do so only by simultaneously considering stylistic and extra-stylistic data.

This may seem obvious enough, even if there are those who disagree. Less obvious are the historical and theoretical consequences which it entails, and which I discuss in Appendices III and IV. The young Roberto Longhi was a futurist, and (as Cesare Garboli has shown) something of a follower of Gentile, and he envisaged the artist as a label, affixed to a series of works situated in an abstract time which had little to do with the profane time of calendar chronology. In his mature work, Longhi sought to establish comparability and compatibility between stylistic and extrastylistic events: now the artist had become someone who ate, drank and wore clothes, just like the patron and the carpenters. In moving from the first position to the second, Longhi was crucially influenced by the discovery (thanks to the work of Bernard Berenson and, indirectly, of Gertrude Stein and Picasso) that a trajectory can be traced from the work of Piero to that of Cézanne (see Appendix III).

Today it seems to me inevitable that my investigations into the work of Piero were destined sooner or later to become investigations also into that of Longhi. Longhi has remained both a model and a continual challenge to me, even where I differ from his conclusions, as I do for instance when I date the *Flagellation* some fifteen years later than he does, making it a work not of Piero's youth but of his maturity. This later date, I note, is now generally accepted, on various grounds, and even by scholars (such as Bertelli) who reject my arguments. Meanwhile, I have continued to work on the *Flagellation*. I have made some alterations to the final chapter, and have radically reworked the Preface to the third Italian edition, which appears here in its new form as Appendix II. Will be seen that here, taking account especially of the objections raised by Luciano Bellosi, I have come, on one important point, to concur with those who have disagreed with me.

This detailed work has contributed to my ongoing reflections, over the last decade, on a more general theme: the theme of proof, which I have

considered several times and in various perspectives. However, I should not insist too much on my methodological concerns. I have gone on working on Piero above all because his paintings have gone on fascinating me.

Notes

In this new edition, I have taken account of the criticisms of my argument on the *Flagellation* advanced by Salvatore Settis, Federico Zeri, Charles Hope and Luciano Bellosi. I am most grateful to them all; final responsibility for what I say here naturally remains mine alone. Other debts are acknowledged in their due place in the text.

Los Angeles, June 1994

- 1. The German and Spanish versions were based on the first edition. The English, French and Portuguese translations took account of the corrections incorporated in the third (1982) Italian edition. The Japanese version is based on the present text.
- 2. I have not attempted to update the bibliographical references to take account of new works on Piero published since 1981 (of which there have been an exceptionally large number, as the quincentenary of the painter's death was celebrated in 1992): to have done so would have meant writing a new book.
- 3. See respectively M. Aronberg Lavin, Piero della Francesca: the Flagellation, new edn, New York 1990, p. 103; and C. Bertelli, Piero della Francesca, Milan 1991, p. 123.
 - 4. G. Romano, Studi sul paesaggio, second edn, Turin 1991, p. xxvii.
- 5. In the original Preface to this work (see above), I wrote that no objections are likely to be raised "if a scholar working in an overtly historical perspective decides not to venture into the field of stylistic analysis". Romano quotes this phrase and comments that such a formulation seems to "exclude style from the realm of historical research, either real or potential" (Romano, *Studi*, p. xxiv). That I was very far from intending any such exclusion would have been clear enough had Romano quoted a little further, for the next sentence continues: "The present work, however, has means and ends that are different, and perhaps more ambitious" (and these are set out in the rest of the paragraph).
- 6. In an absent-minded mood Bertelli wrote that "it must be established whether Piero had already been working at Rimini when he began painting his tale of queens and emperors on the walls at Arezzo" (Bertelli, *Piero*, p. 88). But in providing an obviously positive answer to this question he forgot to mention precisely the Rimini fresco.
- 7. Aspersions of this kind (which were never intended on my part) are rightly rebutted by Romano: see *Studi*, pp. xxiv, xxvii.
- 8. This point is further discussed in my *History, Rhetoric, and Proof*, Hanover and London 1999, pp. 38–53.
- 9. See Bertelli, *Piero*, pp. 123, 80 (where it is argued respectively that the Arab depicted against the light is contemporary with the angel in the *Dream of Constantine*, and that the frescoes of the Arezzo cycle were entirely completed before 1459, and perhaps even before 1455). Bertelli does not discuss my dating.
- 10. The alterations here referred to, together with other authorial changes to the 1982 Italian text, were made before, and incorporated in, the English version of 1985; nor does this version include the "Preface to the third edition" mentioned here.

The Enigma of Piero

for Gabriele

Abbreviations

ACAU Archivio della Curia Arcivescovile, Urbino

ACS Archivio Comunale, San Sepolcro

ASC Archivio di Stato, Cesena ASF Archivio di Stato, Firenze

ASG Archivio di Stato, Gubbio

ASR Archivio di Stato, Roma

BCCF Biblioteca Comunale, Castiglion Fiorentino

BNCF Biblioteca Nazionale Centrale, Firenze

BUU Biblioteca Universitaria, Urbino

On 15 February 1439, John VIII Palaeologus, the Eastern Emperor, made his entry into Florence. The previous year he had disembarked in Italy, together with his retinue, to take part in the Council debating the union of the Eastern and Western Christian Churches. The Council had recently removed from Ferrara to Florence. A contemporary chronicle tells us that the following citizens assembled to do homage to the Emperor: "the Signori, the Colleges, the Captains of the Parties, ten of the Balia, eight of the Officers of the Monte, six of the Mercatanzia, and the seven greater Guilds, and many other citizens with the banner, and then seven Cardinals with the whole court, and all the barons, and other Greeks of the said Emperor, who were already in Florence. It was a fine and a large company." The Emperor "wore a white gown with over it a mantle of red stuff and a white hat coming to a point in front in which he had a ruby bigger than a pigeon's egg and many other precious stones". Men and women thronged the streets to watch the procession: but "then it began to rain very heavily, so that it spoiled the festivity . . . ".1

Among the spectators scattered by the downpour may perhaps have been the young Piero della Francesca. We know for certain that on 7 September of the same year he was working, with Domenico Veneziano, on the (now destroyed) frescoes of the S. Egidio chapel.² And when, some twenty years later, he was required to portray the face of John VIII Palaeologus on the walls of the church of San Francesco at 1 Arezzo, he placed upon the figure's head the unmistakable "white hat coming to a point in front" by which the anonymous Florentine chronicler – like Pisanello and Filarete – had been so struck.³

His stay in Florence in 1439 does indeed mark the start of Piero's history as an artist: but not only (as has hitherto been held) because he then met Domenico Veneziano. The dense network of connections that

bound him to the world of the Council was also destined to leave upon his painting its own unforeseeable and ineradicable mark.

Notes

- Istorie di Firenze dall'anno 1406 fino al 1438, in L.A. Muratori, Rerum Italicarum Scriptores, Mediolani 1731, XIX, col. 182; and see also the account in J. Gill, The Council of Florence, Cambridge 1959, whose translation of the contemporary chronicle is here partly reproduced (see pp. 183–4).
- 2. Longhi, Piero, p. 97.
- 3. The Constantine of Victory of Constantine was identified as a portrait of Palaeologus by E. Müntz (1883) in a contribution that went unregarded (cf. Battisti, Piero, vol. 1, p. 492, n. 282). A. Venturi and A. Warburg (1911 and 1912) later arrived at the same conclusions independently: cf. A. Warburg, "Piero della Francescas Constantinschlacht in der Aquarell-kopie des Johann Anton Ramboux", in Die Erneuerung, vol. 1, pp. 253–4 (and see the editors' note on p. 390). Kenneth Clark (Piero della Francesca, London 1969, p. 78) maintains that in painting the portrait of Palaeologus, Piero drew upon his direct experience of seeing him at Florence, rather than upon Pisanello's medallion, as is supposed by the other scholars we have mentioned; but see below, ch. II. The sleeping Constantine of the Dream has also been identified as Palaeologus: cf. C. Marinesco, in Comptes-Rendus de l'Académie des Inscriptions et Belles-Lettres, 1957, p. 32, and, independently, M. Vickers, "Some Preparatory Drawings for Pisanello's Medallion of John VIII Palaeologus", in The Art Bulletin, LX (1978), p. 423. This second identification has been rightly called into question by Battisti, Piero, vol. I, p. 492, n. 283.

The Baptism of Christ

Most scholars (though not all) hold the Baptism of Christ - now in the National Gallery, London – to be among the earliest of Piero's surviving works. The painting's subject is readily identifiable. De Tolnay, however, noted a departure from the traditional iconography of the Baptism: the three angels are not holding up Christ's robes as he immerses himself in the Jordan. Here, the angel on the left is watching the scene, while the one on the right has one arm over the shoulder of the central angel, 2,3 whose right hand he also holds. This grouping was compared by de Tolnay to the attitude of the three Graces shown on a contemporary medal designed by Niccolò Fiorentino, which bears the legend "Concordia": he interpreted it as an allusion to the Graces as symbols of Harmony.¹ M. Tanner has recently developed this interpretation in greater detail, seeing the gesture made by the two angels in the sight of the third as a reference, modelled on the Roman iconographic depiction of Concord, to the religious concord between the Western and Eastern Churches ratified by the Council of Florence of 1439.2 Tanner's entire interpretation hinges on her reading of the precise significance of this gesture. The figures in the background are identified as Byzantine priests by their oriental clothes and headgear (which will appear again in the Arezzo frescoes). The three angels, and also the colours of their robes red, blue and white - are an allusion to the Trinity, in accordance with the symbolism proposed by Innocent III on the founding of the Order of the Holy Trinity, and they evoke the theological debates conducted over a period of two years, first at Ferrara and then at Florence, between the theologians of the two Churches on the doctrine of the Trinity. In clasping hands, the two angels not only symbolize the end of the schism and the restoration of harmony between the two Churches; they also represent the most theologically important of the conclusions upon which the Council had agreed: the addition to the Credo of the so-called

"Filioque" clause, which decreed (after prolonged resistance from the Eastern Church) that the Holy Spirit proceeded both from the Father and from the Son.³ And the tondo that originally hung above the *Baptism* (and which is now lost) likewise emphasized the trinitarian implications of the ceremony that took place on the banks of the Jordan.

The suggestion that the painting dates from 1440 or soon afterwards follows from all this. Any date much later would be incompatible with the fact that the harmony between the Churches was soon broken, thanks to the renewed strength of the faction in Constantinople hostile to unity with the Church of Rome. It is worth noting that this dating, based exclusively on iconographic features, is substantially the same as that proposed by Longhi on exclusively stylistic grounds (1440–45).⁴

As we have seen, Tanner's interpretation draws together the elements of the *Baptism* into a single, compact and coherent design, which then provides a convincing explanation for the iconographic anomalies. However, Battisti, taking as his starting-point precisely the most striking of these anomalies (the gesture of concord to which de Tolnay drew attention), had suggested, a little earlier, an altogether different interpretation.

Before its final removal from San Sepolcro, Piero's Baptism formed part of a polyptych kept in the cathedral church of St John the Evangelist. On the side panels and the predella (now in the San Sepolcro museum) are depicted, respectively, saints and doctors of the Church, and scenes from the life of St John the Baptist. Neither is by Piero, and both are undoubtedly later than the Baptism. They are hesitantly attributed to Matteo di Giovanni, and dated betwen 1455 and 1465.5 The predella bears the family tree of the Graziani family, one of the most prominent families in San Sepolcro, and it was unquestionably a Graziani who commissioned the predella and the side panels of the polyptych. Battisti suggests that the same person also commissioned the central panel and the tondo that hung above it, painted by Piero. From de Tolnay's reading of the work, he (unlike Tanner) singles out the comparison between the angels and the three Graces, paying no attention to the theme of concord. He offers an explanation of the presence of the angels in the attitude of the Graces on the basis of a passage from Leon Battista Alberti's Trattato della pittura (Treatise on Painting), which explains that this disposition of the Graces, when clad as opposed to naked, signifies one who at once bestows and receives a gift. The iconography of Piero's Baptism would

imply a combination between this passage in Alberti and another, in St Thomas Aquinas's *Summa*, where Christ is presented as the supreme example of generosity. The painting, then, may have been commissioned (so the argument runs) by a rich merchant – probably, one of the Graziani – who wished to expiate, by a generous act, his own sins of usury. Piero, having originally been commissioned by this merchant to paint the entire polyptych, completed the *Baptism* and the lost tondo depicting God the Father before he began to slacken in his work. This obliged the patron to enter into a second contract with Matteo di Giovanni. It follows, suggests Battisti, that the *Baptism* should be dated around 1460, which is almost twenty years later than the traditional dating. In confirmation of all this, Battisti cites a stylistic feature of the painting, the echoes of classical sculpture perceptible in the figures of the angels – echoes that oblige us, he claims, to date the painting after Piero's journey to Rome in 1458–59.6

Here, then, are two interpretations, both beginning from the same detail (the handclasp of the two angels), which nevertheless arrive at completely different conclusions about both the work's iconographic implications and its dating. I should say at the outset that I find Tanner's interpretation very convincing, and Battisti's altogether implausible. However, both are conjectural. To treat them on a par – which in effect would be to place them both in abeyance pending the arrival of external documentary proof that may never be forthcoming – is hardly a reasonable course. What we need, then, is a clarification of what is meant, in this context, by terms like "convincing" and "implausible"; of our grounds for preferring one given interpretation to another; and, more generally, of the way we conceive the problem of how written materials can help in the verification of iconographic research.

We have already seen that the picture is hard to interpret because it does not altogether fit into pre-existing iconographical tradition (the tradition, in this case, of "the Baptism of Christ"). There may be only the slightest anomaly (the attitude of the two angels); but this may sometimes be enough – as in the famous instance of Giorgione's *Tempesta* – to permeate the whole work and to set us the most tantalizing iconographic puzzles. Settis, discussing the various interpretations of Giorgione's picture, has formulated two rules: a) every piece of the puzzle must fit into place; b) the pieces must form a coherent composition.⁷ I would add a third:

c) other things being equal, the interpretation requiring fewest hypotheses should generally be taken as the most probable (though we must not forget that the truth is sometimes improbable).

By these three criteria (comprehensiveness, coherence, economy), Tanner's suggestion is manifestly preferable. For Battisti introduces hypotheses that give rise to further hypotheses, as when the three Graces, to which the angels are said to allude, are made in their turn to symbolize Christian generosity. He can link these two hypotheses together only by surmising a cross-contamination of two texts, connected only by accidental associations that could be indefinitely extended.8 Finally, since his own interpretation centres on the notion of usury, a feature such as the Eastern priests in the background becomes frankly heterogeneous, and can be integrated only through a quite gratuitous postulate that there are several simultaneous layers of meaning.9 Tanner's reading, by contrast, seems harmoniously to unite the picture's multitude of iconographic elements around the theme of the Trinity debated at the Council of Florence. Even in this case, however, we cannot rule out the possibility that this coherence has been unwittingly introduced by the interpreter. 10 First of all, the selection of pieces of the puzzle (that is, of features regarded as iconographically significant) is itself a factor in the interpretation – as we can see from the fact that no scholar before de Tolnay had paused to remark on the attitude of the two angels. Hence the danger of picking out features without iconographic relevance, and then building up from them an interpretation that may be coherent, but which is remote indeed from the painter's intentions. Second, every iconographic feature is polyvalent, and can thus open the way to divergent series of significations. We can follow de Tolnay's suggested comparison between the angels of Piero's Baptism and the medal designed by Niccolò Fiorentino in either of two directions: three angels - three Graces (Battisti), or three angels concord (Tanner). To entertain such an alternative is legitimate, it may be objected, so long as the research is at an early stage: as work proceeds, the initial conjecture is bound to be strengthened or destroyed as internal confirmation is, or is not, forthcoming. The danger, however, is that the polyvalence or plasticity of the images will be more or less consciously exploited to yield apparent confirmation of the favoured hypotheses. How are we to know, in any given picture, if a lamb stands for Christ, or for meekness - or if it is just a lamb? Sometimes the context may determine this: all interpretation (of literary passages, pictures, or

whatever) undoubtedly presupposes a reciprocal interchange between the whole and the parts. In some cases, however, this healthy circularity of hermeneutic interpretation easily becomes a vicious circle.¹¹ It is thus appropriate to introduce into the process of iconographic decoding elements of an external kind, such as commissioning, which allow for verification – and which broaden the notion of context to include the social context. To be sure, research into commissioning does not always yield unambiguous iconographic clues. In cases such as the one we are discussing, however, where there is a partial or total iconographic anomaly, to identify the patron does at least help to cut down drastically the number of iconographic hypotheses under consideration. And in the event of a convergence between the results of the two branches of research (into iconography and into commissioning), the possibility of error is reduced practically to nothing.

In Tanner's reconstruction, the missing piece is, precisely, the unsolved problem of the picture's patron. The subtle theological allusions that she deciphers tend to rule out the possibility that any member of the Graziani family could have commissioned the *Baptism*. The question can now be approached on the basis of the factual data and new hypotheses put forward in E. Agnoletti's recent researches into the painting's peregrinations.

It was known already that the Baptism, transferred in 1807 (when the Priory was closed down) from the high altar of the Priory of St John the Baptist in San Sepolcro to the Cathedral of St John the Evangelist, was then put up for sale on the art market in 1859. Agnoletti has now succeeded in finding evidence about the picture that predates what was previously known, and he has at the same time proposed a new hypothesis about its commissioning. The Baptism, it is suggested, was painted for the altar of the confraternity of St John the Baptist, founded in 1406 by Diosa di Romaldo di Mazarino de Mazzetti, widow of Giovanni di Fidanza. She had endowed a chapel situated "in the Badia del Borgo" – that is, the Abbey of San Sepolcro - "near the main gate upon the right-hand side and supported by the first column, and which is known by the title of St John the Baptist", with the stipulation that mass was to be celebrated there each day for her soul and for her husband's. The Baptism may have remained in the abbey, which by this time had become a cathedral, until 1563, when the altar was dedicated in perpetuity to St Egidius and St Arcanus. What

then became of the picture, or rather of the polyptych, we do not know. Agnoletti suggests that it was removed to the priory of St John the Baptist in 1583, in which year the building's frescoed walls, fallen into disrepair, were white-washed on the instructions of the Papal emissary, Monsignor Peruzzi. The polyptych was certainly in the priory in 1629, for the records of that year's pastoral visitation mention an "iconam depictam in tabula cum imagine S. Iohannis Baptistæ et aliorum sanctorum cum ornamento ligneo deaurato". This, the earliest evidence we possess for the presence of the picture in a particular place, is later confirmed in the records of subsequent pastoral visitations (1639, 1649) and in the inventories of 1673, 1760 and 1787. In 1807 the polyptych returned, as we have said, to the Cathedral of St John the Evangelist, where, according to Agnoletti's reconstruction, it had originally been. This last hypothesis is further supported by the lack of any mention of the polyptych among the property of the Priory at the time of its suppression.¹²

This chain - made up in part of documents, in part of hypotheses bringing them into a whole - contains one weak link: its first. The patron of the Baptism cannot be identified as the Confraternity of St John the Baptist, for the excellent reason that no confraternity of that name has ever existed in San Sepolcro. We can trace it, supposedly, in just one piece of evidence, the will of its presumed founder, the Lady Diosa. However, if we examine the original document, rather than the sixteenthcentury recension tracked down by Agnoletti, no doubt on the point is possible. The will forms part of the record of the acts and dealings of the Confraternity of San Bartolomeo (the richest and most important in San Sepolcro), because this was the confraternity "instituted" by, or in other words made guarantor for, the last will of one of its members, the testatrix Diosa di Ranaldo (not Romaldo) di Mazarino de Mazzetti. She it was who, on 10 March 1406, "instituted the fraternity" ("instituì la fraternita") and "endowed its chapel in the Abbey of the town near the main gate which is of St John the Baptist and is supported by the first column, with the properties undermentioned, to wit: first, with a plot of arable land", and so forth (there follows a full inventory of the properties comprised in the bequest). "For which gift," the will continues, "she desires that the abbot of Borgo San Sepolcro (l'abbate del Borgo) be required in perpetuity to see to the officiating of the said chapel" and that masses be celebrated there "for the soul of the present testatrix and of the said Giovanni her husband and for the worship of God and of the glorious Virgin Mary and

of St John the Baptist". In the celebration of these masses, use was to be made of the "gilded silver chalice" and of the "missal made therefor" which Diosa had previously given. The bequest was also to cover the expenses of Diosa's funeral, as agreed with Bartolomeo, the Abbot of the *badia del Borgo* (the Abbey of San Sepolcro). In default of this, the bequest was to be transferred "from the said monastery and abbey . . . to the said fraternity" of San Bartolomeo. ¹³

The bequest, then, was made to the Camaldolite Abbey (later the Cathedral) of Borgo San Sepolcro. Diosa's will proves that there already existed, in 1406, an altar in the abbey dedicated to St John the Baptist. It is for this altar, according to Agnoletti's shrewd reconstruction, that Piero must have painted his Baptism. The hypothesis could be definitively confirmed only by the hitherto untraceable record of the painting's commissioning. It is none the less extremely probable. Once we stop imagining the patron to have been the non-existent Confraternity of St John the Baptist, and put in its place the Camaldolite Abbey, then the accuracy of Tanner's iconographic interpretation does indeed seem scarcely open to doubt. For it was in 1439 that Ambrogio Traversari, Abbot-General of the Camaldolites, distinguished humanist and determined advocate of reconciliation with the Greek Church, died at Camaldoli. He had been one of the participants in the recently concluded Council of Ferrara and Florence (besides acting as second interpreter, thanks to his having taught himself Greek). He was entrusted, among other tasks, with that of translating into Greek the decree Laetentur coeli (6 July 1439), which officially ratified the ending of the Schism.¹⁴ This explains perfectly how the Baptism came to adorn the Abbey of St John, for it is a picture dense with allusions to the religious concord achieved at the Council. To the eyes of a selected group of spectators, able to follow its implications, the iconography of the Baptism yielded its meaning as an act of homage to Traversari's recently completed labours, and thus as an exaltation of the glories of the Camaldolite Order.

However, the implicit homage to Traversari also touched on local politics and local pride. The abbey of St John the Evangelist, consecrated in 1340, was the symbol of the religious and political power which, since the end of the twelfth century, the Camaldolite monks had exercised over the Borgo (despite its enfeoffment to various feudal lords). The bishops of Città di Castello had on several occasions tried, without success, to displace the monks and to incorporate Borgo San Sepolcro

into their own diocese. Traversari had recently played an important part in this often bitter history of antagonism. On assuming the post of Abbot-General, he had at once set out on a series of journeys, described in detail in his *Hodoeporicon*, which took him to the various abbeys of the Camaldolite Order. In the autumn of 1432 he stayed in San Sepolcro, where Pascasio, the Abbot, gave him details of the struggle with the Bishop of Città di Castello. When he returned home after this journey, Traversari wrote to inform Pascasio that Ugolino, the former Abbot of Faenza, had been sent to Rome to pursue the matter further. The Bishop's claims on the monastery were sure to be rejected, declared Traversari; the "ancient privileges" were certain to remain "inviolate". A year later, Traversari made direct representation to Pope Eugenius IV, asking him to reaffirm, against all machinations from other quarters, the rights of the abbots over the Borgo. 15

Following an unsuccessful invasion by the Bishop of Città di Castello, who was driven out by an uprising of the townspeople, Eugenius IV granted Borgo San Sepolcro to Florence (1441), in payment for the costs of the Council. The period of Florentine rule was inaugurated by a frenzy of building: an anonymous Camaldolite monk wrote to Nicholas V that the town walls had been rebuilt, the churches embellished, and the dwelling-houses renovated.¹⁶ The commission for Piero's Baptism may perhaps date from this same period, and may have come from the Camaldolite Abbot, who at this time was Pascasio - about whom, however, we know almost nothing.¹⁷ The painting's iconography was an indirect tribute to Traversari: not only because the angels' attitude of concord and harmony, and their trinitarian symbolism, invoke his vital contribution to the Council's successful outcome, but perhaps also because we should see, in the image of Borgo San Sepolcro in the background,18 an allusion to his defence of the rights of the Camaldolite Abbey at a difficult period in its history.

Notes

^{1.} C. de Tolnay, "Conceptions religieuses dans la peinture de Piero della Francesca", in *Arte antica e moderna*, VI (1963), p. 214. Salvatore Settis has pointed out to me that the gesture of the angel on the left (the palm of the hand turned down, with the fingers extended) denotes the peacemaker in classical art.

- 2. J. Gill, The Council of Florence.
- 3. On all this, see M. Tanner, "Concordia in Piero della Francesca's Baptism of Christ", in The Art Quarterly, XXV (1972), pp. 1-20. It had already been suggested by C. Marinesco ("Echos byzantins dans l'oeuvre de Piero della Francesca", in Bulletin de la Société des Antiquaires de France, 1958, p. 192) that the figures in the background of the Baptism should be identified as dignitaries who had come to Italy in the retinue of John VIII Palaeologus. M. Aronberg Lavin, in Piero della Francesca's Baptism of Christ, New Haven and London 1981, which appeared at the same time as the first edition of the present work, put forward the hypothesis (on the basis of research by don Agnoletti on which the present author has also drawn) that the Baptism was intended for a chapel of the Badia at Sansepolcro; Lavin further suggests (p. 135) that the iconography may have been inspired by Ambrogio Traversari, though the possibility of a connection with the Council of Florence, suggested by Tanner (p. 68, n. 8 and p. 69, n. 11) is explicitly rejected. Lavin argues that the painting's iconography refers not only to the Baptism of Christ, but also to Epiphany and to the marriage at Cana, celebrated on the same date (6 January) in the liturgical calendar. This coincidence leads Lavin to identify the four people in Oriental costume with the three Magi (pp. 65ff.), to find "connubial connotations", symbolizing marriage, in the iconography of the baptism (pp. 85ff.), to credit Piero with an implausible play of the words on "nut" (noce) and "wedding" (nozze), and so forth. M. Baxandall's interpretation (in Patterns of Intention, New Haven 1985, pp. 103-37) is on an altogether different level. On the one hand, Baxandall denies that there is anything anomalous in the detail which provides Tanner's starting point (the fact that the two angels' hands are joined); on the other, he makes no suggestion as to the possible patron.
- 4. Tanner ("Concordia", p. 20, n. 84) lists various other proposed datings, all of them rather later and thus difficult to reconcile with the iconographic allusions to the Council.
 - 5. Ibid., p. 2.
- 6. Battisti, I, p. 117 (the surprising hermeneutic use that he makes, on pp. 117–18, of Pasolini's *Gospel According to St Matthew* would require separate discussion). Battisti suggests the second half of 1459 or 1460 as the date when work began on the painting (p. 113), and 1460–62 as the date of completion (II, p. 19). Both dates are obviously conjectural.
 - 7. Settis, La "Tempesta", p. 73.
- 8. The chain running from Leon Battista Alberti to St Thomas Aquinas is pursued further by Calvesi, who introduces passages from Gregory of Nazianzus and Marsilio Ficino on the basis of the allusion (of Calvesi's own discerning) of the three Graces to divine Grace. Thus he describes an emerging "free-trade metaphor whereby the three Graces represent the circulation of goods redounding to the benefit of its instigators . . . The Christ-Sun, or Christ-Gold, numinous and numismatic, becomes a model of 'liberality', or even a prefiguring of liberalism; the entire logic of the capitalist economy, from 'interest' . . . to consumerism . . . is here already delineated in a strikingly coherent manner" (Calvesi, "Sistema", pp. 106ff., esp. p. 108).
- 9. See the objections to this notion of "simultaneous layers of meaning" put by Gombrich in *Symbolic Images*, pp. 15–20.
- 10. On this point, see also C. Ginzburg and A. Prosperi, Giochi di pazienza. Un seminario sul "Beneficio di Cristo", Turin 1975, p. 84.
- 11. See C. Ginzburg, "From A. Warburg to E.H. Gombrich", esp. pp. 49-51 (discussing an interpretation suggested by E. Wind).
- 12. E. Agnoletti, La Madonna della Misericordia e il Battesimo di Cristo di Piero della Francesca, Sansepolcro 1977, pp. 33–40. Don Agnoletti kindly drew my attention to this last point in a conversation.
- 13. ACS, s. XXXII, n. 182, cc. 33*r*–*v* (it is will no. 182). The will's content is repeated in brief in c. 129*v*, as well as in a loose sheet inserted in s. XXXII, n. 179. Certain codicils added

- on 1 November 1411 did not affect the bequest to the Abbey (cf. s. XXXII, n. 179, unnumbered pages). For a summary account of the documents deriving from the archive of the Confraternity of San Bartolomeo, see G. Degli Azzi, "Sansepolcro", in *Gli archivi della storia dell'Italia*, Rocca San Casciano 1915, s. II, vol. 4, pp. 139ff. (there is a reference to Diosa's bequest on p. 148). On the confraternity, see I. Ricci, *La fratemita di S. Bartolomeo*, Sansepolcro 1936 (see pp. 22–3 for two extracts, imperfectly transcribed, from Diosa's will). A picture based on fuller and deeper research is now available in J.R. Banker, *Death in the Community: Memorialization and Confraternities in an Italian Commune in the Middle Ages*, Athens (Georgia) 1988.
- 14. For Traversari, see especially the eighteenth-century edition of his correspondence (Ambrosii Traversarii generalis Camaldulensium aliorumque ad ipsum, et ad alios de eodem Ambrosio latinae epistolae, 2 vols, Florentiae, 1759; anastatic reprint, Bologna 1968). On the merits and demerits of this edition see the seminal researches of G. Mercati, Ultimi contributi alla storia degli umanisti, I, Traversariana, Vatican City 1939, with copious unpublished documentation. On the part played by Traversari in the Council of Florence, see Gill, The Council, p. 287, and passim.
- 15. There is an eighteenth-century edition of the *Hodoeporicon* (Florentiae, n.d.), reprinted as an appendix to A. Dini Traversari, *Ambrogio Traversari e i suoi tempi*, Florence 1912; on his stays in Borgo San Sepolcro, three in all, see pp. 46, 53, 125ff. (of the appendix). A detailed account of Traversari's Abbot-Generalship is given, on the basis of the correspondence and the *Hodoeporicon*, by G.B. Mittarelli and A. Costadoni, *Annales Camaldulenses*, VII, Venetiis 1762. On his interventions in the struggle with the Bishop of Città di Castello, cf. *Epistolae*, XVII, 5; V, 13; I, 4; II, 3; II, 24. For a brief chronicle of events, see E. Agnoletti, *Sansepolcro nel periodo degli abati (1012–1521)*, Sansepolcro 1976.
- 16. Mittarelli and Costadoni, Annales Camaldulenses, p. 203; "...instauratus antemuralis terrae nostrae per gyrum omnino totus, et propugnacula circum reparata, et etiam denuo constructa; delubra Sanctorum intra muros miro ordine pulchrificata; arces, aedesque publicae roburatae, instauratae, novatae, constructae..."
- 17. Traversari sent him two letters, in 1431 and 1432, about the quarrels between the Abbey and the Bishop of Città di Castello: cf. Epistolae, 1. XVIII, 5 and 6. The "Pascasius Burgensis" who contributed two epigrams to Piero di Nicolò da Filicaia's mathematical Giuochi is unfortunately a Minorite, not a Camaldolite (cf. BNCF, ms Magl. XI, 15, listed by P.O. Kristeller in his Iter italicum, Leiden-London 1965, I, p. 118). If Salmi ("Piero della Francesca e Giuliano Amedei", L'arte, XXIV [1942], pp. 26-44) is right in his suggestion that the Camaldolite Abbot Giuliano Amedei collaborated in the Misericordia polyptych, this would testify to the persistence of the links between Piero and the Camaldolite order. On Amedei, see also J. Ruysschaert, "Miniaturistes 'romains' sous Pie II" in Enea Silvio Piccolomini – papa Pio II (Conference Proceedings), D. Maffei (ed.), Siena 1968, pp. 257ff. There has recently been some notable research on Piero's early development: see F. Dabell, "Antonio d'Anghiari e gli inizi di Piero della Francesca", Paragone, no. 417, 1984, pp. 73-94; J.R. Banker "Piero della Francesca as Assistant to Antonio d'Anghiari in the 1430s: some unpublished documents", The Burlington Magazine, CXXXV, Jan. 1993, pp. 16-21; J.R. Banker, "Piero della Francesca's S. Agostino altarpiece: some new documents", ibid., CXXIX, Oct. 1987, pp. 645-51, esp. p. 649 (on the dates of Piero's presence in Florence).
- 18. On the identification of the fortress in the background as Borgo San Sepolcro, see Longhi, *Piero*, p. 19. He is followed by Tanner, "Concordia", pp. 1 and 14, who sees (perhaps in an excess of interpretative zeal) in the Tiber flowing past Borgo an allusion to the supremacy of Rome.

II

The Arezzo Cycle

It has been suggested that while Piero was in Florence as a follower of Domenico Veneziano, he met Traversari. To prove that meetings of this kind took place is hardly ever possible. There is evidence that Piero was in Florence in September 1439; in the summer of that year, the Council's deliberations being over, Traversari left the city to seek repose at the monastery of Camaldoli. On 19 October he died, unexpectedly, at Camaldoli. Chronological difficulties apart, however, the Abbot-General of the Camaldolite Order, his time taken up with the business of the Council, would in any case hardly have come within the social ambit of a painter taking the first steps in his career. Nevertheless, Piero did come into contact with Traversari's circle, and this contact did not express itself only in the *Baptism*. For among that circle was a member of the Bacci family who were the patrons of Piero's greatest work – the Arezzo cycle of frescoes.

The Bacci in question was Giovanni, eldest son of Francesco and grandson of Baccio. The latter, an extremely wealthy spice merchant, made the original bequest for the decoration of the family chapel in the church of San Francesco; it was Francesco who decided to set the project in motion, selling a vineyard in 1447 to pay the painter originally entrusted with it, Bicci di Lorenzo.³ Giovanni is a rather different figure. It was Creighton Gilbert who first drew attention to him. Gilbert, drawing upon the materials collected by the seventeenth-century scholar Gamurrini in his *Istoria genealogica delle famiglie nobili toscane et umbre*, noted that Giovanni, whose father and grandfather were merchants, graduated at Siena in 1439, and pursued a career in the Papal administration, becoming a clerk to the Camera Apostolica. This is the basis for suggesting that he played a decisive role (perhaps even putting forward theological ideas) in endowing the iconographic scheme of the Arezzo cycle with the innovations that distinguish it from traditional depictions of the Legend of the True Cross.⁴

This trail – a very promising one, as we shall see – was almost immediately abandoned by Gilbert. However, further research into Giovanni Bacci yields additional, and invaluable, clues. The starting point for this further research is an allusion in a letter published by Gamurrini and remarked on by Gilbert. In this letter, written in 1449, Giovanni Bacci addresses himself to Cosimo de' Medici, and refers to Giovanni Tortelli, a privy servant to the Pope, as "his relative". Following the path pointed out by Gilbert, and taking note also of M. Regoliosi's almost contemporaneous researches into Tortelli, who was a celebrated humanist, and into Bacci himself, we can at least sketch a portrait of the man whose impact on Piero was certainly decisive.

In the first evidence we have about him, Giovanni Bacci's name is closely linked with that of Traversari. It was Traversari, in fact, who in 1432 mentioned a young man whom he calls "Giovanni Aretino" (that is, Giovanni of Arezzo) in a letter to his brother Girolamo, newly appointed Provost of the Lemmo hospital at Florence. Traversari recommends this young man to his brother, mentioning that he has been on the closest terms with him at Rome. Regoliosi rightly suggests that this "Giovanni Aretino" (who at the time cannot have been much older than twenty) is Giovanni Bacci, rather than the much better-known Giovanni Tortelli, who also came from Arezzo.⁶ This would seem to be the same Giovanni Aretino whom Traversari, while at Ferrara in 1439 for the Council, again recommended, this time to Daniele Scotto, Bishop of Concordia and Governor of Bologna. In this latter case, we can be sure Bacci is meant, for in the course of praising his character and his passion for learning Traversari says that he is a clerk to the Camera Apostolica. Bacci was probably appointed to this post during the preceding year; he certainly owed the appointment to the support of the Medici, with whom he was closely connected all his life.7 The position was important, and well-paid: in 1438, Pope Eugenius IV had determined that there should be seven clerks to the Camera Apostolica, explicitly justifying this limited number on the grounds that each clerk would have the prospect of a reasonable income.8

By this time, Giovanni Bacci was already well established in humanist circles. Writing from Bologna in 1437, Lapo da Castiglionchio the Younger recommends him in glowing terms to the Bishop of Arezzo, Roberto degli Asini. A year later, the Aretine humanist Carlo Marsuppini writes to congratulate him on his recent appointment as a clerk to the

Camera, promising (in response, clearly, to his specific request) to send him a codex of Plato's Symposium which had formerly belonged to Niccolò Niccoli, and which had been transcribed by a collaborator of Traversari, the monk Michael. 10 It was at this time that Giovanni was joined at Bologna by Tortelli. We do not know quite how these two were related: both families, the Tortelli and the Bacci, certainly came from Capolona, a village not far from Arezzo.¹¹ Tortelli had just returned from a long voyage in Greece and the Orient, where he had been transcribing codices and epigraphs, collecting material later used in his most important work, the great treatise on Latin orthography, presented in the form of a dictionary (De Orthographia), which was to achieve notable success. 12 At Constantinople he had become acquainted with important figures such as Isidore of Kiev (the future Ruthenian Cardinal) who favoured religious union with Rome; he had then returned to Rome with the Greek delegation sent to the Council of Basel to discuss the reconciliation of the two Churches.

In 1439, Tortelli left Bologna for Florence. The Council - in which his patron, Cardinal Cesarini, was playing a prominent role - moved there at the same time. Bacci, who took his degree in law at Siena this same year. 13 may have followed him. We know that Giovanni Bacci was in Florence in October 1439, for he is mentioned in a letter to Leonardo Bruni from Girolamo Aliotti, a native of Arezzo and the Prior of the Benedictine monastery of St Fiora and St Lucilla (Bacci's devotion to Bruni is emphasized in this letter). Shortly afterwards, this same Aliotti wrote to Bacci from France, where he had been sent as Papal legate, asking for news of the relatives he had left in Arezzo and sending greetings to their common friends at Florence. These friends were Poggio Bracciolini, Carlo Aretino (this is Marsuppini, whom we have already come across, and who had succeeded Leonardo Bruni a few years earlier in the office of Chancellor to the Florentine Signoria), and Leon Battista Alberti. In connection with Alberti, Aliotti recalls "this matter regarding Ambrogio", about which, he says, he has written to Bacci ad nauseam. 14 This is a reference to the project, very dear to Aliotti, of obtaining a life of Traversari. After having spoken of it to Marsuppini, he referred the idea to Alberti, declaring that the theme offered great possibilities and was fully worthy of his high talents. 15 However, neither Marsuppini nor Alberti wrote a life of Traversari: this, perhaps, was one reason why Aliotti, when he came to write his dialogue De erudiendis monachis

(completed in 1442), gave a very prominent place among the interlocutors to "Ambrogio the Camaldolite, that incomparable phoenix of our age", as he wrote in the book's dedication to Pope Eugenius IV.¹⁶

The greatest weight must be given to this documentary proof that Giovanni Bacci, who was to commission work from Piero at Arezzo, was friendly with some of the most illustrious figures of Tuscan humanism (and Bruni's name, as we have said, must be added to those just mentioned).¹⁷ Hitherto, our only certain evidence of any link between Piero and this milieu was the known fact that he stayed at the same time as Alberti in the court of Rimini in 1451, and again in the court of Pius II Piccolomini in 1458–59. It is now possible to reconstruct more fully and more concretely how Piero, through Bacci and his circle, may have assimilated, and developed along new and original lines, certain elements of humanistic culture.

Bacci figures as one of a veritable clan of Aretine humanists. Besides Bacci himself, there were Tortelli, Aliotti and Marsuppini; and less central, because they belonged to a different generation, were such weighty persons as Leonardo Bruni and Poggio (who was not from Arezzo, but from the nearby Valdarno region). In this context, it is also noteworthy that the Alberti family (related, how we do not know, to the Bacci) came from Catenaia, in the Valdarno. 18 We glimpse, here, a solidarity that was geographical as well as generational and cultural. This operated, and reinforced itself, in a dense network of mutual favours and reciprocal recommendations (which are notoriously frequent in the correspondence of the humanists). Bonds of practical help and support often derived from bonds of kinship, whether of the flesh (Bacci was a relative of Tortelli) or of the spirit (Tortelli and Marsuppini were godparents). 19

These links were further strengthened by common cultural and religious interests. On the one hand, there was the passion for the classical world, and more especially for ancient Greece, which found expression in Tortelli's voyage or in Marsuppini's translations of the *Iliad* and of *The Battle of the Frogs and the Mice*; on the other, a desire to bind together again the cords severed in the schism with the Eastern Churches. These themes were harmoniously fused in the character of Traversari, with whom the Arezzo group were all linked, directly or indirectly.

But they are also the themes of Piero's work.²⁰ His iconographic and stylistic choices continued, right into his maturity, to draw upon a double image of Greece, classical and modern. The uncorrupted forms of a

classicism which (to our eyes anyway) appears much more Greek than Roman gave him, more than once, the means to express a political and religious call for the reconquest of Greece and of the once Christian Orient. By tracing the links between these iconographic and stylistic choices and the social network²¹ in which they took form, we shall avoid both unverifiable iconological interpretations and ahistorical invocations of "those visual springs which flow forever underground".²²

We last heard of Tortelli in Florence, together, probably, with Bacci. At this point, their lives took different courses. In 1445, Aliotti recommended Tortelli to the humanist Guarino Veronese.²³ The recommendation evidently bore fruit, for we hear soon afterwards, in a letter from Aliotti to someone identified only as Michelangelo di Borgo San Sepolcro, that Tortelli is likely to obtain a post in the Curia.²⁴ When Niccolò Parentucelli (Nicholas V), a great protector of the humanists, became pope, Tortelli's career in the Curia began: he was appointed a privy servant and made one of the custodians of the Vatican library, then in process of being formed.²⁵ We possess no certain record, on the other hand, of Bacci's movements during these years.²⁶ We know only that at some point he fell into disgrace and was dismissed from the Camera Apostolica. On 6 June 1447, he wrote to Giovanni di Cosimo de' Medici, from Arezzo. His letter is full of lamentations and pleas for help: "All my hope is set on your noble father and on you, his sons . . . My Giovanni, consult with master Alesso as to how you may remove me from here and give me employment in some place where I may be of some good to you. I beg you, come what may, to answer me at once, for things could not be worse with me here and I do not know how I shall stay here any longer. To tell you further how things are, I must say that I have not a very good understanding with my father, for he did not wish me to have worked always against the Patriarch, by whose doing I am now unjustly dismissed."27 This Patriarch, who had brought Bacci's career in the Curia to an abrupt halt, was Ludovico Trevisano, the Patriarch of Aquileia, subsequently Archbishop of Florence and (from 1440) condottiere of the Papal army and Cardinal of S. Lorenzo in Damaso. As Cardinal Camerlingo (Treasurer of the Papal court), he was Bacci's immediate superior and thus well placed to hound him out.²⁸ Political differences may have contributed to the antagonism between the two men. In 1440, Cardinal

Ludovico, together with the troops of the Medici and Francesco Sforza's men, had defeated the Florentine exiles and Niccolò Piccinino at Anghiari. Two years later, these alliances were reversed: in an (unsuccessful) attempt to conquer the Marca, Cardinal Ludovico found himself fighting alongside Piccinino, who had been appointed standard-bearer to the Papal States, against Sforza, now allied with the Medici.²⁹ Perhaps Giovanni Bacci's devotion to the cause of the Medici helped draw down the wrath of the powerful Cardinal Camerlingo. The clash between the two men must in any case have been memorable. Some years later, in 1449, Marsuppini implored Tortelli to use all his authority with the Pope in Bacci's favour, exclaiming: if he has gone astray in the tumult of his anger and passion, as can happen even to the wisest amongst us, it is not right that he should on that account pass his whole life in humiliation especially now that we may hope he has mended his ways.³⁰ Moreover, 4 if Bacci was quick to anger, Cardinal Ludovico was no mouse either, to judge from Mantegna's portrait of him.

Thanks to Marsuppini's insistence and to the prestige that Tortelli enjoyed with the Pope, Giovanni Bacci managed to obtain a pardon. On 28 September 1449, he wrote from Arezzo the letter cited above to Cosimo de' Medici, telling him that he had gone to Fabriano, where the Papal court had removed to escape the plague at Rome. Through Cardinal Colonna's good offices, he had met with Cardinal Ludovico, and had put right the "scandals" of the past. He at once repaid the favours he had received, recommending Marsuppini ("an intimate of mine") to Cosimo on behalf of Tortelli ("a relative of mine"). He then turned to the latest political news: at Fabriano, he had read a letter in which Sigismondo Malatesta unduly ascribed to himself the recent capture of Crema by the Venetians. "Knowing signor Malatesta's character as I do," he remarks at this point:31 and this evidence of Bacci's closeness to Malatesta at that time (1449) has, in the context, an obvious importance. For two years later, Piero was to paint the portrait of Malatesta for the Tempio Malatestiano. It is more than probable that none other than Giovanni Bacci introduced Piero to the court of Rimini. During this period, Bacci (who may have resumed a lay status) had begun a career, benefiting probably from the support of the Medici, in the courts of northern central Italy - a career much less brilliant than the one he had embarked on in the Curia, but which did at least allow him to get away from the detested Arezzo. His links with the Malatesta family continued

for many years: in 1461, he obtained from Malatesta Novello the office of podestà at Cesena.32

The hypothesis that Giovanni Bacci may have made use of his own personal connections to get patrons for Piero presupposes that the two men were already acquainted at this time. For the moment, we have no proof that this was so. Still, it is worth noting that Sigismondo Malatesta is not the only example of a connection of Giovanni Bacci who can be shown to have commissioned work from Piero. Writing from Arezzo to Giovanni di Cosimo de' Medici in 1461. Bacci declared: "Giovanni, it seems to me that nature has made two gentlemen who resemble one another in many respects: Duke Borso and the Signore Federico, who are in their manner of life wiser and more refined than any other gentlemen of Italy." The names of the same two men, here implicitly praised also for their Maecenas-like qualities as patrons of the arts ("refined in their manner of life": Bacci writes "artificiosissimi nel vivere"), reappear a decade later in a letter dated 1472 to Lorenzo de Medici, where they are mentioned alongside Battista Canedoli, Malatesta Baglioni and Francesco Sforza: to all these people, declares Bacci, he had been "very dear".33 Vasari tells us that Piero had first begun work at Ferrara while Borso ruled there, and although doubt was for long cast upon this claim, Gilbert has recently shown it to be well-founded.34 As for Fedrico de Montefeltro, it is almost certain, as we shall see, that his connection with Piero did indeed begin through Giovanni Bacci.

All this also allows us to offer a plausible explanation of how Piero came to be entrusted with the painting of the frescoes in the Chapel of San Francesco in Arezzo. These, as we have said, were begun no later than 5-14 1447 by Bicci di Lorenzo, and it is certain that Bicci was commissioned by Francesco Bacci, who thus fulfilled the terms of his father Baccio's will. Bicci, old and unwell, managed to paint no more than the vault and part of the entrance arch, doing so in his habitual old-fashioned manner; in 1452, aged almost eighty, he died. Why the work's continuation should have been entrusted to a painter such as Piero, barely thirty at the time and a follower of the most modern pictorial style, it is hard to understand - unless Francesco employed Piero on the advice of his son, Giovanni, who had returned to Arezzo after two years in Milan, where he had held the office of "judex maleficiorum" in the court of Francesco

Sforza.³⁵ Then, the great difference between the vault and the walls of the chapel would be readily explained by the generational and cultural gap separating Bacci from his son Giovanni, who had received a humanistic education, and had enjoyed the protection of Traversari and the friendship of Leonardo Bruni and of Alberti.

When Piero obtained the commission for the Arezzo frescoes we do not know. The chronology of the Arezzo cycle, Piero's greatest work, poses problems still unresolved today. The only sure date is a *terminus ante quem*: in 1466, the cycle is referred to as completed.³⁶ The *terminus post quem*, on the other hand, is less certain: 1452 is the likely date, although we cannot rule out the possibility that Piero took over the work a little earlier from Bicci, who was seriously ill by then.

Fourteen years is a long time, even for a painter who habitually worked at a slow pace.³⁷ Repeated efforts have accordingly been made to narrow the span of Piero's activity at Arezzo. Given the usual plentiful lack of evidence, the preferred approach has been by way of internal, stylistic or (more rarely) iconological analysis: the results have been predictably varied. Let us consider some of the more widely debated theories.

Longhi's datings are based solely on stylistic criteria. He makes use of the Rimini fresco, which bears the date 1451, as a kind of fossil telltale for the reconstruction of the entire series. The clue that he follows is the initial presence, and progressive attenuation, of "graphisms" (*grafismi*) of Florentine origin of the kind met at Rimini. This is the foundation of his internal chronology, according to which the cycle begins with the 5,14, two lunettes (the *Death of Adam* and the *Exaltation of the Cross*) and ends with the *Defeat of Chosroes*. To be more precise, Longhi sees the left-hand part of the *Defeat* – one of the few parts of this fresco that is undoubtedly Piero's own work – as marking the end of his activity in the chapel of San Francesco. As we move downwards from the top, "evidence of linear borders of Florentine stamp" (as Longhi again stated in 1950) gives way to an ever more chromatic technique.³⁸

Longhi invoked this criterion of stylistic development in order to establish the chronological place of undated works such as the Monterchi *Madonna del Parto (Madonna of Childbirth)*, the San Sepolcro *Resurrection*, and the *St Mary Magdalen* in the cathedral at Arezzo: the first two works he dates respectively to the beginning and to the culmination (or thereabouts) of the Arezzo cycle, the last to the period immediately after its completion.³⁹ The *St Luke the Evangelist* at Santa Maria Maggiore, in

Rome, poses a more complex problem. Longhi identifies it as the sole surviving work from Piero's activity at Rome, and suggests two alternative dates for it: either 1455, during a break in work on the Arezzo cycle, or else 1459. This uncertainty arises from Vasari's mentioning but one occasion when Piero was in Rome, during the pontificate of Nicholas V – that is, between 1447 and 1455; whereas we have firm evidence only for his having stayed there in 1459, when Pius II was Pope.⁴⁰ This gives two possibilities: either Vasari confused Nicholas V and Pius II, as we might infer from his further claim that Piero left Rome to return to San Sepolcro "on the death of his mother", Romana, who died on 6 November 1459;⁴¹ or else he is referring to a first stay, of which there is no documentary evidence (as there is of the second).

Now Longhi argues that Piero took over from Bicci immediately on the latter's death, in 1452; and that he had "substantially" completed the cycle before his stay in Rome of 1459. At the same time, he draws a stylistic parallel between the St Luke and the early phase of the Arezzo frescoes, and especially those of the second tier (Solomon Receiving the Queen of Sheba and the Discovery and Proof of the Cross). 42 All this necessarily 7, 12 leads us to rule out the possibility that St Luke the Evangelist can have been painted in 1459 – unless, of course, we reconsider either its place in Piero's stylistic development, or the cycle's initial and final dates. However, Longhi does not commit himself unequivocally to the view that the St Luke was painted during Piero's hypothetical stay in Rome at the court of Nicholas V: these "chronological niceties", he says, are beside the point given the difficulty of establishing precise ad annum dates for the "development which took place during the Arezzo fresco cycle". 43 In truth, though, this is a matter, not of "niceties", but of whether the various hypotheses advanced are or are not consistent with each other. It is significant that Longhi waits until this moment to warn us how hard it is to translate the relative chronology, so painstakingly reconstructed on stylistic grounds, into an absolute and, so to speak, calendar chronology significant, that is, that he utters the warning when confronted with a work like the St Luke which, being situated in Rome rather than in Arezzo or its environs, can be more easily connected to documentary evidence of a more or less reliable kind. At this point, moreover, we are entitled to ask what basis there is for the absolute dates (1452-ante 1459) between which Longhi believes Piero's activity at Arezzo must be confined. These are certainly not derived from the internal stylistic

progression made out in the cycle. The Rimini fresco, dated 1451, does indeed give us an unquestioned *post quem*: but nobody can say how fast Piero's style was evolving during these years. Nor can we invoke any of the works identified by Longhi as contemporaneous with the Arezzo cycle, for none of them – not the *Madonna del Parto*, nor the *Resurrection*, nor any of the others – is dated.

Clark suggests an altogether different dating, both relative and absolute. Let us begin with the relative dating. According to Longhi's internal chronology, the two lunettes, and then the various tiers below them, are each to be seen as almost synchronous strata; which implies that Piero must have worked on a single scaffold, occupying the entire chapel. Clark, on the other hand, seems to hypothesize the existence of two scaffolds and two distinct phases of work, the first carried out by Piero himself and the second done largely by his assistants: this hypothesis is based on the fact that (as Longhi had already noted) the frescoes on the right-hand wall show almost no sign of the assistants' participation, which is clearly evident, by contrast, in almost all those on the left-hand wall.44 It must certainly be rejected - first of all, because it seems unlikely that two scaffolds would have been built, since this would have been more expensive and less safe, and second because the greater participation of the assistants on the chapel's left-hand wall can be far more simply explained by the assumption that Piero himself was working at the same time, virtually unaided, on the right-hand wall. Thus while Piero was 5 painting the Death of Adam and the right-hand prophet (both universally recognized as his own work), the assistants were completing a consider-14 able part of the Exaltation of the Cross and the whole of the left-hand prophet; and so forth. (This does not, of course, imply that Piero had no hand in the frescoes on the left-hand side: in the Defeat of Chosroes, he himself clearly did a small part of the work, as he did a large part of it in 13, 12 the Discovery and Proof of the Cross. Piero's almost unaided completion of this latter fresco is balanced by the fact that on this same tier, each of the small scenes that flank the window was entrusted to his assistants.)⁴⁵ In addition to all this, we muse take note of the stylistic points convincingly adumbrated by Longhi, which tend to rule out the chronological succession proposed by Clark.

As we have said, this proposed succession implies a break in the work between the right-hand wall's completion and the commencement of the left-hand wall. According to Clark – and here we enter the domain of

absolute or calendar chronology – this break corresponds with Piero's stay in Rome of 1458–59. Piero, Clark argues, having begun work in Arezzo straight after Bicci di Lorenzo died (in 1452), broke off to go to Rome on the completion of the *Victory of Constantine*. In 1459, he recommenced his labours (entrusting to his assistants, however, most of the execution of the left-hand wall), and he completed them around 1466. The key-stone of this chronological edifice is the *Victory of Constantine*, which Clark holds to have been painted in 1458 on account of its links with Paolo Uccello's *Battle of San Romano*, painted *circa* 1458.⁴⁶ This, plainly, is a very fragile prop; its dating is controversial; at the most, it may provide us with a *terminus post quem*, being insufficient for any *ad annum* dating. This is not to deny that the hypothesis prompts Clark to make some important iconographic observations, to which we return below.

Battisti endorses Longhi's reconstruction of the internal chronology, and explicitly argues, against Clark, that there was only one scaffold. But whereas Longhi held that the cycle was completed before Piero went to Rome, Battisti believes that it was begun only on his return, in about 1463. He offers various reasons for this shifting forward of the cycle's absolute chronology. Let us consider the most important (with one exception, to which we return below). When, in 1473 and in 1486, Piero claimed the payment owed him for the Arezzo cycle, his suit was against various members of the Bacci family, but not the heirs of Francesco. According to Battisti, this proves that neither Francesco's name nor those of his sons figured in the lost contract, and this in its turn is supposed to show that "in all probability" Francesco was at this time "either ill in some way or else absent" or dead; and, since he was buried on 28 March 1459, we are to deduce that the contract was signed only after Piero's return from Rome.⁴⁷ This train of conjectures is patently illogical; Piero, moreover, may have brought no suit against Francesco's heirs for the simple reason that they had already paid their appointed share of the costs of decorating the family chapel. Equally baseless is Battisti's attempt to deduce that Piero cannot have made a long stay in Arezzo in the years before 1458, because we have no record of his having empowered his brother Marco to act on his behalf as he did before going to Rome: Battisti himself is the first to acknowledge that "Arezzo is very close to San Sepolcro", which means that Piero would have been well able to manage his own affairs even while busy working on the San Francesco chapel. As Battisti recognizes, the other reasons that might persuade us to

post-date the beginning of the cycle until after Piero's return from Rome are (in his own words) "largely hypothetical"; what is more, they are largely inconsistent, or entirely beside the point.

The only consideration that appears at first to have some weight is that the *Death of Adam* contains conspicuous classical echoes. However, even this need not presuppose that Piero had visited Rome. Copies of Skopas's *Pothos*, for example, echoed in the figure of the naked youth leaning on a stick, were equally to be found in Florence.⁴⁸ It is worth remarking here that Battisti bases his late dating of the *Baptism* (he puts it at around 1460, whereas it actually dates from some fifteen years earlier) on the same absurd grounds, namely the claim that Piero can have encountered classical sculpture only during his stay in Rome of 1458–59, and not by way of artefacts such as sarcophagi or jewellery, which would have been available, in copies or even in the original, elsewhere.⁴⁹

Gilbert, writing at almost the same time as Battisti, has put forward a different chronology, fusing Clark's relative dating and Longhi's absolute dating. In the former, Gilbert distinguishes three successive stylistic phases. 5,14 1) The lunettes (the Death of Adam and the Exaltation of the Cross); the 96,6 two prophets flanking the window; and the Burying of the Wood (which, as we shall see, should properly be called the Raising of the Wood), on the right of the large window opposite the entrance. In these frescoes, the outlines are more marked, the gestures are more dramatic (as in the upper, and earliest, part of the Misericordia altarpiece at San Sepolcro), the figures are given greater physiognomical individuality (as in the profile of the aged and feeble Eve), and perspective is rarely employed. 2) The 7, 12 two middle tiers (the Queen of Sheba and her Retinue and Solomon Receiving 11 the Queen of Sheba on the left; on the right, the Discovery and Proof of the Cross) and the Torture of the Jew to the left of the window. Here apparent for the first time are the features later generally associated with Piero's painting: the impassive aspect of the figures, the solemnity of composition, the complex perspective enhanced by the presence of buildings. 3) The 8,9 Annunciation and the Dream of Constantine, as well as the lower tier on 10, 13 either side (the Victory of Constantine and the Defeat of Chosroes). Already manifest here, according to Gilbert, is a dominant interest - conceived under the influence of the Flemish school – in rendering the effects of light.

This reconstruction offers little that is new compared with Longhi's, although Gilbert does place more emphasis on the emergence of a distinct stylistic phase (the third) towards the cycle's end, and sees a wider

divergence between the middle tiers and the preceding ones (that is, between the second and the first phase). Much more important is his proposal that this divergence is traceable to Piero's journey to Rome of 1458–59. According to Gilbert, the great prominence given to architectural forms in the *Solomon* and the *Discovery* is the fruit of Piero's 7, 12 encounter with Alberti, and with the whole circle of Pius II's court. ⁵⁰ His stay in Rome would thus have divided his work at Arezzo into two periods, as already hypothesized by Clark; but Gilbert follows Longhi, and differs from Clark, in supposing there to have been a single scaffold, such as would have allowed Piero and his assistants to recommence their interrupted labours simultaneously on both sides of the chapel.

In arriving at a date for the beginning and end of the cycle of the True Cross, Gilbert has recourse, by contrast, to the altarpiece that Piero painted for the Augustinian friars at San Sepolcro during approximately the same period (between 1455, the date of the contract, and 1469, the date of the final payment). Here, once again, we cannot be certain when the work was actually carried out. But Gilbert does point out a likely post quem for the St Augustine polyptych: the spring of 1455. For the contract dates from October 1454, and in January 1455 Piero was away from San Sepolcro, as can be inferred from the fact that the Confraternity of the Misericordia of that town sent for him, requesting him to come and carry out some further work on the polyptych commissioned from him ten years earlier.⁵¹ Now the Saint in the Frick collection - universally recognized, because of its style, as the earliest surviving panel of the St Augustine polyptych (the central panel is lost) – is supposed by Gilbert to date from the same time as the first phase of the Arezzo cycle (the lunettes). One would accordingly expect him to propose a later dating for these lunettes, taking 1455 as a terminus post quem. However, Gilbert rather inconsequentially follows Clark in supposing Piero to have begun work in Arezzo around 1452, finishing about fifteen years later.⁵²

We have seen that there is very general agreement with the internal chronology proposed by Longhi (Clark's being the most important of the few dissenting voices), whereas on the question of when the cycle was begun and completed in calendar terms there are the widest differences of scholarly opinion. The differences involve only a few years – seven, eight, at the most a decade – but they are decisive years. Depending on

whether we suppose that Piero's major work was completed *before* his journey to Rome and his stay at Pius II's court (as does Longhi), *after* it (as does Battisti), or *both before and after* (as do Clark and Gilbert), we shall be led to offer widely different reconstructions of Piero's development as a painter. We propose to examine the question afresh, following the path 2 already taken with the *Baptism*, and combining an analysis of iconography with an analysis of commissioning.

We do not know when the iconographic scheme of the Arezzo cycle was worked out. That is, we do not know whether Bicci di Lorenzo had already contracted to take as his theme the Legend of the True Cross, which Piero thus took over together with his commission, or whether (but this is a far less likely hypothesis) the scheme was fixed only with the change of artist. Even Longhi, inclined as he was to ignore questions of iconography, came to attach "great weight" to the resolution of this question.⁵³ It does indeed seem at first sight something of a paradox that a modern painter such as Piero, imbued with humanistic culture. should have turned his hand to a fresco-cycle on a legendary theme, in part handed down in the apocrypha and later elaborated by Jacopo da Varazze in his Golden Legend.⁵⁴ To soften this paradox, Longhi remarked that if we accept the hypothesis that Piero found himself working on an already pre-determined theme, he undeniably reinterpreted it, transforming the sacred narrative into "an epic of lay, profane life": scenes of work and of court life, battles that resemble tournaments, landscapes by day and by night.55

In assessing the likelihood that Piero (or his patrons) reinterpreted its iconography, we must first of all note that the Legend of the Holy Cross was a traditional theme, generally (though not exclusively) associated with the Franciscan order. This strengthens the hypothesis that it was the Franciscans of Arezzo themselves who suggested to the Bacci that the legend would make an appropriate subject for the walls of the principal chapel, at the time when Bicci was originally commissioned to do the work. Of the three fresco cycles on the legend that predate (admittedly by some decades) the Arezzo frescoes, two had been painted for churches of the Franciscan order, Santa Croce at Florence (by Agnolo Gaddi, 1388–93) and San Francesco at Volterra (by Cenni di Francesco, *circa* 1410). Agnolo Gaddi's frescoes, in particular (and their iconography was imitated by Cenni at Volterra), were studied very closely by Piero. ⁵⁶ Before comparing the two cycles, however, it will be as well to outline

the legend as retold by Jacopo da Varazze in his *Legenda Aurea* – this being the version drawn upon both by Agnolo and, sixty years later, by Piero.

Adam, at the point of death, recalls that the Archangel Michael had promised him a miraculous oil which would save his life. His son, Seth, is sent to the gates of Paradise to fetch the oil, but the angel gives him instead a branch, from which the oil of salvation will flow - but only after five thousand five hundred years have elapsed. Seth returns to his father, but finds him dead, whereupon he plants the branch on his grave. From it, a tree springs up, which Solomon tries to use in the building of the Temple. But he is unable to do so, for whenever the wood is cut it turns out to be either too large or too small. The tree is then lifted out of the ground and thrown across the river Shiloh as a bridge. The Queen of Sheba, on her way to visit Solomon, sees the wood and has a premonition. Instead of walking across it, she kneels before it in veneration. From this wood, she prophetically tells Solomon, will come the end of the reign of the Jews. Solomon, to thwart this prophecy, has the wood submerged in a sheep-pond; but it returns to the surface, and is used to build the Cross upon which Christ is crucified. Three hundred years later, on the eve of his battle against Maxentius at the Milvian Bridge, Constantine sees a vision: an angel appears to him and exhorts him to fight under the sign of the Cross. Constantine does as he is bade, wins the victory, and becomes Emperor of Rome. Converted to Christianity, he sends his mother, Helena, to Jerusalem in search of the wood of the True Cross. Only a Jew by the name of Judas knows its whereabouts, and he refuses to speak. The Empress Helena thereupon has him thrown into a well. When he is brought out seven days later, Judas reveals that the Cross is buried beneath a temple dedicated to Venus. The temple is destroyed on Helena's orders, and the three crosses of Calvary are brought to light. The True Cross is recognized when a dead youth is restored to life after having been touched by it. Helena brings the relic back to Jerusalem.

Three centuries later, the Cross is stolen by Chosroes, King of Persia, who places it upon an altar decorated with idolatrous images and has himself worshipped as God. Heraclius, the Eastern Emperor, makes war on Chosroes, defeats him, and has him beheaded. He returns to Jerusalem with great pomp, but finds the city gates miraculously blocked against him. Only when he obeys the exhortations of an angel and decides to imitate Christ's humble entry into Jerusalem do the gates open. Thus the relics of the Cross are returned to the Holy Sepulchre.

Jacopo da Varazze arranges all this narrative under two headings, which correspond to two dates in the liturgical calendar: the discovery of the True Cross (3 May), and the exaltation of the True Cross (14 September). Under the first, we find the part of the legend that runs from the death of Adam to the Empress Helena's entry into Jerusalem with the rediscovered relic. Under the second, the concluding part is given – the theft of the Cross by Chosroes and its return to Jerusalem by Heraclius.

In the chapel of Santa Croce, Agnolo Gaddi had depicted eight stages of the legend, in six panels and two lunettes. The story begins with the lunette high up on the right (for a spectator facing away from the altar), and is to be followed downwards from there; it is taken up again in the left-hand lunette, at the top, and finishes with the lowest panel on the left. The following stages of the story are shown:

- 1) the Death of Adam
- 2) the Queen of Sheba Kneeling before the Wood of the True Cross
- 3) the Making of the Cross
- 4) the Proof of the Three Crosses by the Empress Helena
- 5) the Empress Helena Taking the Cross to Jerusalem
- 6) Chosroes Taking the Cross from Jerusalem
- 7) Chosroes Worshipped by his Subjects; the Dream of Heraclius
- 8) the Beheading of Chosroes. Heraclius Takes the True Cross back to Jerusalem.

The Santa Croce cycle, which includes both the discovery and the exaltation of the Cross, follows the text of the *Legenda Aurea* faithfully in all respects but one: the angel appears not to Constantine but to Heraclius. Nor can there be any doubt that the figure in question is Heraclius,⁵⁷ given the presence of Chosroes in the picture itself and in the one that follows.

Let us now turn to the Arezzo cycle. Here, the Legend of the True Cross is depicted in ten scenes: more precisely, four large panels, four small ones, and two lunettes. There are also the figures of two unidentified prophets. The whole is laid out along the two side walls and on the two sections of the end wall that flank the chapel window. The following 5–14 scenes are represented:

- 1) the Death of Adam
- 2) the *Raising of the Wood* (usually, and mistakenly, called the "Burying of the Wood")

- 3) the Queen of Sheba and her Retinue (which shows the Queen kneeling before the wood) and Solomon Receiving the Queen of Sheba
- 4) the Annunciation
- 5) the Dream of Constantine
- 6) the Victory of Constantine
- 7) the Torture of the Jew
- 8) the Discovery and Proof of the Cross
- 9) the Defeat of Chosroes
- 10) the *Exaltation of the Cross* (which depicts its return to Jerusalem by Heraclius).

These scenes, listed here in their narrative order, are spatially arranged thus:

10	prophet	prophet 1
8	7	2 3
9	4	5 6

This means that (leaving out the figures of the two prophets) the story begins with the lunette high up on the right, and finishes with the one high up on the left. Along the side walls, the scenes follow each other from top down (on the right-hand wall) and from the bottom up (on the left-hand wall). Each larger panel is preceded by a smaller painting on the section of the wall that flanks the window; this is on the left in the case of the right-hand wall, on the right in the case of the left-hand wall. The beholder's eye is thus drawn along a double trajectory: from top to bottom and from left to right (on the right-hand wall), and from bottom to top and from right to left (on the left-hand wall).

The undeniable coherence of this ordering justifies us in regarding the so-called *Rimozione del ponte* (*Removal of the Bridge*: usually known in 6 English by the equally misleading titles of the *Burying of the Wood*, or the *Queen of Sheba's Prophecy*) as a depiction, rather, of the *Raising of the Wood of the Cross* and its carrying to the river Shiloh, which in the legend comes immediately before the arrival of the Queen of Sheba. Nevertheless, there remain two striking anomalies, situated side-by-side, which visibly impair the narrative succession: the *Annunciation* and the *Defeat of Chosroes*. 8, 13 The reasons for this double alteration must lie (though we cannot clearly

understand them) in Piero's gradual departure from the cycle's traditional iconography. 58

If we consider the earliest part of Piero's work at Arezzo - the lunettes - we see that they do indeed depict the two scenes corresponding, though the spatial arrangement is different, to the beginning and the end of the legend as depicted in Agnolo Gaddi's Santa Croce frescoes: the 5, 14 Death of Adam and the Exaltation of the Cross. Leaving aside the obvious stylistic differences between the two cycles, which are not our present concern, we can make out in both cases one and the same iconographic scheme: the scheme, probably, which the Franciscans of Arezzo, with Francesco Bacci's agreement, suggested to Bicci di Lorenzo. Piero evidently began by following this scheme, though he would no doubt have kept the option of introducing minor variations. However, from the middle tier of the Arezzo cycle onwards we find iconographical novelties appearing, and these endow the entire cycle with implications quite different from those it originally possessed. We do not refer here to the scenes of everyday life depicted in two of the smaller panels at the side of 11,6 the window (the Torture of the Jew and the Raising of the Wood): these can be seen simply as digressions in the narrative. We have in mind the following features, which indicate a decisive alteration in the iconographic scheme:

- 7 1) the scene of Solomon Receiving the Queen of Sheba
- 22 2) the transformation of Agnolo Gaddi's *Dream of Heraclius* into the *Dream* 9 of Constantine a transformation whose significance is enhanced by the evident analogy between the two compositions
- 10 3) the scene showing the Victory of Constantine over Maxentius
- 1 4) the depiction, in the *Victory*, of Constantine with the features of John VIII Palaeologus, the Eastern Emperor.

In all these cases – with the obvious exception of the last – the changes are justified by the text of the *Legenda Aurea*. However, we shall see that their insertion does not appear to derive from any wish of Piero's to abide by the story as told by Jacopo da Varazze.

The depiction of the meeting between Solomon and the Queen of Sheba is a quite unexpected element in the pictorial narrative of the Legend of the True Cross. It was often found on Tuscan marriage-chests of the time,⁵⁹ and Piero would seem to have echoed these in planning his composition, recasting their almost Gothic richness within strictly defined

volumetric and spatial dimensions.⁶⁰ L. Schneider,⁶¹ however, has identified a true iconographic forerunner of the Arezzo cycle in the panel on the same subject sculpted by Ghiberti, in 1436 or 1437, for the east 25 doorway of the Baptistry in Florence. This has been interpreted by Krautheimer as alluding to the hope that unity could be restored between the Christian Churches of the West (Solomon) and the East (Sheba): he has suggested, convincingly, that the theme may have been proposed to Ghiberti by Ambrogio Traversari, whose portrait appears among the bystanders. 62 The same interpretation, argues Schneider, holds good for Piero's fresco. We must note, however, that the situation had been gradually changing during the two decades or so that had intervened. As a result, the allusions perceptible in the scene also changed. When the public first saw Ghiberti's doorway, in 1452, the panel could be understood as a reinvocation of the religious union achieved at the Council of Florence, which had then quickly dissolved. The meeting between Solomon and the Queen of Sheba bore a new meaning when it figured on the walls of the Arezzo chapel, for Constantinople had fallen to the Turks (in 1453), and the theme of religious union with the Eastern Church was henceforth linked inextricably with the theme of the Crusade against the infidel.

Let us now turn to Constantine. Whereas he does not appear in Agnolo's Santa Croce cycle (unlike his mother, the Empress Helena), in the Arezzo cycle two pictures are devoted to him: the Dream and the 9,10 Victory. The fact that he also painted this second scene makes it clear that we cannot see the first simply as Piero's correction of Agnolo's Dream of Heraclius on the basis of the text of the Legenda Aurea. Piero, moreover, 22 fuses together in his Dream two distinct passages, which describe respec- 9 tively the appearance, before the battle of the Danube, of an angel pointing to a Cross in the heavens, and the appearance of Christ holding a Cross in his hand before the battle of the Milvian Bridge. We see here not so much a desire to follow Jacopo da Varazze's text more faithfully as an effort to give unusual prominence to the figure of Constantine. This is clear in the Victory, which Clark has interpreted as alluding to the theme 10 of the Crusade. 63 Such an allusion would be strengthened by the identification of Constantine with John VIII Palaeologus - an identification that has often been pointed out, but never justified except in general terms.64

*

All these elements, then, suggest that from the second tier on we can perceive the emergence of an iconographic scheme connected, in ways that will be made clear, with a crusade. We should recall, moreover, that Longhi had already remarked on the stylistic novelty of the frescoes in the second tier, in comparison with the lunettes that still show a Florentine treatment of the outlines. Gilbert, for his part, had seen in the architectural forms of the *Solomon* and the *Discovery*, forms that reflect Alberti's influence, a legacy of Piero's Roman visit of 1458–59. If we accept this hypothesis, we see that the stylistic and iconographic break coincides with a change of patron: Francesco Bacci died on 28 March 1459, and since his oldest son Niccolò had died meanwhile, the older surviving son, Giovanni, must have taken over the responsibility for the decoration of the family chapel.⁶⁵

It is certainly plausible that Giovanni may have suggested the insertion of the scene showing Solomon Receiving the Queen of Sheba. His personal ties with Traversari, and more generally with the group favouring unity between the two Churches, readily explain why he might have turned to Ghiberti's panel, a product of that same milieu. It is worth noting that the gesture of concord, emotional fulcrum both of Ghiberti's bas-relief and of the Arezzo fresco, had already appeared, bearing the same symbolic and allusive references to Church union, in the picture painted by Piero for the Camaldolites of Borgo San Sepolcro in indirect homage to Traversari's memory: the Baptism of Christ.

But what we know of Giovanni Bacci's life and personality does not explain how John VIII Palaeologus came to appear in the Arezzo cycle under the guise of Constantine. This detail, crucially important in identifying the cycle's iconographic scheme (or, better, its ultimate implications), is to be explained by the intervention of another, much more famous figure: Cardinal Bessarion.

That there was a connection of some sort between Piero della Francesca and Bessarion has been suggested by other scholars, even if their arguments have been vague or (as we shall see) not entirely convincing. However, the suggestion has never been thought relevant to the Arezzo frescoes. A series of factual data nevertheless exists, which makes it very probable that Bessarion did intervene in the reworking of the Arezzo cycle's iconographic scheme.

Among the Greek prelates who came to Italy for the Council in 1438, Bessarion, Metropolitan of Nicea, held a prominent place. Despite his youth (he was born in 1403), he was distinguished both by his erudition and by the personal ties that for some time had bound him to the Emperor John VIII Palaeologus. As the Council's deliberations proceeded, he drew gradually nearer to the positions of the Western theologians, eventually becoming one of the most committed advocates of union with the Roman Church.⁶⁷ It was Bessarion who, together with Cardinal Cesarini, solemnly proclaimed the act of union in Santa Maria del Fiore on 6 July 1439. On his return to Constantinople, he heard news of his appointment as Cardinal priest of the Basilica of the Holy Apostles. In Italy, where he was to return the following year and where he settled permanently, he came to enjoy unquestioned prestige - religious, cultural and political. In 1449, he became Cardinal Bishop first of Sabina and then of Tuscolo; from 1450 to 1455, he was legate a latere for Bologna, Romagna and the March of Ancona; in the 1455 conclave, he was all but elected Pope. His house in the precincts of the Basilica of the Holy Apostles was the real centre of Roman humanism. Here, he gathered together and had transcribed a great number of Latin and above all Greek manuscripts. To bring about a better knowledge of Plato's thought, he had embarked on a volume entitled In calumniatorem Platonis, taking issue with George of Trebizond, which was published in Latin in

This is not the place to give a detailed account of Bessarion's life. We should, however, note that on 10 September 1458 he was appointed Protector of the Order of Greyfriars or Friars Minor. This is one of the missing pieces of the mosaic we are reconstructing. His responsibilities as Protector would indeed have fully entitled Bessarion to intervene in the decoration (temporarily interrupted just at this period) of the Bacci chapel in the church of San Francesco. More than that: such an intervention would not only have been legitimate, but also understandable, given the relations that must have existed between Bessarion and Giovanni Bacci – relations owing less to the latter's past position in the Papal administration than to his kinship, discussed above, with the humanist Giovanni Tortelli, the former Vatican librarian. By this time, Tortelli's career in the Curia was over, but until a few years earlier he had had the closest links with Bessarion, especially through the latter's secretary, Niccolò Perotti. Papal administration, especially through the latter's secretary, Niccolò Perotti.

All this makes it likely that there was a direct relationship between

Bessarion and Giovanni Bacci. There is one additional circumstance that makes it well-nigh certain.

In August 1451, a few years before Piero began work on the Arezzo 28 - 30cycle, a relic of the True Cross, enclosed in a casket adorned with images, arrived in Italy from the Orient. It was brought by Gregory Melissenus, known as Mammas, Patriarch of Constantinople, who was seeking the protection of Rome against the hostility of the faction opposed to the union of the Churches, who had not forgiven him the role he had played some ten years previously at the Council of Florence.⁷⁰ Following the fall of Constantinople (1453), the casket containing the relic remained in Italy. Shortly before his death (in 1459), Gregory left it to Bessarion, who had fought so hard for the union of the Churches. In 1472, Bessarion, by this time an elderly and sick man, travelled on an embassy to France; on the eve of his departure, he left the relic, which was very precious to him (and which had already been the object, in 1463, of a donation "inter vivos"), to the Scuola Grande della Carità at Venice - today the site of the Accademia gallery, where the relic is still to be found.⁷¹ Previously, this relic had belonged to the Palaeologus family. The casket containing it bears a Greek inscription attributed to a certain Princess Irene Palaeologa, "daughter of a brother of the Emperor". This Irene was traditionally identified as the daughter of the Emperor Michael IX, crowned Empress in 1335; nowadays, scholars prefer the view that she was a niece of the Emperor John VIII, which brings the date of the reliquary down to the early fifteenth century.⁷² Certainly it was John VIII who gave it to the Patriarch Gregory, his confessor, who left it, as we have seen, to Bessarion. In the document accompanying it on its donation to the Scuola Grande della Carità, Bessarion gives a detailed account of how the precious relic had come into his hands.⁷³

Of all the relics of the True Cross that had appeared in Italy by this time (including the one preserved at Cortona, not far from Arezzo),⁷⁴ only this one justifies the inclusion in Piero's cycle of the portrait of John VIII Palaeologus. This portrait gives the cycle commissioned by the Bacci an extra dimension, as a glorification of the Palaeologus dynasty and in particular of the Emperor with whom Bessarion had been linked in his youth. More indirectly, the depiction of Constantine, the Emperor who had moved the capital from Rome to the Orient, with the features of John VIII Palaeologus, his remote descendant, was a proclamation of the ideal for which Bessarion had fought, the union of the Churches, and of that for which he was now fighting: the crusade against the Turks.

All this is not to deny that the walls at Arezzo indeed display Longhi's "epic of lay, profane life"; but it is to enrich that epic's meaning with religious and political themes of a quite different order.

At this point, we can sum up the series of circumstances underlying the stylistic and iconographic break dividing the beginning of the Arezzo cycle, the lunettes, from the frescoes that followed. On 10 September 1458, Bessarion was appointed protector of the Franciscan order; in the autumn of 1458, Piero travelled to Rome; on 28 March 1459, Giovanni Bacci's father, Francesco, was buried; in 1459 (before 20 April), Gregory Mammas died,⁷⁵ leaving to Bessarion the casket containing the relic of the True Cross that had formerly belonged to the Palaeologi.

This closely linked sequence of documented events perhaps allows us to suggest approximately the limits between which we must date one further, and decisive, happening, for which documentary evidence does not exist (and perhaps never will): the meeting during which Bessarion suggested to Giovanni Bacci that he should insert into the decoration of his family chapel a portrait of the last Eastern Emperor but one.

Between 1458 and the early months of 1459, Bessarion remained the whole time in Rome. He then left for Mantua, to join the assembly called by Pius II in response to the Turkish threat. We do not know the date of his departure, but at all events – and contrary to some accounts⁷⁶ - he did not follow Pius II in the leisurely journey towards the north which the latter began on 22 January. It is probable that he left Rome towards the beginning of April; on 27 May 1459, he was certainly among the Cardinals who took part in Pius II's solemn entry into Mantua. Now in the account that accompanied Bessarion's gift to the Scuola Grande della Carità, he wrote that he had been left the casket during his stay in Mantua for the Papal council.⁷⁷ This can mean only that it was while he was at Mantua that Bessarion heard the news of the Patriarch Gregory's death. We know, in fact, that on 20 April 1459 - the day Isidore of Kiev, the Ruthenian Cardinal, was made Patriarch of Constantinople - his predecessor had been dead only for a short time ("nuper"). However, Gregory had received Pius II's permission to make a will on 20 September of the previous year.⁷⁸ The will itself, now lost, must have been drawn up soon afterwards. Gregory, an old man now at the point of death, would no doubt have told Bessarion, who was preparing to leave for a long journey, of his plan to leave him the precious relic. It is Bessarion himself who tells us that Gregory loved him like a $\rm son.^{79}$

It follows from all this that Bessarion's decision to celebrate in fitting style the acquisition of the relic was made either shortly before he left for Mantua, or while he was actually there for the council. To choose between these two alternatives, we would need to know Giovanni Bacci's movements during this same period. Of these, however, we are ignorant except that it is reasonable to suppose that he was called back to Arezzo (if not there already) when his father died towards the end of March 1459.

There is, however, reason to think that Bessarion, as well as suggesting the inclusion of John VIII's portrait, may actually have played an active 1 part in its composition. The profile of Constantine in the Victory is 31 derived, we know, from Pisanello's famous medal, struck during the Council either at Ferrara or at Florence and generally regarded as the first modern medal.⁸⁰ Surviving examples have on their upper side a representation of John VIII Palaeologus, wearing on his head the "white hat coming to a point in front" that we met earlier; on the reverse side, Palaeologus is shown on horseback, followed by an equerry. There seems also to have existed a variant, of which no example survives, described by Giovio (who owned one) as bearing on the reverse side "the Cross of 32 Christ, upheld by two hands, representing the Latin and Greek Churches". Only recently have scholars recognized this last image as Bessarion's personal symbol. However, they have also raised doubts as to whether such a medal existed; but Giovio's description⁸¹ is too precise, as well as historically too probable, to be set down as a mistake. It is more plausible that Pisanello's medal did indeed exist in the two versions, and that it was from one of these (the one now lost) that Bessarion, on his return from Constantinople to Rome in 1440, drew inspiration in his choice of a personal symbol as Cardinal.

An exemplar of this lost version must have been given or lent to Giovanni Bacci by Bessarion, to be used as a model for the portrait of Palaeologus inserted in the Arezzo cycle. Under the circumstances, we can also legitimately suppose that Bessarion showed Bacci, and perhaps Piero, two other medals, struck in gold, which were the immediate historical forerunners of Pisanello's. Could we show that this was the case, it would establish that the meeting with Bacci took place in Rome, between late 1458 and the first months of 1459; for it is unthinkable that Bessarion would

have taken his collection of medals along with him on his journey to Mantua. We shall return to this hypothesis in our analysis of the Flagellation.

The two medals, showing Constantine and Heraclius, are first mentioned early in the fifteenth century in the inventory of the Duc de Berry's collections. The Duc de Berry most likely bought them as antiquities (they were at any rate regarded as such in the sixteenth century). Schlosser gives a full account of them in connection with Pisanello's first medal (the one of John VIII), supposing them to form part of a series, probably of Flemish origin, based on the Legend of the True Cross. 82 He later attributed them to either Pol de Limbourg or one of his brothers.⁸³ The connection between them and the Constantine of the Victory has never been pointed out: but Piero would seem to have 10 combined the two medals, giving to Constantine - who is mounted, and seen in profile - the gesture with which Heraclius grasps the Cross in his 33, 34 outstretched arm. Moreover, the black coachman who is turning aside, in the Heraclius medallion, because he has seen that the gates of Jerusalem are miraculously blocked, strongly recalls the black servant whom Piero painted among the retinue of the Queen of Sheba: it is enough to look at their snub-nosed profiles and their characteristic conical caps. All this 35 seems to indicate that Piero was familiar with the medals. It is also worth noting that the latter are accompanied by writings in Greek that display a minute knowledge of Byzantine bureaucratic terminology. These (so Weiss has argued) were drawn up by some official of the imperial chancellory, probably during the visit to Paris of Manuel II Palaeologus, which ended in 1402 - the year the Duc de Berry acquired the Constantine medallion from a Florentine merchant.⁸⁴ This circumstance makes it all the more probable that Bessarion may have owned the two medals, and may have shown them to Bacci, given their connection with the theme of the Arezzo cycle - the Legend of the True Cross - as well as with the relic that had belonged to the Palaeologi. This would explain why Piero made use of the Heraclius medallion only in the middle and lower tiers of frescoes, executed after his return from Rome, rather than in the lunette showing Heraclius carrying the Cross back to Jerusalem (the Exaltation of the Cross), where its use would have been more 14 obviously appropriate.

*

The hypothesis that Bessarion intervened to modify the overall iconographic scheme of the Arezzo cycle depends on a series of very precise factual coincidences; the hypothesis that he met Giovanni Bacci at Rome, upon a chain of conjectures. The meeting, in other words, may perhaps have been at Mantua, some months later. However, this uncertainty does not affect the core of the argument, based as it is upon a convergence between biographical, stylistic and iconographic data, and data concerning the commissioning (direct and indirect) of the cycle.

This convergence confirms with fresh arguments Gilbert's hypothesis that the major part of the cycle (excluding only the lunettes) was painted after Piero's return from Rome in the autumn of 1459. This dating is not contradicted by the one solid argument that Battisti advances: the argument based on the Città di Castello altarpiece, prominently dated 1456 and signed by the same Giovanni di Piamonte whom Longhi identifies as Piero's collaborator in the two scenes flanking the windows, the *Raising of the Wood* and the *Torture of the Jew.*⁸⁵ As Battisti rightly remarks, the altarpiece shows a knowledge of Piero's work, but not of the Arezzo frescoes:⁸⁶ this, however, provides a *terminus post quem* for the start of Giovanni di Piamonte's collaboration, not for the beginning of the cycle as a whole.

When the cycle was begun, we do not know.⁸⁷ What is certain, on the other hand, is that the year spent at Rome was of crucial importance for Piero's development, and not only for his stylistic development. The Platonic and mathematical inspiration of his mature works, as well as the religious and political implications that we have deciphered in the Legend of the True Cross, were fostered by his meetings in Rome with Alberti and with the humanists of Pius II's court – perhaps with Bessarion himself. To this moment we must ascribe the *Flagellation of Christ*, a painting lying precisely on the frontier that (chronologically as in other senses) divides the two phases of the Arezzo cycle.

Notes

- 1. M. Salmi, La pittura di Piero della Francesca, Novara 1979, p. 165.
- 2. It was Scarmagli who established this precise date, on the basis of a letter from Aliotti to Alberti (G. Aliotti, *Epistolae et opuscula*, Arretii 1769, I, p. 33, n. e).

- 3. Salmi, "I Bacci di Arezzo", p. 229.
- 4. Gilbert, Change, pp. 85–6. It is from Gilbert that Battisti draws (unless I am mistaken) the one and only reference to Giovanni Bacci in his monograph (p. 482, n. 181: this reference does not appear in the name index).
- 5. E. Gamurrini, Istoria genealogica, Florence 1673, III, pp. 334–5. G.G. Goretti Miniati reprinted this letter, with many mistakes, as if it were hitherto unpublished, in an article "Alcuni ricordi della famiglia Bacci", in Atti e Memorie della R. Accademia Petrarca di lettere, arti e scienze, n.s., VIII (1930), pp. 96–7. It is here wrongly attributed to a different Giovanni Bacci, from a collateral branch of the family Giovanni di Donato di Angelo di Magio. Gamurrini's Istoria (pp. 328, 334–5), as well as the discussion that follows, makes it quite clear, however, that the Giovanni in question is indeed Giovanni di Francesco di Baccio, of the branch that commissioned the Arezzo frescoes. For the Bacci family tree, see ibid., pp. 324–35, and Salmi, "I Bacci di Arezzo", which has more information. Research into the Spogli Gamurrini (ASF, mss 296–313: this is the documentation Gamurrini worked from) has failed to bring to light any fresh data on Giovanni Bacci's biography.
- 6. On Tortelli, see G. Mancini, "Giovanni Tortelli cooperatore di Niccolò V nel fondare la Biblioteca Vaticana", in Archivio Storico Italiano, LXXVIII (1920), pp. 161-282; R.P. Oliver, "Giovanni Tortelli", in Studies presented to David Moore Robinson, II, St Louis 1953, pp. 1257-71; O. Besomi, "Dai 'Gesta Ferdinandi regis Aragonum' del Valla al 'De Orthographia' del Tortelli", in Italia medioevale e umanistica, 9 (1966), pp. 75-121; M. Regoliosi, "Nuove ricerche intorno a Giovanni Tortelli", ibid., pp. 123-89, and 12 (1969), pp. 129-96 (on Giovanni Bacci, cf. pp. 149-57); O. Besomi, "Un nuovo autografo di Giovanni Tortelli: uno schedario di umanista", ibid., 13 (1970), pp. 95-137; M. Cortesi, "Il 'vocabolarium' greco di Giovanni Tortelli", ibid., 22 (1979), pp. 449-83. Traversari's letter to his brother is discussed by Regoliosi ("Nuove ricerche", 2nd part, p. 152). We do not know the date of Giovanni's birth, only that his parents were already married in 1416 (see the family tree reconstructed by Salmi). In giving a large sum to the hospital of Spirito Santo "for the poor Germans" ("per li poveri Alemanni"), Baccio expressed in his will the wish that his grandson Giovanni should be its first rector (J. Burali, Vite de' vescovi aretini . . . dall'anno CCCXXXVI fino all'anno MDCXXXVIII, Arezzo 1638, pp. 91-2; the bequest and the provision relating to it are not in the extract from the will given in Salmi, "I Bacci di Arezzo", pp. 233-5). It is out of the question that Giovanni was then (in 1417) of an age to assume the duties of hospital rector, given that in 1432 Traversari was speaking of him as "young". The provision in the will must therefore have referred to the future. In any case, 1417 can be taken as a terminus ante quem for Giovanni's birth, which we should probably date around 1410-15.
- 7. Regoliosi, "Nuove ricerche", 2nd part, p. 151. Mancini ("Giovanni Tortelli", pp. 180–1) mistakenly identifies Tortelli as the "Giovanni Aretino" whom Traversari recommended. It is this mistaken identification that explains why Mancini (p. 180) uses the expression "back from the Orient", which actually does not occur in Traversari's letter (*Epistolae*, 1. II, ep. XXV).
- 8. The bull dated from Ferrara, 11 July 1438, in *Bullarium Romanum*, vol. 5, Augustae Taurinorum, 1860, pp. 32–3; this was reaffirmed on 8 July 1444 (ibid., pp. 76–80).
- 9. F.P. Luiso, "Studi su l'epistolario e le traduzioni di Lapo da Castiglionchio juniore", in Studi italiani di filologia classica, VII (1899), pp. 254–5 (and Regoliosi, "Nuove ricerche", p. 152).
 - 10. Ibid., pp. 153-4.
- 11. On the Tortelli family's origins in Capolona, see Mancini, "Giovanni Tortelli", p. 162; for those of the Bacci, see Gamurrini, *Istoria*, p. 314. The Bacci enjoyed the patronage of numerous church places in Capolona: ibid., pp. 316–17 (and Salmi, "I Bacci di Arezzo", p. 233).
- 12. The volume, probably completed in the summer of 1453, and dedicated to Nicholas V, was first published in 1471, and went through several later printings.

- 13. Gamurrini, *Istoria*, III, p. 318 (it is clear from the context that the Giovanni Bacci who graduated at Siena was a different person from his namesake Giovanni di Donato Bacci).
 - 14. Aliotti, Epistolae, I, pp. 27-33.
- 15. Ibid., pp. 33-4 (see also G. Mancini, Vita di Leon Battista Alberti, Florence 1882, pp. 179-80).
- 16. Aliotti, *Epistolae*, II, p. 182. On the relations between Aliotti and Traversari, see ibid., I, p. XIV.
 - 17. Ibid., pp. 27-8.
 - 18. Gamurrini, Istoria, III, p. 327.
- 19. The kinship of the Bacci to the Tortelli is discussed above. As for Marsuppini, a letter from him to Giovanni Tortelli, whom he addresses as "dearest godfather" ("conpatri carissimo"), is given in R. Sabbadini, "Briciole umanistiche", I, in Giomale storico della letteratura italiana, XVII (1891), pp. 212–13 (Sabbadini made use of a copy; the original is in the Vatican, Vat. lat. 3908, c. 53r). In "The Uses and Abuses of Iconology: Piero della Francesca and Carlo Ginzburg" (Oxford Art Journal, 9, 2, 1986, p. 70), R. Black accuses me of "sloppy scholarship" for failing to take into account the almost contemporaneous birth dates of Marsuppini and Tortelli. The sloppiness is Black's: "godfather" translates the term conpatri, a term we should equate, in my view, to the Italian compare, "an appellation reciprocally used between the godfather and the father of a person baptised" (see the entry in S. Battaglia, Grande dizionario della lingua italiana). This interpretation seems to me far more plausible than that offered by Black, who takes conpatri to be a synonym of the classical Latin compatriotae (fellow-citizen): a rarely used term, illustrated in the Thesaurus by just two inscriptions and two glosses.
- 20. In 1979 Salmi put forward (though only in general terms) the hypothesis that Traversari may have influenced Piero in his *La pittura di Piero*, p. 165.
- 21. Our term "network" (Italian *reticolo*: trans.) is here employed metaphorically, rather than in the rigorous sense in which it is now extensively used in sociological and anthropological literature.
- 22. It would be worth citing the entire passage in which Longhi (*Piero*, p. 16) writes of these "visual springs which flow forever underground, coming at crucial moments to the assistance of those whose invention is flagging, and leading them back to the mainstream of the figurative tradition". The suggestion of a "return to order" occasionally hinted at in the monograph of 1927 is here particularly audible. It should none the less be emphasized that the ahistorical tone of this passage is belied by all Longhi's concrete studies, beginning with those on Piero.
 - 23. Aliotti, Epistolae, I, p. 143.
 - 24. Ibid., pp. 161-2.
 - 25. Mancini, "Giovanni Tortelli", pp. 208ff.
- 26. Bacci's name has not hitherto emerged in the course of researches into the archives of the Camera, which are kept partly in the Archivio Segreto Vaticano, partly in the Archivio di Stato at Rome.
- 27. ASF, *Mediceo avanti il Principato* (henceforth referred to as *MAP*), VII, 1 (in the same archive are found twenty-eight other letters of Bacci's, all of which are noted by Regoliosi, apart from *MAP*, V, 905, to Giuliano Piero de Medici, dated 16 March 1474).
- 28. On the Patriarch of Aquileia, long known under the mistaken name of Ludovico Scarampi-Mezzarota, see the seminal study by P. Paschini, Lodovico cardinal camerlengo († 1465), Rome 1939 ('Lateranum', n.s., a. V, n. 1). He continued to be designated "patriarch" even after his appointment as Cardinal: for example, ASF, Signori. Legazioni e commissarie. Elezioni, istruzioni, lettere, n. 15, cc. 147r, 149r. I have been unable to discover exactly when Giovanni Bacci was expelled from the Camera: it was certainly before 1446 (see G. Bourgin, "La 'familia' pontificia sotto Eugenio IV", in Archivio della Società romana di storia patria, XXVII [1904], p. 215, where

six clerks' names, not including Bacci's, are listed). On the presence of six clerks to the Camera Apostolica during certain periods of the pontificate of Eugenius IV (who had laid it down that their number should never exceed seven: see above, p. 16), see A. Gottlob, Aus der Camera Apostolica des 15 Jahrhunderts. Ein Beitrag zur Geschichte des päpstlichen Finanzwesens und des endenden Mittelalters, Innsbruck 1889, p. 115.

- 29. Paschini, Lodovico.
- 30. Sabbadini, "Briciole umanistiche", pp. 212-13.
- 31. Gamurrini, *Istoria*, III, p. 335. Tortelli, too, had followed Nicholas V to Fabriano: Mancini, "Giovanni Tortelli", p. 222. Crema had been unsuccessfully besieged by Malatesta during his time as commander-in-chief of the Venetian army, and had only fallen as a result of the treachery of Carlo Gonzaga, the head of the Milanese forces.
- 32. ASF, MAP, XVII, 292 (letter dated from Cesena, 27 January 1461: Bacci signs himself "potestas Cesenae"; see also Regoliosi, "Nuove ricerche", p. 157). See ASC, Riformanze, 47, c. 12v (1 January 1461).
- 33. ASF, MAP, VII, 4; ASF, MAP, XXIV, 371. In a letter of 6 March 1473 (ASF, MAP, XXIX, 144), Giovanni Bacci names as among those who have protected him "in health and in sickness" Cosimo, Piero and Giovanni de' Medici; Sforza; Borso d'Este; the other "signori of the Romagna"; and the Count of Urbino.
- 34. G. Vasari, Le opere con nuove annotazioni . . . di G. Milanesi, II, Florence 1906 (anastatic reprint, Florence 1973), p. 491; this is available in English as Part II of vol. 1 of the Everyman 4 vol. edn of Vasari, A.B. Hinds, trans., 1927. See also Gilbert (Change, pp. 51–2). Gilbert refers to the date (July 1451) of the lost fresco, evidently influenced by Piero, which Bono da Ferrara painted at the Eremitani.
- 35. C. Santoro, Gli uffici del dominio sforzesco (1450-1500), Milan 1948, p.142: the "eximius vir D. Iohannes de Barciis de Aretio" is appointed "iudex maleficiorum potestatis Mediolani", with a stipend of sixteen florins. The mistake ("de Barciis" for "de Bacciis") is corrected in C. Santoro, I registri delle lettere ducali del periodo sforzesco, Milan 1961, pp. 16, 27, 322, 324. The letter of appointment, dated 24 June 1451, was registered exactly a month later. Bacci's successor, Angelo da Viterbo, took his place on 21 May 1453. Bacci refers to his links with Francesco Sforza in a letter cited above (see n. 33). It is worth remarking that in the Dizionario degli aretini illustri compiled by the Aretine scholar F.A. Massetani, which was completed in 1940 and of which the typescript is kept in the Arezzo State Archives, we find the following entry for "Bacci (de) Giovanni (Messer)": "Lawyer, poet. Served as junior judge to the Duke of Milan Gian Galeazzo Sforza in 1458, and was appointed by the latter, at his death, as lieutenant to the Dukedom. Wrote a poem on the Crusades and translated into Italian Giovanni Boccaccio's De claris mulieribus. We possess a letter written by him to Cosimo de' Medici on 28 September 1449." Now this last item refers without doubt to the Bacci with whom we are concerned, as do the biographical data mistakenly given by Massetani under the entries for "Bacci (de) Giovanni (Mons.) di Francesco di Baccio" and "Bacci (de) Giovanni d'Angiol Antonio" (actually, Giovanni di Francesco). These are instances of the very numerous errors found in the Dizionario, a work which, though not without its uses, is certainly to be handled with the greatest caution. In the entry cited above, "Gian Galeazzo" should obviously read "Francesco". Moreover, there is no junior judge by the name of Bacci at the court of Milan in 1458 (unless there is some confusion here with the office of "iudex maleficiorum" held during an earlier period), nor do we encounter Bacci as ducal lieutenant on the death of Francesco Sforza. (It is odd that Goretti Miniati [Aleuni ricordi, p. 97] should just as groundlessly attribute similar duties, as podestà of Milan in 1453, to Giovanni di Donato Bacci.) No Bacci is recorded among these who translated De claris mulieribus into the vulgar tongue (see A. Altamura, "Donato da Casentino. Un volgarizzamento trecentesco del 'De claris mulieribus' del Boccaccio [estratti da un codice

inedito]", in Atti e memorie della R. Accademia Petrarca, n.s., XXV [1938], pp. 265–71; V. Zaccaria, "I volgarizzamenti del Boccaccio latino a Venezia", in Studi sul Boccaccio, X [1977–78], pp. 285–306). In these circumstances, the attribution to Giovanni Bacci of a poem on the Crusades appears unreliable, or at any rate unverifiable, pending evidence to the contrary (Massetani's bibliographical references are either mistaken, or else fail to justify the attribution). Were proof forthcoming, however, it would further confirm our interpretation of the iconography of the Arezzo cycle.

- 36. Longhi, Piero, pp. 100-1.
- 37. The Misericordia altarpiece, commissioned in 1445 and urgently requested ten years later, was finished, perhaps, around 1462; the altarpiece painted for the Augustinians was commissioned in 1454, and the last payment made for it only in 1469 (though in this case Piero had taken the precaution of asking eight years to complete it) (Longhi, *Piero*, pp. 100, 102; however, see below on the somewhat controversial question of the chronology of the Misericordia altarpiece).
 - 38. Longhi, Piero, pp. 48-9, 51, 85.
- 39. Ibid, pp. 51, 53 (where the *Resurrection* is said "to seem by its style close to, or even earlier than, the most mature work at Arezzo"), 215.
 - 40. Vasari, II, pp. 492-3.
- 41. See respectively Zippel, "Piero della Francesca a Roma" and the documents published by Battisti (II, p. 224). It is probable that Piero had already reached Rome by the autumn of 1458; for on 22 September, he granted power of attorney to his brother Marco, evidently because he was about to set out (Battisti, II, p. 223). On 24 October of the same year, moreover, are recorded the payments made for the scaffolding-wood needed for the Papal chamber to be decorated in fresco (it is for this work that Piero is paid in an entry of 12 April 1459): Zippel, "Piero della Francesca a Roma", p. 86.
- 42. Longhi, *Piero*, pp. 100-1, 214. It should be noted that this work is not unanimously attributed to Piero.
- 43. Ibid., p. 214. In the light of what is said in n. 41 above, Longhi's suggestion would make autumn 1458 the *terminus ante quem*.
- 44. Clark, pp. 38–9, 52. G. Robertson's review of Gilbert, *Change* (see *The Art Quarterly*, XXXIV [1971], pp. 356–8) misinterprets Longhi's position, confusing it with Clark's on this point. Clark's hypothesis that there were two scaffolds is accepted both by Robertson and by P. Hendy (in another review of Gilbert's book: *Burlington Magazine*, CXII [1970], pp. 469–70).
 - 45. In all this, I am following the opinion of Longhi.
 - 46. Clark, p. 52.
 - 47. Battisti, II, pp. 23ff.
- 48. G. Becatti, "Il Pothos di Scopa", in *Le arti*, III (1941), pp. 40ff (Gilbert notes this article in *Change*, pp. 71–2, n. 34). And see, now, R. Cocke, "Masaccio and the Spinario, Piero and the Pothos: Observations on the Reception of the Antique in Renaissance Painting", in *Zeitschrift für Kunstgeschichte*, 43 (1980), pp. 21–32.
- 49. The prevalence in fifteenth-century art of the classical motif of the vanquished warrior brought to his knees (of which Piero himself makes use in the *Defeat*) sufficiently demonstrates how untenable is the criterion invoked by Battisti in support of his proposed dating: see O.J. Brendel, "A Kneeling Persian: Migrations of a Motif", in *Essays in the History of Art Presented to Rudolf Wittkower*, London 1967, pp. 62–71; L. Fusco, "Antonio Pollaiuolo's Use of the Antique", in *Journal of the Warburg and Courtauld Institutes*, 42 (1979), pp. 259–60, esp. p. 260, n. 14.
 - 50. Gilbert, Change, pp. 48-9 and passim.
- 51. Ibid., pp. 27ff. Gilbert interprets correctly the date of the request, which Battisti misunderstands (cf. Beck, "Una data").

- 52. Gilbert, Change, p. 88, n. 40.
- 53. Longhi, Piero, p. 82 (the phrase is in his 1950 essay on "Piero in Arezzo").
- 54. J. da Varazze, Legenda aurea, T. Graesse (ed.), 1890 (anastatic reprint: Osnabrück 1965), pp. 303–11, 605–11.
 - 55. Longhi, Piero, pp. 82-3.
- 56. On the theme in general, see still P. Mazzoni, La leggenda della Croce nell'arte italiana, Florence 1914. On the Santa Croce cycle, B. Cole, Agnolo Gaddi, Oxford 1977; and see also M. Boskovits, "In margine alla bottega di Agnolo Gaddi", in Paragone, 355 (1979), pp. 54–62. On the relationship between Agnolo's cycle and that of Piero, see de Tolnay, "Conceptions religieuses", pp. 222–6, and Gilbert, Change, pp. 73–4, n. 36 (here, among other suggestions, Gilbert puts forward the view, for which there is no apparent evidence, that the left-hand lunette was begun by Bicci di Lorenzo).
 - 57. Mazzoni, pp. 111-12.
- 58. Many scholars have tried to explain the lack of order among these scenes by recourse to supposed typological or other parallelisms: see M. Alpatov, "Les fresques de Piero della Francesca à Arezzo. Semantique et stylistique", in *Commentari*, XIV (1963), pp. 17–38; and L. Schneider, "The Iconography of Piero della Francesca's Frescoes Illustrating the Legend of the True Cross in the Church of San Francesco in Arezzo", in *The Art Quarterly*, XXXII (1969), pp. 22–48, esp. pp. 37–43 (neither essay is convincing, and the first which would explain the frescoes' sequence by the notion that their hidden purpose is to narrate the history of humanity is particularly implausible). A.W.G. Posèq (*The Lunette*, Jerusalem 1974, lithogr., p. 563) formulates the hypothesis of an iconographical change of plan. Freud's famous remark comes to mind: "The distortion of a text is rather like a murder. The difficulty lies not in the execution of the deed but in the doing away of the traces" (*Moses and Monotheism*, Katherine Jones trans., London 1939). Among the traces that we have left unexamined here is the blind Cupid on the left-hand pillar: his presence in the cycle remains unexplained, various speculations notwithstanding.
 - 59. P. Schubring, Cassoni, Leipzig 1915, nos. 192-7, 425-6 etc., and pp. 111, 204.
- 60. See Warburg, "L'ingresso dello stile ideale", in *La rinascita*, pp. 290ff. on the contrast between the historic representation of antiquity (Piero) and the representation of antiquity in contemporary costume (exemplified by a wedding-chest by Benozzo Gozzoli). This contrast is somewhat blurred in E. Panofsky, *Renaissance and Renascences in Western Art*, Uppsala 1965, p. 172.
 - 61. Schneider, "The Iconography".
- R. Krautheimer and T. Krautheimer-Hess, Lorenzo Ghiberti, Princeton (N.J.) 1950, pp. 180-7.
 - 63. Clark, pp. 38-9.
- 64. "... we are able to recognize in the features of Constantine's face ... a personage of the day who did indeed have the right to present himself in this guise: the Greek Emperor, John Palaeologus", writes Warburg ("L'ingresso dello stile ideale", p. 291; cf. by the same author: *Die Emeuerung*, I, pp. 390–1). None of the later commentators has gone beyond this observation that Constantine's portrayal as Palaeologus is consistent with the theme of a crusade.
- 65. Salmi, "I Bacci di Arezzo", p. 236. Giovanni Bacci was not absolutely the first-born, as I mistakenly stated: see Black, "Uses and Abuses", pp. 68, 71. Black argues that it is unlikely, given Giovanni's frequent absences from Florence, that he can have dealt directly with Piero.
- 66. The first to suggest such a connection was, to the best of my knowledge, Marinesco, on the basis of the ties between Bessarion and Federigo da Montefeltro ("Echos byzantins", pp. 193, 202–3). The supposition that Piero may have met Bessarion at Urbino (p. 203) overlooks a possible occasion of their meeting in 1458–59, while Piero was in Rome (on this, see ch. IV below). The reference (p. 202) to a lost portrait of Bessarion by Piero is based on a particularly confused passage in Vasari, on which see below, ch. IV. Marinesco sees Bessarion as having

introduced Piero to certain themes of the Byzantine iconographic tradition. A different connection is suggested by T. Gouma-Peterson, in an essay analysed later in the present work.

- 67. The most comprehensive work on Bessarion is still L. Mohler, Kardinal Bessarion als Theologe, Humanist and Staatsmann, Paderborn 1923, 1927, 1942: there is one volume of biography, and two of published and unpublished texts. This is brought up to date, not only bibliographically but in other respects, by L. Labowsky's excellent entry in the Dizionario biografico degli italiani (Rome 1967, vol. 9, pp. 686–96). On Bessarion's attitude during the Council, see J. Gill, "Was Bessarion a conciliarist or a unionist before the council of Florence?", in Collectanea byzantina, Rome 1977, pp. 201–19. For his relationship with John VIII, see also A. Gentilini, "Una consolatoria inedita del Bessarione", in Scritti in onore di Carlo Diano, Bologna 1975, pp. 149–64 (where there is a discussion of three sermones written on the occasion of the Empress Maria Commena's death).
- 68. R. Loenertz, "Pour la biographie du cardinal Bessarion", in *Orientalia Christiana Periodica*, X (1944), p. 284.
- 69. G. Mercati, Per la cronologia della vita e degli scritti di Niccolò Perotti arcivescovo di Siponto, Rome 1925.
 - 70. Gill, The Council, p. 376f.
- 71. See G.B. Schioppalalba (but publ. anonymously), In perantiquam sacram tabulam Graecam insigni sodalitio sanctae Mariae Caritatis Venetiarum ab amplissimo Cardinali Bessarione dono datam dissertatio, Venetiis 1767. See also G. Cozza Luzi, "La croce a Venezia del card. Bessarione", in Bessarione, VIII (1904), pp. 1–8, 223–36; G. Fogolari, "La teca del Bessarione e la croce di san Teodoro di Venezia", in Dedalo, III (1922–23), pp. 139–60; E. Schaffran, "Gentile Bellini und das Bessarion-Reliquiar", in Das Münster, 10 (1957), pp. 153–7.
- 72. A. Frolow, La relique de la vraie Croix. Récherches sur le développement d'un culte, Paris 1961, pp. 563–5 (and see also the same author's Les reliquaires de la vraie Croix, Paris 1965).
 - 73. Schioppalalba, pp. 117-19.
- 74. Attention has recently been drawn to the importance of this for Piero's cycle by Battisti (I, p. 249) and by A. Chastel, *Fables, formes et figures*, Paris 1978, I, p. 58; Chastel follows up a hint of Schneider's (p. 46, n. 44). On the relics of the True Cross found in Italy, see A. Frolow's studies cited above.
 - 75. G. Mercati, Scritti d'Isidoro il cardinale Ruteno . . ., Rome 1926, p. 134 and n. 6.
 - 76. H. Vast, Le cardinal Bessarion, Paris 1878, p. 234; L. Mohler, I, p. 286.
- 77. Schioppalalba, pp. 118–19: Gregory "ante obitum suum . . . reverendissimo D. Cardinali [i.e. Bessarion] . . . absenti tunc, et in Mantuano conventu degenti legavit" (the passage is from the deed of gift to the Scuola Grande della Carità, and is also given in Cozza Luzi pp. 3–6, who reads "agenti" instead of "degenti").
 - 78. Mercati, p. 134, n. 6.
 - 79. Schioppalalba, p. 118.
 - 80. On the date and antecedents of this medal, see the notes below.
- 81. The description, found in a letter of 1551 to Cosimo I, is as follows: "I still possess a very beautiful medallion of John Paleologus, Emperor of Constantinople, with that odd Grecian-looking little cap the Emperors were wont to wear. And it was made by this same Pisano in Florence at the time of the Council of Eugenius, which was attended by the aforesaid Emperor; the reverse side bears the Cross of Christ, upheld by two hands, token of the Latin and Greek Churches" (G. Bottari and S. Ticozzi, *Raccolta di lettere sulla pittura*, Milan 1822, V, p. 83; Vasari also quotes the passage [III, p. 11]). It has been maintained by J.A. Fasanelli on the basis of this passage (see "Some Notes on Pisanello and the Council of Florence", in *Master Drawings*, III [1965], pp. 36–47) that the medal was struck at Florence in commemoration of the Council's successful outcome, this being indicated by the symbol on the back of the version described by

Giovio; he thus proposes a date for the two versions of the medal between 6 July (the act of union) and 26 August (the Emperor's departure) 1439. R. Weiss (*Pisanello's Medallion of the Emperor John VIII Palaeologus*, London 1966, pp. 16–17) has cast doubt on the existence of the version mentioned by Giovio, ruling out Pisanello's attendance at the Council in Florence on the grounds that he was in Mantua in May 1439; he argues that the medal of John VIII was struck at Ferrara in 1438, and commissioned by Leonello d'Este or by the Emperor himself. V. Juřen ("A propos de la médaille de Jean VIII Paléologue par Pisanello", in *Revue numismatique*, s. 6', XV [1973], pp. 219–25) identifies the cross upheld by two arms as Bessarion's personal symbol, but disagrees with Fasanelli and Hill (*Pisanello*, London 1905, pp. 106–7; *Medals of the Renaissance*, G. Pollard [ed.], London, 1978, p. 36) in regarding the extant version of the medal of John VIII as the only one struck; for it, he proposes the *terminus ad quem* of August 1438, with convincing arguments. The article by M. Vickers ("Some Preparatory Drawings") has nothing new to tell us on the dating, or on the existence or otherwise of the version in Giovio's description. These are questions which must thus remain open for the present.

- 82. Cf. J. von Schlosser, "Die Aeltesten Medaillen und die Antike", in *Jahrbuch der Kunsthistorischen Sammlungen des allerhöchsten Kaiserhauses*, 18 (1897), pp. 64–108, still a fundamental work (for the connection with the history of the cross, cf. pp. 77–8). On p. 92 the two medals are defined as "the oldest forgeries of antiquity". Cf. also O. Kurz, *Fakes*, New York 1967, p. 191.
- 83. Cf. J. von Schlosser, Raccolte d'arte e di meraviglie del tardo Rinascimento, Italian trans., Florence 1974, pp. 44–5 (the original German edn is of 1908). M. Jones also suggests the attribution to the Limbourgs, putting forward some new arguments, in "The First Cast Medals and the Limbourgs. The Iconography and Attribution of the Constantine and Heraclius Medals", in Art History, 2 (1979), pp. 35–44 (though Jones appears not to know of Schlosser's second contribution). That the Limbourgs should be identified as the authors of the drawings on which the medals were based (and not, as Schlosser and Jones would have it, of the medals themselves) had earlier been argued by C. Marinesco, "Deux empereurs byzantins. Manuel II et Jean VIII Paléologue, vus par des artistes parisiens et italiens", in Bulletin de la Société nationale des antiquaires de France, 1958, p. 38.
- 84. Cf. R. Weiss, "The Medieval Medallions of Constantine and Heraclius", in *The Numismatic Chronicle*, 7, III (1963), pp. 129–44 (in particular p. 140); and see also M. Meiss, *French Painting in the Time of Jean de Berry*, London 1967, Vol. I, pp. 53–8.
- 85. Longhi, *Piero*, pp. 40, 212–13; and the same author's "Genio degli anonimi: Giovanni di Piamonte?" in *Fatti di Masolino e di Masaccio*, pp. 131–7.
- 86. Battisti, I, p. 133. It should be noted that in the essay just cited ("Genio degli anonimi"), Longhi himself does not speak of specific debts, in connection with the Città di Castello altarpiece, to the Arezzo frescoes debts that one might legitimately expect to find if the latter had been commenced in 1452 or soon after.
- 87. In support of Longhi's proposed chronology, A. Conti has argued that a fragment of fresco by Parri Spinelli (d. 1453), now housed in the art gallery at Arezzo, derives from Piero's Victory of Constantine (see "Le prospettive urbinati: tentativo di un bilancio ed abbozzo di una biliografia", Annali della Scuola Normale Superiore di Pisa, classe di lettere etc. s. III, VI [1976], p. 1214 n.). The undeniable link between the two works, which had already been remarked by P. Hendy (Piero della Francesca and the Early Renaissance, London 1968, p. 84), can, however, be interpreted in the inverse direction: see M.J. Zucker, Parri Spinelli, New York 1973 (typescript), pp. 316–17, who, on the basis of stylistic considerations, dates Parri's fresco to around 1435–40. It is interesting to note this fresco's original location the monastery of Santa Fiora and Lucilla, whose abbot at the time was Aliotti, a friend of Giovanni Bacci and like him connected with Traversari.

III

The Flagellation of Christ

front. Every aspect of this famous small panel (58 cm by 81 cm) has been the subject of debate, except its authenticity. Doubt has never been raised about the signature to be read in Roman capitals on the step beneath Pilate's feet: "Opus Petri de Burgo Sancti Sepulcri". The rest – its patron, its date, the subject it represents – is uncertain. Innumerable commentaries, coming ever thicker and faster in recent years, have made the *Flagellation* one of the most controversial cases in the hermeneutics of art.

No record of the work is found for three centuries. In the eighteenth century it was kept in the sacristy of the Cathedral at Urbino. An inventory dated 1744 contains the following reference, one of the earliest that we have: "In the sacristy . . . the Flagellation of Our Lord upon the column and, set apart, our most serene highnesses the Dukes Oddo Antonio, Federico and Guid'Ubaldo by Pietro Dall'Borgo." "Set apart": thus did Dean Ubaldo Tosi, in preparing the inventory, stress the most exceptional feature of the painting (we shall return later to his suggested identification of the characters). The scene of Christ's flagellation is immediately recognizable, but it takes place in the background and to one side. A large distance, which Piero has rendered with an extraordinary command of perspective, separates the beaten Christ from the three mysterious figures in the foreground. Why is there such a distance between the two scenes?

The question clearly concerns both the picture's formal peculiarity and its iconographic anomalies.² We shall thus be trying not just to solve an iconographic riddle, but to decipher an element crucial to an understanding of the work as a whole, in all its aspects – including its patron and its date.

*

In identifying the fundamental hermeneutical problem, we also provide ourselves with a criterion by which to analyse the principal interpretations of the *Flagellation* put forward hitherto. Rather than reviewing these in the order in which they were first advanced, we shall divide them into three distinct groups: 1) those which state that there is no significant connection between the group in the foreground and the flagellation of Christ, which are purely and simply juxtaposed; 2) those which hold that the characters in the foreground form an organic part of the scene of Christ's flagellation; 3) those which hold that the two scenes are separated (even in the time of their occurrence), and that there exists between them a relation that has to be determined. For the moment, we will simply give the essence of the principal interpretations, taking up later, where relevant, more detailed points of individual scholarship.

The first thesis is elliptically maintained by Toesca in his claim that Piero here manifests "sovereign disinterest . . . in the principal subject" (that is, in the flagellation of Christ).³ Creighton Gilbert formerly argued (though he has subsequently changed his views) for a still more anachronistic interpretation, taking the three men in the foreground to be anonymous passers-by, and viewing the picture itself as a slice of life, "prefiguring Tintoretto and Degas".⁴

The second thesis has been far more widely accepted. Gombrich surmised that the bearded man was Judas, in the act of giving back to the members of the Sanhedrin the price paid for his treachery; however (as Gombrich himself acknowledges), the picture contains no trace of the thirty pieces of silver. 5 In a second contribution, Gilbert based his analysis on the phrase "Convenerunt in unum", which, according to Passavant (1839), used formerly to accompany the painting (today, the inscription has disappeared, together with the frame to which it was probably attached).6 This is a reference to the second verse of Psalm 2: "Adstiterunt reges terrae, et principes convenerunt in unum adversus Dominum et adversus Christum eius" (The kings of the earth set themselves in array and the rulers were gathered together against the Lord and against his Anointed). In the Acts of the Apostles (iv. 26–7), the psalm is quoted in reference to Christ's passion: "Convenerunt in unum adversus Dominum et adversus Christum eius. Convenerunt enim . . . Herodes, et Pontius Pilatus, cum gentibus et populis Israel." Gilbert, following an observation of P. Running,7 has identified the latter passage as the textual basis of Piero's Flagellation. This would then depict, apart, of course, from Pilate

on his throne, Herod (the turbaned man whose back is turned towards us and who faces Christ) and, in the foreground, from left to right, a gentile, a soldier, and Joseph of Arimathea. According to Gilbert, the picture's iconography is by no means novel: in other pictures of similar subject-matter (and of Sienese provenance) – such as Pietro Lorenzetti's fresco in the lower church at Assisi, or the small panel by the so-called Maestro dell'Osservanza in the Vatican Gallery⁸ – groups of people present at Christ's torment, and standing a little apart, are to be found. However, neither of these comparisons is very convincing: in Piero's *Flagellation*, the three men in the foreground are much farther away from the scene of Christ surrounded by his tormentors, on which, moreover (and this is the most telling point), they have turned their backs.

A similar attempt to find a scriptural correspondence that will explain Piero's entire composition has been made recently by L. Borgo.9 He draws attention to the passage in the Gospel of St John (xviii. 28) in which we are told that the members of the Sanhedrin remained outside Pilate's palace in order not to defile themselves before Passover. This textual correspondence, precise though it seems to be, neverless leaves several features unexplained: why, for example, is the young man in the centre wearing a tunic, and why does he go barefoot, while the two men are shod and wear modern clothes? Borgo sets out, by way of some very frail arguments,10 to trace three more or less analogous characters in various flagellations, some earlier and some later than Piero's; and he explains this iconographic tradition by reference to a ninth-century Hebrew text concerning Jesus's trial. In this, three opponents of Pilate's are mentioned – a priest, an old man, and someone called "the gardener" because it was in his garden that Jesus was eventually buried. Apart from the difficulty (acknowledged by Borgo himself) of identifying the barefoot young man as "the gardener", there is another and graver objection: we don't have any evidence that this Hebrew text can have circulated in fifteenth-century Italy. Borgo is thus obliged to postulate a missing source, connected in some way with this Hebrew tradition, on which Piero's picture may have been based. But why should the members of the Sanhedrin be placed in the foreground? Borgo argues that Piero drew his inspiration from the lost Flagellation of Andrea del Castagno in Santa Croce. The fact that this fresco had been "scratched and spoiled" (as Vasari wrote) "by children and other simpletons, who have scratched out all the heads and the arms and almost all the remainder of the figures

of the Jews"¹¹ is meant to prove not only that these latter were fully visible, but even that they were most probably "situated to some significant extent towards the foreground" of the composition. Leaving aside the captiousness of this conclusion, it seems clear that Borgo's edifice of interpretation rests on two rather shaky pillars: a text we cannot trace, and a lost fresco.

It is true that a Flagellation does exist which would seem at first sight to confirm Borgo's hypothesis of an iconographic tradition that singled out three well-characterized figures from among Pilate's interlocutors. This is 39 an anonymous small panel painted in oil, probably in the early decades of the sixteenth century, and kept today in the Prado in Madrid. We see Christ being beaten by his tormentors in an open gallery, while outside it, a little set apart from Pilate's throne, three men are standing by: an old man with a beard (clearly a priest), a middle-aged man and a youth. Are these R. Joshua ben Perachiah, Marinus, and the "gardener", R. Judah, mentioned in the ninth-century Hebrew text, and did this text also make its way, by unknown intermediate stages, to the knowledge of Piero, or of whoever commissioned him?¹² The explanation is probably simpler. The Prado Flagellation has been attributed, at various times, to different artists - to a Spanish follower of Bosch, to Juan de Flandes, to Alejo Fernandez or a painter of his circle. The question remains open, in any case. But the great prominence given to the architecture has led scholars to suppose that the painting was inspired by some Italian model (in the past, significantly, it was attributed to Antonello da Messina). It has been remarked that the ruined building that is the scene of Christ's martyrdom derives from a well-known engraving bearing Bramante's signature. 13 This name we associate with Urbino - and with Piero (since Bramante was said to have been his "follower"); and Post has indeed invoked Piero's Flagellation in connection with the Prado panel, surmising that its painter had travelled to central Italy. 14 Some connection between the two works, direct or indirect (perhaps by way of Pedro Berruguete, who worked at Urbino and who completed the altarpiece by Piero, now in the Brera, featuring Federico da Montefeltro's hands and arms), does indeed seem plausible. The positioning of the three men seems to echo that of the three characters in the foreground of Piero's painting: more specifically, the brocade mantle of the old priest in the Madrid painting irresistibly recalls that worn by the old man in Urbino. To be sure, their physiognomies are quite different, and the gestures and clothes of the two

outside figures have been, so to speak, reversed. Above all, we seem able to make out in the Madrid panel a desire to normalize the iconography of Piero's *Flagellation*:¹⁵ the three men stand to one side of Christ, rather than turning their backs on him at a distance (and one of them is actually pointing to him, turning towards the other two); the richly clad old man has been given a long beard, identifying him as a Hebrew priest and placing him unambiguously in the sacred scene; the middle-aged man, who is speaking, wears a black cap, rather than an oriental hat; the young man has neither tunic nor bare feet. Whether or not it is connected in some way with Piero's *Flagellation*, this *Flagellation* in the Prado in any case confirms the latter's absolute iconographic uniqueness.

It is precisely this singularity that is denied by those who see Piero's picture as a variant of the normal *Flagellations*. Their efforts, however, are confounded not only by the painting's overall compositional structure, but by something else: the physiognomical individualization and contemporary clothes of two of the three men in the foreground. The possibility that these may be portraits leads us at once to ask who the persons depicted may be, and by what link they are connected with the flagellation scene in the background. And this brings us to the third, and most numerous, group of interpretations.

Among these is included the oldest interpretation, formulated during the eighteenth century by Urbino scholars, and found as part of the entry in the 1744 inventory that we have already quoted. According to this, the three in the foreground are Oddantonio, Count of Urbino (in the middle), his brother Federico (on the right), and the latter's son, Guidu-40 baldo (on the left). This triple identification, which is patently absurd, since the respective ages of the persons shown are not congruous with it and since Federico's unmistakable features are conspicuous by their absence, was later corrected. Oddantonio, the sole survivor from the first hypothesis, was now thought to be flanked by the wicked counsellors Manfredo dei Pio and Tommaso dell'Agnello, who were killed together with Oddantonio himself in the plot of 1444.16 Further confirmation for this interpretation was found in the phrase from Psalm 2 that we have already discussed, "Convenerunt in unum". The words were applied not only to Christ but also to the murdered Count, and a relation of analogy thus proposed between the scene in the foreground and that in the

background. This iconographic decoding gave rise to a *terminus post quem* – 1444, the year of the conspiracy and of Oddantonio's death – which was deemed to be probably very close to the date of the painting's actual execution, since its presumed patron, Federico da Montefeltro, would hardly have delayed long in commemorating his murdered brother.

To date the picture this early, and thus to set it among the earliest of Piero's works to have come down to us, raises quite serious stylistic difficulties, of which Longhi himself was ultimately forced to take cognizance, despite his long-held commitment to the view (together with all its implications) that the picture portrayed Oddantonio.¹⁷ From a strictly iconographic point of view, the interpretation appears altogether baseless, since the identification of the figures came very late,¹⁸ the parallel between Oddantonio and Christ seems implausible, and the verse of the Psalm recalled by the phrase "convenerunt in unum" is singularly illadapted to its supposed evocation of the counsels of the two wicked ministers (and still less appropriate as a reference to the plot), speaking as it does of "reges terrae, et principes".

Despite this, the interpretation went unchallenged until the middle of the present century. (Toesca's solitary dissenting view, expressed, as we have seen, in somewhat impatient anti-historical terms, found no supporters.) In 1951, Clark rejected it, quietly but effectively setting out the grounds for an altogether different reading.¹⁹ It is worth remarking that his argument's point of departure was not iconographic but stylistic: the echoes of Alberti's architecture, and more especially of the porticos of San Pancrazio and Santo Sepolcro Rucellai, which are discernible in Pilate's loggia (itself in turn compared to the loggia where Solomon greets the Queen of Sheba in the Arezzo fresco). Thus the date implied by the identification of the young man as Oddantonio (1444 or very soon afterwards) was rejected, being too early in terms of Alberti's stylistic development, and the identification itself was refuted, on the grounds that a tyrant such as Oddantonio was hardly likely to have been shown with bare feet, or more generally to have been commemorated at all following the conspiracy that had killed him. Instead, the hypothesis was put forward that the three figures were intently meditating on Christ's sufferings, which were a symbol of the tribulations undergone by the Church at the hands of the Turks (evoked by the turbaned figure with his back towards us). A similar meaning was to be found in the verse "Convenerunt in unum", which is part of the liturgy for Good Friday²⁰

and which in the Books of Hours often accompanies images of the flagellation. All this formed the basis of a broader suggested dating of the work – roughly between 1455 and 1460 – as well as of two more specific suggestions: that the picture was painted in 1459, on the occasion of the assembly called to Mantua by Pius II to exhort the Christian princes to the crusade, or else in 1461, when Thomas Palaeologus, brother of the dead Emperor John VIII, conveyed to Rome the famous relic of the apostle Andrew.²¹ Clark in fact discerned "a certain resemblance" to the Palaeologi in the bearded man, but he neverless admitted that this interpretation left unresolved the identity of the richly dressed figure (certainly a portrait) in the foreground, and the significance of the "arcadian youth" at his side.

Clark's contribution marked an important date in the history of the Urbino picture's interpretation – both for its intrinsic value, and because in its complete rebuttal of the hitherto accepted thesis it opened the way for a debate that has now extended over thirty years. We have already considered the group of suggestions that attempt, as if in reaction to Clark, to replace Piero's picture within the more or less canonical iconography of the flagellation of Christ. Meanwhile, other scholars have tried to effect a compromise between Clark's thesis and the traditional one. Siebenhüner identifies the three characters, from the left, as John VIII Palaeologus, Oddantonio and Guidantonio da Montefeltro: he holds the picture to be connected with Pius II's projects for a Crusade, to have been commissioned by Federico da Montefeltro, and to have been executed in 1464–65.²² According to Battisti, the three are (from the left) a Byzantine ambassador, Oddantonio, and either Filippo Maria Visconti or (if you prefer) Francesco Sforza; the patron was Federico da Montefeltro, who was seeking to rehabilitate Oddantonio's memory; and the date is 1474, or 1463, or else an intermediate date (1465-69).²³

These identifications rest, for the most part, on little or no documentary basis. More analytic, but no less unacceptable, is M. Aronberg Lavin's lengthy essay,²⁴ which puts forward an altogether new interpretation. She argues that Piero depicts, on the left, Ottaviano Ubaldini della Carda – a courtier of Federico da Montefeltro, and the painting's patron – in conversation with Ludovico Gonzaga, the Marquis of Mantua (on the right). They are talking, Lavin argues, about the family misfortunes which

both had suffered: the death of the former's son (1458), and the illness of the latter's nephew (1456–60). The central figure depicts this nephew before he became ill. Ubaldini, it is argued, is exhorting Ludovico to resignation, and reminding him, by way of the example of the flagellation evoked in the background, that Christian glory is higher than earthly woes. This interpretation, as several critics have insisted,²⁵ is altogether baseless taken as a whole; but it does contain some useful hints, to which we shall return.

T. Gouma-Peterson's rewarding essay, 26 on the other hand, returns to the line of interpretation opened up by Clark, deepening it in certain respects. Her scholarly analysis begins with the identification of Pilate with John VIII Palaeologus (an identification already put forward by Babelon which nobody had followed up). This is definitively confirmed by the detail of the crimson stockings, which formed part of the regalia of the Eastern emperors. Christ's flagellation is held to symbolize (as Clark had suggested) the sufferings of the Church at the hands of the Turks. Pilate's inaction - for he does nothing to halt these sufferings - is 41 matched by that of the right-hand figure in the foreground, whom Gouma-Peterson sees as a "western prince", without identifying him more precisely. The bearded man stands between these two; he is a Greek, as shown by his clothes and his hat, and possibly an ambassador. His position in the picture seems to mark him out as a mediator between East (Pilate-John VIII) and West (the "prince" in the foreground). The young man, on the other hand, is to be seen as an allegorical figure, the "champion of virtue", ready to do battle. And he is exhorting the bearded Greek himself to battle against the Turks (depicted in the background), so that Christ's sufferings may be relieved. The latter are represented as an "archetypal event inserted into the context of historical reality".27 The gap between the two worlds, that of the present (the figures in the foreground) and that of the past (the flagellation), is emphasized, not only by the spatial distance, but also by the existence of two different light-sources (respectively from the left and the right). Gouma-Peterson follows Lavin in attributing to this feature an expressive and even a symbolic value.²⁸ The picture would thus have a decidedly political meaning. Gouma-Peterson argues that it was commissioned by Cardinal Bessarion, who then sent it to Federico da Montefeltro (with whom he was very closely linked) to convince him of the necessity of a crusade against the Turks. Its dating may fall within either of two

periods, 1459–64 or 1459–72, since at these times plans were being laid (by Paul II and Sixtus IV respectively) for crusades – plans which Bessarion warmly supported. Gouma-Peterson asks whether we should not see the bearded Greek in the foreground as a portrait of Bessarion. Her reply is in the negative: the bearded man's face is unlike Bessarion's, and besides he wears neither the insignia of a Cardinal nor the habit of a monk of St Basil in which Bessarion is generally portrayed. She concludes that we are to see this as a "crypto-portrait" of Bessarion, in the guise of a Byzantine ambassador.

It is not clear how we are meant to take this last expression: how can one speak of a portrait, if the data are inconsistent with those which ought to characterize the person in question? We shall see below whether a less contradictory conclusion cannot be reached on this point.

This review of the scholarly literature, summary and incomplete as it is, should suffice to show that the same ingredients, cooked in different hermeneutic sauces, can produce concoctions of very varying flavour. One might be pardoned for a somewhat sceptical reaction to this spectacle of thirty years of extremely close discussion about the *Flagellation*, which have failed to result in even the most minimal agreement about the painting's date, or its patron, or the subject that it represents.

This last element is the key in the present case. Since no documents have been traced on the painting's commissioning, or even its original location, scholars have had to connect their various hypotheses about its patron to the identification of its subject. The same has gone, at least in most cases, for its dating: leaving aside the interpretative line that manages to see Piero's painting as just one more flagellation more or less conforming to the norm, all the other iconographic suggestions have also implied a dating, more or less elastic and conjectural.

What this means is that the contest over the *Flagellation* is played out entirely on the terrain of iconographic decoding. And the briefest glance at the series of interpretations hitherto advanced shows that some progress, despite everything, has been made. If we leave aside the most improbable and unfounded theses (including the traditional identification of Oddantonio as one of the painting's subjects), then the competing interpretations can be reduced to two. First we have Gilbert's suggestions, put forward in his second contribution, that Piero's *Flagellation* must be placed in a

pre-existing iconographic series – which then makes it a picture of a sacred subject, where every figure depicted plays a role in an episode of Christ's passion. Alternatively, there is the hypothesis put forward by Clark and considerably modified by Gouma-Peterson, which proposes a decidedly anomalous iconography – the picture refers to contemporary political and religious events, just as it depicts, in the foreground, contemporary personages (apart from the young man, whom Gouma-Peterson regards as an allegorical figure); and the scene of the flagellation represents the subject of their reflections (Clark), or an archetypal event (Gouma-Peterson), alluding symbolically to the sufferings inflicted by the Turks upon the Church of Christ.

These two overall views give rise, as we have seen, to completely different interpretations of every, or nearly every, element making up the picture. However, the enigma of its iconography remains unresolved. We must now take up our position on the basic options we have outlined, in order to offer, if possible, an analytic interpretation more convincing than those put forward so far.

Notes

- 1. BUU, Fondo del Comune, ms. 93 (miscell.), c. 224r. The passage forms part of a "Catalogue of paintings preserved in the metropolitan city of Urbino, with information on their authors". Systematic research into the pastoral visitations might establish whether the Flagellation was always kept in the Metropolitan sacristy. The visitation of 1636 makes this seem questionable: on 16 September, after having forbidden the "deambulationes, nugas, circulos, negociationes" that were occurring in the Metropolitan sacristy, it was ordered that seats should be brought into it "ubi sacerdotes missae sacrum facturi genuflectere ac sese colligere et orare valeant, proposita desuper crucifixi effigie aut aliqua alia pia immagine" (ACAU, Fondo visite pastorali; italics added). The last phrase suggests that the sacristy walls were not at this time hung with any paintings of religious subject-matter. L. Pungileoni (Elogio storico di Giovanni Santi, Urbino 1822, p. 97) refers to a much earlier document, an "inventory of things to be found in this Metropolitan made in 1504 by the Notary Federico di Paolo", as containing "a note on the paintings, too, but . . . scanty and disordered". It is possible that this inventory still forms part of the deeds drawn up by this same lawyer (Federico di Paolo Guiducci), which are kept in the Urbino state archives, but I have been unable to find it.
- 2. C. Gilbert insists on this point in "On Subject and Not-Subject in Italian Renaissance Pictures", in *The Art Bulletin*, XXXIV (1952), p. 208, n. 21; however, as argued below, his suggested solution is unacceptable.
 - 3. P. Toesca, "Piero della Francesca", in Enciclopedia italiana, Rome 1935, XXVII, p. 211.
 - 4. Gilbert, "On Subject" pp. 208-9.
 - 5. E.H. Gombrich, in his review of Clark's Piero, Builington Magazine, 94 (1952), pp. 176-8;

and "The Repentance of Judas in Piero della Francesca's 'Flagellation of Christ'", Journal of the Warburg and Courtauld Institutes, XXII (1959), pp. 105–7.

- 6. C. Gilbert, "Piero della Francesca's 'Flagellation': The Figures in the Foreground", in *The Art Bulletin*, LIII (1971), p. 41, n. 5. The "gilded frame", now lost, is mentioned in an inventory of 1754 (BUU, *Fondo di Urbino*, ms. 93, c. 386r; for the date, see c. 388r).
 - 7. P.D. Running, in The Art Bulletin XXV (1953), p. 85 and Gilbert, "Figures", pp. 41-51.
- 8. On the "maestro dell'Osservanza", see Longhi, Fatti di Masolino e di Masaccio, p. 60; A. Graziani, Il Maestro dell'Osservanza, Florence 1948 (extract from Proporzioni); F. Zeri, "Il Maestro dell'Osservanza; una 'Crocefissione'", in Paragone, 49 (1954), pp. 43–4; E. Carli, Sassetta e il Maestro dell'Osservanza, Milan 1957, pp. 89ff.
- 9. L. Borgo, "New Questions for Piero's 'Flagellation'", *Burlington Magazine*, 121 (1979), pp. 547–53. This essay has been convincingly countered in criticisms by M. Aronberg Lavin (ibid., p. 801) and by C.H. Clough (ibid., 122 [1980], pp. 575–7).
 - 10. See Clough's observations, ibid., p. 577.
 - 11. See Vasari, II, pp. 672-3; and Borgo, "New Questions", pp. 550-1.
 - 12. Ibid., p. 548.
- 13. D. Angúlo Iñíguez, "Bramante et la 'Flagellation' du musée du Prado", in *Gazette des Beaux-Arts*, vol. XLII, a. 95 (1953), pp. 5–8. The engraving is actually the work of B. Prevedari: cf. E. Borea, "Stampa figurativa e pubblico", in *Storia dell'arte italiana*, 1, 2, pp. 346–7.
- 14. It was Sabba da Castiglione who described Bramante as having been "creato" (follower) of Piero (see Longhi, *Piero*, p. 117); the reference to Piero in connection with the Prado painting attributed, uncertainly, to Alejo Fernandez is in C.R. Post, *History of Spanish Painting*, Cambridge (Mass.) 1950, X, p. 90.
- 15. Something of the same intention is discernible in Bartolomeo della Gatta's illumination for the Urbino *Antifonario*, depicting the martyrdom of St Agatha (cf. M. Salmi, *La miniatura italiana*, Milan 1956, p. 50 and illustr. XLIV). Gilbert (*Change*, p. 106) supposes this to derive directly from Piero's *Flagellation*: it shows three onlookers facing towards and pointing at the saint bound to the column.

16. The details of this interpretation, and its history, are charted in M. Aronberg Lavin, "Piero della Francesca's 'Flagellation': the Triumph of Christian Glory", in *Art Bulletin*, L (1968), pp. 321–42.

- 17. Ibid., pp. 6ff.
- 18. See n. 22 below.
- 19. Clark, Piero (1st edn), pp. 19-21.
- 20. They are the antiphon of the first nocturn for Good Friday, at Matins: so far as I know, this was first pointed out by W. Bombe, "Die Kunst am Hofe Federigos von Urbino", in *Monatshefte für Kunstwissenschaft*, V (1912), p. 470.
- 21. The second hypothesis was put forward by Clark in the revised (1969) edn of his *Piero*, pp. 34–5.
- 22. H. Siebenhüner, "Die Bedeutung des Rimini-Freskos and der Geisselung Christi des Piero della Francescas", in *Kunstchronik*, 7 (1954), pp. 124–5. Siebenhüner identifies Oddantonio by referring to a late fifteenth-century portrait, today at Vienna, which comes from the Ambras collection; in it, the Count, named as such by a prominent inscription, does indeed have features very similar to those of the young man in the *Flagellation*. F. Kenner, who published a reproduction of the portrait, supposed it to have been copied from a lost original by Gentile da Fabriano (see "Die Porträtsammlung des Erzherzogs Ferdinand von Tirol", in *Jahrbuch der Kunsthistorischen Sammlungen des allerhöchsten Kaiserhauses*, 17 (1896), pp. 269–70. Bombe ("Die Kunst", p. 470) who later substituted for Gentile's name that of Piero, attributed the copy to Alessandro Allori. See below, p. 85.

- 23. Battisti, I, pp. 318ff; there is a reference (involving some bibliographical confusion) to the portrait formerly in the possession of the Archduke of the Tyrol on p. 324.
- 24. Aronberg Lavin, "Triumph"; this article, together with a hypothesis on the painting's original destination, appears in book form in Lavin's *Piero della Francesca: the Flagellation* (New York 1972). A new edition has now appeared (Chicago 1990), with a bibliographical appendix.
- 25. See Gilbert's detailed discussion, in "Figures" and B. Cole's review of the book mentioned in n. 24 in *Burlington Magazine*, 115 (1973), pp. 749–50.
- 26. T. Gouma-Peterson, "Piero della Francesca's 'Flagellation': an Historical Interpretation", in *Storia dell'arte*, 28 (1976), pp. 217–33.
 - 27. Ibid., p. 229. On Babelon's contribution, see ch. IV, n. 72.
- 28. Aronberg Lavin, "Triumph", p. 330; the point is reasserted in the course of a polemic against Borgo (*Burlington Magazine*, 121 [1979], p. 801). C. Brandi had already noted the existence of two light sources, but he drew no interpretative conclusions from his observation: see "Restauri a Piero della Francesca", *Bollettino dell'Istituto Cenrale del Restauro*, 17–18 (1954), p. 91. I am no longer inclined to accept Brandi's hypothesis that the central portion of the ceiling was made lighter in the course of a restoration.

IV

Further Thoughts on the Flagellation

The presence, or otherwise, of portraits of contemporary people in Piero's picture is evidently of decisive importance in understanding its iconographic implications. The existence of any such portraits has often been flatly denied. When Gilbert put forward the thesis (which he himself later refuted) that the three men in the foreground were mere passers-by, arrived by chance at the scene of Christ's flagellation, he stated that their faces corresponded to physiognomical types recurrent in Piero's work. This was proved, he argued, by the fact that the man in the brocade cloak appears again among the kneeling figures at the Madonna's feet in the Misericordia altarpiece in San Sepolcro, and that the blond youth has the same face as one of the angels in the Baptism in the National Gallery, London.¹

Both comparisons are undeniably valid. However, the conclusions that Gilbert draws from them are quite illogical. It is clear, first of all, that the powerful facial individuality of the man in the brocade cloak is quite another matter from the youth's angelic aspect — which is generically typical (and sublimely so). Only in the first case can we suppose that we are looking at a portrait. Gilbert however rules this out, because 1) the man in the Misericordia altarpiece is not a portrait;² and 2) supposing he were one, this would make the figure in the *Flagellation* a citizen of San Sepolcro, not a chancellor of Federico da Montefeltro. But there is no basis for the first statement; and the second puts forward (even if only as a *per absurdum* hypothesis) a gratuitous choice of alternatives. Actually, *tertium datur*: there is a third alternative, and things are more complicated.

It is absolutely certain that the man kneeling at the feet of the Madonna della Misericordia and the man in the brocade cloak in the *Flagellation* are one and the same person. The decisive proof (not that this is needed, given the evident resemblance) lies in the identical modification made in

both cases to alter the outline, and slightly reduce the dimensions, of the unknown person's cranium.³ This can only reflect the artist's scrupulous 45, 46 determination, not just to paint a portrait, but to render with the greatest precision the features of his model.

Piero, moreover, painted this same person on a third occasion, in one of the Arezzo frescoes. In a note which (unless I am mistaken) has escaped the attention of subsequent researchers,4 Clark pointed out that, notoriously risky though it is to identify resemblances, there can be no doubt that the man seen in profile to the left of Chosroes is the same person, 47 grown a little heavier with age, whom we see at the feet of the Madonna della Misericordia. Bringing this identification together with the one (not mentioned by Clark) between the Misericordia portrait and the man in the brocade cloak, we must conclude that we are dealing with the same individual in all three cases. It is enough to note the thick neck, with its deep fold of skin; the chin, the mouth, the eyes; above all, the very unusual ear, sharply pointed and indented at the top, fleshy at the lobe. On the basis of these characteristics, of which he gives a point-by-point list, F. Hartt⁵ has compared the man in the Flagellation, the man in the Misericordia altarpiece, and one of the figures in Solomon's retinue in Solomon Receiving the Queen of Sheba. However, the inclusion of this last 48 figure is a little less convincing: his profile differs from the others in being slightly indented at the top of the nose and in having a rather more prominent upper lip. We shall play safe and limit our series of profiles to the three already identified: those in the Flagellation, the Misericordia altarpiece, and the Defeat of Chosroes.

In his second discussion of the *Flagellation*, Gilbert correctly refuted Lavin's mistaken identification of the man in the brocade cloak as Ludovico Gonzaga, supporting instead his own suggestions and those of Hartt. However, this did not lead him to reject his earlier thesis that the character in the *Flagellation* is a physiognomic type recurrent in Piero's work: it was just that the casual passer-by had now become Joseph of Arimathea.⁶

In actual fact, the figure in question was a man well known to Piero, whose name we can discover from his presence in the *Defeat of Chosroes*. In the final fresco, gathered about the defeated king, Piero portrayed the patrons of the Arezzo cycle. "And so for this work," wrote Vasari, "he deserved to be richly rewarded by Luigi Bacci (whom he drew therein, standing by at the beheading of a King, together with Carlo and other of

his brothers, and many citizens of Arezzo who at that time excelled for their learning)." However, as often happens, Vasari is a little inexact here – rather oddly, in the present case, since (as Salmi points out) he had married a descendant of the family, Nicolosa Bacci. But Salmi's researches into the Bacci family tree have brought to light neither a Luigi nor a Carlo. He therefore suggests that the man in profile beside Chosroes should be identified as Francesco Bacci, and the two men on either side of him as his nephews, Andrea and Agnolo. This identification is conjectural, since we have no other portrait of any of these three. Salmi's choice of names was prompted by a document from which we learn that in September 1447 Francesco Bacci, the uncle, and his two nephews had sold a vineyard in order to pay "the painter whom he has chosen to paint our great chapel of San Francesco". This "painter", as we know, was the artist who began the work, that is to say Bicci di Lorenzo.

Salmi's hypothesis is unlikely, however. In the Defeat of Chosroes Piero painted the portraits, not of those who had paid for his predecessor's work, but of representatives of the three generations of the Bacci family who had conceived the project of decorating the chapel, had had the work begun, and had seen it finished – that is to say (from left to right) of Baccio, who decided on 5 August 1416 "that we shall have adorned with paintings the whole of the great chapel of the church of San Francesco at Arezzo"; of his son, Francesco, who had the work begun in 1447; and of Francesco's son, Giovanni, who oversaw its completion following his father's death in 1459. In the case of grandfather and son, the identification, though highly probable, is conjectural; but it is certain in the case of the grandson, Giovanni. He was the man who had himself painted in profile near Chosroes. "Piero", wrote Longhi, "did not judge even his patrons at Arezzo to be worthy of his own brush, except to a very small extent." This "very small extent" comprises, we are claiming, 49,50 the splendid profile of Giovanni, to whom Piero had probably been linked for some years, and who at that moment was responsible for the decoration of the chapel. Assistants, on the other hand, could quite well be entrusted with the portrayal of the father and the grandfather, who were both dead.

The physiognomical identity of the patron of the Arezzo cycle (seen in profile) and the man in the brocade cloak of the *Flagellation* irresistibly suggests the name of Giovanni Bacci. We quoted earlier from his letter of 1461, which mentions the names of Federico da Montefeltro and

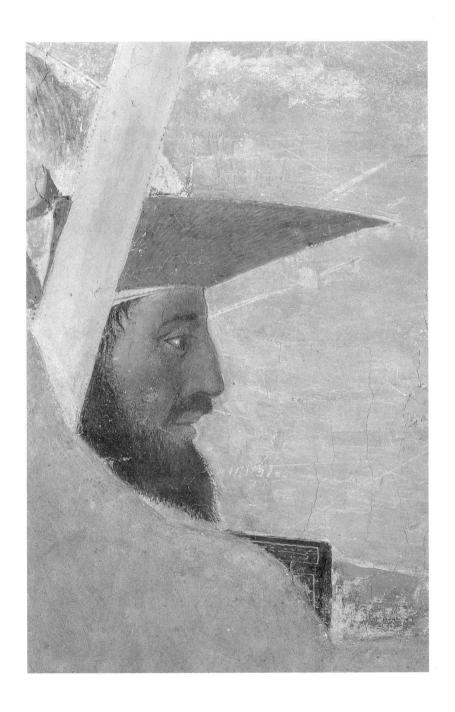

1. Piero della Francesca, Victory of Constantine (detail). Arezzo, San Francesco.

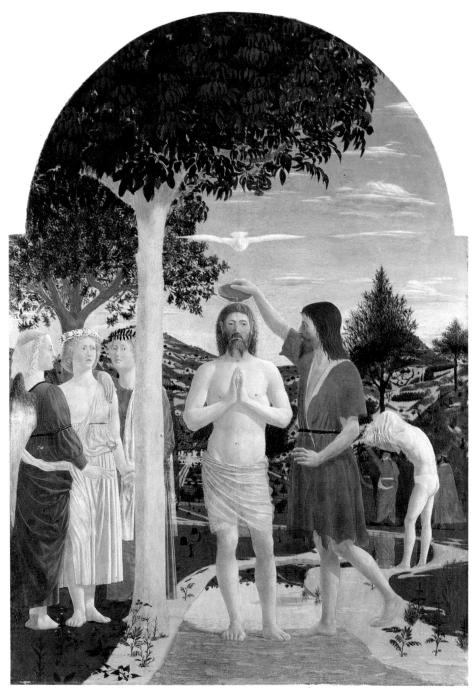

2, 3. Piero della Francesca, *Baptism of Christ* (2. full and 3. in detail). London, National Gallery.

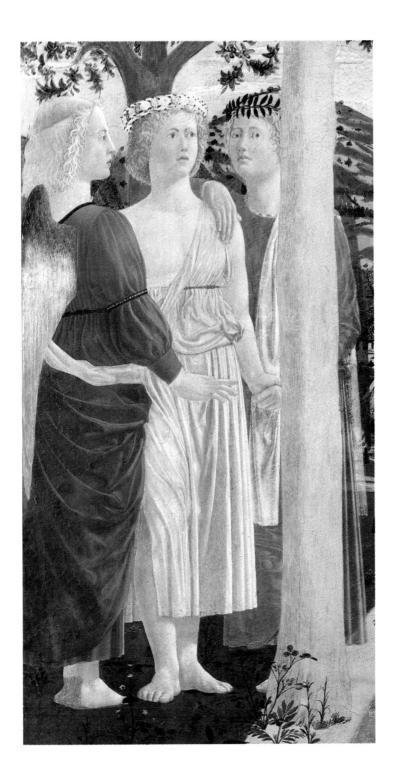

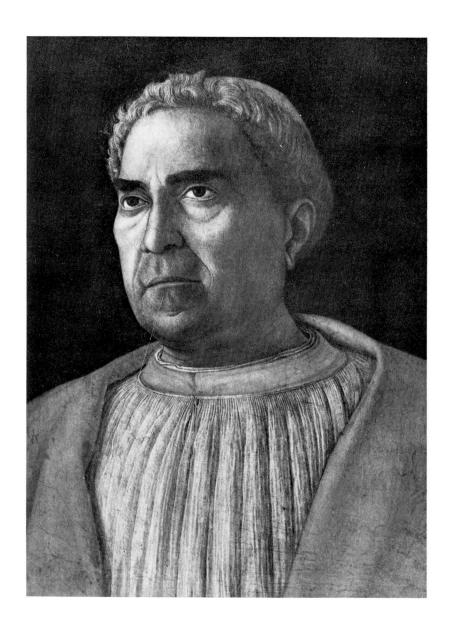

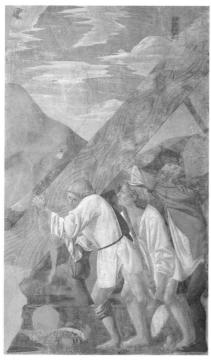

- 5. Death of Adam. Arezzo, San Francesco.6. Raising of the Wood. Arezzo, San Francesco.

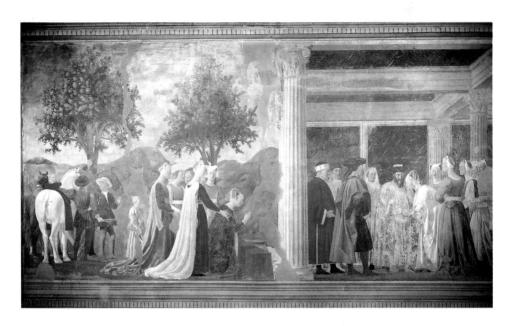

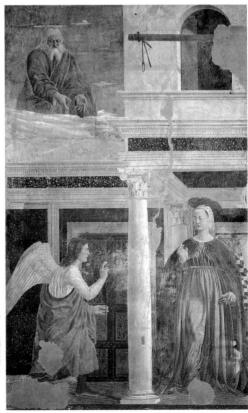

- 7. Queen of Sheba and her Retinue. Solomon Receiving the Queen of Sheba. Arezzo, San Francesco.
- 8. Annunciation. Arezzo, San Francesco.

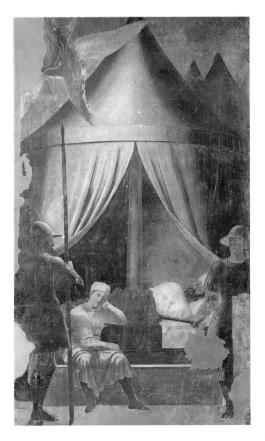

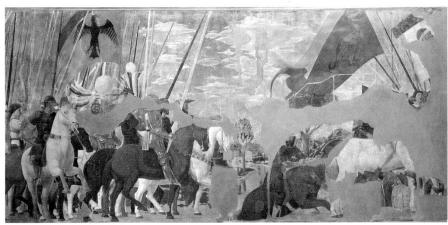

- 9. Dream of Constantine. Arezzo, San Francesco. 10. Victory of Constantine. Arezzo, San Francesco.

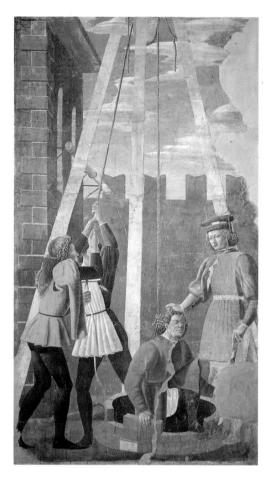

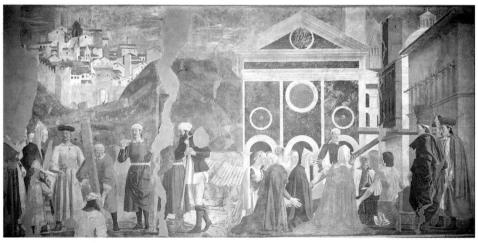

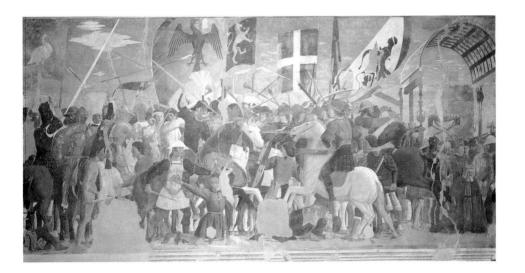

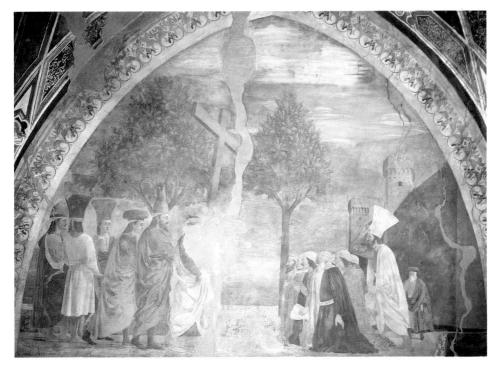

- Torture of the Jew. Arezzo, San Francesco.
 Discovery and Proof of the Cross. Arezzo, San Francesco.
 Defeat of Chosroes. Arezzo, San Francesco.
 Exaltation of the Cross. Arezzo, San Francesco.

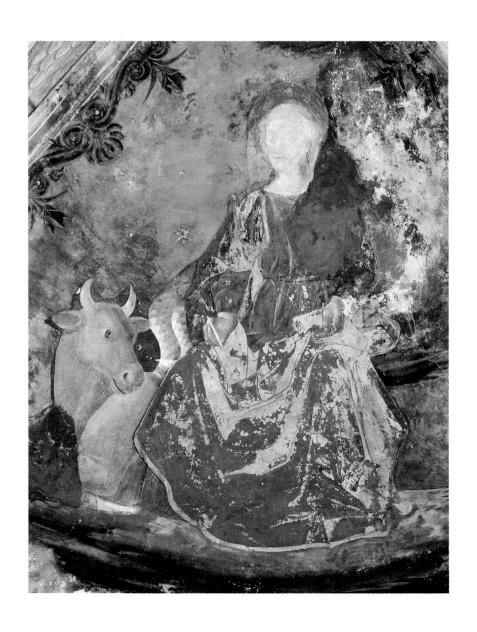

15. Piero della Francesca, St Luke the Evangelist. Rome, Santa Maria Maggiore.

,

- 16. Death of Adam. Florence, Santa Croce.17. Queen of Sheba Kneeling before the Wood of the Cross. Solomon Burying the Wood. Florence, Santa Croce.

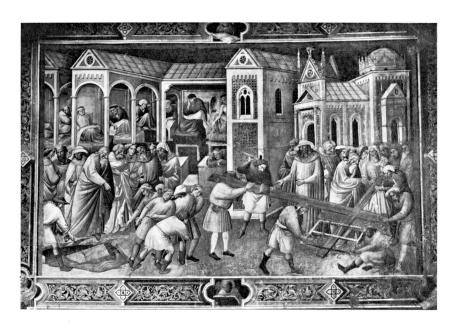

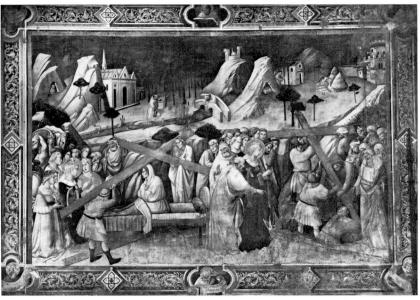

- 18. Making of the Cross. Florence, Santa Croce.
 19. Empress Helena Making Proof of the Three Crosses. Florence, Santa Croce.

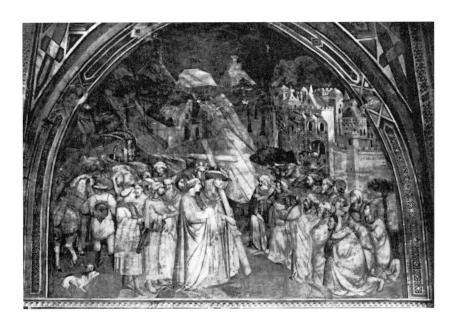

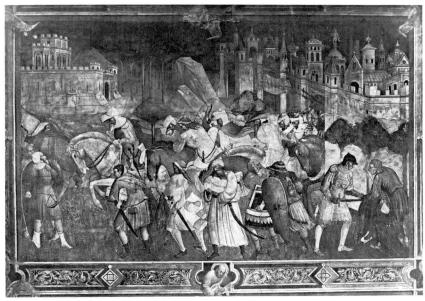

- 20. Empress Helena Taking the Cross to Jerusalem. Florence, Santa Croce. 21. Chosroes Removing the Cross from Jerusalem. Florence, Santa Croce.

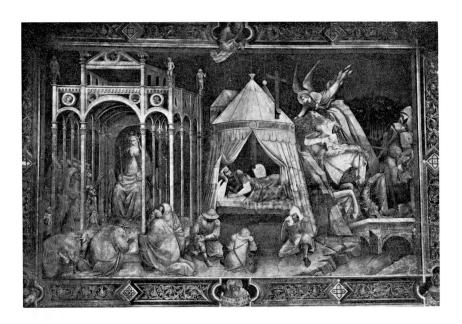

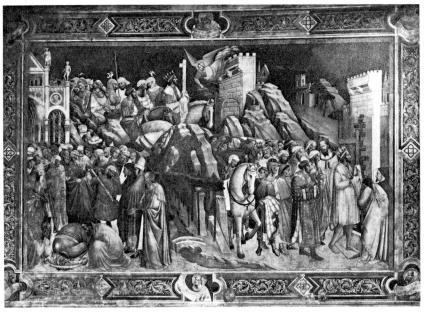

- 22. Chosroes Worshipped by his Subjects. Dream of Heraclius. Florence, Santa Croce.
 23. Beheading of Chosroes. Heraclius Returning the Cross to Jerusalem. Florence, Santa Croce.

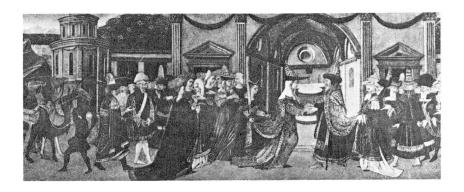

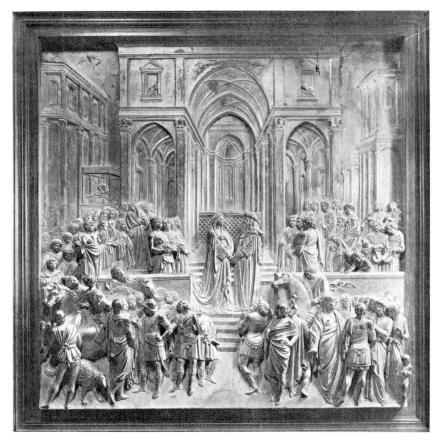

- Florentine wedding-chest painting. Solomon and the Queen of Sheba (detail). London, Crawford Collection.
 Lorenzo Ghiberti, Solomon and the Queen of Sheba. Florence, Baptistry.

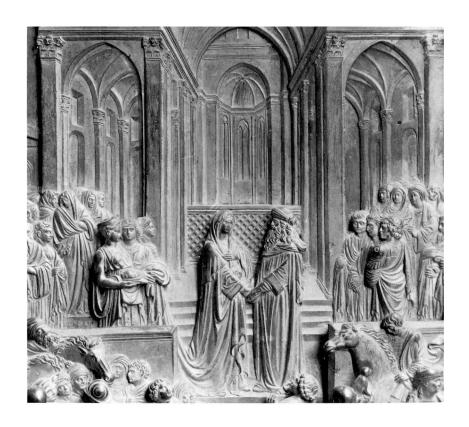

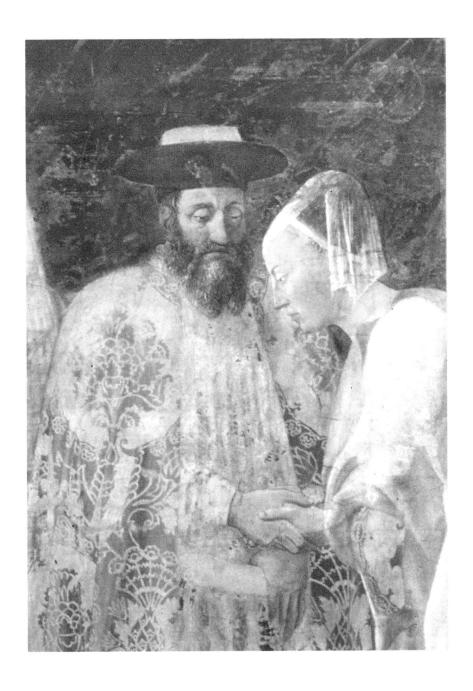

27. Piero della Francesca, Solomon Receiving the Queen of Sheba (detail). Arezzo, San Francesco.

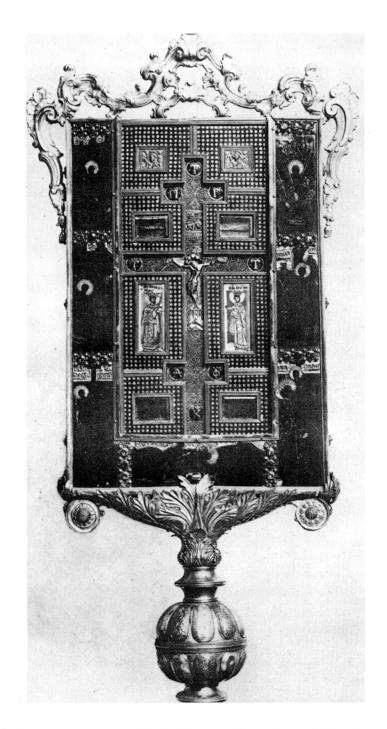

28. Casket, once the property of Cardinal Bessarion. Venice, Gallerie dell'Accademia.

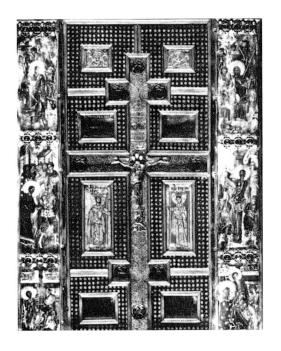

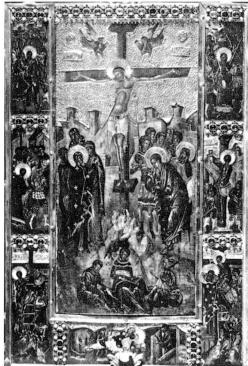

29, 30. Bessarion's Casket (29. closed and 30. open). Venice, Gallerie dell'Accademia.

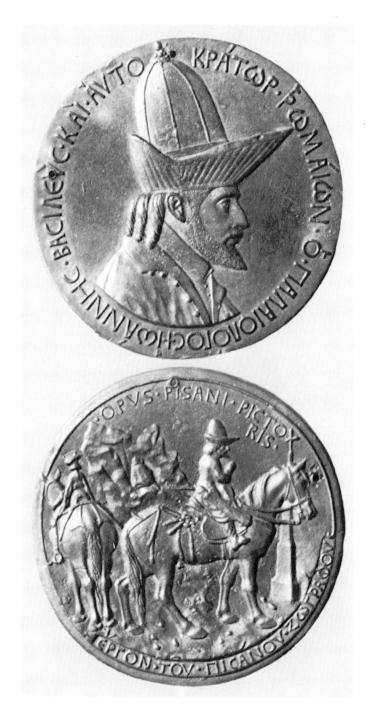

31. Pisanello, Medal of John VIII Palaeologus. Florence, Bargello.

32. Anthem-book given by Bessarion, no. 2 in series (detail). Cesena, Biblioteca Malatestiana.

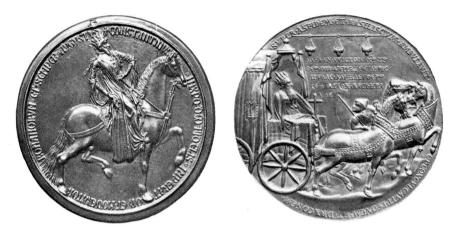

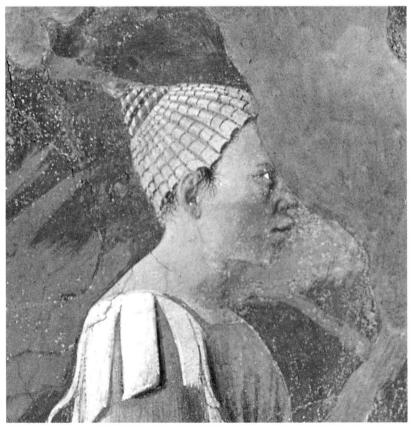

- 33. Medal of Constantine (face). Vienna, Kunsthistorisches Museum.
- 34. Medal of Heraclius (reverse side). Vienna, Kunsthistorisches Museum.
 35. Piero della Francesca, *Queen of Sheba and her Retinue* (detail). Arezzo, San Francesco.

- 37. Pietro Lorenzetti, Flagellation of Christ. Assisi, San Francesco, Basilica inferiore di San Francesco.
- 38. Maestro dell'Osservanza, Flagellation of Christ. Rome, Vatican Gallery.

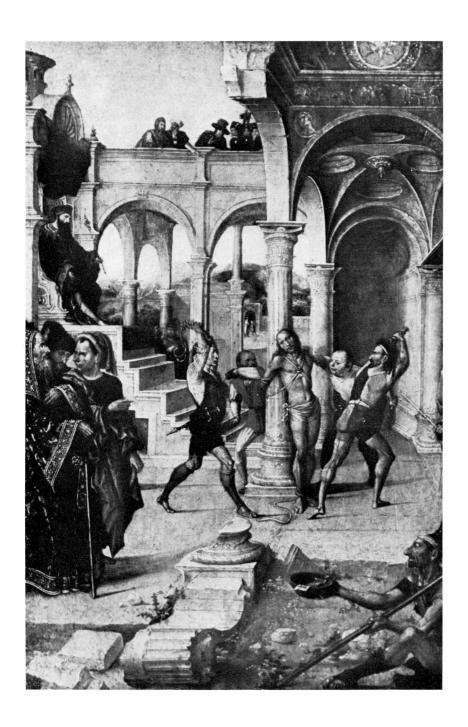

39. Alejo Fernandez (?), Flagellation of Christ. Madrid, Prado.

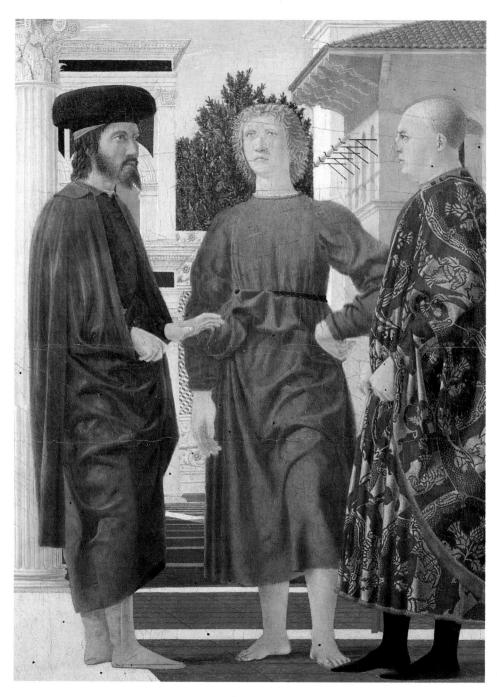

40, 41 Piero della Francesca, *Flagellation of Christ* (details). Urbino, Galleria Nazionale delle Marche.

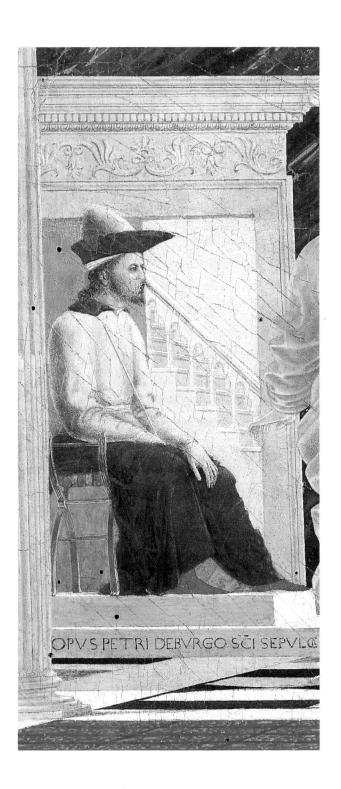

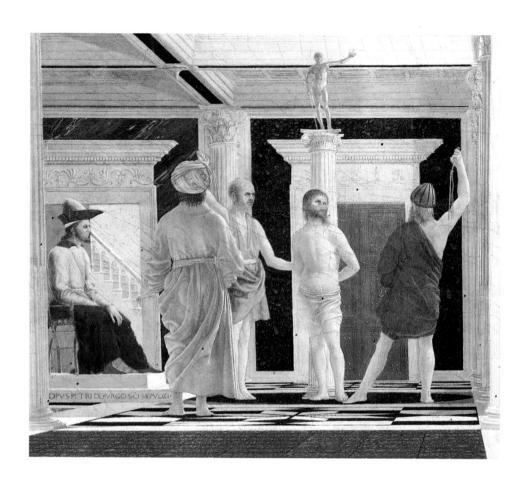

^{42.} Piero della Francesca, *Flagellation of Christ* (detail). Urbino, Galleria Nazionale delle Marche.

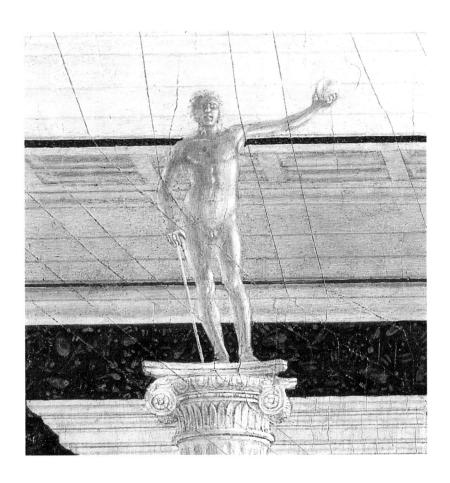

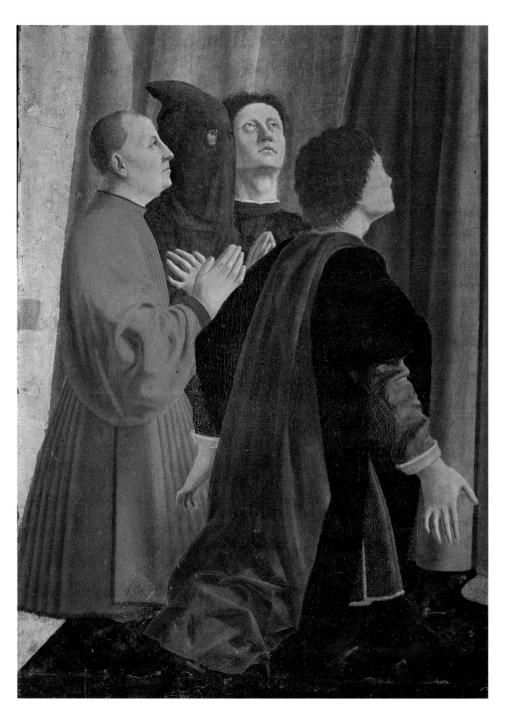

44. Piero della Francesca, Madonna of the Misericordia (detail). San Sepolcro, Museum.

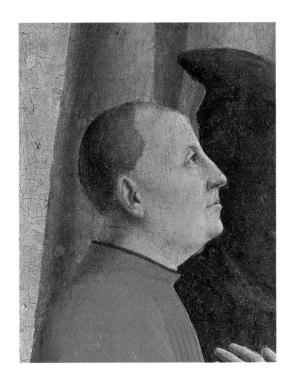

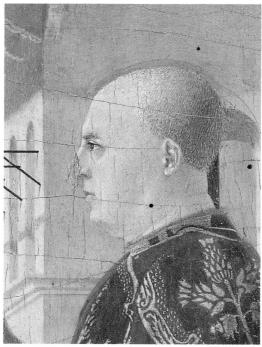

Piero della Francesca,

45. Madonna of the Misericordia (detail).
San Sepolcro, Museum.
46. Flagellation of Christ (detail).
Urbino, Galleria Nazionale delle Marche.

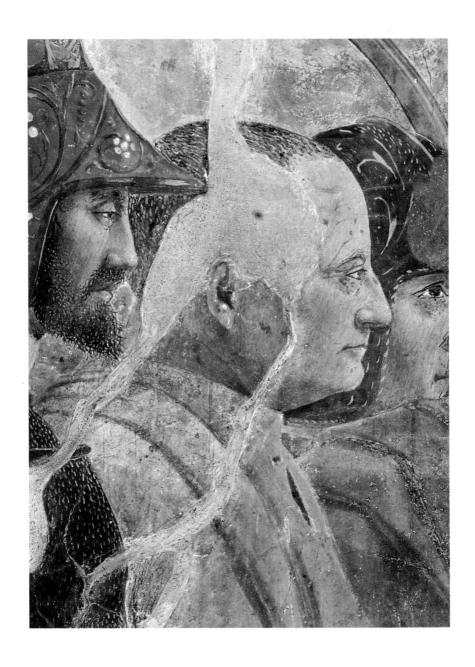

47. Piero della Francesca, Defeat of Chosroes (detail). Arezzo, San Francesco.

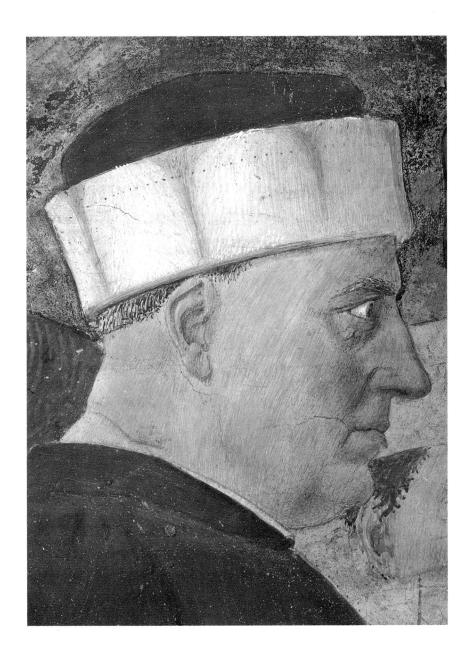

48. Piero della Francesca, Solomon Receiving the Queen of Sheba (detail). Arezzo, San Francesco.

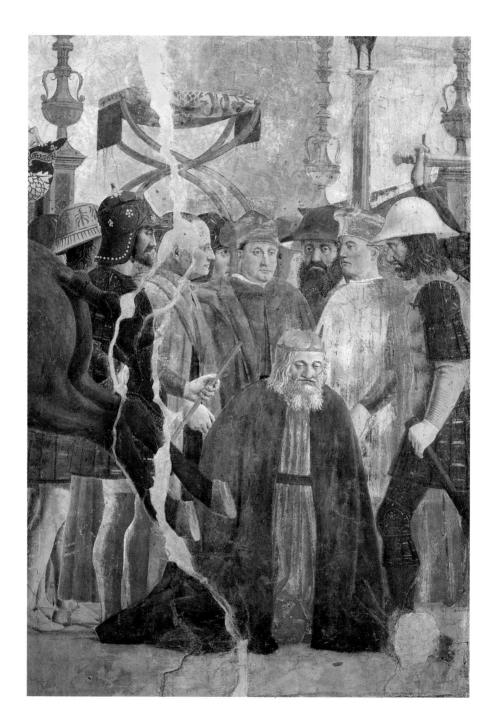

49. Piero della Francesca, Defeat of Chosroes (detail). Arezzo, San Francesco.

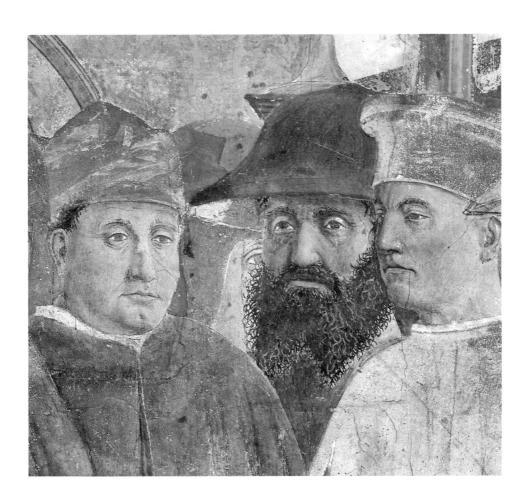

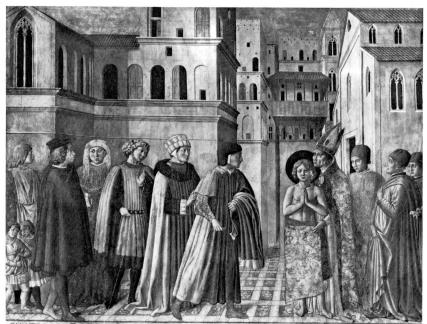

QVALITER B-F-CORA EPISCOPO ASISII-RENVIT-PATRI-HEREDITATEN PATERNAN ET. ONA VESTINENTA ET FENORALIA BATRI-REIECIT

^{51.} Benozzo Gozzoli, St Francis Stripping Himself of his Possessions. Montefalco, Museo di San Francesco.

^{52.} Giotto, Dream of Innocent III. Assisi, Basilica superiore di San Francesco.

^{53.} Benozzo Gozzoli, *Dream of Innocent III* and *The Approval of the Franciscan Rule*. Montefalco, Museo di San Francesco.

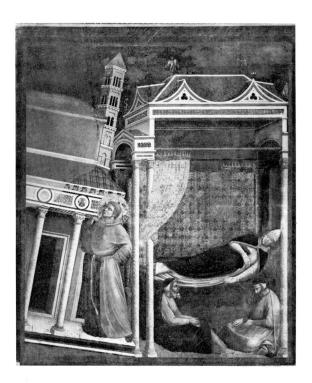

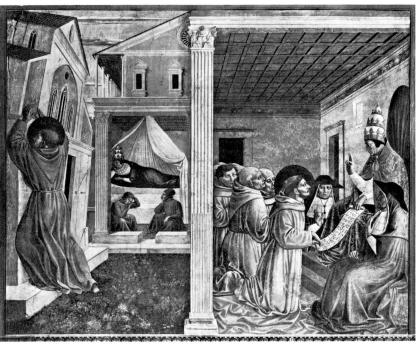

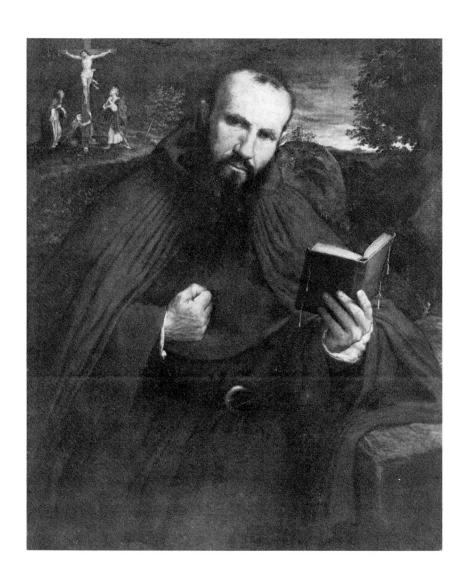

54. Lorenzo Lotto, Brother Gregorio Belo of Vicenza. New York, Metropolitan Museum. 55. Taddeo di Bartolo (?), Flagellation of Christ (from Articles of the Credo). Siena, Museo

dell'Opera del Duomo. 56. Beato Angelico, *Flagellation of Christ*. Florence, Museo di San Marco.

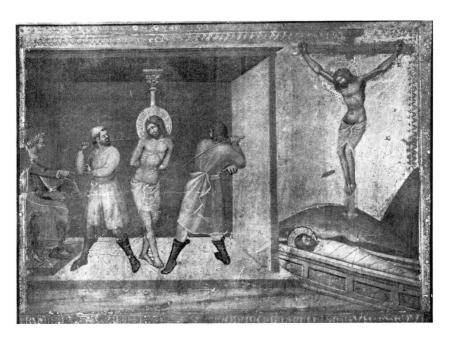

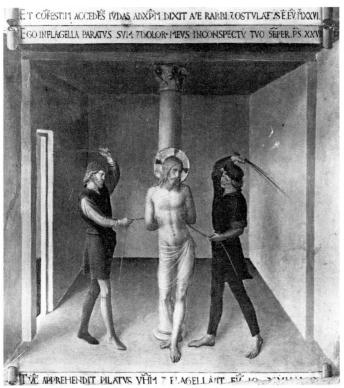

57. Filippino Lippi, *Triumph* of *St Thomas* (detail). Rome, Santa Maria sopra Minerva. 58. Marten van Heemskerck, *View of the Lateran*. Berlin, Kupferstichkabinett.

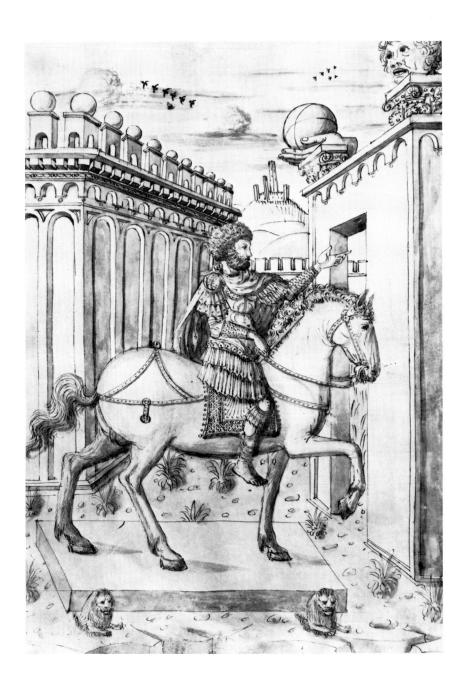

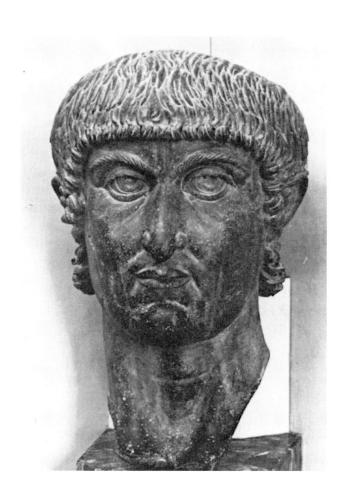

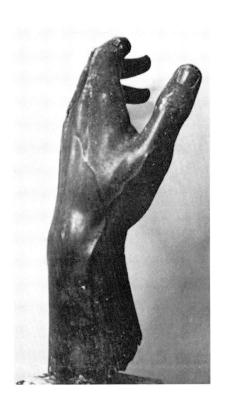

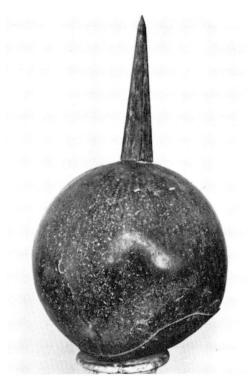

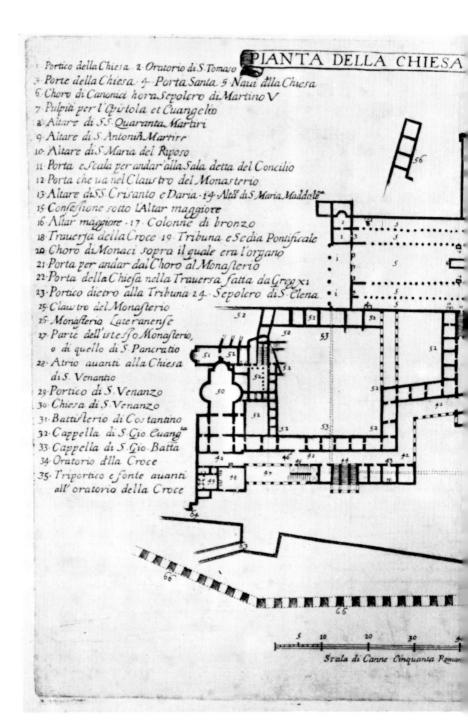

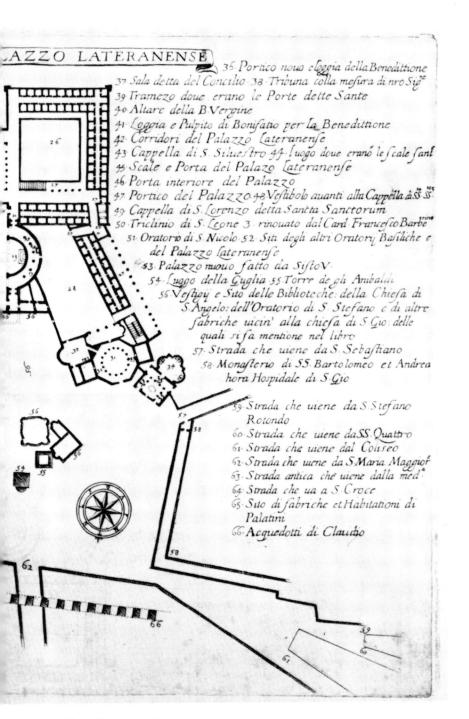

63. Plan of the Lateran (from Severano's Memorie Sacre). Bologna, Biblioteca Comunale.

- 64. "Pilate's doorways", near the Scala Santa, Rome.
- 65. Stone and column with "mensura Christi", from the cloister of St John Lateran, Rome.

68, 69. Column with "mensura Christi", from the cloister of St John Lateran, Rome (68. full and 69. in detail).

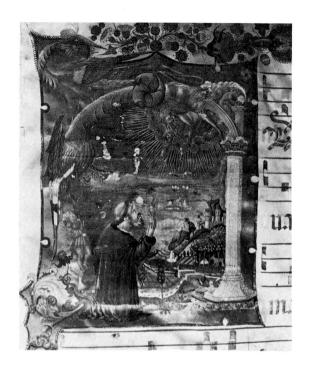

71, 72. Anthem-book given by Bessarion, no. 2 in series, frontispiece (71. full and 72. in detail). Cesena, Biblioteca Malatestiana.

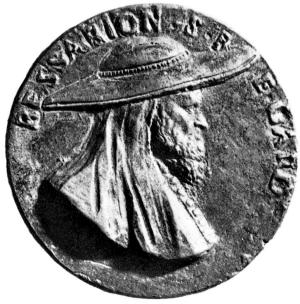

73. Graziano the Minorite, Summa de casibus conscientiae, frontispiece (detail). Paris, Bibliothèque Nationale, nouv. acq. lat. 10002.
74. Medal of Bessarion (face). Weimar, Nationale Forschungs-und Gedenkstätte.

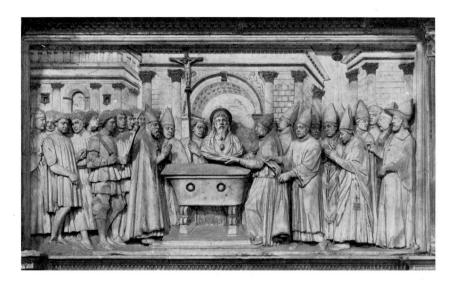

- 75. Paolo Romano (completed by a follower of Andrea Bregno), funeral monument of Pius II: the gift of the relic of St Andrew's head. Rome, Sant'Andrea della Valle.
- 76. Guillaume Fichet, Rhetorica, frontispiece. Venice, Biblioteca Marciana, membr 53.
- 77. Bessarion, *Epistolae et orationes*, frontispiece. Rome, Biblioteca Apostolica Vaticana, vat. lat. 3586.

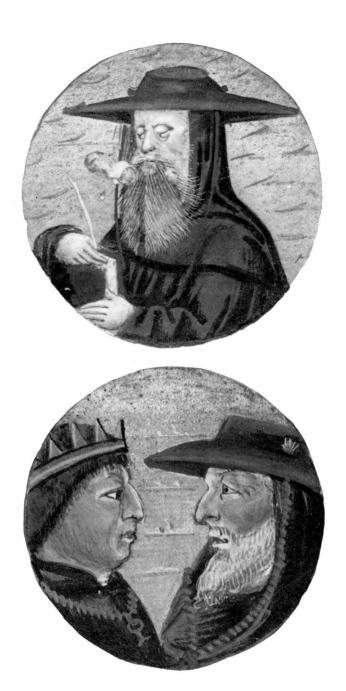

78. Andrea Contrario, Obiungatio in Platonis calumniatorem (detail). Paris, Bibliothèque Nationale, lat. 12947, f 11r.

^{79.} Bessarion, Adversus calumniatorem Platonis (detail). Paris, Bibliothèque Nationale, lat. 12946, f 29r.

^{80.} Gentile Bellini, Bessarion kneeling before the casket given to the Scuola Grande della Carità. Vienna, Kunsthistorisches Museum.

^{81.} Pedro Berruguete (?), Bessarion. Paris, Louvre.

^{82.} Fifteenth-century anonymous painter (after Gentile Bellini?), *Bessarion*. Venice, Gallerie dell'Accademia.

^{83.} Diptych of Bessarion. Venice, Biblioteca Marciana (after Kyros).

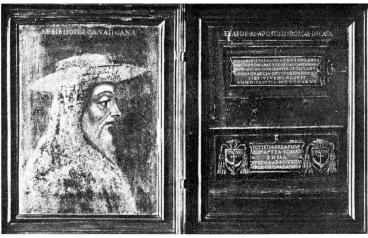

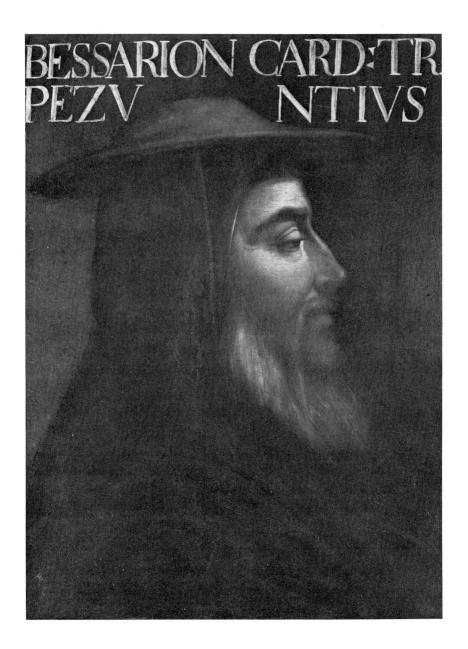

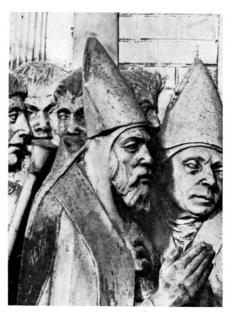

- 86. Guillaume Fichet, *Rhetorica*, frontispiece (detail). Venice, Biblioteca Marciana, membr.
- 87. Paolo Romano (completed by a follower of Andrea Bregno), funeral monument of Pius II: the gift of the relic of St Andrew's head (detail). Rome, Sant'Andrea del Valle.
- 88. Illuminated initial with portrait of Bessarion (from *Ludovici Bentivoli virtutis, et nobilitatis insignia*). Bologna, Biblioteca Universitaria.

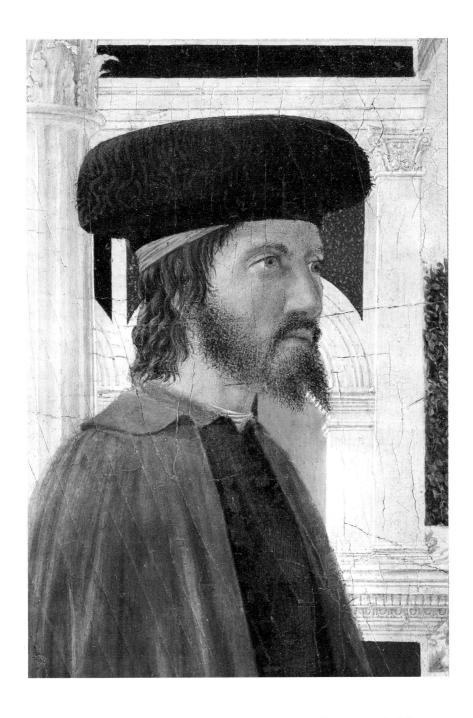

89. Piero della Francesca, *Flagellation of Christ* (detail). Urbino, Galleria Nazionale delle Marche.

Vittore Carpaccio,

90. Vision of St Augustine. Venice, Scuola di San Giorgio degli Schiavoni. 91. Drawing. London, British Museum.

92, 93. Vittore Carpaccio, drawing (92. recto and 93. verso of same folio). Moscow, Pushkin Museum.

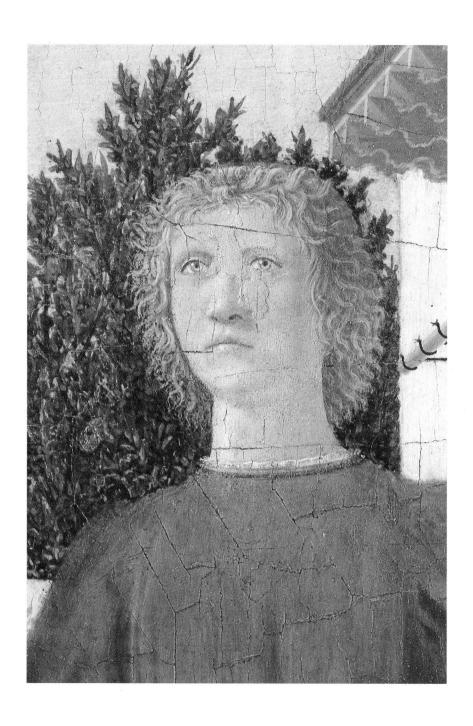

94. Piero della Francesca, *Flagellation of Christ* (detail). Urbino, Galleria Nazionale delle Marche.

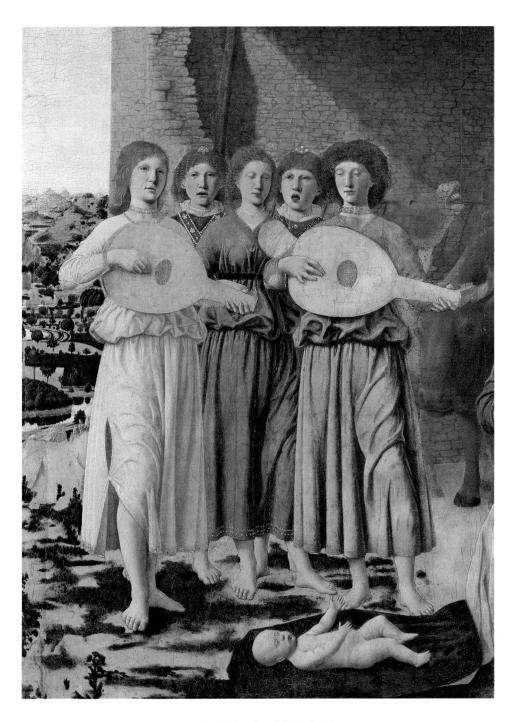

95. Piero della Francesca, Nativity (detail). London, National Gallery.

96. Piero della Francesca, Prophet. Arezzo, San Francesco.

97. Giovanni di Piamonte, Sant'Anna Metterza with SS Michael, Catherine, Mary Magdalen and Francis. Berlin, Staatliche Museen.

98. Piero della Francesca, Mother and Child with Four Angels. Williamstown, Clark Art Institute.

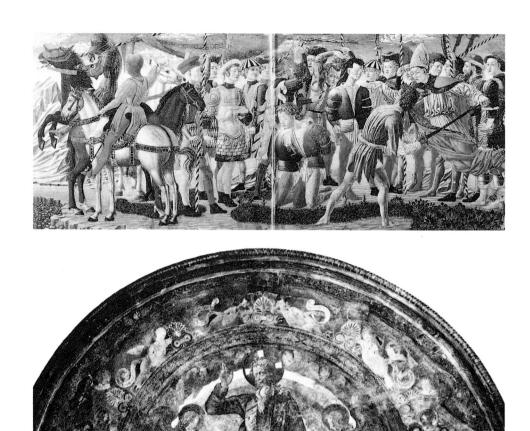

^{99.} Giovanni di Francesco, predella with *Scenes from the Life of St Nicholas*. Florence, Casa Buonarroti.

^{100.} Giovanni di Francesco, God the Father with Angels. Florence, Ospedale degli Innocenti.

Giovanni di Francesco,

101. Carrand Triptych (Madonna and Child with SS Francis, John the Baptist, Nicholas and Peter). Florence, Bargello.
102. Crucifix. Brozzi (Florence), Sant'Andrea.

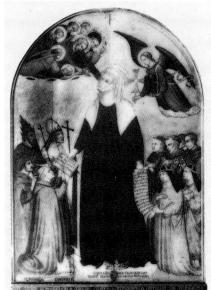

- 103. Giovanni di Francesco, Madonna and Child with St Bridget and St Michael. Los Angeles, Getty Museum.
- 104. Maestro del 1399 (Giovanni di Tano di Fei?), St Bridget Giving the Rule of the Order. Formerly in Milan, Bassi collection.

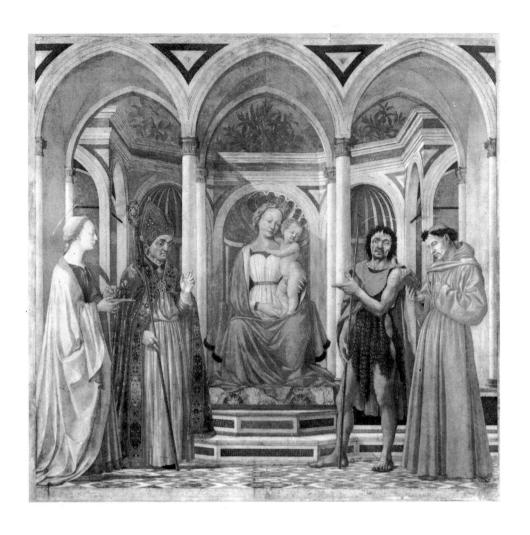

Giovanni di Francesco,

106. S. Biagio (altar-frontal). Petriolo (Florence), San Biagio.107. Madonna and Child. Contini Bonacossi bequest.

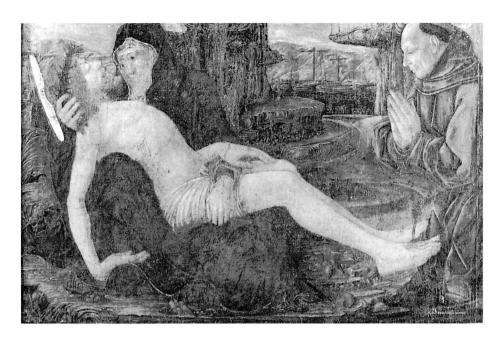

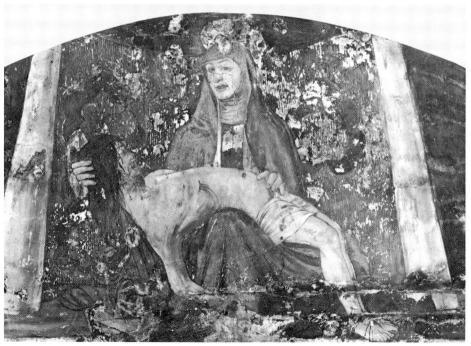

108. Francesco del Cossa, *Pietà with St Francis*. Paris, Musée Jacquemart-André. 109. Giovanni di Piamonte, *Pietà*. Florence, S. Pancrazio, Rucellai Chapel.

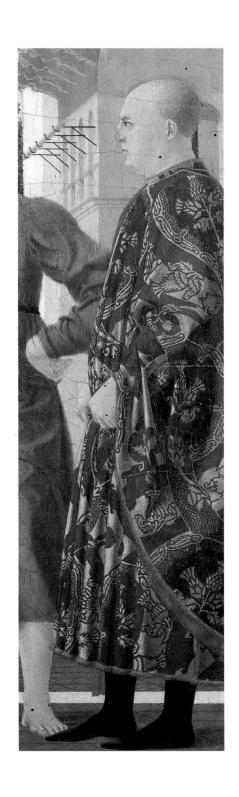

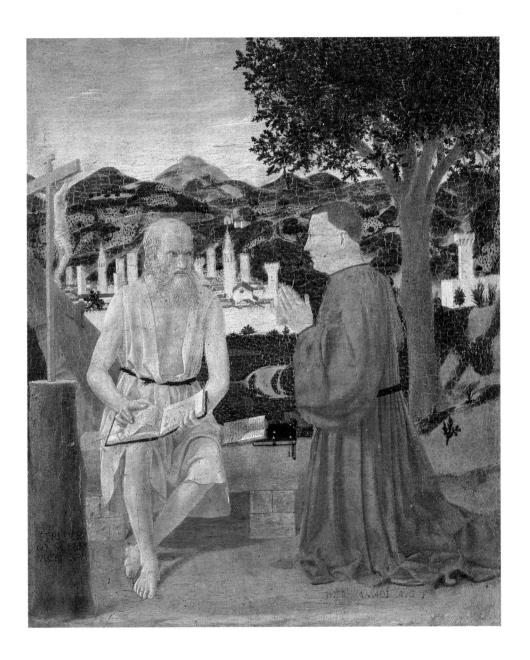

Piero della Francesca,

110. Flagellation of Christ (detail). Urbino, Galleria Nazionale delle Marche. 111. St Jerome with a Disciple. Venice, Gallerie dell'Accademia.

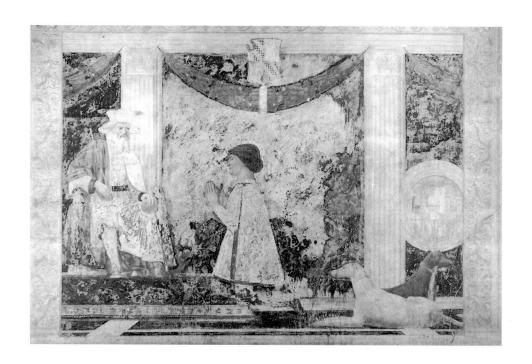

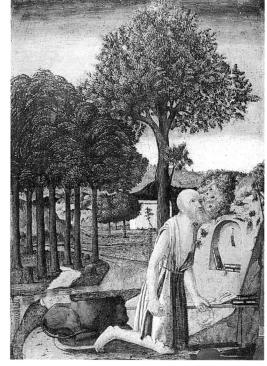

Piero della Francesca,

- 112. Sigismondo Malatesta kneeling before his Patron Saint. Rimini, Tempio Malatestiano.
- 113. St Jerome. Berlin, Staatliche Museen.

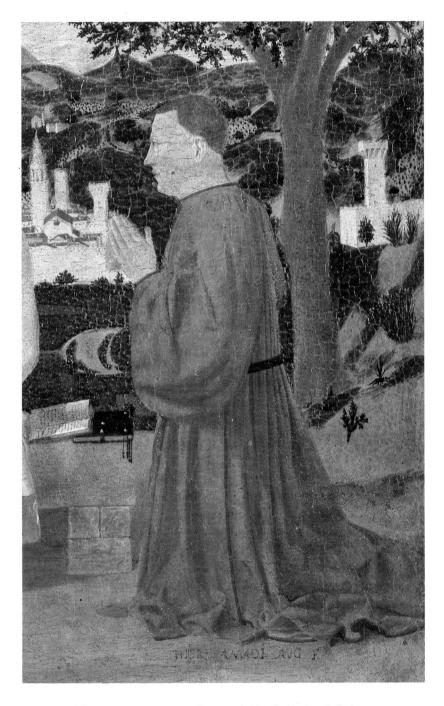

114. Piero della Francesca, *St Jerome with a Disciple* (detail). Venice, Gallerie dell'Accademia.

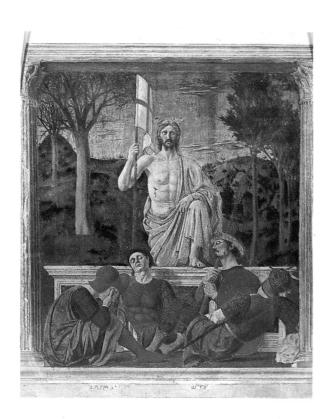

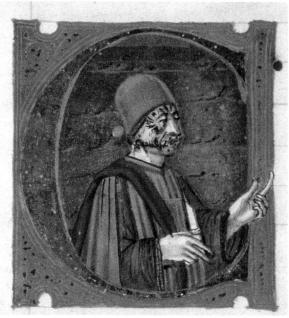

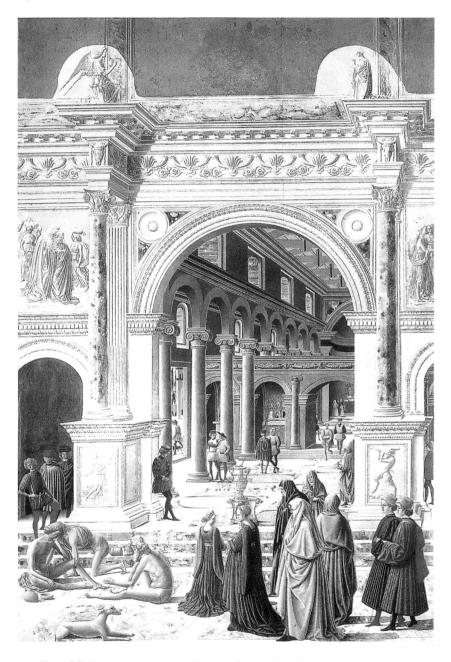

115. Piero della Francesca, Resurrection. San Sepolcro, Palazzo Comunale.

116. G. Tortelli, De Orthographia, ms. Urbinate Latino 303, f.1 (illuminated initial with portrait of the author). Rome, Biblioteca Apostolica Vaticana.
117. Fra Carnevale (?), Presentation of the Virgin in the Temple. Boston, Museum of Fine

Arts.

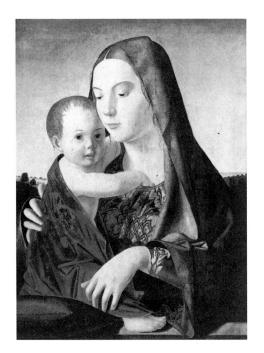

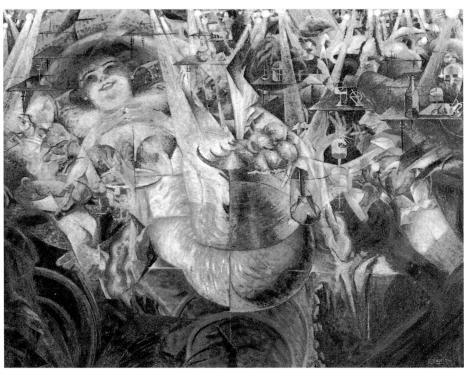

^{118.} Antonello da Messina, Benson Madonna. Washington, National Gallery of Art.

^{119.} Pablo Picasso, *Nude*, Paris, Spring 1910. Formerly in New York, Alfred Stieglitz Collection.

^{120.} Umberto Boccioni, The Laugh. New York, Metropolitan Museum.

^{121.} Piero della Francesca, Discovery and Proof of the Cross (detail). Arezzo, San Francesco.

^{122.} Paul Cézanne, Gardanne. New York, Brooklyn Museum.

123. Umberto Boccioni, *Portrait of Ferruccio Busoni*. Rome, Galleria Nazionale d'Arte Moderna.

Borso d'Este, described by Bacci as "in their manner of life wiser and more refined than any other gentlemen of Italy". This description was based on personal experience: for three terms, from January 1456 until June 1457 (an unusually long period), Giovanni Bacci held the office of *podestà* at Gubbio, at that time under the rule of the Montefeltro family. He held the same post again from June to November of 1468. The *Flagellation* was certainly commissioned by him, as a gift to Federico.

The identification of the man in the brocade cloak as Giovanni Bacci scotches once and for all any interpretation of Piero's *Flagellation* as a variant of the usual treatments of Christ's flagellation. Bacci, the painting's donor, is certainly not depicted as a by-stander at an episode in Christ's life. The flagellation is relegated to the background. What links it to the scene taking place in the foreground?

Attempts to answer this question have been made by those who see in the picture the depiction of two distinct scenes, rather than a single scene based on a scriptural subject. According to Clark, Christ's flagellation is expressive of the thoughts of the three foreground figures. ¹² Lavin sees the flagellation as an "apparition", whose meaning Ottaviano Ubaldini is elucidating to the Marquis of Mantua. ¹³ For Gouma-Peterson, it is an "archetypal event", whose contemporary political and religious significance the Greek ambassador is explaining to the Western prince. ¹⁴ These interpretations, various as they are, all emphasize one common element: the distance between the two scenes not just in physical but (we might say) in ontological terms. As we have noted, Lavin, followed by Gouma-Peterson, has observed that this gap is accentuated by the different lighting, which falls upon the event taking place beneath the loggia not from the left but from the right.

The representation of different levels of reality within the framework of a single pictorial entity (a painting or a fresco-cycle) is common in European art from the fifteenth century onwards. Sandström's researches¹⁵ have shown how, as artists mastered the illusionistic resources of pictorial representation, they came to make use of a variety of means – from *grisaille* to light-effects – to depict the gap between reality and fiction, or between natural and supernatural reality. In the *Flagellation*, Piero not only employed different light-sources; he also used perspective. The grasp of perspective displayed in the Urbino painting is not offered (as is

commonly held) as a virtuoso performance. It represents a deliberate expressive choice.

In making it, Piero was following the example of Benozzo Gozzoli, at Montefalco. To suggest such an influence may seem surprising, for the great disparity in the quality of the two painters' work has meant that Benozzo has been seen as Piero's debtor in every respect. The possibility of a reverse indebtedness has been ruled out a priori, despite the contrary evidence of chronology. Once again we see how hard it is to dispel conventional ideas about genius. In fact, even if we follow the hypothesis of Longhi and others in dating the beginning of Piero's work on the Arezzo frescoes to 1452, they cannot possibly have influenced Benozzo's depiction of the life of St Francis at Montefalco, for an inscription roundly states that the latter work was finished in 1452. Borrowings from Piero are indeed discernible in it, but from the Piero of 2 the Baptism of Christ, which was painted shortly after 1440 and which is echoed in the gesture of St Francis as he strips himself of his possessions; 51 not, assuredly, from the Piero of the Arezzo cycle. 16 Piero must have turned off to Montefalco in the autumn of 1458 (if not earlier), as he travelled down the Tiber valley from Borgo San Sepolcro towards Rome. 52 There, he would have seen among other frescoes one depicting the *Dream* of Innocent III. At Assisi, Giotto had expressed the gap between the everyday reality of the sleeping Pope on the one hand, and his vision on the other, by tilting at an angle of forty-five degrees the image of Francis supporting the Lateran. Benozzo, however, had recourse to a more modern language, relegating the Pope to the background while propelling 53 St Francis right into the foreground. In his Flagellation, Piero used the same perspective device, but in reverse: everyday reality is shown in the foreground, while the other reality (we shall see how to define it shortly) is projected on to the background.

Between the two planes is a distance which, as we have said, is not only physical but ontological. What, in the sphere of everyday reality, has evoked the depiction of Christ's martyrdom? In Benozzo's fresco, the vision appears to the sleeping Pope. Here, there are neither sleepers nor apparitions such as sleepers see. And Clark's hypothesis – that it is the thoughts of the three in the foreground that are expressed in the flagellation – ignores the variety of their attitudes. The bearded man is

actually speaking: his mouth is half-open, his left hand is lifted to waistheight in a gesture accompanying some statement.¹⁷ He is undoubtedly talking about Christ's flagellation (Lorenzo Lotto, less than a century later, was to depict in similar fashion the sermon on the Crucifixion given by Gregorio Belo of the brotherhood of St Vincent; the portrait is now in New York). Giovanni Bacci is listening, his gaze fixed on the speaker. But the bearded man does not return Bacci's look; his eyes are turned to the right, outside the picture. Between the two, the youth's clear and unmoving eyes are fixed on a point to the spectator's left. We are thus excluded from this play of intersecting and diverging glances. Nevertheless, the bearded man's words summon up the scene of the flagellation before us, and the Turk, seen from the back, virtually compels us to participate in it.¹⁸ What holds the whole composition together, in narrative terms, is the gesture of the man who is speaking.

We know that at the beginning of the nineteenth century a written phrase, "Convenerunt in unum", accompanied the picture. In Covi's view, this was inauthentic, since the phrase must have been attached to the frame, a rare practice in Piero's day. However, it was not unheard of: we might cite the lines from the Credo that accompany the panels (ante 55 1412) attributed to Taddeo di Bartolo. Gilbert, moreover, has pertinently drawn attention to the example of reliquaries, a class of images to which the Flagellation seems to belong by its shape, its iconography and its provenance (the sacristy of a church). Angelico's silver-reliquary (c. 1450) is accompanied by Biblical passages written on mock frames. 19 There is 56 thus no reason to doubt the lost inscription's authenticity. As we have already stressed, it was perfectly suited to a representation of Christ's flagellation: the antiphon read for the first nocturn at matins on Good Friday consists, precisely, of the words "Convenerunt in unum", which open the second verse of Psalm 2.20 At this point, however, a difficulty arises: since we have ruled out the idea that Piero's picture is an ordinary flagellation, what significance should we give to the words "Convenerunt in unum"? They must clearly refer not just to the scene of the flagellation, which as we have seen constitutes the picture's secondary subject, but also to the principal subject, namely the mysterious scene in the foreground. In other words, the caption suggested to the spectator the theme on which the bearded man, his mouth half-open, is speaking as he

invokes Christ's flagellation in illustration of the verse "Convenerunt in unum".

This interpretation is confirmed by the presence of the turbaned Turk, seen from the back, who is attending the flagellation (and may indeed have commanded it); and also by the depiction of Pilate wearing the cap and the crimson stockings of the Byzantine emperors.²¹ These are the kings and princes mentioned in the psalm: the bearded man is commenting on that psalm, with reference to contemporary reality. Clark originally surmised an allusion to the assembly called by Pius II at Mantua, in 1459, to resist the Turkish threat.

If there is a gap between the group in the foreground and the flagellation taking place in the background, it cannot be ruled out that the bearded man's speech is being delivered at a precise and identifiable time and place. Let us begin with the place.

The loggia that is the site of Christ's flagellation is clearly an imaginary building. Clark, it will be remembered, referred to its Albertian characteristics as evidence that the picture should be dated around 1459–60. Lavin supposes that Piero may also have drawn upon the information (which is actually very vague) given about "the houses of Pilate" in a contemporary traveller's account of a voyage to the Holy Land. More recently, Borgo (followed by Lavin) has indicated another possible source of Piero's inspiration in a reference in the *Jewish Wars* of Flavius Josephus to the "towers" of the Antonia Fortress, which was thought to have been the site of Pilate's praetorium. This reference is very fleeting; and in any case, Piero never seems to have attempted exact archaeological reconstruction of the kind undertaken by Mantegna. Much more illuminating is another suggestion of Lavin's: that the staircase visible through the doorway before which Pilate sits in the *Flagellation* implies an allusion to the Scala Santa.

The Scala Santa has occupied its present site only since the demolition of the ancient patriarchal court, carried out by order of Sixtus V to make room for the new Lateran Palace. At that time, the Scala Santa was transferred to below the Sancta Sanctorum, and housed in Domenico Fontana's specially constructed building. Previously, however, it had been situated – as Severano wrote almost half a century after the thorough reconstruction of the Lateran – "near the gate of the new Lateran Palace,

which faces north".26 All earlier evidence agrees on this point. Some idea of how the Papal building's northern façade looked at that time can be gained from a detail in Filippino Lippi's Triumph of St Thomas, painted in fresco in the Caraffa chapel at Santa Maria sopra Minerva (1489-93), and from a drawing by Marten van Heemskerck (1532-36).27

57, 58

The relic had been greatly venerated since the jubilee of 1450. It was commonly known as the "scala di Pilato", scala Pilati, probably a corruption of scala Palatii, "scala del Palazzo" (the staircase of the palace). Saint Helena, the Emperor Constantine's mother, was traditionally held to have brought it to Rome from Pilate's praetorium, where Christ was supposed to have climbed it three times before being led away to Calvary. Giovanni Rucellai, who was in Rome for the jubilee of 1450, gives in his Zibaldone one of the earliest accounts of the veneration of the relic, and of the custom (still flourishing) by which pilgrims climbed the stairs on their knees during Holy Week. After mentioning the "pleasant chapel . . . called Sancto Sanctorum", situated "outside the body of the church" of St John, Rucellai continues:

"Item, near the said chapel of Sancto Sanctorum there is a staircase descending into the Piazza of St John, six braccia in width and with steps cut from a single piece of marble, and this was the staircase of Pilate's palace at Jerusalem, where Christ stood when sentence of death was passed on him, and it came from Jerusalem; and the more to show their devotion, those who come to the jubilee, and especially those from beyond the mountains, climb it upon their knees . . .". He then refers to the statue of Marcus Aurelius on horseback (believed at that time to be a statue of Constantine) which stood in front of the Lateran and which is now in the Piazza del Campidoglio, and adds:

"Item, in this piazza, upon a piece of a column, a giant's head in bronze and an arm with a bronze ball.*28

Here we can recognize the original of the statue on top of the column 43 to which Christ is bound in the Flagellation. As W. Haftmann first noted,29 Piero indeed drew his inspiration for this from the remnants of a giant statue that used to stand in front of the Lateran, as we know from travellers' accounts from the twelfth century on, and later from successive editions of the Mirabilia Urbis. According to legendary tradition, it was originally housed in the Temple of the Sun, its remains later being removed by Pope Silvester to their site outside the Lateran. One of the illustrations to the copy of Giovanni Marcanova's Antiquitates belonging 59

to the Dukes of Este shows the fragments' situation in the mid-fifteenth century. Although it is largely imaginary, and quite different from the precise and almost contemporaneous description in Giovanni Rucellai's *Zibaldone*, it does place them (on the basis, evidently, of verbal descriptions) before the northern façade of the Papal buildings, not far from the equestrian statue of Marcus Aurelius.³⁰ At the end of the century, the head, the hand, and the ball (popularly known as the "palla Sansonis") were removed to the Campidoglio and placed together first outside and then within the Palazzo dei Conservatori, where they are still to be found. They are now generally thought to be fragments of a gilded bronze statue, about three metres high, which represented, as has recently been shown, the Emperor Constantine.³¹

So specific an allusion cannot have predated Piero's journey to Rome – the journey, that is, for which we have documentary evidence, and which took place during the pontificate of Pius II, for until we have evidence to the contrary the other visit, under Nicholas V, must be regarded as a figment of Vasari's confusion. This means that the *Flagellation* may have been painted at Rome, between the autumn of 1458 and that of 1459, and then moved elsewhere, presumably to Urbino; or it may have been painted at some later period. This rules out suggestions of an early date, beginning with Longhi's proposal; it is congruent with the later date (1458–59) put forward, on other grounds, by Clark.

The Scala Santa was not the only relic from Pilate's praetorium kept in the northern part of the Lateran Papal buildings. There were also two doors and three columns traditionally held to have been brought to Rome by Saint Helena, the mother of Constantine.³² To reconstruct the history of their removal, we can bring together a series of documentary accounts with the very accurate plan of the Lateran drawn up at the 63 beginning of the seventeenth century by the architect Contini. 33 According to the Tabula magna continens elenchum reliquiarum et indulgentiarum sacrosanctae ecclesiae Lateranensis, drawn up in 1518, the three doors used to stand in a "cappella" (chapel) or "aula" (hall), of which no further details are given. The same document informs us, however, that another famous relic was kept nearby: the stone upon which Judas's thirty pieces of silver were counted out, and upon which the soldiers later diced for Christ's clothes. This was supported by four marble columns supposedly of the same height as Christ.34 Now we know that this "mensura Christi" was to be found - after 1484, at any rate - in the so-called

Council Chamber or aula del Concilio, which was in the Palazzo Nuovo built by command of Boniface VIII, behind the loggia from which benedictions were given and which opened on to the Piazza (see Contini's plan, nos. 37-9). During the coronation ceremony for Innocent VIII, in fact, the Pope's seat was placed just in front of the relic.³⁵ Its cult was certainly long established, given the aura that surrounded it. Lauer thought that the stone supported by the columns was a relic of the table of the Last Supper, bearing the inscription "mêsa Christi", which was later misinterpreted as "mensura Christi". This brilliant hypothesis seems to be confirmed by the mention of a mensa domini in the inventory of Lateran relics drawn up by Giovanni Diacono in 1170.36 There is no reason to think this relic was situated elsewhere in the middle of the fifteenth century. In the same hall were kept two octagonal columns "with some rings of iron . . . which they say stood once in Pilate's palace in Jerusalem". 37 In the reorganization of the Lateran carried out under Sixtus V, the relics were variously dispersed. 64 We have spoken already of the Scala Santa. The doors were removed into the corridor running along the front of the Sancta Sanctorum; the "mensura Christi" and the two columns, however, were placed in the cloisters, together with two other columns, known as "Pilate's columns" (which were cylindrical, and decorated with ivy leaves).³⁸

65-67

There can be no doubt that Piero drew inspiration for his Flagellation from this group of Lateran relics. The proof of this does not lie principally in the fact that the two doors ("Pilate's" doors) served as starting-points for his depiction of the two doorways at the back of the loggia where Christ's martyrdom takes place; it lies, rather, in the other relic kept in the aula del Concilio - the "mensura Christi".

In a famous essay, Wittkower and Carter identified the modular unit underlying the architecture of the Flagellation.³⁹ This module is one-fifth of the unit proposed by Pacioli in his De divina proportione, it measures 1.85 pollici, or 4.699 centimetres. Carter points out, however, that another, separate unit of measurement also plays a central part in the picture's formal organization: the height of Christ.⁴⁰ This is equal to 17.8 centimetres. Now, the columns that formerly stood near the Scala Santa, and which were thought to be exactly equivalent in height to Christ, measure 187 centimetres. But an inspection of their base reveals clearly the line that separates the column properly so-called from the rougher part, which in the past was driven into the earth. If we eliminate this part, which was 68,69

formerly invisible, then we have a column 178 centimetres high. 41 Thus, irrespective of the fact that Piero measured not in centimetres and metres but in *piedi* and *braccia*, there is a 1:10 relation between the height of Christ in the *Flagellation* and the height attributed to him by the tradition based on the Lateran columns. Taking Christ's height in the *Flagellation* (17.8 cm) as the unit of measurement, then the picture's breadth works out at 4½ times that unit; its height, at 3¼ times; the height of the columns in the foreground, at 2½ times; and the distance between their bases, at 2 times.

Piero, then, built his picture with scrupulous accuracy on the basis of what he clearly saw as a pricelessly valuable piece of evidence – the evidence of the exact measure of the stature of the Man–God, model of perfection in his bodily form as in all else. Priceless evidence; but hardly unique, for written and monumental documents of the same period gave other measurements of Christ's height, differing more or less from that derived from the Lateran columns.⁴² We hear, a little later, of the scores of men and women who would stick up "behind the door of the house or in the shop" a printed prayer–sheet containing an image of Christ together with a length accompanied by the following words: "This is the measurement of our blessed Saviour Jesus Christ; who was fifteen times as high as this is long" – giving him, in this case, a height of 150 centimetres, or a little under 5 feet.⁴³

The Corinthian columns that stand out in the Arezzo fresco of *Solomon* 7 *Receiving the Queen of Sheba* were described by Vasari as "divinely measured".⁴⁴ Clark, in his discussion of the *Flagellation*, speaks of the "*mystique* of measurement".⁴⁵ These phrases must now be understood literally as well as metaphorically.

Many features of its iconography, as well as the actual formal construction of the *Flagellation*, are thus closely linked with monuments situated on the northern side of the Lateran, or opposite it: the Scala Santa, the fragments of the statue of Constantine, "Pilate's" doors, and the "mensura Christi" (*see* Contini's plan, nos. 45, 65, 38 and 39). There are thus two possibilities: either Piero used material from the Lateran in depicting an evocation of Christ's flagellation that takes place in some unspecified place; or the place is in fact the Lateran, and the scene in the foreground is set in front of the Scala Santa.

The second hypothesis seems improbable, because the marble constructions in the background and the same rose-tinted building in the foreground cannot possibly be identified with the medieval Papal buildings. We fall back on an attempt to make the first hypothesis more precise, using time as the index of place – which means that we must seek to specify the moment at which the bearded man is evoking the flagellation of Christ.

But we have not yet ascertained the identity of the bearded man who is speaking. There are those, it must be said, who regard this as an inadmissible question: however, having recognized the man in the brocade cloak as Giovanni Bacci, we are now justified in pushing this line of enquiry further.

In the course of his justified rebuttal of Lavin's identification of the man as Ottavio Ubaldini, Gilbert notes that, other considerations apart, the fact that the figure is bearded makes it impossible that we are dealing with a portrait: at the period in question, men went clean-shaven in Italy. "Without exception," he writes, "beards are worn only by (a) figures from the past, for example Christ and Constantine, (b) foreigners, especially Greeks such as the Emperor John Palaeologus, (c) Italians after *circa* 1485, when the fashion for beards slowly revived." ⁴⁶ But the man in the *Flagellation* falls, precisely, into category (b). As has often been pointed out (most recently by Borgo, who however draws conclusions quite different from our own), ⁴⁷ his long-sleeved gown and his forked beard mark him out immediately as one of the Greek prelates who came to Italy for the Council of 1438–39.

One of them – or, better, the most famous of them, Bessarion. Gouma-Peterson, it will be remembered, was on the verge of reaching the same conclusion, but then returned to her thesis that the figure was a "cryptoportrait". This, as we have said, is historically and logically untenable – besides being based on a cursory, and partial, survey of the existing evidence. It will be necessary to re-examine this evidence.

Two photographs of the same person may, as we know, differ to an extraordinary degree; how much more so two paintings or two bas-reliefs. We must proceed, here, with great caution, for in Bessarion's case

the surviving portraits present us (as Gouma-Peterson herself has noted)⁴⁸ with very marked physiognomical differences.

Unfortunately, most of the iconographic evidence about Bessarion has disappeared. Galasso's fresco in the church of the Madonna del Monte at Bologna – in which Bessarion, then a Papal legate, had himself portrayed beside Nicholas V, together with his own secretary Niccolò Perotti (whom we met with earlier) – has been destroyed.⁴⁹ The painting by Gentile Bellini for the hall of the Maggior Consiglio at Venice, which showed Bessarion with the Pope and the Doge in the act of sending an embassy to the Emperor Frederick, exists no longer. A portrait also by Bellini and kept in the same room was burned in 1546.⁵⁰ On the other hand, there is very little in common, physiognomically, apart from the long beard, in the many paintings of the Venetian school where Bessarion (according to Vast) appears in the guise of St Jerome.⁵¹ Leaving aside portraits that are either doubtful or of too late a date,⁵² we are left with the following list (which, however, is certainly not complete):

- 71,72 a) a miniature contained in the second of the eighteen anthem-books made for Bessarion in 1455, which he subsequently gave to the convent of the Observant Friars at Cesena. Bessarion (identified by Weiss)⁵³ wears Franciscan dress; kneeling, and wearing on his head his Cardinal's hat, he is in the act of offering up to God his soul in the form of a new-born child.
 - of Graziano the Minorite (Paris, Bibliothèque Nationale, nouv. acq. lat. 10002). Bessarion, in the habit of a monk of St Basil, and wearing a Cardinal's hat, is receiving the book as a gift from the author, who kneels at his feet. The manuscript is dated 14 October 1461.⁵⁴
 - 74 c) a fifteenth-century medal, undated, belonging to Goethe's collection and now in the Weimar museum. Here, too, Bessarion is seen in profile, wearing a Cardinal's hat. This medal was probably the source of the portrait incorporated in the monument which Bessarion, during his lifetime, had built in 1466 in the basilica of the Holy Apostles. The portrait has disappeared (together with the monument, which was replaced by an inscription dated 1682); but a copy remains a copper diptych,
 - 75 d) a bas-relief that forms part of the funeral monument of Pius II, originally in St Peter's and now in Sant'Andrea della Valle. Bessarion, in

sent to Venice from the Vatican library in 1592.55

the costume of a bishop, is shown giving the Pope the relic of St Andrew's head. This ceremony took place in 1462; Pius II died in 1464. The monument, begun by Paolo Romano, may have been finished by a pupil of Andrea Bregno, and dates from 1465–70.⁵⁶

- e) the miniature that stands at the front of the copy of Guillaume Fichet's 76 *Rhetorica*, dedicated, and given to Bessarion. This was printed in Paris in 1471 (Venice, Biblioteca Marciana, membr. 53): the miniature shows the author presenting his book to Bessarion, who is in the habit of a monk of St Basil, and has a Cardinal's hat on his head.⁵⁷
- f) the illuminated frontispiece of the dedicatory copy of Bessarion's 77 *Epistulae et orationes*, presented to Edward IV of England (Vat. lat. 3586: the book is a parchment incunabulum, printed in Paris in 1471).⁵⁸ Bessarion, in the black cloak of a monk of St Basil and wearing the Cardinal's hat, lays his hand in a protective gesture on Guillaume Fichet's shoulder, while the latter offers the King the volume whose publication he had overseen.
- g) an illuminated portrait of Bessarion, whose figure, with those of six 78 other philosophers, frames the *incipit* of Andrea Contrario's *Obiurgatio in Platonis calumniatorem* (Paris, Bibliothèque Nationale, lat. 12947, c. 11r.).⁵⁹
- h) a medal, framed in laurel, which depicts Bessarion and King Ferdinand 79 of Aragon, both in profile: this is a miniature framing the *incipit* of a Parisian manuscript (Bibliothèque Nationale, lat. 12946, c. 29*r*) of the *Adversus calumniatorem Platonis* written by Bessarion himself and completed in Naples in 1476.⁶⁰ Both in this miniature and in the preceding one, he has the Cardinal's hat upon his head.
- i) Gentile Bellini's painting in the Vienna Kunsthistorisches Museum, 80 which was probably executed shortly after the death of Bessarion, 61 who is shown in the habit of a monk of St Basil kneeling before the casket we have already mentioned, which he gave to the Scuola Grande della Carità.
- j) a painting, probably the work of Pedro Berruguete, based on a drawing 81 by Justus of Ghent, and painted around 1480 for the study of Federico da Montefeltro. This is now in the Louvre. 62

This *corpus* of images is very heterogeneous in form, in the materials employed, in destination and in quality. What information does it give us about Bessarion's features?

One point springs to our eyes at once. The Louvre portrait is

completely unlike the series as a whole from the point of view of physiognomy. The Bessarion depicted in it is a creature of the imagination, painted soon after his death by someone who probably never met him. It is very remarkable that such a painting should have been destined for the court of Urbino, with which Bessarion was so long and so closely connected: but we must accept the evidence. Now it is precisely this portrait that constitutes the principal basis on which Gouma-Peterson (who even provides a full-page reproduction of it) rules out the possibility that the bearded man in the *Flagellation* can be identified as Bessarion.

In terms of physiognomy, the rest of the series of portraits is fairly uniform. There is one element, however - the nose - that is subject to varying degrees of alteration. It is slightly humped, and rounded towards 87 the end, in Pius II's funeral monument and in all the miniatures we have 73 listed – apart from that contained in the Summa of Graziano the Minorite, on which (given its dimensions) we can place less reliance, physiognomically, and where there is no trace of any hump, while the tip is particularly 74 fleshy. In the Weimar medal, it is decidedly humped, while the tip becomes sharp and downward-pointing. In these last two images, we might say, one characteristic (the humped appearance or the fleshiness) is accentuated to the prejudice of the other. Two physiognomical traditions stem from this, both posthumous (and this cannot be a matter of coincidence). Evidence of the first can be seen in the painting by Gentile 80 Bellini that is now in Vienna: here, Bessarion is given a very pronounced nose, with no hump whatever, and in the sixteenth-century copy now in 82 the Accademia, which was painted from memory of a portrait by Gentile Bellini that was stolen in 1540,63 it has become a veritable snub nose. In the second tradition, exemplified by the picture that is now in the 83 Marciana, Bessarion has a straight, almost Grecian nose. In similar fashion, two non-identical profiles derive from copies of the portrait of Bessarion which was kept in the Museo Gioviano di Como, the work respectively 84 of Cristoforo Altissimo in 1566, and of an unknown engraver for the 85 edition of Giovio's Elogia virorum literis illustrium, which appeared at Basel in 1577. We are dealing here with copies of a copy - a copy commissioned by Raphael (so Vasari informs us) from Giulio Romano of Bramantino's frescoes, now lost, in the Vatican, where Bessarion's portrait appeared as one in a series of famous men. Vasari is, however, undoubtedly mistaken in attributing the work to Bramantino.64 The original (whoever the artist may have been) probably dates back to the midfifteenth century. These copies, to be sure, are not much to be relied upon in matters of physiognomy. Nevertheless, their minor differences confirm the tendency of copyists, to simplify Bessarion's profile along divergent lines.

The conjectural reconstruction of this *stemma nasorum* may strike some as an unprofitable, even trivial, exercise. But our roamings in this forest of noses – painted, sculpted and illuminated – have not been without their purpose, for they have enabled us to single out those portraits of Bessarion that are most reliable from a physiognomical point of view. They are, it may be concluded, the first eight of the series, all of which were produced when he was alive.

Can we add to them the bearded man in the *Flagellation*? Some features 86–89 of his face are undoubtedly very similar to those found in the portraits of Bessarion: the sunken eye-sockets; the heavy eyelids; the prominent nose, slightly arched, with its rounded tip and deeply incised nostrils; the full lips, their corners turning down; the forked beard, which is evident for example in the Marciana miniature.⁶⁵ In the latter, as in the Cesena 72 miniature and in Pius II's funeral monument, we find exactly the same carriage of the head, with the neck stretched slightly forward.

All this should incline us to an affirmative conclusion. In particular, the comparison with the medallion-shaped illumination of the Parisian codex of the *Adversus calumniatorem Platonis* seems almost decisive from a 79 physiognomical point of view. However, there are two extremely serious difficulties. The first, already pointed out by Gouma-Peterson, concerns the costume: Piero's figure, unlike other portraits of Bessarion, is not wearing the black habit of a Basilican monk, nor does he bear any of the insignia of a Cardinal. The second concerns age: in 1459, Bessarion was fifty-six. Now the bearded man in the *Flagellation* is clearly much younger – younger, even, than the kneeling monk in the Cesena miniature, recognized by Weiss as a very rare image of Bessarion at a relatively early age. Neither of these difficulties, however, presents itself if, adhering to 71 the date proposed for the *Flagellation*, we suppose Piero to have depicted Bessarion *prior* to his appointment as a Cardinal.

Bessarion was made Cardinal on 18 December 1439. On 4 January 1440, he received the title of the Holy Apostles *in absentia*. By that time, along with the other Greeks returning from the Council,⁶⁷ he was

already sailing towards Constantinople, where he arrived on 1 February 1440 after an exceptionally long voyage lasting three and a half months. It is generally held that he had not been informed of his appointment even though on 11 August of the previous year, Pope Eugenius IV had offered him a handsome pension on condition that he moved to Italy, and possibly to Rome. Sometime during 1440 (and at any rate after 4 May, when he took part in the election of the New Patriarch) Bessarion left Constantinople for good; on 10 December he received his Cardinal's beret at Florence. Obviously, he had by then been officially informed of his appointment. When, and by whom, we do not know. We propose to identify the bearer of this news as Giovanni Bacci, and to suggest that, in commissioning Piero's painting, he was commemorating, at a distance of twenty years, the crowning moment of his political career.

In the very brief autobiographical note (the earliest we possess) compiled in the mid-seventeenth century by Alessandro Certini of Città di Castello, Giovanni Bacci is described as "clerk to the Camera, nuncio to Caesar, most celebrated jurisconsult". ⁶⁹ The otherwise incomprehensible formula "nuncio to Caesar" is very readily explained if, in 1440, Bacci had received a mission from the Pope to travel to Constantinople as nuncio extraordinary to give Bessarion the solemn news of his appointment as Cardinal. At that date, Bacci was clerk to the Camera Apostolica and in favour with Eugenius IV, partly because of his kinship with Giovanni Tortelli, who had but lately returned from a political and religious (as well as cultural) mission to Greece and Constantinople.

We are dealing, for the time being, with a hypothesis only, though one that is backed, as we have seen, by a measure of documentary evidence. At all events, it allows us to explain a series of features of Piero's painting, notably 1) the youthful appearance of Bessarion, who in 1440 was thirty-seven years old (one might also note that his beard is shorter than in later paintings); 2) the fact that he wears none of the insignia of a Cardinal; 3) the splendour of Bacci's robes, which would certainly be appropriate to a Papal messenger (again, the vitality of his expression – very much in contrast to his somewhat lifeless appearance in the profiles at San Sepolcro and Arezzo – could also be due to Piero's desire to portray his model as he was at an earlier stage of his life); 4) the presence of John VIII Palaeologus, who was Emperor in 1440, in the guise of Pilate.

Piero's painting should therefore be understood as doubly evocative: of Bacci's mission to Constantinople (the scene in the foreground) and of the flagellation of Christ (the scene in the background). Bessarion's words, which connect the two scenes, summon up, metaphorically for Giovanni Bacci, physically for us, the spectators observing the events – Pilate, the tormentors, Christ bound to the column. The distance of perspective expresses a distance at once temporal and ontological – between profane and sacred history, between reality and its verbal evocation.⁷⁰ The relics of Pilate's palace conserved in the Lateran and the other antiquities situated in front of it are projected upon an imagined Constantinople, thus creating an architecture both visionary and prescient, from which the probable constructor of the Palazzo Venezia, Francesco del Borgo, fellow-townsman of Piero, was to draw inspiration (the door-frames, for example).⁷¹

The scene in the background thus translates in visual terms the speech delivered by Bessarion when he accepted his appointment as Cardinal of the Holy Roman Church, and thus of his decision to abandon (permanently, as it proved) Constantinople and the Greek church of which he was one of the most illustrious representatives. His words can be construed as follows: the reigning Emperor, John VIII Palaeologus, is to be compared to Pilate in his behaviour, since this makes him an accomplice in the martyrdom the Turks are preparing to inflict on the Christians of the East, of whom Christ bound to the column is the symbol. To both figures – the Emperor and the Turk – Bessarion applies the phrase "Convenerunt in unum", thus justifying his acceptance of the appointment announced to him by Giovanni Bacci. In the face of the calamities assailing Christianity, only a choice in favour of Rome could keep alive the flickering ideal of unity between the Christian churches.

But how are we to explain the presence of John VIII Palaeologus in the guise of Pilate?⁷² Bessarion had maintained very close links with him since his youth. The fact that he prevailed upon Giovanni Bacci to have John VIII celebrated as Constantine in the Arezzo cycle (if my hypothesis is correct) testifies to his loyalty to his memory. Is it possible that in a contemporaneous painting – commissioned by Bacci, but certainly not in conflict with Bessarion's ideas – John VIII can have been accorded so dishonourable a role? But the contradiction lessens if one thinks of the different destinations of the two works. The Arezzo fresco was a public tribute; the *Flagellation* was a picture for private use, in which it was

possible to hint at a negative political judgement on the Emperor's character. On his return to Constantinople from the Council, John VIII had been reluctant to take sides in the bitter struggles between those who favoured and those who opposed union with Rome. As a result, the decree proclaimed at Florence in 1439 lost all effect, and the Emperor was politically isolated.⁷³ It is more than plausible that Bessarion, who from the time of the Council of Florence had been among the most ardent advocates of union with Rome, saw John VIII's attitude as comparable to that of Pilate: both, through their inaction, had given consent to Christ's martyrdom.

The allusion to the Good Friday liturgy, which includes the phrase "Convenerunt in unum" that was placed over the painting, allows us to date the scene precisely: 25 March 1440. It is a plausible date: given that Bessarion was appointed Cardinal on 18 December 1439, one may presume that the messenger made responsible for conveying news of this to him had left Italy a little later and arrived in Constantinople (supposing a voyage of average duration) towards the middle of March.

But why – if we allow that our proposed interpretation is so far accurate – should Giovanni Bacci have commissioned from Piero a re-evocation of his mission to Constantinople twenty years previously, in order to then present it to Federico da Montefeltro? Bacci's motive was certainly not a simple desire to gratify personal vanity. In reality, the time elapsed since the scene depicted had taken place converts the speech attributed to Bessarion at the moment when he receives the news of his appointment from Bacci into a sort of "prophecy with hindsight", rich in allusions to the contemporary political and religious situation. The marble palaces of Constantinople indirectly evoke their destruction by the Turks during the invasion of 1453; Christ's flagellation betokens the sufferings undergone by the Christians of the East up to the time of the very recent invasion of the Morea in 1458–59.74

We have already supposed that a meeting took place between Bessarion, Giovanni Bacci and Piero della Francesca – in all likelihood between the end of 1458 and the first months of 1459 – in connection with the alteration of the Arezzo cycle's iconographic scheme. During this period, Bessarion's thoughts were all of the crusade. News had reached Rome of the Turkish army's invasion of the Morea, in which they were later

opposed, during the early months of 1459, by the despot Thomas Palaeologus.⁷⁵ Pope Pius II decided, above all because of the pressure he was under from Bessarion, to convene a diet at Mantua to persuade the Christian princes of the need to move against the Turks. On 22 January he had left Rome, accompanied by six Cardinals, planning to move northwards at a leisurely pace.⁷⁶ It was intended that the rest of the Sacred College, comprised of men who were sickly or advanced in years, should make the journey in a more favourable season.⁷⁷ Bessarion, who was delicate in health, must have begun his journey in the early spring: what is known for certain is that on 7 May, preceding the Papal procession by two days, he entered Bologna alone (where he had been apostolic legate).⁷⁸ But before his departure from Rome, in discussions whose content we can only imagine, the plan of a painting to be delivered to Federico da Montefeltro must have taken shape.

Christ's flagellation on the orders of the man with the turban evokes, as we have already pointed out, the sufferings of the Christians, especially of the Greeks, under Turkish rule. We said above that the classical-style gallery beneath which Christ's martyrdom takes place was not inspired by any archaeological concern to reconstruct Pilate's praetorium exactly as it was. May we perhaps discern in it a symbolic meaning? For humanists such as Bessarion or Pius II, the fall of Constantinople to the Turks had an additional meaning: as well as being a political disaster and a religious profanation, it was the final disappearance of classical Greece. "O nobilis Graecia ecce nunc tuam finem, nunc demum mortua es?", Piccolomini had asked, before he became Pius II, in his oration De Constantinopolitana clade et bello contra Turcos congregando. "Heu quot olim urbes fama rebusque potentes sunt extinctae. Ubi nunc Thebae, ubi Athenae, ubi Mycenae, ubi Larissa, ubi Lacaedemon, ubi Corinthiorum civitas, ubi alia memoranda oppida, quorum si muros queras, nec ruinas invenias? Nemo solum, in quo iacuerunt, queat ostendere. Graeciam saepe nostri in ipsa Graecia requirunt, sola ex tot cadaveribus civitatum Constantinopolis supererat . . . ".79 But even Constantinople now survived no longer.

But the painting commissioned of Piero was not simply commemorative of past events and expressive of the pain caused by present misfortunes. The second psalm, moreover, in which the phrase "Convenerunt in unum" recurs, is not just an expression of anguish in the face of the assaults against the Messiah that the Kings and Princes have inspired. The

verse quoted is followed immediately by a call to battle: "Dirumpamus vincula eorum et proiciamus a nobis iugum ipsorum". 80 Four years later, Bessarion, in an Instructio pro praedicatoribus per eum deputatis ad predicandum crucem, advised that Psalm 129 should be read as an exhortation to the crusade: "Saepe expugnaverunt me a iuventute mea, dicat nunc Israël: saepe expugnaverunt a iuventute mea; etenim non potuerunt mihi. (...) Dominus iustus concidit cervices peccatorum. Confundantur et convertantur retrorsum omnes qui oderunt Sion, fiant sicut faenum tectorum, quod priusquam evellatur exaruit . . . ". 81 He did not hesitate, however, to make use also of more concrete arguments. On 20 May he wrote from Ferrara, where he was staying with the Papal family en route for Mantua, a long letter to Fra Giacomo della Marca, the Provincial of the Franciscans of the Marca of Ancona (who was later made a saint). In this he encourages Fra Giacomo to gather together an army of crusaders, who were to go to the Morea, where a fresh Turkish offensive was feared. The letter opens with a description of the riches of the Morea: there is abundance of "panem, vinum, carnes, caseum, lanam, bombicem, linum, setam, chremisinum, granum, uvas passas parvas, per quas fit tinctura . . . Frumenti dantur pro uno ducato duo staria magna Marchesana . . . " It concludes with an exhortation to make haste: better to have five, four, even three hundred men at once, than many thousands later.82

Bessarion does not dwell on the more properly religious themes that would have been involved in preaching the crusade in the Marca. These, clearly, could be taken for granted. In the *Flagellation*, however, they are invoked, and from this point of view the picture can be regarded as a figurative sermon, addressed to anyone who appeared to underestimate the gravity of the Turkish threat.

That Piero's picture was meant for Urbino is certain, at any rate, until proof to the contrary is offered. Now Gouma-Peterson has pertinently observed that Federico da Montefeltro was anything but favourably disposed to plans for the crusade: in 1457, he had gone so far as to prohibit any collecting of money for such a project in his dominions, leading Pope Callistus III to threaten him with excommunication in consequence.⁸³ The danger that the Turks might invade the Morea, which led Bessarion to plead, in the summer of 1459, for a crusading force to be equipped in the Marca of Ancona, obviously also made it

advisable to put pressure on Federico. This was very probably another motive (though not, as we shall see, the only motive) for the picture's being sent in that same year.

It is certain, anyway, that Bacci commissioned it (for otherwise it would be impossible to explain why it contains his portrait). His links with Federico da Montefeltro, as evidenced by his having been appointed podestà at Gubbio three years earlier, thanks to the intercession of the Medici,84 provided ample reason for Bacci to send a painting to Urbino. In the letter of 1472 from which we have already quoted, Giovanni Bacci, having mentioned the gentlemen to whom he had been "very dear", went on to offer his own services to Lorenzo de' Medici in the following words: "Once again I would remind Your Magnificence to select someone whom you make bold to refer to and to speak to you on every matter. Lacking such guidance, people have often fallen into grave misfortunes. Our present Pope [Sixtus IV] knows that I alone had the courage to write to Pope Paul on every issue, and so I have done also with the above named Lords."85 Among these Lords, it will be remembered, was Federico da Montefeltro: we can imagine him receiving the Flagellation together with a letter in which Bacci "made so bold" as to insist on the necessity of a crusade. A gesture of that kind would have been consistent with his (largely frustrated) ambitions as a political counsellor.

The idea of putting the figurative sermon on the flagellation into the mouth of Bessarion was justified by the Cardinal's links with the picture's patron and, above all, with its recipient. We have already proved that the former links existed, in our analysis of the iconographic transformation that affected the Arezzo cycle during the break in the work coincident with Piero's stay in Rome. (It is to be noted that this is, indeed, a proof, rather than a presupposition based upon the Flagellation - which, given the doubts about the identification of Bessarion, would have involved us in a truly vicious circle.) The links with Federico go back at least to 1445, in which year Bessarion was appointed commendatory abbot of the abbey of Castel Durante, in the dominions of the Montefeltro family.86 In the years that followed, he stayed many times at the court of Urbino, forming a deep friendship with Federico and enjoying particularly affectionate relations with his sons, Buonconte and Antonio. On the death of Bessarion, a portrait of him (the one by Berruguete that we mentioned earlier) was included in the series of famous men that adorned Federico's

studiolo; with it was an inscription dedicated "amico sapientissimo optimoque".87

Giovanni Bacci, Federico da Montefeltro and Bessarion were joined, then, in a mutually interlocking network of relations. How intimate they were we cannot say with any certainty, but they were quite close enough to lend credence to the reconstruction we are putting forward. There is, however, one figure in the picture which our account has deliberately ignored hitherto: the mysterious blond youth.

None of the very numerous interpretations proposed over the years has offered an acceptable explanation of his presence. His clothes, his face and his attitude all seem incongruous with what is going on around him. Barefoot, clad in a simple tunic, he stands between two men who are shod and wearing elaborate modern dress. He neither speaks (like the man on his right) nor listens (like the man on his left).⁸⁸ The former's solemn gravity, like the latter's attentiveness, leaves him unmoved. His beautiful face is unruffled by any recognizable emotion or sentiment. His eyes are fixed upon something that we cannot see.

The young man is dead.

Hitherto, we have been trying to decode the political and religious implications of the *Flagellation*. Now we have arrived at its most intimate and private core. We propose to identify the young man as Buonconte da Montefeltro, the illegitimate son of Federico, who was made legitimate in 1454 and who died of the plague at Aversa in the autumn of 1458, aged seventeen.⁸⁹

Enamoured as he was of manuscripts and of classical antiquity, Federico had given the young man whom he intended to be his heir a complete humanistic education. In 1453 Bessarion and Flavio Biondo were staying at Urbino. While they were at table (so Biondo, writing a few years later, relates), Federico showed Buonconte a letter that was written in "vulgari materno" (the vulgar mother-tongue) and common in its expression. Buonconte, then twelve years of age, translated it into an elegant Latin. Already at this time, perhaps, or anyway not much later, Federico had appointed as his son's tutor a humanist from Ciociaria, Martino Filetico da Filettino.⁹⁰

Bessarion was struck by the boy's intellectual precocity; and when he received a letter from him written in Latin and in Greek, he in turn replied in Greek. This undated letter of Bessarion's now survives only in a Latin translation, made by his secretary, Niccolò Perotti - who himself in due course sent a note to Buonconte.91 It was a miracle, wrote Bessarion, that a boy, still of tender years, should know Latin and Greek - truly a divine gift, a comfort to his father and to his father's friends, and an extraordinary hope for the future. He urged Buonconte to attend to his father's example, and to imitate his virtues: wisdom, prudence, courage, justice, honesty, mercy, loyalty, magnanimity. With these he should combine, Bessarion advised, the study of letters, for this (as the divine Plato had said) was God's greatest blessing. And Bessarion also expressed the wish that he might confirm Buonconte, thus giving a further, spiritual strength to the bond of friendship that joined him to the boy's father. In this way (observed Bessarion) Buonconte, Federico's son in the flesh, would become his own son in the spirit. He thus promised to come to Urbino as soon as possible; and he invited Buonconte to learn by heart the letter that he was sending him, so that he would be able to repeat not just isolated words, but whole phrases, in Greek or Latin, as he chose. He promised to question the boy closely on it all.92

Bessarion, no doubt, had been deeply impressed by the fact that Federico's son was learning Greek as well as Latin. The same admiration was felt, however, by others who occasionally visited the court at Urbino, such as Biondo, as well as by professional eulogizers such as the humanist, Porcellio, in whose epigrams Buonconte is lauded for his beauty, his genius, his strength and his skill: "Vera Iovis soboles forma facieque decora/Et mira ingenii nobilitate puer,/Romano eloquio indulget pariterque Pelasgo/Dulceque mellifluo stillat ab ore melos./Aeacides qualis micuit Chirone magistro/Ense, oculis, dextra, mobilitate pedum/Talis in arma puer, vel si contenderet arcu/Et calamis Phrygium vinceret ille Parim./Nunc spumantis equi duro premit ilia clavo/Dirigit in girum Tyndaridae assimilis./Hic cantu hic choreis hic clarus in arte palestrae/Clarus et arte pilae, clarus et arte lirae . . . ".93

Buonconte, although still very young, soon began to take a part in the responsibilities of government. In 1457, during his father's absence, he wrote to Sigismondo Malatesta to deplore the damage done by soldiers near Sassoferrato.⁹⁴ The following summer, he left Urbino in company with Bernardino, the son of Ottaviano Ubaldini della Carda, and travelled

to the Aragonese court at Naples. On their way through Rome, they were received by the Pope: "and he was astonished," wrote Guerriero da Gubbio in his chronicle, "as were the other Cardinals, to find so great a cleverness in so small an age". 95 Bessarion must surely have been proud of his pupil.

From Rome, the two young men went on to Naples. At Aversa, they fell victim to the plague. Buonconte died at once; Bernardino on the journey home, at Castel Durante, not far from Urbino. When this happened, we do not precisely know, but Biondo, in a letter to Galeazzo Sforza, Count of Pavia, dated 22 November 1458, speaks of Buonconte's death as a recent event ("nuper defuncto") which had caused a great stir throughout Italy. 96

The virtues of Buonconte and Bernardino, and their untimely deaths, were recorded in the chronicles of Giovanni Santi and Guerriero da Gubbio, and in Porcellio's epigrams. Federico da Montefeltro's reply to Francesco Sforza's letter of condolence survives today: ... certainly it was a great comfort in my grief. My Lord I know that because of my sins our Lord God has plucked out my eye and this little son who was my life and contentment and that of my subjects, who did whatever I required according to my desire. Nor can I remember anything he did to displease me."

No portraits exist of Buonconte.⁹⁹ To identify him as the young man is thus to offer a conjecture. However, various features do make the identification probable. First of all, there is his angelic aspect, which assimilates him to the dead: as has been noted, his bare feet and his tunic recall Piero's angels, whether those in the *Baptism* or those in the *Nativity* in the National Gallery, London. There is his pallor, which contrasts with the athletic solidity of his body and calls to mind the similar unnatural pallor which indicates, in the portrait of Battista Sforza in the Uffizi, that the portrait is posthumous.¹⁰⁰ There is his detachment from his surroundings – a detachment not merely psychological but existential, so to speak, as of one who does not see and cannot be seen.¹⁰¹ There is the date: if, as is shown by the interconnected features that we have pointed out in the course of our discussion, the painting was made in 1459, Buonconte had been dead for about a year. There are the links between Buonconte and the inspirer and the recipient of the pictures, respectively his spiritual

father and his father in the flesh: through Giovanni Bacci, Bessarion was sending Federico a memorial of the young man whom they had both loved while he was alive, and whose recent death they both mourned. (Indeed Federico, in all likelihood, is the absent interlocutor to whom Bessarion – whose eyes are looking at a point outside the picture – is addressing his sermon.) Finally, there is the theme of the flagellation, which is appropriate, as has been remarked, to a funerary purpose, and perhaps to the decoration of a reliquary. ¹⁰²

The young man's attitude, however, recalls the attitude of Christ bound to the column. Through this analogy with the Christian archetype of pain, the sufferings of Buonconte (the potential soldier of Christ cut down by an early death) were assimilated to those of the Greeks languishing beneath the oppression of the Turks, and Federico's private grief to the grievances of the Church. This network of references to personal feeling and to pressures for political and military intervention itself made Piero's Flagellation a difficult image to decipher. It is not surprising that a century after the representation of Federico's dead son the painting came to be wrongly interpreted as a portrait of his brother, Oddantonio, 103 giving rise to a hermeneutic legend that is still in circulation. And the difficulty of decoding the subject of the picture was heightened by its formal characteristics, which hinge upon the contrast between the perspectival unity and the ontological heterogeneity of the reality it depicts. The dead youth, whose sufferings are compared to Christ's, is spiritually present, but invisible to the two men in the foreground. Equally present and equally invisible is the flagellation evoked by Bessarion's words. Only for the painter (and for us the spectators) is this contrast resolved in a higher unity, which is first of all a spatial unity.

Against all this, it might be objected that, even if we accept that the young man represents someone who is dead, it is by no means uncontroversial to identify him as Buonconte; his identification depends, in the last analysis, on the bearded man's identification as Bessarion – and this itself, as we have seen, poses some problems. These have been resolved through recourse to a hypothesis for which, as yet, there is no decisive documentary proof. If, on the other hand, having put forward the identification of Buonconte on the basis of that of Bessarion, we then prove the latter on the basis of the former, we are clearly arguing

in a vicious circle. Only if we were to establish with certainty that the description "nuncio to Caesar", used of Giovanni Bacci by his seventeenth-century biographer, referred to a mission undertaken to Constantinople in 1440, could the enigma posed by the *Flagellation* be resolved beyond all doubt.

This does not mean, however, that the whole reconstruction put forward here would be doomed to collapse should the identification of the bearded man as Bessarion turn out to be mistaken. The elements of which it is composed - the portrait of Giovanni Bacci, the relation between foreground and background, the allusions to the Turkish invasion, the references to the relics in the Lateran - all these are independent of the suggestion that we can trace Bessarion's portrait in the picture; and if they are to be confuted, it must be on equally independent lines. There is one exception: the presence of Buonconte. If we have been led to place him in the painting's context, that is because of his relations with Bessarion. By placing him there, we have arrived at a very concise and coherent overall interpretation. Interpretative coherence, however, cannot have the certainty of factual verification. Documentary evidence about commissioning and location - such as allowed us in the 2, 3 case of the Baptism to test Tanner's iconographical account - has not yet come to light for the Flagellation; let us hope it will do so, some day. Pending new documentary discoveries, we have to admit that our proposed interpretation is in large part conjectural. Given the picture's iconographical anomalies, and our ignorance of its original recipient and location, it would probably have been difficult to proceed in any other way.

When and where was the *Flagellation* painted? Here, too, lack of documentary evidence means that we are confined to conjectures. Since the painting is small, Piero could well have begun it at Rome and finished it at Arezzo. Such a hypothesis is favoured, moreover, by the curve that we remarked in the profile of Giovanni Bacci's cranium. Giovanni must have been recalled to Arezzo, if he was not there already, by the news of his father's death, at the beginning of April; at the same period, Bessarion left Rome for Mantua. Piero probably began work on the painting soon afterwards, on the basis of their joint instructions. On returning to San Sepolcro on the occasion of his mother's death (6 November 1459), he

saw Giovanni Bacci again, and was able to correct his portrait from life. We have seen that he introduced similar corrections in the portrait of Bacci in profile which is found, for reasons unknown, at the feet of the Madonna della Misericordia in the San Sepolcro altarpiece, which was completed or nearing completion at this time. 104 In Bessarion's case, however, no such checking against reality took place: Piero had already been gone from Rome some time when Bessarion, who after the diet at Mantua went first to Venice, then on to Germany, returned there in November 1461.

The completion of the Flagellation would thus coincide with Piero's resumption of work on the Arezzo frescoes following the hiatus of his Roman visit. This perhaps allows us to identify the exact point at which he had left off painting them. Longhi, in a famous essay of his youth, drew attention to the extraordinary formal similarity between the young 40,96 man in the Flagellation and the prophet situated at Arezzo, to the right of the choir window – the only one of the two painted by Piero himself. 105 This is a similarity upon which the datings later proposed by Longhi (c. 1445 for the Flagellation, 1452-ante 1459 for the Arezzo frescoes) can shed very little light, but which is most readily explained adopting the reconstruction we have proposed. The two figures are in fact exactly contemporaneous: they are cut, we might say, from the same cloth. This claim is to be taken literally: "Piero", Vassari tells us, "was in the habit of making clay figurines, which he then covered in densely pleated pieces of cloth, as aids to his drawing."106 A procedure of just this kind seems to be discernible behind the two figures.

If this reconstruction is correct, Piero finished the Flagellation and painted the right-hand prophet between late 1459 and early 1460. It is certain that the architectural forms that appear in the middle row of frescoes - Solomon Receiving the Queen of Sheba and the Discovery and Proof 7, 12 of the Cross - closely echo those found in the Urbino painting. 107

For nearly three centuries prior to its reappearance in the Urbino inventories in the mid-eighteenth century, we have no records concerning the Flagellation. However, there are indirect echoes of Piero's painting: above all, the canvas traditionally known as St Jerome's Study, which forms part of the series painted by Carpaccio for the Scuola di San Giorgio degli Schiavoni. Not many years ago, a most detailed iconographic analysis

showed that the subject represented is in fact a different one – the *Vision of St Augustine*. According to a legend current at the end of the fifteenth century, St Augustine, while he was writing a letter to St Jerome, saw a sudden light. A voice from beyond the grave – the voice, in fact, of St Jerome – announced the speaker's death, which had recently occurred; it then gave answers to a variety of questions about the Trinity, the procession of the Son from the Father, and the angelic hierarchy. On the basis of his resemblance (which is actually no more than generic) to certain existing portraits, Perocco had already previously suggested that Carpaccio intended this saintly humanist, immersed in books and codices, as a depiction of Bessarion, who had granted an indulgence to the Scuola di San Giorgio in 1464. This brilliant hypothesis was then proved definitively by Branca, who recognized the half-effaced seal in the foreground to be unmistakably that of Bessarion. ¹⁰⁸

Since Bessarion had been dead more than thirty years when this picture was painted, there is nothing surprising about the portrait's lack of physiognomical fidelity. It is more surprising, however, that nobody (as far as I am aware) has pointed out the close links between this famous work of Carpaccio's and Piero's *Flagellation*. 109

There is, in the first place, the comparison between the decorated ceiling of the St Augustine and the lacunar ceiling in the Flagellation: both are at the same angle of perspective. The two doors in the back wall of the saint's study are near copies of those in Pilate's loggia; in both cases. moreover, the left-hand doorway is open, and reveals an illuminated interior. The statue of Christ in the Venetian painting is the Christianized mirror-image of the idol on top of the column in the picture at Urbino. The empty seat that stands next to St Augustine's prie-dieu is almost identical in form to the chair Pilate sits on. And there is something more: like Piero in the Flagellation, Carpaccio also introduces into his picture two contrasting light-sources, one natural and the other supernatural. The room that we can see through the open door is lit from the left; the saint's study, by contrast, is lit from the right. This contrast provides a very simple device by which the spectator is impressed with the marvellous nature of the event that has suddenly distracted St Augustine from his work. Here, too, as in the Flagellation, we are witnessing the juxtaposition, in a single scene, of the two ontologically distinct levels of reality.

All this implies that Carpaccio was acquainted with the Flagellation. By

what means did he come by this knowledge? Perocco, although he does nor refer to the picture at Urbino, has already answered this question in his suggestion, made with reference to the St Augustine, that Carpaccio came to know of Piero's researches into perspective by way of Luca Pacioli, who was teaching mathematics in Venice soon after 1470. We can add to the detail of this conjecture. Pacioli, a fellow-countryman of "maestro Pietro de'Franceschi", and an admirer and plagiarist of his work, described him (in a dedicatory message to Guidubaldo, Duke of Urbino) as "the reigning painter of our time". After his youthful sojourn in Venice, Pacioli became a friar and embarked on a wandering life that took him, among other places, to Perugia, to the court of Urbino, to Florence, where he taught from 1500 to 1507, and back to Venice. There, on 11 August 1508, he delivered, to a packed audience in the church of San Bartolomeo di Rialto, the introductory lecture to a course on the second book of Euclid. 110 The last of the paintings destined for the Scuola di San Giorgio - the St Augustine included among them¹¹¹ have been attributed to the same period (the dates proposed vary between 1507 and 1511). In the dedication that precedes the Summa de Arithmetica of 1494, Pacioli records the discussions on perspective that he had had with Gentile and Giovanni Bellini; those which he probably held with Carpaccio, during his later Venetian stay, would surely have been equally fruitful. It is very probable that a copy of the masterpiece of perspective which Piero had painted and which belonged to the Montefeltro family would have been displayed and commented upon in their discussions.

In establishing a connection between the *Vision of St Augustine* and the *Flagellation* we provide a concrete basis for the debt, so often emphasized, that Carpaccio owes to Piero. We also confirm Perocco's hypothesis that Carpaccio's education and development included a distinctive Urbino element. And perhaps the fact that Carpaccio, wanting to portray Bessarion, turned precisely to Piero's painting for inspiration, is not a pure coincidence, but an additional – if hypothetical – element favouring the identification we have previously advanced of the bearded man in the *Flagellation*. It is true that there is no physiognomical resemblance between St Augustine and the bearded man in the *Flagellation* – even though the two heads are almost at the same angle (St Augustine holding his slightly farther forward). If it was by way of Pacioli that Carpaccio came to know of Piero's painting, then he would have had directly before him a drawing that emphasized its compositional elements, not the physiognomical

details of the people depicted in it. However, Pacioli, who was familiar with the court of Urbino, must have been well informed about their identities

The drawings connected with the Vision of St Augustine confirm this 92. 93 hypothesis precisely, and allow us to trace step-by-step the way in which Carpaccio modified his plans. In the drawing now in the Pushkin Museum in Moscow, an old man with a beard sits on the right. He has a pair of compasses in his hand, and is turning to the left. His study is furnished with codices and antiquities that bring to mind those of the St Augustine, but the expression of his face is altogether different, and lacks, above all, any recollection of Piero's Flagellation. That Carpaccio was indirectly acquainted with the work is apparent, however, on the verso of the same sheet: at the back of the elderly bearded man, who sits writing, appears for the first time one of the two doors of the open gallery where Christ's flagellation takes place – the open door, to be more exact, through which can be seen Pilate's staircase, which is very clearly visible in this drawing. 113 Here, we have a precise borrowing, later dropped by Carpaccio, who replaced it with the no less precise derivative features we 91 have listed above. A drawing kept today in the British Museum documents a much more advanced stage of the work, just prior to its completion. Some parts, barely sketched in, correspond to equivalent alterations made in the final drawing: the animal on the left in the foreground, which is not a dog but a ferret, and the figure of the saint. The latter's face, which is no more than outlined, is quite different either from those in the earlier drawings, or from that in the picture: it does not even have a beard. Muraro has made the very reasonable suggestion that this drawing in London constitutes a draft that Carpaccio prepared while he was waiting, perhaps, for the instructions he needed before he could portray Bessarion's face. 114 It is none the less true that the final result offers no more than a generic resemblance to the existing portraits of Bessarion: at this point we may perhaps be allowed to make the point that the bearded man in the Flagellation is much closer to these, from the point of view of physiognomy, than is Carpaccio's St Augustine, where the identity of the person depicted is avouched by the presence of the Cardinal's seal. Pacioli, who along with Piero had been a "sedulous" courtier at Urbino, 115 thus assured that his colleague's painting, destined though it was for purely private consumption, enjoyed the posterity it deserved.

Notes

- 1. Gilbert, "On Subject", p. 208. Aronberg Lavin ("Triumph", p. 335. n. 71) will admit to no more than a typological similarity with the man in the Sansepolcro altarpiece, proposing instead a comparison with the kneeling donor at the feet of the *St Jerome* in the Accademia, which may have derived from the same cartoon: but Lavin herself owns that the similarity holds "except for the face".
- 2. The emphatic tone of this denial is, however, immediately softened in the footnote (Gilbert, "On Subject", p. 208, n. 22).
- 3. Lavin notes the alteration to the *Flagellation*, but offers an historically untenable explanation for it ("Triumph", p. 335): "These changes could have been for aesthetic reasons in relating this curve to the arching top of the window in the palace backdrop." Another similar observation of Lavin's is rejected by Gilbert ("Figures", p. 43). The alteration to the Misericordia altarpiece is noted by Battisti (II, p. 92). I do not know of any discussion analysing these two alterations in the same context.
 - 4. Clark, Piero (1969 edn), p. 79, n. 36.
 - 5. F. Hartt, History of Italian Renaissance Art, New York n.d. (but publ.1970), p. 244.
- 6. Gilbert, "Figures", p. 43: "These persons are not portraits, but men who participate in scenes as in the *Flagellation*" (and see the whole of this essay).
 - 7. Vasari, II, p. 497.
 - 8. Salmi, "I Bacci di Arezzo", pp. 229, 231-2.
 - 9. Ibid., p. 233; Longhi, Piero, p. 45.
 - 10. See ch. 2, n. 33.
- 11. ASG, Riformanze, reg. 25, cc. 110v-111v, "Noticia ellectionis domini Johannis de Baccis de Aretio potestatis Eugubii" (12 January 1456); reg. 26, c. 35v (21 June 1457: appointment of the accountants and auditors responsible for checking Bacci's work during the preceding period); reg. 27, c. 109v (10 June 1468: swearing in of Battista de Torcellis, adjutant of the podestà, Giovanni Bacci); reg. 28, c. 8r (17 November 1468: presentation of the libri malleficiorum for the period of Bacci's tenure of the podestà); reg. 28, c. 13r (21 and 28 November 1468: election of the auditor and accountants responsible for checking Bacci's work). I am grateful to Dr. P.L. Menichetti for kindly allowing me to consult the card-index he is preparing on the podestà of Gubbio. A note on his appointment as podestà of Gubbio is found in a letter from Bacci to Cosimo de Medici (ASF, MAP, VII, 3).
 - 12. Clark, Piero, p. 34.
 - 13. Aronberg Lavin, "Triumph", p. 339.
 - 14. Gouma-Peterson, "Historical Interpretation", p. 229.
- 15. S. Sandström, Levels of Unreality, Uppsala 1964 (for the period 1470–1524); and the same author's "Présence médiate et immédiate", in Archives de l'art français, XXV (1978), pp. 407–17 (which discusses instances as late as Gauguin and Redon). For another angle, see also M. Meiss, Giovanni Bellini's St Francis in the Frick Collection, Princeton (N.J.) 1964. It is worth considering these pieces of research in the light of Italo Calvino's essay on "I livelli della realtà in letteratura", in Una pietra sopra, Turin 1980, pp. 310–23.
- 16. A. Padoa Rizzo, *Benozzo Gozzoli pittore fiorentino*, Florence 1972, pp. 41–2 (which points out the borrowing from the London *Baptism*). After having dated the *Flagellation* to 1451 and the commissioning of the Arezzo cycle to 1452, Rizzo notes (p. 42, n. 87) "the speed with which Benozzo absorbed the lesson of Piero's art", but does not go so far as to reverse the standard account of the relations of influence between the two painters.

- 17. Baxandall, p. 61.
- 18. This has been stressed by Gouma-Peterson ("Historical Interpretation", p. 229). See also M. Koch's *Die Rückenfigur im Bild*, Recklinghausen 1965 (pointed out to me by S. Settis).
- 19. E. Carli, *Il Duomo di Siena*, Siena 1979, p. 87 (on the *Credo* panels, with a list of earlier attributions); Gilbert, "Figures", p. 41, n. 5. On the surmise that the *Flagellation* may have constituted one of the panels of a reliquery, see Gilbert, "Change", p. 107.
 - 20. See ch. III, n. 20.
 - 21. This detail was ascertained by Gouma-Peterson ("Historical Interpretation", pp. 219ff.).
 - 22. Aronberg Lavin, "Triumph", pp. 324-5.
- 23. Borgo, "New Questions", p. 550; and Aronberg Lavin, in *Burlington Magazine*, 121 (1979), p. 801.
 - 24. See also in the same journal the remarks of C.H. Clough, 122 (1980), p. 577.
- 25. Aronberg Lavin, "Triumph", p. 325. We may note, incidentally, that this same detail probably inspired Luca Signorelli to introduce into one of his frescoes at Monte Oliveto the device of an open door in the background (cf. A. Chastel, "La figure dans l'encadrement de la porte", in *Fables*, II, pp. 145–54, esp. p. 151).
- 26. G. Severano, *Memorie sacre delle sette chiese di Roma*, Rome 1630, I, p. 543. Severano speaks of "scale sante" (in the plural), referring to the two sets of steps that flanked the principal stairway, as well as to the latter on which see also the useful summary of M. Cempenari and T. Amodei, *La Scala Santa*, Rome 1974 (2nd edn).
- 27. Both are reproduced in P. Lauer, *Le palais du Latran*, figs 10, 114. On the former, see C. Bertelli, "Filippino Lippi riscoperto", in *Il Veltro*, VII (1963), pp. 59–60. On the latter, see C. Huelsen and H. Egger, *Die Römischen Skizzenbücher von Marten van Heemskerck*, Berlin 1913–16 (anastatic reprint, Soest 1975), I, pp. 36–9; and, in general, the study by J.M.Veldman, *Marten van Heemskerck and Dutch Humanism in the Sixteenth Century*, English trans., Maarssen 1977 (with bibliography).
- 28. Giovanni Rucellai e il suo Zibaldone, I, Il Zibaldone Quaresimale, A. Perosa (ed.), London 1960, pp. 70–1. Giovanni Rucellai and Giovanni Bacci, let us note, knew each other well. The latter wrote to one of the Medici (9 November 1473) that "the nature of all we Bacceschi can be known from your Giovanni Rucellai, and from a great many other learned and perfect men besides" (ASF, MAP, XXIX, 982).
- 29. W. Haftmann, *Das italienische Saülenmonument* . . ., Leipzig and Berlin 1939, pp. 95–7; and see also W.S. Heckscher, *Sixtus IIII Aeneas Insignes Statuas Romano Populo Restituendas Censuit*, 's Gravenhage [1955], with English summary on pp. 46–7. Battisti (I, p. 320) sees a connection between the idol and the remains of the statue fronting the Lateran; he refers, however, to C. Vermeule, *European Art and the Classical Past* (Cambridge, Mass. 1964, p. 40), where a different and unconvincing derivation is actually suggested.
- 30. Codex Urbis Romae Topographicus, K.L. Urlichs (ed.), Würzburg 1871, pp. 121, 136, 160; Codice topografico della città di Roma, B. Valentini and G. Zucchetti (eds.), III, Rome 1953, pp. 196, 353; E. Stevenson, "Scoperte di antichi edifici al Laterano" offiprint from the Annali dell'Instituto di corrispondenza archeologica, Rome 1877, p. 52 (for the tradition concerning the Temple of the Sun); Lauer, pp. 24–5; P. Borchardt, "The sculpture in front of the Lateran as described by Benjamin of Tudela and Magister Gregorius", in Journal of Roman Studies, XXVI (1936), pp. 68ff. On the drawing that illustrates Marcanova's Antiquitates, see C. Huelsen, La Roma antica di Ciriaco di Ancona, Rome 1907, p. 29 and Plate VII. On the copy of this work at the Biblioteca Estense, Modena, see A. Campana, "Biblioteche della provincia di Forli", in Tesori delle biblioteche d'Italia, Emilia-Romagna, D. Fava (ed.), Milan 1932, p. 97. On the copy now at Princeton, see H. Van Mater Dennis, "The Garrett Manuscript of Marcanova", in Memoirs of the American Academy in Rome, VI (1927), pp. 113–26. On the illustrations in both, see E.B.

Lawrence, "The Illustrations of the Garrett and Modena Manuscripts of Marcanova", ibid., pp. 127–31. Huelsen's thesis that the illustrations derive from designs by Ciriaco has since been called in question (cf. R. Weiss, "Lineamenti per una storia degli studi antiquari in Italia", in *Rinascimento*, IX [1958], p. 172) or denied (cf. Cocke, "Masaccio and the Spinario", p. 22), not least because of their unreliability from an archaeological point of view. Disagreeing with Heckscher, Cocke (pp. 22–3) maintains that the columns were lower than those depicted in Marcanova's *Antiquitates*, and the fragments therefore much more visible. In support of this thesis, one might recall that Giovanni Rucellai described the remains of the "giant" as being "on a piece of a column". A very useful account of the ancient sculptures in front of the Lateran is P. Fehl, "The placement of the equestrian statue of Marcus Aurelius in the Middle Ages", in *Journal of the Warburg and Courtauld Institutes*, 37 (1974), pp. 362–7.

- 31. A Catalogue of the Ancient Sculptures Preserved in the Municipal Collections of Rome. The Sculptures of the Palazzo dei Conservatori, H. Stuart Jones (ed.), Oxford 1926, pp. 173–5 (with bibliography). Faint traces of gilt still remain on the hand (p. 174). On the presence of the fragments in the Palazzo dei Conservatori in 1510, cf. F. Albertini, Opusculum . . . , in Codice topografico, IV, p. 491. On the identification with Constantine, see K. Krast, "Das Silbermedaillon Constantins des Grossen mit dem Christusmonogramm auf dem Helm", in Jahrbuch für Numismatik und Geldgeschichte, 5–6 (1954–55), pp. 177–8.
- 32. See the narrative compiled by "Magistrum Monacum Monacum S.S. Andreae et Gregorii de Urbe", published as an appendix to G. Soresini, *De Scala Sancta ante Sancta Sanctorum in Laterano*, Romae 1672.
- 33. This plan, which subsequently became the basis for all later reconstructions, was introduced by Severano, who first published it, in the following terms: "a plan which the architect, Francesco Contini, most meticulously compiled on the basis of the site [i.e., the Lateran] and its remains; from the plan of classical Rome printed by Bufalino in the time of Julius III; from the drawings of it to be seen in S. Pietro Montorio and in the Vatican Library; and from the accounts of those who had seen some part of it" (Severano, *Memorie sacre*, I. p. 534).
- 34. Lauer, *Le palais*, p. 298 (the lacunae are in his text): "Item in cappella . . . est lapis quadratus quattuor columnis marmoreis, sub cujus . . . altitudo Domini Nostri Jesu Christi, antequam crucifigeretur, staturam corporisque magnitudinem denotat, supra quem numerati fuerunt triginta denarii a Judaeis Judae traditori, ac etiam a Judaeis super Christi vestem jactae sortes. In fine presentis Aulae sunt tres Portae antiquae, quae erant in Domo Pilati, per quas transivit Jesus Christus, dum a Judaeis traheretur."
- 35. Johannes Burckhardi Liber Notarum ab anno MCCCCLXXXIII usque ad annum MQVI, E. Celani (ed.), Città di Castello 1910 (Rerum Italicarum Scriptores [n.s.], XXXII, I), I, p. 83 (12 September 1484): "benedictione per pontificem, ut supra, data, ascendit per basilicam predictam ad palatium lateranense et quum pervenisset ad primam aulam magnam, que aula concilii nuncupatur, positum fuit faldistorium ante gradus lapidis, super quattuor columnas positi, qui mensura Christi appellatur, ubi papa sedit, renibus ad dictum lapidem versis" (and cf. ibid., p. 66, 26 August 1484). Both passages refer to the coronation ceremony of Innocent III, not that of Alexander VI, as G. Rohault de Fleury erroneously says in Le Latran au Moyen Age, Paris 1877, p. 257. The "aula" mentioned in the Tabula of 1518 (see n. 34 above) is clearly the Council Chamber ("aula concilii"). These pieces of evidence are only apparently contradicted by a passage in A. Fulvio (Antiquitates Urbis . . ., [Romae], 1527, cc. XXIIIr-v): "Ab altera vero Basilicae parte ubi nunc aeneus surgit equus extant iuxta Sancta Sanctorum marmorei gradus numero XXVIII, per quos Christus ad Pilatum ascendisse dicitur, ubi pensilis et flexuosa longo incessu occurrit porticus ab Eugenio IIII instaurari coepta a Nicolao V et Syxto IIII successive restituta, ubi in primo aditu iuxta basilicam S. Ioannis a sinistris mensura staturae Christi ubi lapis super quo numerati dicuntur XXX argentei quibus venundatus est a discipulo Iuda. Paulo

ulterius occurrunt tres portae marmorae per quas ingressus dicitur ad Pilatum iuxta antiquam pontificum suggestum, deinde duae porphyreticae sedes ubi novus pontifex attrectatur . . . ". The sixteenth-century translator renders the obscure phrase "ubi in primo aditu iuxta basilicam S. Ioannis occurrit a sinistris mensura staturae Christi" by referring the "ubi" to the "porticus" that precedes: "and in the first vestibule of the said portico [del detto portico] along by the church of S. Giovanni there is on the left hand the measure of the height and stature of Christ" (A. Fulvio, L'antichità di Roma . . . con le aggiuntioni et annotationi di Girolamo Ferrucci, Venice 1588, c. 54r). "Ubi in primo aditu" actually refers to the northern façade of the Papal buildings ("ab altera vero Basilicae parte"): there indeed follow ("paulo ulterius occurrunt") the three doors known as "Pilate's doors", situated in the Aula del Concilio, and then ("deinde") the two porphyry seats placed together in front of the San Silvestro chapel (Johannes Burckhardi Liber ..., I, p. 83, as well as nos 39 and 43 of Contini's plan, already referred to). Fehl (pp. 363-4, n. 10) notes the obscurity of the passage from Fulvio, without, however, clarifying its meaning. On Fulvio, see R Weiss's general account in "Andrea Fulvio romano (c. 1470-1527)", in Annali della Scuola Normale Superiore di Pisa, classe di lettere, etc., s. II, XXVIII (1959), pp. 1-44.

- 36. Lauer, Le palais, p. 104; J. Mabillon, Musei Italici, tomus secundus, Lutetiae Parisiorum 1689, p. 564.
- 37. Severano, I, pp. 587–8, records the two columns "near . . . the stone", without specifying their whereabouts, but clearly alluding to the Aula del Concilio.
- 38. On the present position of the three doors, see P. Lauer, *Le trésor du Sancta Sanctorum*, Paris 1906 fig. 1; and *Le palais*, p. 321; M. Cempenari and T. Amodei, p. 80. On the stone and on "Pilate's" columns, see Lauer, *Le palais* p. 333; E. Josi, *Il chiostro lateranense. Cenno storico e illustrazione*, Vatican City 1970, p. 17, nos. 167–8.
- 39. R. Wittkower and B.A.R Carter, "The Perspective of Piero della Francesca's 'Flagellation'", in *Journal of the Warburg and Courtauld Institutes*, 16 (1953), pp. 292–302.
 - 40. Ibid., p. 296.
- 41. Rohault de Fleury gives an identical measurement (*Le Latran*, Atlas plate 51). All this decisively refutes the intrinsically untenable thesis that Piero's *Flagellation* should actually be seen as a representation of the *Vision of St Jerome*. This thesis was suggested to Pope-Hennessy by the compositional similarities the work shares with two Sienese works depicting the *Vision of St Jerome* (as noted by E. Trimpi, *Burlington Magazine*, CXXV, August 1983, n. 965, p. 465): the *predella* by Sano di Pietro, painted circa 1440 and now in the Louvre, and that by Matteo di Giovanni, painted in 1476 and now in the Art Institute, Chicago. There is no doubt that elements of Pietro's painting are taken from Sano di Pietro, and that Matteo di Giovanni draws on Piero; but these compositional similarities are no basis for claiming that the iconography is the same.
- 42. On the column in the church of Santo Stefano in Bologna, which was also held to be equal to Christ in height (it was about 173 cm high), see G. Uzielli, *L'orazione della misura di Cristo*, Florence 1901 (offprint from *Archivio storico italiano*), p. 6. The manuscript evidence is discussed in the following note.
- 43. Ibid., pp. 7ff. The prayer-book begins: "Most holy prayers to be said daily with all devotion and to be hung up in the entrance of the house or in the shop or else carried about the person to ward off the plague and every adversity." In a manuscript now at the Riccardiana Library, Florence, on the other hand, Christ's stature is given as 1.74 m; other instances give greater heights, up to approximately 1.80 m (cf. G. Uzielli, Le misure lineari medioevali e l'effigie di Cristo, Florence 1899). According to Uzielli, the linear measures or braccia then current in Italy derived from the various measurements attributed to Christ's height, on a ratio of 1:3: thus the "raso" or "braccio" of Turin, equal to .599 m, corresponds (to within 6 mm) to one-third of the height of Christ in the Holy Shroud (1.78 m) (ibid., p. 10). The thesis, in all honesty, seems

interesting rather than convincing. It is worth noting in passing that Uzielli states that the figure covered by the Holy Shroud measures 1.78 m – the same height as the Lateran columns (to which he does not refer). On the other hand, those who believe in the authenticity of the Holy Shroud hold Christ to have been 1.83 m tall, and (despite the evidence) claim that this is the same as the height of the Lateran columns: cf. P. Savio, *Ricerche storiche sulla Santa Sindone*, Turin 1957, pp. 172ff. On the wish to obtain a physical image of Christ, the apocryphal *Epistola di Lentulo* is interesting: the text of this fifteenth-century document (widespread also in the following century) is given in the Italian edition of Baxandall, *Painting (Pittura ed esperienze sociali nell'Italia del Quattrocento*, Turin 1978, pp. 64–5).

- 44. Vasari, II, p. 496.
- 45. Clark, Piero, p. 35.
- 46. Gilbert, "Figures", pp. 43-4.
- 47. Borgo, "New Questions", p. 549. Here the bearded man is identified as a Hebrew priest, and Piero is credited with the belief that the Greek priests had continued the traditions of the Old Testament in the matter of their habiliments.
 - 48. Gouma-Peterson, "Historical Interpretation", p. 232, n. 87.
- 49. Among the various references to this lost fresco, it is worth noting Ghirardacci's, who tells us (*Historia*, III, I, p. 159) that Bessarion appeared "kneeling without a hat".
 - 50. F. Sansovino, Venetia città nobilissima et singolare, Venice 1581, cc. 131r, 132v.
- 51. Vast, p. 299. Among other works, Vast refers to Bartolomeo Montagna's altarpiece and to Vincenzo Catena's *Holy Conversation*, both in the Accademia. A posthumous portrait of Bessarion has also been identified in Cosimo Rosselli's fresco of the *Crossing of the Red Sea*, in the Sistine Chapel; this has traditionally been attributed to Piero di Cosimo, but it is now generally denied that the latter had any hand in this group of frescoes (cf. M. Bacci, *Piero di Cosimo*, Milan 1966, pp. 128–9, where the discussion on this point is summarized).
- 52. The painting preserved in the canonical sacristy of Urbania cathedral (which I was able to see by courtesy of Don Camillo Leonardi) is something of an exception. E. Rossi (Memorie ecclesiastiche di Urbania, Urbania 1936, p. 104) held it to be a portrait of Bessarion, very different physiognomically from other portraits (see C.H. Clough, "Cardinal Bessarion and Greek at the Court of Urbino", in Manuscripta, VIII, Nov. 1964, pp. 166-7, n. 33), whereas it is actually a copy of the portrait of Taddeo Barberini in the costume of a prefect, by Maratta (cf. M. Aronberg Lavin, Seventeenth-Century Barberini Documents and Inventories of Art, New York 1975, fig. 5 and p. 429). Among the posthumous portraits, no reliance can be placed on the basrelief from Ferrara reproduced in Miscellanea Marciana di studi bessarionei . . ., Padua 1976; and that reproduced in I.-J. Boissard, Icones quinquaginta virorum illustrium (Frankfurt 1597, I, p. 136) is altogether imaginary. On the other hand, and even though it is a late copy, the small portrait 88 preserved in Ludovici Bentivoli virtutis, et nobilitatis insignia . . ., Bononiae 1690, is interesting from a physiognomical point of view (see Aula V, Tab. I, H. III. 37.2, Bologna University Library; T. De Marinis mentions another copy of this extremely rare little book in La legatura artistica in Italia nei secoli XV e XVI, Florence 1960, II, pp. 3-4). The text of a speech given by Bessarion in 1455, on the occasion of his bestowing on Ludovico Bentivoglio a sword that he had been given by Nicholas V, is reproduced in this work, from a manuscript belonging to Bentivoglio; the little book opens with a dedication by J. de Bergomoriis. The "L" of the incipit ("Leto iucundoque animo . . .") is illuminated with a tiny portrait of Bessarion; this, like the other engravings that accompanied the volume (printed in Bologna), was derived from the miniatures that decorated Bentivoglio's manuscript, now lost. (The text of this same speech of Bessarion is given in Vat. Lat. 4037, without the miniature; this, like the volume printed in Bologna, is referred to by L. Bandini, De vita et rebus gestis Bessarionis cardinalis Nicaeni . . . commentarius, in PL, 161, p. XIX, n. 46).

- 53. R. Weiss, "Two Unnoticed 'Portraits' of Cardinal Bessarion", in *Italian Studies*, XXII (1967), pp. 1–5. Weiss regards the first of these two "portraits" (which is not reproduced here) as very stereotypic, whereas he believes that the second can properly be called a true portrait of Bessarion around the year 1455, when the Cardinal was a little over fifty. The anthem-books are now discussed exhaustively in an essay by G. Mariani Canova, "Una illustre serie liturgica ricostruita: i corali del Bessarione già all'Annunziata di Cesena", in *Saggi e memorie di storia dell'arte*, 11 (1978), pp. 9–20.
 - 54. This was pointed out by L. Frati, Dizionario bio-bibliografico . . . , Florence 1934, p. 83.
- 55. On the medal, see A. Armand, Les médailleurs italiens des quinzième et seizième siècles, Paris 1883, III, p. 158, no. 6. The diptych, reproduced in the monograph by A.A. Kyros (Athens 1947; 2 vols) was kept in the Marciana: in 1954, however, it proved to have been lost (cf. M. Luxoro, La biblioteca di San Marco nella sua storia, Florence 1954, p. 21, n. 14).
- 56. Cf. S. Ortolani, S. Andrea della Valle, Rome n.d., caption to fig. 25; C. Seymour jr., Sculpture in Italy 1400 to 1500, London 1966, pp. 156, 158.
 - 57. It is reproduced before the frontispiece in the Miscellanea Marciana.
- 58. Miniature del Rinascimento (Vatican City 1950, p. 55) does not recognize Bessarion as the Cardinal depicted in the miniature (which is described as "of the French school"); see, however, the earlier note by R. Rocholl, Bessarion, Leipzig 1904, p. 213.
- 59. T. De Marinis, La biblioteca napoletana dei re d'Aragona, II, Milan 1947, pp. 53–5, and III, plate 77. The codex was written in 1471 by Joan Marco Cinico, and illuminated by Cola Rapicano: De Marinis surmises that Cola Rapicano may have had as his collaborator Andrea Contrario himself, since the latter's pictorial talent was praised by Perotti and by Valla.
- 60. De Marinis, II, pp. 28–9, and III, plate 32. The codex was illuminated by Gioacchino de Gigantibus, berween 1472 and 1476. J. Ruysschaert ("Miniaturistes 'romains' à Naples", in De Marinis, *La biblioteca, Supplemento*, Verona 1969, pp. 272–3) attributes the portraits, including the one of Bessarion, to a collaborator of Gioacchino, possibly the same miniaturist who illuminated the codex cited in the preceding note.
 - 61. Schaffran, pp. 153-7.
- 62. On the disputed question of collaboration between Justus of Ghent and Pedro Berreguete, C. Gnudi's essay remains valuable ("Lo studiolo di Federico da Montefeltro nel palazzo ducale di Urbino [Giusto di Gand-Pedro Berruguete"], in *Mostra di Melozzo e del Quattrocento romagnolo*, Forlí 1938, pp. 25–9). Post (*A History of Spanish Painting*, Cambridge [Mass.] 1947, IX, I, p. 134) attributes the *Bessarion* to Justus of Ghent, referring to G. Briganti's researches. Briganti, however, drew a distinction between drawing (by Justus) and painting (by Pedro): cf. "Su Giusto di Gand", in *La critica d'arte*, XV (1938), p. 111.
- 63. Cf. the work by Schioppalalba (but publ. anonymously), *In perantiquam*, pp. 149–50, where the copy is attributed to Giannettino Cordeliaghi, known as Cordella, a pupil of Giovanni Bellini (whom Fogolari mistakenly identifies with Andrea Previtali: cf. Schaffran, p. 157, n. 17a). See S. Moschini Marconi, *Gallerie dell'Accademia di Venezia opere d'arte del secolo XVI*, Rome 1962, pp. 200–1.
- 64. On the history of Giovio's compilation, and especially on the copies of the portraits of famous men, see L. Rovelli, L'opera storica ed artistica di Paolo Giovio . . . Il museo dei ritratti, Como 1928, pp. 144ff. A more general account is P. Ortwin Rave, "Das Museo Giovio zu Como", in Miscellanea Bibliothecae Hertzianae . . ., Munich 1961, pp. 275–84. The passage from Vasari forms part of his life of Piero: "And then, having been called to Rome by Pope Nicholas V, Piero carried out two stories [i.e., two narrative sequences] in the upper chambers of the palace, competing with Bramantino of Milan" (VI, pp. 528–9). There follows a digression concerning Bramantino's portraits and on the copies of them made by Raphael. We have already commented on the implausibility of Piero's alleged trip to Rome under Nicholas V: meanwhile, as Milanesi

long ago remarked, there is no possibility that Piero and Bramantino ever competed, because it was out of the question chronologically, since Bramantino is thought to have been at work in the Vatican half a century later, in the early sixteenth century (Vasari, VI, pp. 528–9). Moreover, it has now been denied, on stylistic grounds, that Bramantino could have painted the lost originals from which some of the portraits in the Museo Giovio (including the one of Bessarion) are probably derived: the series of fresco portraits in the Vatican actually date, it is argued, to the mid-fifteenth century (cf. W. Suida, *Bramante pittore e il Bramantino*, Milan 1953, pp. 91–3). Battisti has recently claimed that Vasari probably mis-attributed to Bramantino a series of fresco-portraits done by Piero in an adjoining room (I, p. 110).

- 65. According to a famous anecdote related by Pius II, the beard cost Bessarion election to the Pontificate, because some of the Cardinals maliciously interpreted it as a sign of enduring links with the Greek schismatics (*Pii secundi . . . commentarii*, p. 42).
- 66. For a general account, see R. Weiss, "Jan Van Eyck's Albergati Portrait", in *Burlington Magazine*, XCVII (1955), p. 146.
- 67. A. Coccia, "Vita e opere del Bessarione", in *Il cardinale Bessarione nel V centenario della morte (1472–1972)*, Rome 1974, p. 25 (kindly pointed out to me by Dr C. Bianca). In my argument here I take account of the objections raised by S. Settis in his review of the first edition of the present work (in *La Stampa*, 1 June 1981), subsequently elaborated in correspondence with me (7 July 1981). I am very grateful to Settis. The responsibility for any remaining errors is of course my own.
 - 68. R. Loenertz, "Pour la biographie", pp. 117-18.
- 69. Compendio delle sette età di Arezzo descritto da Don Alessandro Certini Castellano, dated 1650 (BCCF, ms 369, unnumbered pages). Here, under the heading "Insigniti di dignità ecclesiastiche", the following biographical note appears: "Gio. Francesco Bacci [which should read Giovanni di Francesco], clerk to the Camera, nuncio to Caesar, most celebrated jurisconsult, very dear to the House of the Medici, who laboured tirelessly on behalf of the Holy Church. Anno 1445" (the significance of this date escapes me). This evidence is referred to by G.B. Scarmagli, the seventeenth-century editor of Aliotti's writings (cf. Aliotti, Epistolae et opuscula, I, p. 27, note b).
- 70. The correlation between the development of linear perspective and the rise of modern historical consciousness is a theme addressed by Panofsky on a number of occasions. Cf. also C. Ginzburg, "From A. Warburg to E.H. Gombrich".
- 71. On Francesco del Borgo, in the past wrongly considered a relative of Piero, see the researches of Ch. L. Frommel, some of whose results were presented at a conference held recently in the Biblioteca Hertziana at Rome.
- 72. J. Babelon, "Jean Paléologue et Ponce Pilate", in *Gazette des Beaux-Arts*, s. VI, IV (1930), pp. 365–75 (on p. 367, through an oversight, Bessarion is said to have died shortly after the Council of Florence). It should be noted, all the same, that the examples mentioned by Babelon all post-date the *Flagellation*, so testifying to the success enjoyed by Piero's decision (whether the first of its kind, we do not know) to portray John VIII as Pilate. See also Gouma-Peterson, "Historical Interpretation", p. 219.
- 73. J. Gill, Personalities of the Council of Florence, Oxford 1964, pp. 102–24, and more specifically the same author's *The Council of Florence*, pp. 402–3, where Gill insists that the Emperor's hesitancy was a decisive factor in the failure of the Council of Florence. Cf. also ibid., pp. 349, 369.
- 74. On the complex position of the patron during this period, see now S. Settis's rich study "Artisti e committenti fra Quattro e Cinquecento", in *Intellettuali e potere*, C. Vivanti (ed.), Torino 1981 (*Storia d'Italia Einaudi, Annali*, 4), pp. 701–61.
 - 75. F. Babinger, Maometto il Conquistatore, Turin 1970, p. 174.
- 76. F. Cerasoli, "Il viaggio di Pio II da Roma a Mantova..." in *Il Buonarroti*, s. III, IV (1890), pp. 213–18.

- 77. Pii Secundi . . . Commentarii, Romae 1584, p. 68. The six cardinals were Calandrini, Borgia, Estouteville, Taillebour, Colonna and Barbo; cf. also G. Voigt, Enea Silvio de' Piccolomini, Berlin 1863, pp. 30–1.
 - 78. C. Ghirardacci, Historia di Bologna, A. Sorbelli (ed.), Bologna 1933, III, I, pp. 169-70.
- 79. Pius II, Orationes politicae et ecclesiasticae, G.D. Mansi (ed.), Lucae 1755, I, p. 268. Translation: "O noble Greece, are you now brought to your demise and death? How many once famous and powerful cities are now extinguished? Where today shall we find Thebes, Athens, Mycenae, Larissa, Lacedemon, Corinth, and those other memorable strongholds whose walls, and even whose ruins, now exist no longer? No one can so much as show us where they stood. We have often sought after Greece in Greece itself, when in truth it was only Constantinople, among so many corpses of cities, which had survived."
- 80. "Let us break their bands asunder, and cast away their cords from us" (Authorized Version). Battisti has already drawn attention to the relevance of Psalm 2 to the theme of the Crusade (I, p. 320: in line with his own interpretation, he also detects in them a possible exaltation of dynastic power).
- 81. "Many a time have they afflicted me from my youth, may Israel now say: Many a time have they afflicted me from my youth: yet they have not prevailed against me . . . The Lord is righteous: he hath cut asunder the cords of the wicked. Let them all be confounded and turned back that hate Zion. Let them be as the grass upon the housetops, which withereth afore it groweth up . . ." (Authorized Version: the psalm is 129 in AV, whereas in the *Bibbia Concordata* [Milan 1968] it is 128). Cf. L. Mohler, "Bessarions Instruktion für die Kreuzzugspredigt in Venedig (1463)", *Römische Quartalschrift*, III–IV (1927), pp. 347–9.
- 82. (Translation: "Bread, wine, meat, cheese, wool, silkworms, linen, flax, crimson tinctures, wheat, tiny raisins used to dye stuffs . . . Grain costs one ducat for two large Marquesan bushels . . . ") Cf. Mohler, "Kardinal Bessarion", III, pp. 490–3. During the same few days, Pius II sent a letter in the same vein from Ferrara to Giacomo della Marca: cf. L. Wadding, *Annales Minorum*, Romae 1735, XIII, pp. 117–18.
 - 83. Gouma-Peterson, "Historical Interpretation", p. 231.
- 84. See the letter sent from Arezzo to Piero di Cosimo de' Medici on 25 November 1455 (ASF, MAP, V, 632). At the same time, Bacci sent another, to Cosimo (now lost). The letter in ASF gratefully acknowledges "of what great benefit your letters were to me in respect of the illustrious Signor Count of Urbino". Similar sentiments are found in ASF, MAP, VII, 3 (dated 18 February 1456, to Piero di Cosimo de' Medici).
 - 85. ASF, MAP, XXIV, 371.
 - 86. Mercati, "Per la cronologia", p. 48, n. 1.
 - 87. Gouma-Peterson, "Historical Interpretation", pp. 230–1.
- 88. Many interpreters, however, have seen all three of the foreground figures as involved in a conversation.
- 89. The date of Buonconte's death is undisputed; not so that of his birth. According to F. Ugolini (*Storia dei conti e duchi d'Urbino*, I, Florence 1859, pp. 370ff.), Buonconte was fourteen when he went to the court of Alfonso of Aragon at Naples; this would mean that he was born in 1443. It is probably on this basis that Aronberg Lavin states that the sources indicate that Buonconte and Bernardino Ubaldini, who accompanied him to Naples, were "in their early teens" ("Triumph", p. 338). G. Franceschini, on the other hand, claims that when Pier Candido Decembrio was a guest of Federico at Urbino in 1449, Buonconte was nine years old, from which it would follow that he was born in 1440 (*Figure del Rinascimento urbinate*, Urbino 1959, pp. 115–16). Such a difference is not altogether negligible; even if, as would seem likely, the young man in Piero's painting is a somewhat idealized portrait, it is relevant to know whether Buonconte died at fifteen or at eighteen (in support of the latter view, see also G. Franceschini,

"La morte di Gentile Brancaleoni [1457] e di Buonconte da Montefeltro [1458]", in Archivio storico lombardo, s. VIII, II [1937], pp. 489–500). Now, our only evidence for deciding on Buonconte's age at the time of his death is the letter in which Biondo Flavio tells Galeazzo Sforza of that event. In it, Biondo recalls an incident that took place during his visit to Urbino with Bessarion, when Buonconte, then aged twelve ("annum agens tertium decimum"), demonstrated his knowledge of Latin (cf. Biondo Flavio, Scritti inediti e rari, B. Nogara [ed.], Rome 1927, pp. 175–6). Since the visit of Bessarion and Biondo to the court of Urbino took place in 1453 (cf. L. Michelini Tocci, "Ottaviano Ubaldini della Carda e una inedita testimonanza sulla battaglia di Varna [1444]", in Mélanges Eugène Tisserant, Vatican City 1964, VII, p. 103), we may conclude that Buonconte died when he was aged seventeen, and was born in 1441. For the place of his death, see Cronaca di ser Guerriero da Gubbio . . ., G. Mazzatinti (ed.), Città di Castello 1902 (Rerum Italicarum Scriptores, n.s., vol. XXI, Pt IV), p. 68.

90. Biondo Flavio, pp. 175–6. In a letter written to Federico while the latter was away from Urbino, Buonconte speaks of "Philetius vero praeceptor meus amatissimus" (Ugolini, II, p. 519). It is not clear when Filetico became attached to the court at Urbino – at least in 1454, according to R. Sabbadini (*Epistolario di Guarino Veronese*, Venice 1919, III, pp. 474–5), who, however, misinterprets Biondo's letter to Galeazzo of 1458, claiming that the anecdote it relates concerning the thirteen– (actually, twelve–) year–old Buonconte would have taken place "a little earlier" (in fact, it occurred five years previously). Doubt has already been cast on Sabbadini's conjecture by C. Dionisotti, in "Lavinia venit litora.' Polemica virgiliana di M. Filetico", in *Italia medioevale e umanistica*, I (1958), p. 296, n. 3.

91. For Perotti's note, itself a reply to a letter from Buonconte, see Mercati, "Per la cronologia", pp. 150-1.

92. Bessarion's letter, already remarked by Mohler, is published, as amended by L. Labowski, in Clough, Cardinal Bessarion, pp. 161–2.

93. Urb. lat. 373, cc. 120*r*–*v* (the ode, which opens the second book of Porcellio's *Epigrammi*, is entitled: "Ad Boncontem divino ingenio adolescentulum Federici prin. filium"), with emendations based on Urb. lat. 708, cc 55*r*–*v*, where there is the variant reading "Dirigit in girum nunc quoque victor eques". Translation: "In the beauty of his face and figure, and in the wonderful nobility of his intelligence, the boy is truly the offspring of Jove. He expresses himself alike in Latin and in Greek, and sweet is the melody that flows from his honeyed mouth. Just as Aeacus's grandchild, instructed by Chiron, was fleet of sword, eye, hand and foot, so is this child, who would vanquish even the Phrygian Paris should he vie with him in archery. Now he presses the hard spurs to the flanks of the foaming steed; now, like the son of Tyndaris, he guides him in the course. He is famed for his singing, his dancing, his gymnastics, his skill at ball, and his playing of the lyre . . . " The same verses are quoted by G. Zannoni, "Porcellio Pandoni ed i Montefeltro", in *Rendiconti della R. Accademia dei Lincei* (cl. di scienze morali ecc.), s.v. IV (1895), p. 119.

- 94. Ugolini, I, p. 371.
- 95. Cronaca, p. 67 (the passage is from the first version).
- 96. Biondo Flavio, pp. 175-6.
- 97. Federico da Montefeltro duca di Urbino. Cronaca di Giovanni Santi, H. Holtzinger (ed.), Stuttgart 1893, pp. 52–3; Cronaca di ser Guerriero da Gubbio, pp. 66–7; Urb. lat. 373, cc. 125v–126r ("Sepulchrum Boncontis Montefel."). For more verses on Buonconte, see ibid., cc. 124r–v ("Bonconti adolescentulo omni virtum (!) generum praedisertissimo"). On Porcellio, see, in addition to G. Zannoni ("Porcellio Pandoni"), U. Frittelli, Giannantonio de' Pandori detto il "Porcellio", Florence 1900.
 - 98. Franceschini, "La morte", p. 499.
 - 99. His likeness is not preserved on any of the coinage of the period (cf. R. Reposati, Della

zecca di Gubbio e delle geste de' conti e duchi d'Urbino, 2 vols, Bologna 1772; on p. 263 of vol. I, thanks to a misinterpretation of B. Baldi's Vita e fatti di Federigo di Montefeltro [of which see the Rome 1824 edn, vol. II, p. 48], it is said that Buonconte died when he was fourteen); nor do we have any medals portraying him (there is no record of his name in G.F. Hill, Corpus of Italian Medals of the Renaissance before Cellini, 2 vols, London 1930).

- 100. Cf. Battisti, I, p. 357. Aronberg Lavin ("Triumph", p. 339, n. 100) remarks that the youth is much paler than the two people between whom he stands, and compares this pallor to the pallor of the scourged Christ.
- 101. The history of this iconographic *motif* might be taken as a starting-point and developed in more depth. See P. Fehl's interesting but rather cursory remarks: "The Hidden Genre: a Study of the *Concert Champêtre* in the Louvre", *Journal of Aesthetics and Art Criticism*, XVI (1957), pp. 153–68.
 - 102. Battisti, I, p. 507, n. 406.
 - 103. See ch. III, n. 22.
- 104. The chronology of the Misericordia altarpiece is obscure, though the work on it, which was to have been completed, according to the contract, in three years (cf. Battista, II, p. 10), clearly dragged on for very much longer. Commissioned in 1445, it was still unfinished in 1455, at which point the Confraternity confronted Piero with a sort of ultimatum, asking him to complete the work within forty days (cf. Beck, "Una data"). It has been noted by Battisti - counter to Gilbert's supposition that this request relates to a different commission, not otherwise documented - that in 1458 Piero was probably still defaulting on some contract entered into while he was a minor: hence his signature is validated by that of his father when, on the eve of his departure for Rome, he empowers his brother Marco to act on his behalf. This hypothesis seems confirmed by the sum paid by the Confraternity of the Misericordia of San Sepolcro to Marco in January 1462 "in part payment for the picture painted by his brother Maestro Piero" (Battisti, II, p. 11). Unless we accept Gilbert's convoluted hypothesis, this "picture" can only have been the polyptych commissioned in 1445, now clearly finished ("painted"). How long it had been complete we do not know (Battisti offers no good reason for his claim that "we can consider 1462 as a far, not close, terminus ante quem": cf. ibid.). At all events, this chronology, based on documentary evidence, is not inconsistent with Piero having intervened to alter the portrait of Giovanni Bacci in 1459. It should be noted that Longhi's proposed chronology, based on stylistic factors, does not hesitate to compare the later sections of the altarpiece - that is, the figures of the worshippers - to the Uffizi diptych (Piero, p. 207).
- 105. See R. Longhi, "Piero dei Franceschi e le origini della pittura veneziana", in *Scritti giovanili (1912–1922)*, I, Florence 1961, p. 87, which demonstrates the connection between Piero and Antonello da Messina by comparing the latter's *San Sebastian*, now at Dresden, with the scourged Christ and the blond youth in the *Flagellation*, and the latter to the Arezzo *Prophet* ("the identity is complete"). See also the same author's *Piero*, p. 47.
- 106. Vasari, II, pp. 498–9. E.H. Gombrich drew attention to this passage in an article in the *Burlington Magazine*, 94 (1952), p. 178.
- 107. On the basis of this formal analogy, and others, Gilbert ("Change", pp. 31–2) argues that the Urbino picture is close in time to this phase of the Arezzo cycle; but he dates both around 1463.
- 108. H.L. Roberts, "St Augustine in 'St Jerome's Study': Carpaccio's painting and its Legendary Source", in *Art Bulletin*, XLI (1959), pp. 283–97; E.E. Lowinsky, "Epilogue: The Music in 'St Jerome's Study'", ibid., pp. 298–301. See further J. and P. Courcelle, *Iconographie de Saint Augustin*. *Les cycles du XVI siècle*, Paris 1969, p. 104, n. 2 and plates LXIV, CIX; and the same authors' volumes devoted to the fourteenth- and fifteenth-century cycles (Paris 1965,

- 1972) for other representations of St Augustine's vision. Also, see G. Perocco, "La scuola di San Giorgio degli Schiavoni", in *Venezia e l'Europa. Atti del XVIII congresso internazionale di storia dell'arte*, Venice 1956, pp. 221–4; and *Carpaccio nella Scuola di S. Giorgio degli Schiavoni*, Venice 1964, p. 134; Z. Wazbinski, "Portrait d'un amateur d'art de la Renaissance", in *Arte veneta*, XXII (1968), pp. 21, 28, n. 5 (which refers to an oral communication by V. Branca).
- 109. It was my daughter Lisa, then aged twelve, who made me aware of the existence of an analogy between the two paintings.
- 110. Tutta la pittura del Carpaccio, G. Perocco (ed.), Milan 1960, pp. 12–13; L. Pacioli, Summa de arithmetica . . ., Venice 1523 (first edn 1494), dedication; Euclid, Opera, Venetiis 1509, cc. 31 r–v (where there is a list of those present at the introductory lecture). For a swift biographical sketch of Pacioli, see G. Masotti Biggioggero's appendix to the De divina proportione, Milan 1956.
- 111. Perocco, *Tutta la pittura*, p. 59 (in connection with the date, now illegible, on the *St George Slaying the Dragon*). Perocco suggests 1507 as the date of the cycle's completion; J. Lauts (*Carpaccio*, London 1962, p. 31) suggests 1508.
- 112. Perocco, *Tutta la pittura*, p. 15. Longhi has emphasized Carpaccio's indebtedness (by way of Antonello) to Piero: see "Il Carpaccio e i due 'Tornei' della National Gallery", in *Ricerche sulla pittura veneta*, Florence 1978, p. 82; for the link with Antonello, see "Per un catalogo del Carpaccio", in "*Me pinxit*" e quesiti caravaggeschi, Florence 1968, pp. 78–9.
- 113. Vittore Carpaccio Catalogo della mostra, P. Zampetti (ed.), Venice 1963, p. 300, no. 10 (with bibliography). V. Goloubeff, who first published the two drawings, hypothesized that they were in this sequence ("Due disegni del Carpaccio", in Rassegna d'arte, VII, 1907, pp. 140–1). Goloubeff observed that the figure in the first drawing more resembles an astrologer or an alchemist. Lauts (p. 273) takes the two Moscow drawings, and a drawing similar in style of a young, beardless scholar seen in profile kept in the British Museum, to be three of a projected series of portraits of philosophers; he is therefore inclined to rule out any connection between these drawings and the Vision. The opposite opinion is maintained by D. von Hadeln, Venezianische Zeichnungen des Quattrocento, Berlin 1925, p. 57.
 - 114. M. Muraro, Carpaccio, Florence 1966, p. 104, n. 10.
 - 115. Cf. Pacioli, Summa, dedication.

Conclusion

We have traced a complex set of iconographic references to Church unity and the Crusades in the *Baptism* and the *Flagellation*, and in the second and larger part of the Arezzo cycle. All of these relate in one way or another to the cultural, political and religious interests of Giovanni Bacci or of those who for various reasons were connected with him. Negative proof of this is given by the fact that such themes disappear from Piero's paintings after the completion of the Arezzo cycle, when Bacci ceased to play the role of patron.

It may now be asked whether this influence was a matter of iconography alone. Once finished with the Arezzo frescoes, it is certainly true that Piero (then aged barely forty-five) engaged upon a very different and less demanding stylistic course. It hardly seems right to speak of a regression (though some have done so)2 when we look at work such as the Uffizi diptych, the Senigallia Madonna (now at Urbino), or the Brera altarpiece. It would be absurd, certainly, to challenge the fanciful image of the artist shut away amid his wholly formal researches by overemphasizing the influence a patron may have exercised over purely stylistic options. All that is permitted is the cautious hypothesis that Piero's exceptional mastery of perspective would have helped to attract the attention of a cultural circle interested in every type of technological innovation. Let us recall in this connection a fact that may be pertinent: Tortelli inserted under the heading "Horologium" in his De Orthographia a long list, drawn up by Lorenzo Valla, of inventions undiscovered in classical times. The list includes some connected with art, such as the manicordo and the niello. Bessarion himself, moreover, wrote a letter shortly after 1440 advising Constantine Palaeologus, the despotic ruler of the Peloponnese, to avail himself of the advances made by Western technology.3

Giovanni Bacci's dependent situation as a client of the Medici does, on

the other hand, help to explain, paradoxically, why Piero received no Florentine commissions. That did, indisputably, owe something to reasons of taste.4 It is equally certain, however, that Bacci was able to recommend his protégé to Sigismondo Malatesta or Federico da Montefeltro thanks to the intercession of the Medici, but not to put forward his name to the Medici themselves. Bacci, in his letters to his patrons, recalled in tones half-gratified and half-nostalgic the protection he had formerly enjoyed, and the experiences he had gathered as he travelled from court to court; he gave advice on the situation in Arezzo, urging Piero di Cosimo to appoint a sheriff "who might go searching and running around the country and make some show of terror" to put down "the insolence and boldness" of the peasants towards "merchants, craftsmen and gentle folk".5 He asked Lorenzo for a post that would allow him to get away from Arezzo, reminding him discreetly that Federico da Montefeltro "is used to keep and to give every emolument to his friends and to his men".6 The Medici, however, remained deaf to his pleas. In vain, Bacci returned to the charge: "I stay here where I have never been content, and so pray Your Magnificence to deign to take me away from this hell, for my heart could know and feel no other hell than to dwell in this city which is set in a worse condition than any other I have ever seen."7

This plea, one of so many, dates from 29 April 1476. Giovanni Bacci's last surviving letter was written in December of the same year. We do not know when he died: shortly afterwards, perhaps. He wished to be buried in Rome, in the church of Santa Maria Nova, where another clerk to the Camera Apostolica, also from Arezzo, had been buried before him.⁸ His mausoleum, destroyed during the alterations made to the church in the second half of the seventeenth century, no doubt bore some nostalgic record of his brief career in the Papal administration, which had been so rudely broken off, thirty years earlier, when he fell out with the Cardinal Camerlengo, Ludovico Trevisano.

Notes

1. De Tolnay remarks on this, but in general fashion, and in a context that minimizes the importance of the point: "Allusions to the history of the Eastern and Western Churches make up no more than secondary episodes in his painting. They disappear following the Arezzo cycle.

The important point is that his ability to build up a complete and solid universe was due to the quality of his Faith..." ("Conceptions réligieuses", p. 239; trans. from the French. The essay is dedicated to Jacques Maritain.).

- 2. This thesis is put forward in Clark's monograph. Longhi uses much less forthright language, speaking of a lack of "further real progress . . . following the first great poetic invention at Arezzo"; elsewhere, he notes that part of Piero's later work, starting with the Roman frescoes, has been lost (*Piero*, pp. 57, 91). We have argued above that this chronology cannot be maintained.
- 3. A. Keller, "A Renaissance Humanist Looks at 'New' Inventions: the Article 'Horologium' in Giovanni Tortelli's *De Orthographia*", in *Technology and Culture*, 11 (1970), pp. 345–65, which should be read in the light of O. Besomi, "Dai 'Gesta Ferdinandi'"; A.G. Keller, "A Byzantine Admirer of 'Western' Progress: Cardinal Bessarion", in *Cambridge Historical Journal*, II (1965), pp. 343–8.
 - 4. Longhi, Piero, p. 98.
 - 5. ASF, MAP, XVII, 328 (the letter is addressed to Piero di Cosimo de' Medici).
 - 6. ASF, MAP, XXIX, 144 (the letter is dated 6 March 1473).
 - 7. ASF, MAP, XXXIII, 312 (the letter is addressed to Lorenzo de' Medici).
- 8. "Monsignor Giovanni di Francesco Bacci, clerk to the Reverend Camera Apostolica, lived for many years, as . . . can be seen from his tomb in the church of San Francesco in the Campo Vaccino at Rome": so wrote Gamurrini (Istoria, III, p. 328). The church in question was actually Santa Francesca Romana, formerly known as Santa Maria Nova. Not long after Gamurrini wrote these words (in 1673) the restoration of the church, which radically altered its appearance, must have taken place; in course of this, many of the funeral monuments within it were destroyed, among them those of Gentile Fabriano (cf. P. Lugano, OSB, S. Maria Nova [S. Francesca Romana], Rome, n.d., p. 5) and of one "Flodericus de Aretio", clerk to the Camera Apostolica, who died in 1403 (cf. V. Forcella, Iscrizioni delle chiese e d'altri edificii di Roma dal secolo XI fino ai giorni nostri, Rome 1873, II, p. 6). Forcella does not mention Giovanni Bacci's funeral monument among those to be found, or formerly to be found, in Santa Maria Nova (cf. ibid., pp. 3-16, 527-8). I have examined in vain ms. Vallicelliano G. 28, Antiquae Inscriptiones Ecclesiarum Romanae Urbis collectae a Carolo de Secua (recte, Serva) Antonio Bosio et Ioanne Severano (on Santa Maria cc. 33-4). Nor have I been able to trace Giovanni Bacci's will: neither in the State Archives at Florence, nor in the collection of legal instruments from Santa Maria Nova kept in the Rome State Archives (ASR, Congregazioni religiose soppresse, Olivetani, S. Maria Nova, no. 5), nor in the documents published by O. Montenovesi ("Roma agli inizi del secolo XV e il Monastero di Santa Maria al Foro", extr. from Rivista storica benedettina, 1926), which in any case refer to a period earlier than that with which we are concerned. I was unfortunately unable to gain access to the archives of the Arezzo Fraternita dei Laici, which are currently being put in order.

Appendices

Appendix I

Giovanni di Francesco, Piero della Francesca and the Date of the Arezzo Cycle

for Giovanni Previtali

Pittura di Luce ("Painting made of Light"), an exhibition curated by Luciano Bellosi and his colleagues at the Casa Buonarroti in Florence in May–August 1990, stood out in the increasingly crowded exhibition calendar not only because the paintings on display were of the highest quality, but also because the exhibition was inspired by a genuine problem in art-historical research. It offered, to be frank, a great contrast to the cynical (and rightly condemned) Titian show in Venice. The catalogue, with an introductory essay by Bellosi, was – taken as a whole, and notwithstanding the occasional slips to which I refer below – on the same high level as the exhibition. The closely argued reflections in Bellosi's essay include some comments on the much-debated question of the chronology of Piero della Francesca's Arezzo cycle of frescoes.

Most scholars believe that the cycle was completed before Piero's first visit to Rome (in 1458–59). Several years ago, the present author argued in favour of the view upheld, in different ways, by K. Clark and C. Gilbert, namely that the cycle (with the exception of the two upper lunettes, executed before the Roman visit) was completed following Piero's return to Arezzo: that is to say, at some time during or after 1459 (but not later than 1466). Bellosi has recently developed two new arguments in favour of the former dating, which I shall refer to as early, and these are set out in the introductory essay in the *Pittura di Luce* catalogue. The first of them is based on a discussion of an altarpiece painted in 1456 by Giovanni di Piamonte (an assistant of Piero's at Arezzo), now located in Città di Castello.

Bellosi carries out a series of comparative analyses by which he aims to demonstrate that Giovanni di Piamonte's Madonna Enthroned and Saints

108 APPENDIX I

must post-date the lunettes in the fresco cycle, and that it was probably painted at the same time as Piero was completing the cycle as a whole.² We need not concern ourselves over the probability that Giovanni di Piamonte was entrusted with the task of restoring the Arezzo frescoes in 1486-87 (no more than a hypothesis, but a plausible one), although if this is the case it becomes difficult to estimate precisely his share in the original work.3 For the truth is that Giovanni di Piamonte's evolution as a painter, which Bellosi so brilliantly reconstructs, itself in my view tells against the early dating of Piero's fresco cycle. The Città di Castello Madonna of 1456 certainly reveals the influence of Piero, which may have involved works by the latter which have now been lost; but it does not reveal a close and detailed knowledge of Piero's cartoons. Such a knowledge is, however, evident in the vastly superior mastery of perspective displayed in another, dated work that Bellosi attributes to Giovanni di Piamonte, the 1471 Sant'Anna Metterza now 97 kept in the Staatliche Museen at Berlin. This work unquestionably post-dates not only the Arezzo frescoes but also the Mother and Child by Piero now at the Clark Art Institute in Williamstown (a work whose composition, we note, was assigned by Longhi to the decade 98 1460-70).4

Bellosi admits that the resemblances between di Piamonte's Città di Castello *Madonna* and Piero's fresco cycle become less evident in the lower tiers of the latter, which were the last to be completed. Why, then, does he maintain that Piero finished his cycle around 1456? Here he brings to bear his second argument, which is much more compelling than the first. This is based on the resemblance between Piero's frescoes and the predella by Giovanni di Francesco, depicting the story of St Nicholas, now in the Casa Buonarroti. In particular, the battle-scene that takes up the right-hand part of the predella echoes the representation of the *Defeat* 99, 13 of *Chosroes* in one of the lower sections of the Arezzo cycle.

The resemblance has been recognized for many years. Some scholars (such as Witting and Weisbach) have argued, untenably, that the predella was painted first; others (such as Schmarsow and Antal) have sought to restore the priority to the fresco cycle.⁵ Longhi, convinced that the early dating of the frescoes was correct, invoked the resemblance in support of the view that Giovanni di Francesco's predella was "unlikely to have been painted before 1455".⁶ Bellosi turns this the other way up: Giovanni di Francesco del Cervelliera, also known as Giovanni da Rovezzano, died

APPENDIX I 109

in 1459 (he was buried on 29 September); therefore, argues Bellosi, the Arezzo cycle must already have been completed by that date.⁷ There is indeed no answer to this argument – providing Giovanni di Francesco del Cervelliera, who died in September 1459, was indeed the painter of the predella in the Casa Buonarroti. It is this attribution which I wish to examine here.

Piero Toesca, in an essay published in 1917, was the first to designate a particular individual as the so-called "Master of the Carrand Triptych", a name of convenience that had been used to designate the painter of a group of stylistically homogeneous works.8 The basis of Toesca's argument was as follows. Vasari had stated that il Graffione was the painter of the lunette depicting God the Father with Angels in the door of the 100 Ospedale degli Innocenti at Florence. H.P. Horne, referring to a document discovered by G. Poggi, had attributed this lunette to one "Giovanni di Francesco", and had suggested that the latter was to be identified with Giovanni da Rovezzano, whom Vasari had listed among the pupils of Andrea del Castagno.9 Toesca argued that the lunette was the work of the "Master of the Carrand Triptych", and he suggested that the "Giovanni di Francesco dipintore" (named in the records of the Ospedale degli Innocenti as the recipient of a number of payments in 1458 and 1459) was to be identified with Giovanni di Francesco del Cervelliera - provided that the latter was in fact, as Milanesi had suggested, one and the same as Giovanni da Rovezzano. 10 The grounds 101 for this last point are plain: given the obvious echoes of Andrea del Castagno in the work of the "Master of the Carrand Triptych" (evident, for instance, in the Brozzi crucifix), Giovanni da Rovezzano is obviously 102 the strongest of the various possible candidates named Giovanni. However. Toesca himself was well aware that his proposed identification (in so far as his argument was about named individuals rather than stylistic parallels) could only be tentative. Indeed he ended his essay by noting that other painters known as Giovanni di Francesco were active in Florence during the relevant years: for example, in 1462 a "Giovanni di Francesco" decorated the Chapel of the Annunciation in the Chiesa dei Servi in gold and blue. Toesca comments that "this may have been the same artist who had worked three years earlier in the nearby church of the Innocenti" 11 – a hypothesis incompatible with the attribution of the Innocenti lunette to Cervelliera, since in 1462 the latter had been dead for three years.

Toesca's caution was soon forgotten, and it became generally accepted that Giovanni di Francesco da Rovezzano, alias del Cervelliera, was to be identified as the "Giovanni di Francesco" who painted the Carrand Triptych (for this was undoubtedly the baptismal name of the "Carrand Master"). 12 Things were further complicated by a suggested attribution made in 1974 by B. Fredericksen (one of the many attributions which over the years have enlarged the catalogue of Giovanni di Francesco's works). In a short monograph on the triptych now in the Getty 103 Museum at Malibu, which Longhi had attributed to the so-called "Master of Pratovecchio", Fredericksen took up and endorsed the suggestion formerly made by Berenson that the "Master of Pratovecchio" was to be identified with Giovanni di Francesco. 13 Here we must pay close attention to Fredericksen, especially inasmuch as Bellosi, so lucid as a rule, has (in my view) misread him in a crucial passage. Fredericksen anchors his argument in iconography, specifically in the very unusual fact that the Madonna is flanked, in the left-hand panel of the triptych, by St Bridget, who holds a scroll in each hand. This has led scholars to suppose that the painting comes from a convent of the Sisters of St Bridget, namely the Paradiso convent near Bagno a Ripoli, a supposition confirmed by a document dating from 1439 in which a painter from the neighbourhood, Giovanni da Rovezzano, is contracted to make a painting representing "Our Lady with the baby on her lap, and on one side St Bridget standing upright with the brothers and sisters on their knees at her feet and with two books in her hands, who is giving them their rules and therefore the brothers and sisters are taking the rules from St Bridget; and also Our Lord and Our Lady with angels around them who are speaking to her and on the other side St Michael the archangel who is weighing the souls" (and this is followed by a description of the predella). 14

Now it is beyond dispute that Giovanni da Rovezzano and Giovanni di Francesco del Cervelliera are one and the same, as is clear from land registers and various other documents.¹⁵ The triptych as painted does not depart very significantly from the instructions given in this commission (which are now known to derive from an iconographic tradition favoured by the Bagno a Ripoli convent),¹⁶ and Fredericksen therefore shows no hesitation in attributing the Getty triptych (quite rightly, in my view) to Giovanni da Rovezzano, alias Giovanni di Francesco del Cervelliera. Bellosi writes that because the painting departs from the terms of the commission, Fredericksen "is somewhat tentative in making his case".¹⁷

111

This is incorrect. Fredericksen's doubts concern a quite separate question, namely the identification on stylistic grounds of the "Master of Pratovecchio" with Giovanni di Francesco, an identification already suggested (as we have noted) by Berenson, but which Fredericksen as a connoisseur is reluctant to endorse even though he believes, wrongly, that he has discovered documentary proof of its correctness. His reluctance is in fact completely justified: as Bellosi so clearly explains, the "Master of Pratovecchio" and Giovanni di Francesco are certainly two different painters. So where does this leave us?

APPENDIX I

The knot is very easily untied: 1) the "Master of Pratovecchio" and Giovanni da Rovezzano, alias Giovanni di Francesco del Cervelliera, are one and the same person, as Fredericksen has shown; 2) the "Master of Pratovecchio" and Giovanni di Francesco (that is, the "Master of the Carrand Triptych") are two different people, as Fredericksen suspected and as Bellosi has now stressed; 3) *ergo*, Giovanni di Francesco, the "Master of the Carrand Triptych", has nothing to do with Giovanni da Rovezzano, alias Giovanni di Francesco del Cervelliera. He is another Giovanni di Francesco altogether. 20

Two objections might be brought against this chain of reasoning: a) Vasari states that Giovanni da Rovezzano had studied with Andrea del Castagno, and this fact is very consistent with the character of Giovanni di Francesco's work, but much less consistent with that of the work of the "Master of Pratovecchio". However, Vasari might have confused the two different artists known as Giovanni di Francesco, just as (to instance one of his numerous errors) he attributed to il Graffione the lunette in the Ospedale degli Innocenti; b) Bellosi notes that the date of 1439 given to the Getty triptych is "highly improbable", being too early for a work which so clearly shows the influence of Domenico Veneziano.²¹ However, Fredericksen had already observed that 1439 was the date not of the painting's execution but of the commission.²² We may add that we can presume, with Longhi, that Domenico Veneziano was active in Florence from circa 1435.23 Bellosi alludes implicitly to this view, but is disinclined to accept it,24 and goes on to remark that the Getty triptych seems at the least to show the influence of the Santa Lucia dei Magnoli altarpiece - a 105 remark whose force one may doubt, given that so much of Domenico Veneziano's work has been lost (not least, to limit ourselves to the period in question, the S. Egidio frescoes).

The two objections seem to me to carry little weight in comparison

112 APPENDIX I

with the argument that I have developed here. I believe we can legitimately conclude that we are by no means obliged to set the date of 1459 (in which year Giovanni del Cervelliera died) as the *terminus post quem non* for the completion of the Casa Buonarroti predella, which shows so clearly the influence of Piero's frescoes. The same reasoning applies to the dating of the frescoes themselves. One may or may not be convinced by the argument that they were painted over a long period (we know that Piero worked very slowly), interrupted by the painter's visit to Rome in 1458–59: but that argument cannot be refuted on grounds connected with the date of the death of Giovanni di Francesco, which is unknown.

The argument here involves, as any researcher (including Bellosi) takes for granted, interlocking evidence, in part stylistic, and in part extrastylistic – account books, land registers, and so on. It is a pity that some still seek to set up an opposition between these two kinds of evidence, and that the *Pittura di Luce* catalogue, which otherwise maintains such high scholarly standards, should include a vacuous diatribe along those lines.²⁵ No art historian can easily afford to do without the clarifications derived from such pedestrian documents as registers of births and deaths.²⁶ Let me back up this claim by adducing what we might call a negative instance.

In 1933, reviewing the "Mostra del Tesoro" at Florence, R. Offner attributed an altar-frontal depicting S. Biagio, from the church at Petriolo, 106 to Giovanni di Francesco.²⁷ He pointed out that here we had a unique example of a dated work by the painter (the date being 1453 in the Florentine calendar, or 1454 by our current reckoning), apart from the 100 lunette in the Ospedale degli Innocenti, painted in 1459. Offner based this latter date on the documentary evidence published by Toesca, but he said nothing about Toesca's suggestion that Giovanni di Francesco should be identified with Giovanni del Cervelliera. His silence was not due to some casual oversight. Giovanni di Francesco's works, Offner noted, contained stylistic echoes of Andrea del Castagno and Alesso Baldovinetti. In particular, they could be seen as developing Baldovinetti's style: and since the only dated works by Giovanni di Francesco are from the sixth decade of the Quattrocento, when Baldovinetti was still a young man, it is unlikely that Giovanni can have been much older. The conclusion follows that if the Carrand triptych belongs to the sixth decade of the century, then the now dispersed altarpiece kept partly in Lyon and

APPENDIX I 113

partly in the Contini Bonacossi collection (the so-called "Lyon–Contini altarpiece") must have been painted later, well into the artist's maturity:²⁸ that is (we may add), after the death of Giovanni di Francesco del Cervelliera.

This chronology, diametrically opposed to that suggested by Longhi in 1952,²⁹ matches that put forward by Bellosi. Offner writes of stylistic analogies, the product of a "mysterious sympathy" between Ferrara, Padua and Siena (and, later, Germany); Bellosi regards the Contini Bonacossi *Madonna* as evidence of the transmission of pictorial ideas into the figurative culture of Ferrara.³⁰ The evidence of traffic in the reverse direction, but of similar import, would include the very clearly perceptible connection between one of Cossa's incunabula, the *Pietà with St Francis* now kept in the Musée Jacquemart–André, and the dramatic *Pietà* in the Rucellai Chapel, a fresco painted (as Bellosi recognized) by Giovanni di Piamonte.³¹

108, 109

While this connection implies that Cossa visited Florence early in his career, it does not exclude the possibility that examples of Florentine work were at that time already circulating in Ferrara.³² What becomes ever clearer is that in the development of Italian painting in the mid-Quattrocento, the Apennine passes played a role as crucial as that played by the Adriatic coast between Pesaro and Venice (to which Longhi's work has drawn attention). This is a crucial nodal point. As research on it progresses, scholarship can only gain from the confutation of erroneous views concerning both the identity of Giovanni di Francesco and (above all) the date of his death.

Notes

This Appendix first appeared in *Paragone*, XLII, 499, dated September 1991 (but published in 1993), pp. 23–32, under a slightly different title ("Ancora su Giovanni di Francesco e Piero della Francesca"). The following note by the editors of the journal accompanied the essay: "The Editors of *Paragone* are delighted to welcome Carlo Ginzburg to these pages. Ginzburg's interdisciplinary researches, conducted over a period of years, are of great interest, and often concern matters which were in the past considered to be the exclusive preserve of art historians. Indeed, the present essay is devoted to quintessentially art-historical topics: the identification of Giovanni di Francesco del Cervelliera with the Master of the Carrand Triptych, and the chronological issues to which this gives rise. Although we cannot endorse the conclusions arrived at here, we believe that the publication of the article may pro-

voke further valuable discussion and assist in the search for a solution to this long-debated problem."

- 1. See ch. II above.
- See L. Bellosi, "Giovanni di Piamonte e gli affreschi di Piero ad Arezzo", Prospettiva, 50 (July 1997), pp. 15–35.
- 3. See G. Centauro, *Dipinti murali di Piero della Francesca*, Milan 1990, p. 37. Centauro attributes to Giovanni di Piamonte a recently discovered graffito: *A di 22 di lugl[i]o Giani* Pimt* in manj[bus] 1487/1486*, and he relates it to the restoration of the church which was agreed on in 1485–86 (ibid. p. 113). (Salvatore Settis brought this passage to my notice.)
- See R. Longhi, Piero della Francesca, Florence 1963 (vol. 3 of Longhi's Opere Complete), pp. 222–3.
- 5. F. Witting, Piero dei Franceschi. Eine kunsthistorische Studie, Strasbourg 1898, pp. 158–62; W. Weisbach, "Der Meister der Carrandschen Triptychons", in Jahrbuch der königlich preussischen Kunstsammlungen, 22 (1901), pp. 35–55, esp. p. 52 (where the predella is attributed to Giuliano Pesello, who died in 1446); A. Schmarsow, in Kunsthistorische Gesellschaft für photographische Publikationen, 6 (1900), pp. 6–7, who notes that the Casa Buonarroti predella cannot be attributed to Pesellino (who died in 1457) if it is held to derive from Piero's Arezzo frescoes; F. Antal, "Studien zur Gotik im Quattrocento. Einige italienische Bilder des Kaiser-Friedrich Museums", in Jahrbuch der preussischen Kunstsammlungen, 46 (1925), pp. 3–32, esp. p. 17.
- 6. R. Longhi, "Ricerche su Giovanni di Francesco" (1928), in "Me pinxit" e quesiti caravaggeschi, Florence 1968 (vol. 4 of Longhi's Opere Complete).
- 7. L. Bellosi, Pittura di Luce. Giovanni di Francesco e l'arte fiorentina di metà Quattrocento, Milan 1990, p. 42.
- 8. P. Toesca, "Il 'pittore del trittico Carrand'. Giovanni di Francesco", in Rassegna d'Arte, 17 (1917), pp. 1–4.
- 9. See H.P. Horne, "Il Graffione", in *Burlington Magazine*, VIII (1905), pp. 189–96. On il Graffione, see Vasari, *Le vite*, ed. G. Milanesi, vol. 2, Florence, 1906, p. 598; and on Giovanni da Rovezzano, ibid., p. 682. (For further bibliographical information on this edn, see n. 34 to ch. II, above.)
 - 10. Ibid., vol. 2, p. 682, n. 2.
- 11. Toesca, "Il 'pittore del trittico Carrand'", p. 4. In n. 2 on p. 3, Toesca corrects an oversight of Milanesi, who in his edition of Vasari (vol. 2, p. 444, n. 5) had attributed the decoration of the Chapel of the Annunciation to Giovanni di Francesco da Rovezzano. The relevant entry in the Libro di Fabbrica della cappella della Nunziata speaks only of "Giovanni di Francesco dipintore". Cf. P. Tonini, Il santuario della Santissima Annunziata di Firenze, guida storico-illustrativa compilata da un religioso dei Servi di Maria, published anonymously, Florence 1876, pp. 87–9, 295–6.
- 12. Since it is of no direct consequence for my present argument, I say nothing here about the controversy as to whether this is also the Giovanni di Francesco who brought a highly contentious lawsuit against Filippo Lippi, of whom he was a pupil. It seems unlikely that the question can be resolved on the basis of the existing documentary evidence: see Bellosi, *Pittura*, p. 17, n. 7.
 - 13. B.B. Fredericksen, Giovanni di Francesco and the Master of Pratovecchio, Malibu 1974.
 - 14. Ibid., p. 11.
- 15. Ibid., pp. 13f. Fredericksen here develops (and in a few places corrects) the fundamental research carried out by M. Levi d'Ancona (*Miniatura e miniatori a Firenze del XIV al XVI secolo*, Florence 1962, pp. 144–7). Fredericksen writes "they are almost certainly the same person" (*Giovanni di Francesco*, p. 12): I see no justification for the reservation expressed here.

- 16. See G. Bacarelli, "Le commissioni artistiche attraverso i documenti: novità per il maestro del 1399 ovvero Giovanni di Tano Fei per Giovanni Antonio Sogliani", in *Il "Paradiso" in Pian di Ripoli*, ed. M. Gregori and G. Rocchi, Florence 1985, pp. 96–103. Bacarelli here discusses the altarpiece on a similar subject painted in 1399, by an artist whom Boskovits identifies as Giovanni di Tano di Fei.
- 17. Bellosi, *Pittura*, p. 31. Earlier (p. 28), Bellosi writes: "Thus Fredericksen is inclined to conclude that the painting in the Getty Museum comes from the Paradiso convent and is the work of Giovanni di Francesco, another of those sometimes known as Giovanni da Rovezzano." In terms of his own view (which, it will be seen, I cannot share), Bellosi should here rather have written "Giovanni di Francesco, sometimes also known as Giovanni da Rovezzano".
- 18. See Fredericksen, *Giovanni di Francesco*, pp. 13, 21, and esp. 24. Here, apropos of a painting by Digione which depicts *St James, St Anthony and a Donor* (and which Longhi attributes to Giovanni di Francesco), he writes that were this work not related to the Lyon–Contini triptych, it "might have been seen as a transitional piece" between the Master of Pratovecchio and Giovanni di Francesco. (K. Christiansen has since tentatively suggested that Berenson's identification should be re-examined: see *Burlington Magazine*, CXXXII [October 1990], pp. 738f.)
- 19. A conclusion already arrived at by G. Bacarelli ("Le commissioni", p. 100), and from which he drew the erroneous further conclusion that Giovanni del Cervelliera was therefore not in question.
 - 20. At this point, Longhi would no doubt have invoked the "genius of homonyms."
 - 21. Bellosi, Pittura, p. 31.
 - 22. Ibid., p. 12.
- 23. See R. Longhi, "Il 'Maestro di Pratovecchio'", in "Fatti di Masolino e di Masaccio" e altri studi sul Quattrocento, Florence 1975 (vol. 8, 1 of Longhi's Opere Complete), pp. 99ff., esp. pp. 104–5.
- 24. Pittura, p. 31: "if indeed we can suppose that he [i.e. Domenico Veneziano] may have been active in Florence some time earlier".
- 25. See G. Agosti, "Ai ragionati margini di un esposizione", in *Pittura*, pp. 191–7, esp. p. 197.
 - 26. Even "stylistic personalities" die (I owe this remark to L. C.).
- 27. R. Offner, "The Mostra del Tesoro di Firenze", in *Burlington Magazine*, LXIII (October 1933), p. 177.
- 28. Offner, "Mostra", p. 177: "If, as I believe, the Carrand triptych also belongs to this [sixth] decade, the Lyon–Contini altarpiece should have been painted later in a period of advanced maturity."
 - 29. Longhi, "Il 'Maestro di Pratovecchio'", p. 115.
 - 30. Bellosi, Pittura, p. 45.
- 31. See, respectively, R. Longhi, Officina ferrarese, Florence 1968 (vol. 5 of Longhi's Opere Complete), pp. 29, 38, and fig. 83; L. Bellosi, "Giovanni di Piamonte", p. 16 and fig. 4. Apropos of the Pietà in the Museé Jacquemart-André, C. Volpe compared the work's representation of "solemn, unadorned, motionless mass" to what we find in Piero della Francesca ("La grande officina ferrarese", in Tuttitalia. Emilia-Romagna, II, Florence 1961, p. 479; quoted in D. Benati, "La pittura rinascimentale", in La basilica di San Petronio, II, Milan 1984, p. 158). The Jacquemart-André painting is in very poor condition (especially the left-hand portion), and needs restoring. It is not on public display. I must thank Mme Huyghe, then Director of the Museum, for allowing me to see it in the spring of 1990.
 - 32. D. Benati (in "La pittura rinascimentale") insists on this point.

Appendix II

The Flagellation: Conjectures and Refutations

I

During the last forty years, the most divergent interpretations have been offered of the iconography of Piero's famous *Flagellation*, displayed in the Galleria Nazionale delle Marche in Urbino. Scholarly disagreement in the field of iconology is by no means unusual. However, in the present case differences of opinion have been so marked as seemingly to confirm the view that when it comes to the interpretation of texts and images, anything goes.¹

I have no sympathy whatever for such scepticism, fashionable though it has nowadays become. The case I shall make against it here draws on my own research into Piero's *Flagellation* in order to test the scope of evidential proof in the realm of iconographical studies. At the end of this methodological exercise, I will outline the conclusions I have reached: somewhat self-destructive conclusions, as will appear. Nevertheless, failure can be just as instructive as success – if not more so.

I shall begin with a brief summary of the interpretation of the *Flagellation* put forward in 1981, in the present book. Like many earlier scholars, I was convinced that the distance separating the three figures in the foreground from the events taking place in the background made it impossible to see this as a more or less "normal" representation of Christ's flagellation. Following a suggestion of Kenneth Clark, I argued that the figure of Christ being scourged beneath the eyes of the turbaned figure seen from the back must be read as implying an allusion to contemporary political events, namely to the suffering of the Christian community in Greece at the hands of Turkish invaders. I made use of Thalia Gouma-Peterson's observation that Pilate's crimson stockings and pointed cap were to be seen as referring quite specifically to an Emperor of Byzantium. These elements were incompatible with the older interpretation according to which the picture commemorated Oddantonio da Montefeltro, killed in a plot in 1444, and they suggested a rather later date for

117 APPENDIX II

its composition (1450-60) than had been formerly accepted. Clark had argued for this later date on the grounds that the architecture painted by Piero showed echoes of Leon Battista Alberti's work in Santo Sepolcro Rucellai. I argued that a more precise date could be arrived at if elements in the scene of Christ's flagellation were identified as certain antique fragments and relics from the Holy Land to be found in and around the Lateran Palace in the mid-fifteenth century. In addition to the Scala Santa (already recognized by Marilyn Lavin), I argued that one can recognize doors and columns traditionally supposed to have been brought from Pilate's palace; a column held to match exactly the height of Christ (the so-called mensura Christi); and fragments of the huge bronze statue kept today in the Palazzo dei Conservatori. I decided that these references to Roman relics were so precise that they implied a terminus ante quem non, a date earlier than which the painting could not have been completed: namely, 1458-59, when we know from documentary evidence that Piero visited Rome. Moreover, the possibility that the sacred drama unfolding in the background contained references to contemporary events prompted the thought that the profane scene in the foreground might be interpreted similarly. I proposed that the bearded man, represented as in the act of speaking (he is gesturing with his hands and his mouth is half-open), was talking about Christ's flagellation; and that the distance separating the two scenes was at once chronological and ontological. The words "Convenerunt in unum", taken from the second Psalm, were formerly legible on the picture (probably on its frame), and the phrase forms part of the liturgy for Good Friday. I concluded that in his picture of the flagellation, Piero was illustrating in the background the theme on which the bearded man in the foreground was preaching. By way of a series of physiognomical comparisons, I was led to the view that this bearded figure is a slightly idealized portrait of Cardinal Bessarion (Gouma-Peterson, on the basis of less comprehensive comparisons, having written more cautiously that the figure was no more than a "crypto-portrait"). The man on the right in 89 the brocade cloak, listening attentively, is presumably to be identified (I suggested) as the person who had commissioned the painting. Kenneth Clark, among others, had already pointed out that this same person had already twice been painted by Piero, once at Arezzo, in the fresco which shows Chosroes surrounded by members of the Bacci family, and again in the altarpiece of the Madonna of the Misericordia, where he is among those kneeling at Our Lady's feet. In this last case, the slope of the out- 47, 44

line of the cranium is identical with the corresponding feature of the figure in the brocade cloak. This man, I argued, was Giovanni Bacci, heir to the family of Arezzo merchants for whom Piero executed the fresco-45, 46 cycle of the True Cross in the Church of San Francesco. I hypothesized that he had commissioned this representation of himself at the apex of his brief career in the Papal court, in his role as nuncio extraordinary sent from Rome to Constantinople to inform Bessarion that he had been appointed in his absence as a Cardinal of the Holy Roman Church. It is certain that such a nuncio was sent to Constantinople at this time, and it seemed to me plausible that the person in question may have been Giovanni Bacci, since he is referred to in the single, brief biographical note we possess about him, which dates from the seventeenth century, as "nuncio to Caesar" - that is, to the Emperor. Several elements converged to lead me to the view that the scene represented by Piero could be located precisely in time and place: that it had taken place on Good Friday 1440 (which fell that year on 25 March), in Constantinople. Bessarion would be shown, then, in the act of accepting his nomination as a Cardinal, and thus of taking leave of Constantinople for Rome, while he justified his departure (so my interpretation ran) in a speech comparing the Emperor, John VIII Palaeologus, to Pilate, because of his failure to act against the threat from the Turks. Moreover, the speech thus silently depicted in Piero's painting would have both a commemorative meaning to its patron, Giovanni Bacci, and a contemporary meaning to the man for whom we may presume it was intended, Federico da Montefeltro, who in 1459 was being approached by Bessarion and Pope Pius II Piccolomini to lend his support to their projects for a crusade against the Turks. This attempt at persuasion would also explain the presence of the barefoot young man wrapped in a tunic, with his eyes fixed on a point outside the painting: this must be Buonconte da Montefeltro, Federico's natural son, who had been loved and admired for his precocious gifts by Bessarion, and who had died of the plague in 1458.

H

Virtually no one accepted my interpretation.² This surprised me not in the least. I had known very well that my work was bound to be seen as a provocation in its claim to trace in Piero's painting, without the support of explicit external evidence, such a dense (and minutely reconstructed)

network of religious, political and personal allusions. Was such an iconographical anomaly, such a hapax as I claimed to have discovered, historically possible?³ – and allowing that it might be, was it really feasible to decode it? Robert Black, commenting on my book in the Oxford Art Journal (1986), spoke of the "use and abuse of iconology", thus turning the tables on me, since some years earlier I had expressed my own criticisms of Panofsky's researches into Titian in similar terms. However, if the charge against me is that I constructed an argument based solely on a series of unproven hypotheses, then I must plead not guilty. The 1:10 ratio between the height of Piero's Christ and the mensura Christi in the Lateran is in my view an unanswerable piece of evidence, which clinches my exposition of the Roman allusions to be found in the scene in the background - and also goes to disprove, conclusively in my view, the once common attribution of the Flagellation to an early phase of the artist's career. On the other hand, as I explicitly acknowledged, the identification 68, 69 of the barefoot young man as Buonconte is purely conjectural: the conjecture being made plausible (but not certain) by the identification of the bearded man as Bessarion. This latter identification was, I stated, highly probable, though it could only be argued for on the intrinsically limited basis of physiognomical likeness; but I noted two factors that counted against it, namely the figure's youthfulness and the absence of any of the insignia of a Cardinal. These were obstacles to my argument in the first Italian edition of this book, in which, against all the evidence, I tried to insist that the date of the painting's likely composition (circa 1459) was also the date of the scene which it depicted. I was able to put right this mistake thanks to a question posed by Salvatore Settis in his review of the book: was not this a portrait, asked Settis, of Bessarion before his elevation to the position of Cardinal? It was only then that I was able to modify my interpretation (as reflected in the English text of 1985, reprinted in the present volume), and to identify the scene in the foreground as representing the moment when Bessarion received the news of his nomination in absentia as a Cardinal. I saw the red scarf hanging from Bacci's right shoulder down to his calf, unobtrusive, but clearly visible, as material evidence of the news that Bacci was bearing.

Ш

To the best of my knowledge, no scholarly commentator on the *Flagellation* had paid any attention to this red scarf. Eugenio Battisti was the only one to have *seen* it, interpreting it (in a reading quite unlike my own) as a symbol of political power.⁴ The discovery of this detail led me to modify on a fundamental point the argument I had advanced in the first Italian edition of my book. Here at last, it seemed, was the clue which allowed me to grasp the meaning of the scene in the foreground, which I now backdated by twenty years (from circa 1460 to 1440). Even the phrase "nuncio to Caesar", applied to Giovanni Bacci in a surviving document, fell unexpectedly into place as a piece in the interpretative jigsaw.

I have always thought that an inclination towards audacious hypotheses is and should be perfectly consistent with rigorous research into evidence. In the material added to the third Italian edition of this book, I wrote that not even the red scarf or sash thrown over Bacci's shoulders amounted to conclusive proof: only a document attesting that Giovanni Bacci had travelled to Constantinople in 1440, as papal nuncio, would suffice to remove the last remaining doubts about my interpretation. I have found no such document, but I thought that I had found something better.

One of the very few works bearing Piero's signature is the picture of

St Jerome with a Disciple, now in the Accademia in Venice. It was not
Piero, however, who wrote the inscription in capitals (contemporary with
the painting itself) which appears beneath the figure of the disciple:
HIER. AMADI AUG. F. Until we have proof to the contrary (and
despite the baseless objections raised by Battisti),⁵ we must take this
person, Girolamo Amadi the son of Agostino, to be the work's patron. St
Jerome – in Italian, Girolamo – is looking rather fiercely at his namesake,
who is shown kneeling in profile, rather as in the much larger-scale
Rimini fresco (depicting a far higher social milieu), which was probably
executed about ten years before the painting in the Accademia, Sigismondo Malatesta kneels in profile before his patron saint.⁶

There are plainly no grounds for the doubts that have sometimes been expressed about the identity of the saint in the Accademia painting. The work combines elements from two iconographic traditions developed in Italian art during the Quattrocento, *St Jerome in the Desert* and *St Jerome*

Reading in his Study.⁷ Those who have questioned the figure's identity have based their argument on the fact that (as has often been remarked)⁸ there is no depiction here of the insignia pertaining to a Cardinal generally found in paintings of St Jerome from the Trecento onwards. Foremost among these is the red Cardinal's hat which appears in the foreground of the St Jerome by Piero now hanging in the Staatliche Museen in Berlin.

There is no trace of any Cardinal's hat in the picture in the Accademia. It has not been remarked, however, that a red sash or scarf is depicted. Here too it is shown as a red stripe, thrown over the right shoulder of the kneeling figure, disappearing as it falls, appearing again like some subtle thread twisted close to the waist, once more vanishing, and then finally re-emerging to gather on the ground beside the disciple's knees.

Battisti was in fact very well placed to see, if not to understand, the red stripe, but it escaped him by a hair's breadth. Commenting on the material condition of the work, he remarks:

In my view it is evident that the alteration in the colours is due above all to the action of the solvent, since not just the browns, but also the red of the patron's clothes have been transformed. Here, moreover, in the mantle, we can make out two retouched areas – one high up on the back, another lower down, just beneath the sleeve – in which the colour is brighter, as it is in the slippers [an allusion altogether mysterious to me – C. G.], probably because it was applied with a drier brush. I would hold that this colour approximates most closely to the original red.⁹

S. Moschini Marconi's entry in the Accademia catalogue, which takes account of the observations made by Mauro Pelliccioli on the occasion of the painting's cleaning in 1948, tells a different story:

The recent restoration has improved the clarity of the painting, by means of a light general cleaning. It has also removed the traces of former retouchings to the earth, the soil, the bench, and especially the face of the disciple, leaving us able to see the exact extent of the blank spaces which were left as background: and in some places features such as the scarf on the disciple's back, damaged by the working through of the underlying green, have been restored.¹⁰

It is Battisti himself, in another part of his lengthy monograph on Piero, who quotes this passage. He fails to realize that the "retouchings" which he finds in the mantle correspond exactly to the "scarf" mentioned in what he rightly praises as the "extremely accurate" note in the Accademia catalogue.

In this "scarf" I recognized the sash of a Cardinal. It seemed to me that the picture in the Accademia was absolutely certain confirmation of the hypothesis that I had formulated without any reference to it: the bearded man in the *Flagellation* was Bessarion, and he was being presented with the insignia of a Cardinal. While some uncertainty was involved in the physiognomical identification of Bessarion, the iconographical grounds for the identification of St Jerome were completely certain. What I had thought of as a *hapax*, a unique expedient, namely the red Cardinal's sash draped around the shoulders of a man who was not a Cardinal, now seemed a device, at once formal and narrative, that was part of Piero's habitual practice as a painter.

This anomalous feature in the St Jerome with a Disciple could be explained in two different but (in my view) complementary ways. From one point of view, to depict Jerome without the insignia of a Cardinal, as Piero had done (even if only partially and tentatively), was to go some way towards a philologically and historically more faithful narrative of the saint's life. In the course of the Middle Ages, Jerome had been made first into a priest, then into a Cardinal of the Holy Roman Church, and finally, in the account of his life written in the middle of the twelfth century by Nicola Maniacutia or Maniacoria, into a Cardinal with the title of St Anastasia. In the early 1300s, in his little work Hieronymianus, Giovanni d'Andrea, a doctor of canon law from Bologna, identified the Cardinal's hat (together with the lion) as chief among the insignia of the saint whose veneration he was seeking to promote. D'Andrea, when he had the façade of the house he lived in at Bologna decorated with a series of frescoes (now lost), included among the chief scenes of St Jerome's life his consecration as a Cardinal.¹¹ This legend lasted until the advent of Erasmus. In the famous life of Jerome which he prefixed to the edition of the saint's works published by Froben in Basel in 1516. Erasmus roundly declared that St Jerome had never been a Cardinal, and moreover that there was no way he could have been one, since in his days neither the title nor the office had existed. 12 Critical remarks about the hagiographical tradition began to be heard, however, during the fifteenth century, in humanist circles and among those affected by humanist learning. In his extremely useful book Saint Jerome in the Renaissance, Eugene Rice junior

(who does not, however, refer to Piero's painting of the saint) notes that St Antonino, Bishop of Florence, referred in his Chronicon to an anecdote which had entered the legendary tradition some time earlier, telling how women's clothes had been concealed in Jerome's bed for a joke and to expose him to public ridicule. "Sed hoc non est multum autenticum," comments Antonino. Erasmus was to write of the same episode: "mihi non fit verisimile". 13 St Antonino expresses the same scepticism about one of the miracles mentioned in Jacopo da Varazze's Golden Legend. 14 St Antonino's Chronicon dates from 1458, almost the same year as the presumed date of Piero's St Jerome with a Disciple. Some ten years earlier, Agostino Dati, a humanist from Siena, had given a profuse oration on the occasion of St Jerome's festal day (30 October) without making any mention of his nomination as a Cardinal. 15 Others were more forthright. Andrea Barbazza, the celebrated professor of canon law at the University of Bologna, offers a lengthy evaluation of the factors for and against the veracity of the tradition which made St Jerome a Cardinal, and concludes that there is no truth in it. Barbazza's work, written in 1450 or very soon after, was dedicated to the papal legate who had recently arrived in Bologna - Cardinal Bessarion. 16

Piero, I guess, must have become aware of the doubts that were being expressed about the historical accuracy of the story that Jerome was made a Cardinal (doubts that, according to Barbazza, could be traced back over two centuries to Uguccione of Pisa, a well-known lexicographer and doctor of canon law). Perhaps they prompted him to slightly decardinalize the saint. How, though, would the painting's patron, Girolamo Amadi, have reacted to such a move? Unfortunately, we know nothing of Amadi but his name. However, some light may be thrown on our investigations if we consider the history of his family, surprisingly neglected by scholars.¹⁷ In the mid-1600s, the book-lover and antiquarian Francesco Amadi owned a most splendid collection of paintings, including works by "Giovanni Bellini, Titian, Giorgione, il Pordenone, Raphael of Urbino, Michelangelo, and other famous painters; as well as many medals in gold, in silver and in metal, statues and jewels, marbles and urns, and other ancient objects, about which he had much special knowledge, so that he was esteemed the first antiquarian in Venice and it was him to whom all the amateurs would turn and whose judgement they would follow".

The passage just quoted is from Cicogna's *Iscrizioni Veneziane*, which in its turn draws on a manuscript, once in the possession of the Gradenigo

family and now kept in the Biblioteca Marciana, entitled Cronaca di famiglie cittadine originarie venete. This contains a variety of information about the Amadi family, probably gleaned from records kept by the Francesco Amadi referred to in the quotation and updated by his son Agostino. 18 From this family of "Counts Palatine" have sprung, so the Cronaca informs us, "a great number of men distinguished and excellent alike in war and in letters, and also famous men of the church, and others too whose great wealth has won them renown in their native country as great and estimable citizens. Among them may be reckoned three cardinals of the Holy Church, seven bishops, three abbots, twelve doctors and theologians, and several canons, knights and counts of dominion and Palatine dignity." These three Cardinals, heading the list, are named in the manuscript. The first is Rainaldo, who was "bishop-elect of Faenza in the year 947 in succession to his uncle Rainaldo Intelminelli, and he was legate to the Apostolic See under the emperor Lothar, and at last he was made cardinal with the title of St. Aquila and Prisca by Pope Boniface VII, in the year 975". Then comes "Giovanni, of great renown as a doctor of laws" who "in the last years of his life was elected bishop of Venice in succession to Paulo Fosca in the year 1379 while he was with the Emperor, and who not much later was elected cardinal of the Holy Church, with the title of [blank in ms.], by Urban VI, as witness both Platina and other authors, and also Pietro Giustiniano in his book Dell'Historie Venete". Finally there is Daniele, a "most dear friend" of Pope Benedict XII, who made him "priest-cardinal of Santa Sabina together with Angelo Guidiccioni also of Venice, and eight others of divers nations, all of them confirmed in the dignity of cardinals after the death of Benedict. This cardinal died in Avignon in the year 1402 . . . ". 19

As Cicogna convincingly demonstrated, these three Cardinals – Rainaldo, Giovanni and Daniele Amadi – never existed. They were invented as part of a calculated strategy of social advancement. The *Cronaca* which we have been citing represents the Amadi as Counts Palatine, of historic Bavarian extraction, who had come to Italy with Charlemagne, but in reality they were cloth merchants from Lucca. In 1570 Agostino, the son of Francesco Amadi, sought to be recognized as a citizen of Venice. But the family had higher aspirations: as the *Cronaca* puts it,

Had they been content to remain here in Venice, from the year 1297 they would have been members of the body of the Council of nobles:

125

115

but they traded into France and England, and were absent when the council at Venice closed its ranks, and if Marco and Nicolò had not died they would have entered the council without a doubt, and the privilege of the nobility of Venice would have fallen to them [that is, to the family]. And yet without it they were always well reputed, and always married noble women and so gave their daughters to noblemen, and they have always been rich, they have had in their house cardinals, and bishops of Venice and of other places, and other prelates, and huge amounts of merchandise; they have had ventures in infinite numbers of ships, and a very great quantity of property and possessions.²³

The boast that they "have had in their house cardinals" was thus central to the Amadi family myth. If, as is possible, this myth was already developing by the mid-fifteenth century, Girolamo Amadi might well have looked favourably on the idea (which can only have come from the artist himself) that Piero should depict him in the act of conferring a Cardinal's sash on St Jerome.

The iconographic anomaly of St Jerome with a Disciple would thus derive from three connected and converging factors: the social aspirations of a family of merchants; humanistic criticism of a medieval hagiographical legend; and a formal and narrative invention especially favoured by Piero. It is this last element, of course, which is unique. The invention to which I refer can be seen already in the Baptism of Christ now in the National Gallery in London. Michael Baxandall acutely observes that here the pink 2, 3 scarf that hangs over the shoulder of the right-hand angel alludes to Christ's vestments.²⁴ The colour, a very clear pale pink, is the same as that of the robe of the risen Christ in San Sepolcro.

What had long seemed to me a complete anomaly, a hapax, is in fact a series comprising three elements. The same motif is repeated, with variations, from Piero's Baptism, through his St Jerome with a Disciple, to the Flagellation.²⁵ In all three cases, a detail – a piece of clothing, a Cardinal's sash - is transferred to a secondary character although it connotes the principal figure. Piero thus conceals this detail, to the point where it is almost invisible (and indeed most interpreters fail to see it).26 The thin red stripe thrown over Giovanni Bacci's shoulders in the Flagellation seemed to me to be the hidden pivot of the story at once public and private, sacred and profane, that the picture told.

IV

For some time I thought that the red sash proved incontrovertibly the correctness of the interpretation of the *Flagellation* which I had put forward more than ten years earlier. Then I stumbled suddenly across an unexpected obstacle. I was checking over a passage in an article about the humanist Giovanni Tortelli, a friend of the Giovanni Bacci whom I had identified as one of Piero's patrons. I had read the article several times, but had never paid any attention to a detail which now leapt out of the page as I looked at a rather poor black-and-white reproduction of the initial capital in the manuscript of Tortelli's *De Orthographia* (ms. Urbinate latino 303). The author of the article noted that the letter contains a portrait of Tortelli, depicted wearing a red scarf over his right shoulder.²⁷

I realized at once that this detail undid the argument I had based on the Cardinal's sash. The red stripe I had identified in the Accademia St Jerome and in the Flagellation was clearly a scarf or sash without any specifically ecclesiastical meaning. When I turned for assistance to Luciano Bellosi, he identified the garment as a becchetto – a long scarf, with its ends hanging loose from a kind of turban, much worn in Italy in the Quattrocento.²⁸ He informed me that a man with a red becchetto on his right shoulder is depicted in profile in the right-hand portion of one of the Barberini tablets, painted by an artist now identified as Fra Carnevale, an associate of Piero.

My attempt had failed: I had been unable to prove that Giovanni Bacci was the individual who went to Constantinople to inform Bessarion of his nomination as a Cardinal of the Holy Roman Church. Plainly this failure does not invalidate the whole of my argument about the *Flagellation*. My claims concerning the picture's date, the possibility that Giovanni Bacci was its patron, the possibility that Bessarion had inspired it, and so on: mistaken or not, these are altogether independent of the Cardinal's sash which I had mistakenly thought I recognized in Piero's painting. I could draw some consolation from the fact that this series of erroneous conjectures had allowed me to make some new discoveries about the Amadi family, patrons of Piero's *St Jerome* at Venice, and about Piero's practice as a painter. But I was serious when I said that the present account was the tale of a failure. I would much rather have told you about a success.

Conjectures and refutations both play their part in research. I hope you will agree that it has been worth spending some time on them here.

Notes

This Appendix is the largely unaltered text of a lecture which I gave in the autumn of 1993 at the Städelsche Museum in Frankfurt. Earlier versions, drawing on earlier phases of my research, had been given at the Palazzo Comunale at Sansepolcro (in September 1992, at the close of the international conference on Piero della Francesca) and at the Italian Cultural Institute in London, in January 1993. I must express warm thanks to those who invited me to speak: respectively, Margret Stuffmann, Marisa Dalai and Francesco Villari.

- 1. See D. Carrier, "Piero della Francesca and his Interpreters: is there Progress in Art History?", in *History and Theory*, XXVI (1987), pp. 450-65.
- 2. J. Pope-Hennessy, referring to the first Italian edition of this book, spoke of "a mythomaniacal study, filled with imaginary history" (Pope-Hennessy, *The Piero della Francesca Trail*, London 1991, p. 10).
- 3. See F. Lollini, "Ancora la 'Flagellazione': addenda di bibliografia e di metodo", in *Bollettino d'arte*, 67 (May–June 1991), pp. 149f.
- 4. E. Battisti, *Piero della Francesca*, Milan 1971, I, p. 325. Battisti identifies the figure as either Filippo Maria Visconti or Francesco Sforza. In his *Piero della Francesca*, Milan 1992, R. Lightbown again argues unconvincingly for this second identification: see pp. 67–9.
 - 5. Battisti, Piero, I, pp. 522-3, n. 517.
- 6. It is worth noting that Battisti (ibid.), even though he rejects the view that Girolamo Adami was the donor, dates the painting on the basis of a document concerning an ambassadorial mission to Tuscany carried out in 1475 by Girolamo's brother Francesco.
- 7. See E.F. Rice jr., Saint Jerome in the Renaissance, Baltimore 1985, pp. 75ff. A different combination is effected in a picture of St Jerome doing penance in his study, by a member of Joos van Cleve's circle, now in the Princeton Art Gallery, which is reproduced as fig. 44 in Rice's book. On the theme as a whole it is still worth consulting A. Pöllmann, "Von der Entwicklung des Hieronymus-Typus in der älteren Kunst", in Benediktinische Monatsschrift, 2 (1920), pp. 438–522. D. Russo, Saint Jerôme en Italie. Etude d'iconographie et de spiritualité XIIème-XVIIème siècle, Paris and Rome 1987, has many flaws.
- 8. See the note by M.C. Castelli in P. Dal Poggetto (ed.), Piero e Urbino, Piero e le corti rinascimentali, Padua 1992, pp. 110ff.
 - 9. Battisti, Piero, I, p. 523.
 - 10. Quoted in ibid., II, p. 60.
 - 11. See Rice, Saint Jerome, pp. 64f.
 - 12. Ibid., pp. 116 ff., esp. p. 131.
- 13. See A. Morisi Guerra's critical edition of Erasmus's *Life of St Jerome* (Erasmo da Rotterdam, *Vita di san Girolamo*, L'Aquila 1988), p. 58.
 - 14. Rice, St Jerome, pp. 64f.
- 15. A. Dati, *Opera*, Siena 1503, pp. lviv–lviiir ("Oratio prima de laudibus divi Hieronymi"). Rice quotes this in his *St Jerome*, pp. 95ff., dating it before February 1447, and lists other orations given on similar occasions at around this same time.

- 16. See A. Barbazza, "De praestantia cardinalium", in *Tractatus illustrium in utraque tum* pontificii, tum Caesarei iuris facultate iurisconsultorum, vol. XIII, part 2, Venice 1584, cc. 63*r*–85*r*. The entry in the *Dizionario biografico degli Italiani* gives the date of the first printed edition as 1487.
- 17. The "full account of research into the Venetian archives relevant to Amadi" carried out by Battisti, to which C. Bertelli refers in his *Piero della Francesca* (Milan 1991, p. 182), is in fact rather a disappointment. Battisti, led astray by his determination to identify a patron in San Sepolcro for the *St Jerome* (*Piero*, vol. II, pp. 60f.), almost completely ignores the information about the Amadi family, beginning with Francesco Amadi and his collections, that is provided in E.A. Cicogna, *Delle iscrizioni veneziane*, VI, 1, Venice 1853, pp. 576–85.
- 18. Cicogna, *Iscrizioni*, VI, p. 581. See 7r–17v in the *Cronaca di famiglie cittadine originarie* venete (Marc. It., VII, 27 [= 7761]), a seventeenth-century paper codex, for the account of the Amadi family. This is in all likelihood based on a 154-page paper codex formerly owned by the Gradenigo family, containing "a book of memoirs left by Francesco Amadi Viniziano, concerning his family" (G. degli Agostini, *Notizie istorico-critiche intorno la vita*, e le opere degli scrittori viniziani, II, Venice 1754, p. 486); cf. Museo Correr, MS Gradenigo Dolfin, no. 56, "Memorie lasciate da Francesco Amadi della sua famiglia", which Lightbown cites in his *Piero*, p. 286, n. 22.
- 19. Cronaca di famiglie cittadine originarie venete (cited in previous note: henceforth: Cronaca di famiglie) 8r-v, 11r-v, 12r.
 - 20. Cicogna, Delle iscrizioni, VI, 1, pp. 577, 585f.
- 21. See T. Bini, *I Lucchesi a Venezia. Alcuni studi sopra i secoli XIII e XIV*, 2 vols, Lucca 1853, 1856. See esp. vol. II, pp. 291f., 335 (in 1568 or 1569, one Agostino Amadi was rector of the Scuola dei Lucchesi at Venice). On p. 332 an extensive treatment of the Amadi family is promised for the third volume of the work, which I do not believe ever appeared.
 - 22. Archivio di Stato di Venezia, Avogaria di Comun, Cittadinanze originarie, b. 365.
 - 23. Cronaca di famiglie, 9v-10r.
- 24. See M. Baxandall, *Patterns of Intention*, New Haven 1985, p. 129. C. Bertelli reaches the same conclusion in his *Piero*, p. 59 (where there is no reference to Baxandall).
- 25. M. Bussagli well says that "the people who inhabit Piero's world may be likened to intellectual 'lines' integrated into the painter's 'stanzas'" (see the supplement, "Piero della Francesca", in *Arte e dossier*, September 1992, pp. 17f.).
- 26. Although he offers no interpretation of Piero's picture, Bellosi has commented that "a thread seems to unite the enigma of the Urbino Flagellation with the 'hidden subject' (to use Settis' term) of Giorgione's Tempest", and he remarks that here, confirming the connection "on which Longhi always placed such emphasis", we have "another link between the painter from San Sepolcro and the pictorial world of Venice" (Bellosi, in Una scuola per Piero, Venice 1992, p. 44).
- 27. G. Mancini, "Giovanni Tortelli cooperatore di Niccolò V nel fondare la Biblioteca Vaticana", in *Archivio Storico Italiano*, LXXVIII (1920), II, p. 237 and fig. 1.
- 28. In the discussion that followed my paper in the seminar at the Italian Cultural Institute in London, Charles Hope objected that what I had seen as a Cardinal's sash was in fact a stole of the kind made fashionable by the Venetian taste for Roman costumes. Hope's interpretation, which I rejected at the time, has essentially been confirmed, with further qualifications, by Bellosi.

Appendix III

Berenson, Longhi, and the Rediscovery of Piero della Francesca

For Cesare Garboli on his sixty-fifth birthday

I

Preface, notes to the preface, the documents and their annotations, appendices, notes to the appendices: the Berenson–Longhi correspondence edited by Cesare Garboli (with the assistance of Cristina Montagnani and including an essay by Giacomo Agosti, "Longhi editore fra Berenson e Venturi") presents a complex landscape. Those familiar with Garboli's earlier work, in particular his memorable study of Pascoli, will know what to expect. The flow of the narrative fascinates the reader, even as it disperses itself into the myriad rivulets of the appendices and notes which bring us to a pause, send us back over our tracks, and encourage us to compare one passage with another as we re-read.

This short but tightly packed volume obliges us to reconsider the careers of Berenson and Longhi in the light of what they exchanged and borrowed from each other, their rivalry, and the open and hidden tensions between them: everything that united and (above all) divided them. Garboli shows that the work of each of these very dissimilar scholars was deeply influenced by their relationship. The book throws light above all on Longhi, but in the introductory essay we find valuable suggestions about Berenson as well. In what follows, I shall attempt to draw out some of these.

II

In the notebook published here, the young Longhi asks about one of Berenson's key terms: "Meaning of *life-enhancement*. Physiological, or *Life*

of spirit?" He soon resolves the dilemma, adding between the lines: "see Ribot"² (the physiologist Théodule Ribot was an exponent of positivism). An abyss, unsurprisingly, separates the cultural world in which Berenson, born in 1865, was educated from that in which Longhi, twenty-five years his junior, grew up. This is confirmed by the allegiance of the early Berenson to the ideas of Morelli. In the introduction to his book on Lorenzo Lotto (in the second, revised edition of 1901), Berenson remarks that a painting's less expressive details - ears, hands, hair, drapery - which may elicit a minimum of attention, but involve a maximum of mastery, offer the perfect clues to an artist's development.3 It was by following such clues that Berenson sought (without much success) to demonstrate that Lotto had been a pupil of Alvise Vivarini. However, by using his ideas in this genealogical and positivistic spirit, Berenson was already preparing to take his distance from Morelli, whose thought is rooted in the very different soil of romanticism. Fifteen years later Berenson was to observe that Morelli's method, in appearance so detached, clinical and iconoclastic, was actually inspired by romantic ideals of genius and by the untenable belief that great artists never stoop from the height of their own greatness.4 This critique can be seen to anticipate the accusation which Longhi (starting from quite different premises) would bring against Morelli, namely that the latter had been unable to sense the difference between "quality" and "ingenious diligence".5

If Morelli was one influence, Art Nouveau was another: Botticelli seen through Japanese prints, Bergognone arm-in-arm with Whistler.⁶ For many years, Berenson's work would be determined by these early tastes and preferred methods. Now Berenson, looking back on his career during the Second World War, was to suggest that so far as his serious contribution to learning was concerned, it would probably have made little difference if he had died on reaching fifty.⁷ He here seems to identify a break in his own intellectual career. Berenson was indeed just approaching the threshold of his fifties when his work took an unexpected direction, even if only for a very brief time. This happened in 1912–13: crucial years for Berenson, for Longhi, and for the relations between them.

Ш

In the March 1913 *Gazette des Beaux-Arts*, Berenson published an essay on the Madonna and Child from the Benson collection (the *Benson Madonna*), now in the National Gallery of Art in Washington, DC. Berenson identified the painting as a major work by Antonello da Messina.⁸ He remarked that the work's conical structure reminded one of 118 contemporary work by the cubists. He praised the *Madonna* as being "almost as wonderful as that *Head of a Young Girl* by Vermeer van Delft, at the Hague, which, as an achievement, points backward to Piero dei Franceschi and forward to Cézanne".⁹ Garboli appropriately comments that here it is as if Berenson "almost absent-mindedly outlines, in 1913, the main traits – *avant la lettre* – of Longhi's system".¹⁰ How did Berenson come to formulate the matter in these terms, which are so unlike those current in the cultural world of his youth?¹¹

The question is very simply answered. In the summer of 1912, Berenson had been sent the August number of Camera Work, the journal edited by Alfred Stieglitz, the great American photographer, curator and collector. This had been sent him from Paris by Gertrude Stein. The journal contained two brief essays by Stein, on Matisse and on Picasso, followed by some reproductions of their works. 12 In the spring of 1902, Stein and her brother Leo, who like the Berensons were expatriate American Jews, had begun visiting Villa I Tatti. The relations between them had grown progressively closer. Stein habitually sent Berenson copies of her works as they came off the press: in 1909, Three Lives; in 1912, Portrait of Mabel Dodge at the Villa Curonia. 13 Berenson had met Gertrude and Leo in Paris, at their apartment in the rue de Fleurus, and had seen their paintings - works by Cézanne, by Picasso, by Matisse. It was through the Steins that he met Matisse in 1908 and Picasso in 1913. Matisse spoke enthusiastically to Berenson about Giotto and Piero della Francesca. Picasso told him, when asked why he had become a cubist, that "he could not do otherwise" (in a letter to his wife, Berenson compared this phrase to Luther's).14

On 23 November 1912, Berenson wrote to Stein that he would try "in a moment of perfect peace" to see whether he could "puzzle out the intention of some of Picasso's design" (he was in fact referring to just one of the drawings reproduced in *Camera Work*). As for Stein's prose, that, 119 he confided, seemed "vastly more obscure still. It beats me hollow, and

makes me dizzy to boot. So do some of the Picassos by the way. But I'll try again."15

The meditations on Picasso which presumably followed no doubt contributed significantly to the flux of intellectual activity into which Berenson was to plunge during the next few months. Mary Berenson wrote in February 1913 to an American friend, Alys Smith Russell, that Bernard was spending the mornings "spinning out his articles faster than I can type". The articles referred to would be the essay on Antonello da Messina, which Berenson dated "January 1913", and the April 1913 essay on the *Santa Giustina* in the Bagatti–Valsecchi collection at Milan, once misattributed to Alvise Vivarini and now attributed to Giovanni Bellini. ¹⁷

Garboli remarks that Berenson's article on Antonello "must have startled the young Longhi in more ways than one". 18 We can now see why this would be so. The article allowed Longhi to travel, vicariously, to Paris in 1913, as his friend Boccioni had actually done in 1911. Boccioni reworked his painting *The Laugh* after seeing work by Picasso in Paris. 19 Longhi's reading of Berenson's essay on Antonello, which implicitly rethinks the entire tradition of painting from the standpoint of the Cézanne–Picasso nexus, must have led him to modify profoundly the great essay on Piero ("Piero dei Franceschi e le origini della pittura veneziana") on which he was then working and which was to appear in 1914. 20

IV

Longhi himself, in a passage added in 1962 to his work on the history of Piero's reputation and influence, has denied the truth of such a hypothesis as we now advance. He wrote then:

My modern cultural formation, which was consolidated around the year 1910, was based – I am obliged once again to repeat – by no means on the moment of cubism, still less on the moment of "metaphysics" which was still to come [this is a polemical allusion to Otto Kurz's essay – C. G.]. It was based on the moment of reconstructive post-impressionism which we owe to Cézanne and Seurat. These two painters, with their ability to synthesise form and colour through perspective (we may well believe that the expression "le tout mis en perspective" is authentically attributable to Cézanne), together

opened up the way which leads, not indeed into the aesthetic confusion of the last fifty years of art, but towards a project of criticism and research capable of retracing the history of a great poetic idea that emerged in the first half of the Quattrocento. In a word, the critical rediscovery of Piero is owing to Cézanne and Seurat (or to those who have come to his work by way of theirs), and not to the rhapsodic genius of Picasso.²¹

These comments are made, however, as Longhi acknowledges, with the wisdom of hindsight, and in the light of developments that had come to pass during the intervening half-century. Anyone seeking to retrace "chronological subtleties" (whose establishment Longhi himself singled out for praise in work by Berenson that he reviewed)²² must allow that a phrase as vague as "around the year 1910" actually prevents us grasping the nature of an intellectual metamorphosis which took place in the span of a few brief years or indeed months.

In his essay "I pittori futuristi" which appeared in the April 1913 number of *La Voce*, Longhi passed some critical remarks, from the standpoint of futurist dynamism, on the static aspect of the work of Cézanne and the cubists, making an exception only of Picasso:

The forms which Cézanne is well known to favour – the sphere, the cone, the cylinder – also have a static tendency. Picasso alone perhaps shows an understanding, in his *Homme nu*, of the kinds of curves which are able to encompass movement: there, a scattering of curves fans out from an ellipsoidal kernel, seeming to propel the body as if by twisting it.²³

In "La scultura futurista di Boccioni", Longhi again speaks of "the formal, congealed manner derived from Cézanne and the cubists", in terms which echo those used by the futurists: the cubists, he says, "are bent on the portrayal of the immobile, the frozen, and of whatever in nature is static". ²⁴ In the same year, however, Longhi was re-reading Piero by way of Cézanne, in his essay "Piero dei Franceschi e le origini della pittura veneziana". When he writes there that "spatiality in Piero is architectonic spatiality, achieved by the disposition of regular volumes at regular intervals", he has Cézanne in mind, as is explicitly indicated in his comment on the village seen high up in the background of the *Discovery and Proof of the Cross*, in the Arezzo cycle: in this, writes Longhi, "not a

curve is to be seen, except for the arch of the entrance-gate; here things are solid, as they will not be again until Paul paints the view of Gardanne". Longhi goes so far as to imagine Piero turning to an artist friend ("Antonio Rizzo, for instance") and anticipating Cézanne's words by saying: "Everything in nature is a sphere or a cylinder!" In his book *Breve ma veridica storia della pittura italiana*, published in July 1914, Longhi hails Cézanne as "the greatest artist of the modern age", who had

composed a new, monumental and integral whole from the formal experiments of Courbet, the coloristic experiments of Manet, and the spatial experiments of Degas. He expressed his faith as a painter in these terms: "traiter la nature par le cylindre, la sphère, le cône, le tout mis en perspective, soit que chaque object au côté d'un objet, d'un plan se dirige vers un point central". As you can see, such a declaration of faith might well have been made by Piero dei Franceschi or Antonello da Messina.²⁶

Simplifying somewhat, we might say that "La scultura futurista di Boccioni" marks the close of Longhi's youth, while his splendid maturity is inaugurated by "Piero dei Franceschi e le origini della pittura veneziana". Between these two essays, in the space of a few months, his view of Cézanne (initially accused of being "static") undergoes a transformation. Boccioni must be left behind, in a valedictory burst of fireworks, if the road is to be taken which leads to the discovery of Piero as a central figure and of the tradition which goes back to him. Longhi might well have contributed to Boccioni's turning towards Cézanne two years before his sudden and unexpected death.²⁷

It was Berenson who opened the way for Longhi, allowing him to rinse his clothes (so to speak) in the waters of the Seine; and, indirectly, Stein. Berenson in 1913 saw Cézanne (as we have noted) through the filter of Picasso. Was this the case for Longhi too? Fifty years after the event, Longhi denied this, but the question is none the less perhaps still open.

V

Garboli has shown that Longhi's work drew hidden energy from the contrasting example of Berenson, which led the younger scholar to strike out along paths which his predecessor had rejected or ignored and encouraged him to seek in hitherto unexplored regions for materials which could further our understanding of Italian painting. Garboli's marshalling of the evidence is exemplary. Yet I suspect that alongside the impulse to make himself different, another and opposite tendency was at work in Longhi: the desire to contend directly with Berenson and to defeat him in open combat. Here, too, I must quote a couple of passages. The first is from Berenson's *North Italian Painters*, which came out in 1907:

[Tura's] figures are of flint, as haughty and immobile as Pharaohs, or as convulsed with suppressed energy as the gnarled knots in the olive tree. Their faces are seldom lit up with tenderness, and their smiles are apt to turn into archaic grimaces. Their claw-like hands express the manner of their contact. Tura's architecture is piled up and baroque, not as architecture frequently is in painters of the earlier Renaissance, but almost as in the proud palaces built for the Medes and the Persians. His landscapes are of a world which has these many ages seen no flower or green leaf, for there is no earth, no mould, no sod, only the inhospitable rock everywhere. . . . There is a perfect harmony in all this. His rockborn men could not fitly inhabit a world less crystal-hard, and would be out of place among architectural forms less burdensomely massive. Being of adamant, they must take such shapes as that substance will permit, of things either petrified, or contorted with the effort of articulation. . . . Nothing soft, nothing yielding, nothing vague. His world is an anvil, his perception is a hammer, and nothing must muffle the sound of the stroke. Naught more tender than flint and adamant could furnish the material for such an artist. 28

When Emilio Cecchi translated this passage for his very fine version of Berenson's book, published in 1936, he must of course have been aware of Longhi's *Officina Ferrarese*, which had appeared two years earlier (and which Garboli calls "one of Longhi's most Longhian works").²⁹ Here I quote only the opening lines of Longhi's justly celebrated discussion of Tura in that work:

In him one admires an imagination which flourishes on method and draws from it a pitiless and sometimes obsessional consistency. . . . Everything else in the work is at this same unvarying pitch, in a fierce equality. If the Florentines had advocated the organic in architecture,

here Tura creates his own architectural super-organism, with echoes of the Assyrians and of Solomon. The varied regions of the universe take on similarity as they fall under the fierce gaze of the master. Under the sway of medievalism, he starts out from the conviction that there can be no painting unless its objects are first cast in some rare and choice material (for such is the teaching of medieval mysticism regarding stones and gems); this is how he interprets the organicist principles which he has heard of from the Tuscans. Nature as stalagmitic; humanity as enamel and ivory, with crystal joints. . . . Figures edged with emerald-green or ruby-red strain against a sky as blue as lapis-lazuli. 30

Here, in a remarkable moment of defiance, a master of *ekphrasis* issues a challenge to his fellow: an invitation to a hand-to-hand fight. Passages like this are abundant compensation for the fact that nothing ever came of the planned translation of Berenson's *North Italian Painters* which was the occasion for the correspondence so excellently presented in this book.

Notes

This is a slightly modified version of a paper given at the Fondazione Longhi in December 1993, on the occasion of publication of the Berenson–Longhi correspondence. Other contributors included Mina Gregori and Enrico Castelnuovo, as well as the editors of the volume.

- 1. B. Berenson and R. Longhi, Lettere e scartafacci 1912–1957, ed. C. Garboli and C. Montagnani, with an essay by G. Agosti, Milan 1993 (henceforth cited as Berenson–Longhi).
- 2. Berenson–Longhi, p. 198 (this resolves the perplexity expressed by Garboli on p. 189). (Translators' note: phrases in italics are in English in Longhi's original text.)
 - 3. B. Berenson, Lorenzo Lotto, 2nd edn, London 1901, pp. xix-xxi.
- 4. B. Berenson, "Leonardo" (May 1916), in *The Study and Crititicism of Italian Art*, vol. III, London 1927, pp. 34f.
- 5. On this last point, see G. Romano, *Studi sul paesaggio*, 2nd edn, Turin 1991, p. xxv. In his fragmentary "Rudiments of Connoisseurship" (written *circa* 1890), Berenson wrote that the usefulness of mechanical indications was in inverse proportion to the greatness of the artist concerned, concluding that "the Sense of Quality is indubitably the most essential equipment of a would be connoisseur" (*Study and Criticism*, vol. II, London 1920, p. 147).
- 6. See respectively B. Berenson, Florentine Painters of the Renaissance, London 1896, p. 74; and B. Berenson, North Italian Painters of the Renaissance, London 1907, pp. 101f.
- 7. Garboli refers to the passage (from Berenson's *Rumour and Reflections*) in Berenson–Longhi, p. 18. Kenneth Clark's ill-natured remark that "for almost forty years after 1900 [Berenson] did nothing except authenticate pictures" dates the watershed a decade and more earlier (K. Clark, *Another Part of the Wood. A Self-Portrait*, New York 1974, pp. 141f.).

- 8. The original English text was reprinted, with a brief Appendix, in Berenson, *Study and Criticism*, vol. III, London 1927. The French version that appeared in the *Gazette des Beaux-Arts*, which Garboli cites and quotes, is not always faithful.
- 9. Study and Criticism, vol. III, London 1927, pp. 82, 90. The phraseology is almost identical in a note added, with what Garboli calls "an anti-Longhian intention", to North Italian Painters (see Garboli, in Berenson–Longhi, p. 58; the reference is to the Italian edition of Berenson's book, I pittori italiani del Rinascimento, trans. Cecchi, Rome 1936, p. 183n.).
 - 10. Garboli's comment in Berenson-Longhi, p. 17.
- 11. We should note, however, that in his *North Italian Painters* Berenson describes the *Autumn* attributed to Cossa, now in Berlin, in the following striking phrase: "She is as powerfully built, as sturdy and firm on her feet, as if she had been painted by Piero himself; but in atmospheric effect and in expression she reminds us of Millet and Cézanne" (pp. 62f.). Longhi does not include this comment in his compilation of critical judgements on Piero.
- 12. In his (anonymous) editorial, Stieglitz stated that these two articles by "Miss Gertrude Stein, an American resident in Paris" constituted the *raison d'être* of the issue. They were likened to a sort of "Rosetta stone", which might offer a way of understanding the artistic movement of which they formed an integral part.
- 13. Mary Berenson's letters show her becoming increasingly exasperated by Gertrude Stein: see *Mary Berenson. A Self Portrait from her Letters and Diaries*, ed. B. Strachey and Jayne Samuels, New York and London, 1983, pp. 103, 156, 184, 187. Stieglitz published *Portrait of Mabel Dodge at the Villa Curonia* as a special number of *Camera Work* (June 1913).
- 14. See E. Samuels, *Bernard Berenson. The Making of a Legend*, Cambridge (Mass.) 1987, pp. 32, 154f., 160. (This is a most thorough narrative history, with a wealth of quotations from Berenson's letters.)
- 15. A. Gallup, The Flowers of Friendship. Letters Written to Gertrude Stein, New York 1953, p. 66. E. Samuels quotes this in part in his Bernard Berenson, p. 155.
 - 16. Quoted in Samuels, Bernard Berenson, p. 155.
 - 17. See Garboli, Berenson-Longhi, pp. 16f., 160f.
 - 18. Ibid., p. 24.
 - 19. See G. Ballo, in Boccioni a Milano, Milan 1982, pp. 42f.
- 20. It is stated in this essay that Berenson "triumphantly" attributed the *Benson Madonna* to its true author (see R. Longhi, *Scritti giovanili*, Florence 1956, p. 83).
- 21. R. Longhi, *Piero della Francesca*, Florence 1963, p. 168. Garboli cites other passages to the same effect (see Berenson–Longhi, pp. 56f.).
 - 22. See Longhi, Scritti giovanili, p. 377.
 - 23. Ibid., p. 50.
- 24. See ibid., p. 137; and also *Prima esposizione pittura futurista Roma ridotto del Teatro Costanzi Galleria G. Giosi*, [Rome] 1913 (the authors signing the catalogue were Boccioni, Carrà, Russolo, Balla, and Severini). In his essay "La scultura futurista di Boccioni", Longhi claims to have been the only person "outside the camp of the futurists themselves, to have affirmed furturism's profound independence of and superiority to cubism" (p. 136).
 - 25. Longhi, Scritti giovanili, pp. 67, 69, 86.
 - 26. R. Longhi, Breve ma veridica storia della pittura italiana, Florence 1980, pp. 183-6.
- 27. See M. Volpi Orlandini, "Roberto Longhi", in Annali della Facoltà di Lettere Filosofia e Magistero dell'Università di Cagliari, vol. XXIII, pt. 2 (1970), pp. 1–15.
- 28. B. Berenson, *North Italian Painters*, pp. 56f. E. Cecchi's Italian version of 1936, under the title *I pittori italiani del Rinascimento*, appeared in Milan (see p. 202).
 - 29. See Berenson-Longhi, p. 37.
 - 30. R. Longhi, Officina Ferrarese, Florence 1968, pp. 23f.

Appendix IV

Absolute and Relative Dating: on the Method of Roberto Longhi

I

A Jove principium. These reflections arise – and could only have arisen – from the work of Roberto Longhi, whose influence unquestionably presides over these scholarly endeavours. My book *Indagini su Piero* (*The Enigma of Piero*) was, moreover, a tribute (even if not everyone realized this) to his achievement, a tribute in the only possible mode, that of critical discussion.

When he republished his youthful writings in 1956, Longhi remarked that his 1913 essay on Mattia Preti was "marked by idiosyncratic antiphilological and anti-psychological pretensions, though in fact it was based on my first tentative researches as a connoisseur, which were themselves philological". This judgement should not be attributed to the distorting wisdom of hindsight. Even the "pure figurative criticism" attempted (so the subtitle proclaims) in the essay on Preti undeniably involved the reconstruction of the catalogue of his paintings, so as to include, for instance, the Martyrdom of S Bartholomew which at that time was to be "wondered at . . . in the storehouses of the Galleria Nazionale at Rome". Nevertheless Longhi's impatience with biographical and chronological data, which he displays in the sarcastic conclusion to this youthful piece, had its theoretical justification, which was spelt out a few years later in the posthumous debate with E. Petraccone which has recently been the subject of some discussion. Here Longhi wrote that "in working as a figurative critic" he had "always intended to work as a historian". He went on to explain that he had sought to demonstrate the unity of criticism and history

by way of particular historical studies, which have always been conducted through a "pure" figurative method, that is, through the closest

attention to all the formal elements which, if we examine them sufficiently keenly as they appear in the relationship between one work and another, inevitably arrange themselves in terms of a successive historical development, which bears, however, only an inessential relation to any kind of chronological succession (emphasis added).

Longhi goes on to spell out what he means by this last statement:

In writing this history of forms, pure figurative criticism has no substantial need, intellectually, of the biographical and chronological aid which historical criticism may furnish. Such aid only ever amounts to a kind of administrative assistance in the course of research, perhaps saving time and allowing us to establish more rapidly the critical evaluation which is our sole important objective; but it is in no way to be credited with the achievement of that objective. . . . Bio-chronological criticism is thus a sort of physical (but never intellectual) aid to the kind of figurative criticism which we may very well conceive, to use Wölfflin's recent and prescient term, as "Kunstgeschichte ohne Namen", "art history without names" – and, I would add, without dates (emphasis added).²

How are statements such as these to be reconciled with the chronological obsession which dominates Longhi's work, an obsession which – backed up as it was by his extraordinary eye and his extraordinary memory – allowed him (as Contini pointed out) to utter judgements such as "Cremona 1570", "the cultural ambience of 1615", and so on? There is a double problem here, at once historiographical and theoretical. There is no doubt that Longhi's innermost personality as a scholar, formed very early in his work, was subsequently enriched in many ways without ever being repudiated. However, I would argue as follows:

- 1) Longhi's persistent use of the term "history" (which is synonymous, for him, with "criticism") denotes, right from the start, two coexistent but different approaches to works of art, one more properly morphological, the other historical;
- 2) The two approaches are inextricably connected, but they are to be verified by recourse to two different kinds of control;
- 3) Longhi may put forward the thesis that the second (historical) approach is merely *instrumental* with respect to the first (which I am proposing to call morphological), but this thesis is in fact invalidated by his claim to establish not just relative but absolute datings;

4) This insistence on absolute datings offers an opening through which we may take Longhi's researches further, along paths in part similar to his own and in part different from them.

H

I shall seek to demonstrate these arguments by discussing some instances of Longhi's methods of attribution. My first example is his ascription to Fra Bartolommeo of the Holy Family now in the Galleria Borghese.3 Longhi at once dismisses the work's traditional attribution to Lorenzo di Credi, along with subsequent scholarly ascriptions to the school of Verrocchio, to the school of Sodoma, and to a pseudo-Lorenzo di Credi. "There is no doubt", he declares, "that these are instances of false particularization, arrived at by deduction from a vast, vague generality; purely deductive procedures always being terribly dangerous in the realm of Italian art history, made up as it is of so many densely-packed individual cells". One should proceed, rather, inductively, starting from the singularity of the work: contact with the work will set off the spark of "historical judgement, which wrests from the sublime silence of graphic symbols the secrets that they hold", or prompt the attribution. 4 Droysen defines the act of historical understanding as "immediate intuition . . . a soul immersing itself in a soul, a creative act like that of a woman in the moment of conception".5 Longhi puts the matter somewhat similarly:

The mode in which the critic arrives at the truth is a form of spiritual intimation so mysterious that if anyone tried to describe it as it actually happens, without evasion or circumlocution, nobody would understand or believe them. So one is constrained to display, as the steppingstones of one's *gradus ad veritatem*, those superficial elements acquired through scholarly endeavour, which are the controls by which one confirms the convictions reached by far more subterranean ways.

A sharp distinction is thus set up between the way the truth is grasped and the way it is communicated. It is grasped in a synthetic judgement, which is immediate and intuitive; it is communicated by way of a judgement that is analytical, mediated, and thus subject to *control*. Longhi continues:

Let us suppose (for example) that I explained my conviction that this work is by Fra Bartolommeo by saying that it sprang up in me at a

APPENDIX IV 141

stroke because my spirit posited a qualitative identity between the vital and, I would say, enthusiastic mode in which the academic technique apparent in the work is employed, at once sensitively and impeccably, and the distinctive manner and style found, in the last years of the Quattrocento, only in the works of Fra Bartolommeo. It might be objected that the second part of my explanation presupposes a range of historical knowledge, which allows me to speak of "that" mode, to specify "the last years of the Quattrocento", and to say that something is proper "only" to a given individual called "Fra Bartolommeo". My response would be that I would have been able to affirm this qualitative identity without reference to particular knowledge about chronology and historically determinate individuals; which is not to deny that a sensitivity to form needs to be nourished by a knowledge of the variety of forms, such knowledge indeed being more or less an embryonic and abstract history.

This declaration that "particular knowledge about chronology and historically determinate individuals" is irrelevant for the purposes of attribution recognizably, and exactly, echoes the reference, in Longhi's debate with Petraccone a few years earlier, to "art history without names and without dates". The "embryonic and abstract history" whose necessity he acknowledges here is, however, a history in name alone. What is really involved is morphology: an extremely detailed inventory of distinct forms, thanks to which it is possible to grasp the differentia specifica of the tondo in the Galleria Borghese and thus to identify the artist as Fra Bartolommeo. Botanists, one might say, proceed in the same way when their familiarity with the family Pinaceae allows them to distinguish, at a glance, between the leaves of the Pinus silvestris and those of the Pinus pinea. There seems to be a clear analogy between the two intellectual procedures: the individual entity (a leaf, a painting) is ascribed to a class (Pinus silvestris, the works of Fra Bartolommeo) on the basis of the recognition of its distinctive formal properties. Nothing mystical is involved here – just a very rapidly condensed series of rational processes.⁶ There is, however, a difference: the individual artists who people Longhi's universe, even though they may be unequivocally identified, are neither isolated nor fixed. They form part (we might say, metaphorically) of a galaxy which is in motion. Here, small stars are pulled from their orbits by the attractive power of larger ones; vast supernovae explode without

warning, modifying the whole system; asteroids collide with planets and shatter into fragments. Longhi's intellectual project might be defined as a dynamic morphology: an ambitious project, which, as we know, has preoccupied, in different ways, both the human and the natural sciences since the nineteenth century. However, the "successive historical development" that arises from his dynamic morphology "bears only an inessential relation to any kind of chronological succession". The world of artistic forms is completely cut off from the world of everyday life (as Garboli rightly points out, it is here that we should see the root of Longhi's distaste for aestheticism of all kinds, which confuses art and life). The "bio-chronological" criticism which tries to build a bridge between these two worlds is pursuing a chimera. The chronology of artworks which the connoisseur-historian reconstructs is thus purely relative – and whatever coincidence it has with calendar dates is purely symbolic.

Given the cultural context in which Longhi was formed and in which he worked, it is unsurprising that he gives this morphological approach the name "history", even if only "embryonic and abstract history". However, this should not be allowed to conceal the deep affinities between his procedures and those favoured in the morphological researches which at that time were being conducted or advocated in disciplines such as literary studies, folklore and anthropology (and of which we still lack any adequate overall account). The passages we have just been quoting from Longhi were written in 1926. It was in that year that Vladimir Propp's Morphology of the Folktale appeared; A. Jolles's Einfache Formen, begun in 1923, came out in 1930; Wittgenstein's Notes on Frazer's Golden Bough were composed in 1931. Propp and Jolles (and, indeed, Wittgenstein) stated that their starting-point was Goethe's morphological reflections.8 For Longhi, the starting-point was perhaps Riegl9 - and even, through a kind of attraction of opposites, Morelli: Morelli's intellectual formation has yet to be retraced, but it is probable that Goethe's morphological writings played an important part in it. The fact that Longhi wrote sarcastically about Morelli's fundamental limitation, his lack of a sense of quality (a charge repeated in connection with the Galleria Borghese tondo), 10 does not rule out a partial, subterranean convergence between the aims of the two scholars. Longhi took more from Morelli than he cared to admit (a point to which I shall return below). However, Morelli was never his only master. Longhi's morphology was far more differentiated and far subtler.

Ш

Now the identification of the Holy Family in the Galleria Borghese as the work of Fra Bartolommeo, though grasped "at a stroke", only becomes convincing if it is expounded in an analytical discourse: otherwise, "nobody would understand or believe" it. In other words, Longhi goes on to explain, "embryonic and abstract history" must yield, for exclusively practical reasons, to "a concrete history, which employs the usual spatial and temporal categories". A series of increasingly rigorous formal comparisons allows us to allocate the work to an ever more precisely defined class of works, until at last we can place it exactly, in the cell which bears the name "Fra Bartolommeo". First the work is placed in "the last decade of the Quattrocento, in Florence"; then we note its "dependence on Leonardo, partly direct and partly . . . by way of Piero di Cosimo"; then we come to Fra Bartolommeo. In this last stage one turns to internal comparisons, since "most people will find these alone convincing enough to allow us to move from similarity to identity": to drapery, facial types, the disposition of chiaroscuro, details of landscape, all of which are compared to parallel elements in the 1497 Annunciation at Volterra, the 1499 Last Judgement, and so on. There is an air of condescension in the way these details are exhibited: "let us now observe . . .", "most people will find these alone convincing . . .", "we shall not trouble to mention". Longhi, the great juggler, waits impatiently for the astonished public to arrive at last at the certainty which he by his own route reached long ago: "But we are anxious, after having spent so much time on these procedures of methodical demonstration [emphasis added], to return to that sense of qualitative identity which alone can authorize us to declare that the problem of the work is solved by ascribing it to Fra Bartolommeo."

But has there been any such "demonstration"? Yes, if we take the term metaphorically, as a synonym for the kind of argumentation which constrains us irresistibly to agree. However, it is impossible to lay claim to rigorous demonstration on the basis of formal analogies, exemplified in the comparison of details (which may or may not be reproduced photographically) — even if these are marvellously well translated into verbal terms. A theorem in Euclidean geometry concludes in the perfect superimposition of two figures (q.e.d.), but no such conclusion can be reached concerning the figures painted by Fra Bartolommeo, owing to their very uniqueness which Longhi so often proclaims. The same

consideration rules out recourse to geometrical modelling, a method used with success in the case of natural forms (most obviously, crystals, but also leaves and shells).¹¹ Longhi *shows* – he indicates, he points out, he makes us see; he does not *demonstrate*. And, in this case at least, recourse to "the usual spatial and temporal categories" has an exemplificatory rather than a demonstrative role with respect to the formal contiguity that becomes apparent in the realm of "embryonic and abstract history".

IV

None of this in the least damages either the subjective assurance felt by Longhi, or the certainty he so often succeeds in instilling in his readers. It does, however, underline that scientific procedure here is *sui generis*, governed by the kinds of control that may be attained in the practice of attribution (which in this respect has some similarities with other cognitive practices, for instance psychoanalysis).

No external aspect or feature of the Galleria Borghese tondo gives any clue as to its painter, or even its date, patron, or original location. Stylistic analysis therefore offered the only way forward. In other cases, where external documentation exists, Longhi is not slow to make use of it. Let us consider his essay of 1927 on Rubens's La Notte, at Fermo. 12 Longhi describes how he is led to the Church of Santo Spirito, also known as San Filippo, by the mention, in an old guide to Fermo, of a painting of the manger attributed to Rubens. He enters the church with no great expectations, thinking that at the best he may see "a reasonable piece of work left by some northern follower of Caravaggio as he passed on his way through la Marca". Instead, he finds a veritable Rubens, "in the first person". But he does not stop here, at this moment of affirmation or recognition. An examination of "the external historical circumstances" shows that there is excellent "material supporting evidence to place alongside the likelihood of this attribution and its long standing" (the attribution, it is discovered, can be traced back to Mengs). Here it is: "The church of Santo Spirito, as can be shown from an inscription, was assigned to the Padri dell'Oratorio in the lifetime of San Filippo Neri (and thus earlier than 1595), and was rebuilt, on the site of a smaller preceding church, from 1597 on, under the superintendence of Archbishop Alessandro Strozzi; by 1607, it had already been consecrated." This gives rise to "two most singular coincidences":

The first is that this church was an endowment of the same Philippine fathers who turned to Rubens when they were looking for an artist to decorate their church at Rome; the second is the chronological coincidence that the dedication of the church at Fermo, and so in all probability the production of the most important of its furnishings, took place just at the time when Rubens was working on the paintings for the Chiesa Nuova in Rome (1606–1608).

It is on this basis that Longhi advances

the hypothesis (which is, let it be understood, a pure hypothesis) that the picture at Fermo, painted for a provincial house of the Philippine fathers, to be consecrated in 1607, was commissioned from Rubens by the Padri in the capital so they could assess his abilities as a painter before they made the definite decision to entrust him with the more important commission for the mother-house at Rome, the great altar of Santa Maria in Vallicella.

It would be foolish to quarrel with Longhi's proposed attribution, given this impressive convergence of material drawn from a series of different documentary sources. In this case, then, can one speak of a "demonstration"? In the sense in which one usually speaks of historical demonstration, we certainly can. It should not be forgotten, however, that every historical demonstration partakes, by its very nature, of the probable – sometimes (as here) the very probable - rather than of the certain. Echoing Bloch's comments in his The Historian's Craft, 13 we might suggest that the painting at Fermo is by a pupil or imitator of Rubens; that it is no more than a coincidence that the Philippine fathers were the patrons both at Rome and at Fermo, and no more than another coincidence that the works may be presumed to have been composed at nearly the same time; and so on. To this, it may be objected that the work itself, "in the first person", speaks in favour of Rubens. We have already seen, however, that evidence of this kind does not conduce to a demonstration - either in the strong, geometrical sense, or in the weak historical sense.

V

There are, then, two kinds of arguments, internal and external. The first bases itself on resemblances, and points to formal (morphological)

similarities which may be sufficient to instil in us the subjective certainty that two or more works are by the same painter – who may or may not be identifiable as a named individual. The second is based on contiguities, and demonstrates the likelihood, and in some cases the infinite probability, that the occurrence of determinate series of events can be verified. The first kind of argument helps us recognize the "Rubens-ness" of the Rubens at Fermo; the second allows us to state that Rubens painted the picture for the Philippine fathers of the town, perhaps before he received the commission for his work at the Roman mother-house, and at any rate during the same few years. I am inclined to associate the first kind of argument with the metaphorical pole of language and the second with its metonymic pole: I recall Jakobson's claim, in his great essay "Two aspects of language and two types of aphasic disturbances", that the dichotomy between metaphor and metonym has "wide scope and importance for the study of any symbolic behaviour".¹⁴

However, let us return to Longhi. Longhi never doubted that internal (formal) evidence was superior to external evidence. But is this really a question of superiority, rather than of priority in the experience of the researcher? It is clear that these two things are by no means equivalent. The way in which one arrives at what we might call the act of attribution is one matter; the relative weight accorded to the various means which allow us to control or check our judgement is another. Longhi has much to say about the latter, and particularly about the kinds of control favoured by Morelli: he treats them as superfluous materials, of use only to "critical doubting Thomases", and indeed hardly ever makes direct use of them himself. Writing in 1925 about a fragment of the altarpiece of Santa Lucia dei Magnoli by Domenico Veneziano, he says: "For once, I will spare myself the trouble of invoking the aid of those little bureaucratic Morellian controls."15 A year later, concluding his argument for the ascription to Girolamo di Giovanni of a fresco in the Eremitani, he writes: "If I wanted to, I could go on to play a fine puzzle à la Morelli, but I leave that to those who enjoy such things, since I am certain that one's convictions concerning figurative identity are not reached by way of the tradesman's entrance."16 We see that however he may display his contempt for them, Longhi is not above invoking Morelli's methods. even if he does not use them to serve heuristic ends. If he chooses not to speak of them, it is because they confirm his conclusions.

In other cases, however, external evidence plays a much more strategi-

cally important role. Let us take as an example the splendid essay "Stefano fiorentino" (1943). Here Longhi reconstructs, *ex nihilo*, the oeuvre of a Trecento painter (later dubiously identified, by others, with Puccio Capanna).¹⁷ The centrepiece is his analysis of a small painting in the Vatican, formerly attributed to Piero Lorenzetti, of the *Madonna Enthroned between Two Angels*. Longhi brings all his usual mastery to bear on the task of finding a verbal equivalent for the very unusual style of the painter, in whom he recognizes "a new personality in Florentine painting". However, one of the features to which his description draws attention has an external character, and is indeed the kind of thing Morelli might have noted, even if Longhi's discussion of it modulates into an expressive key: "the haloes, which are not printed from a block, but drawn by hand, fan out irregularly". Longhi now takes us into his laboratory. He notes that the Vatican painting

precious as it is, was probably used for purposes of private devotion, and it seems problematic that it should have had no cover; or in other words that it should not have formed, together with a companion painting, a folding diptych. The usual iconography more or less required the counterpart to be a Crucifixion. Now, bringing to mind a very small *Crucifixion*, in the Kress collection, which I had seen several years ago, I was at once reminded of the Vatican painting; and indeed there was every reason for this, since when it was placed alongside the edge of the Roman picture, everything matched perfectly: its measurements, the marginal engravings, the random-like streaked haloes. In other words, the second picture, which lacked edges (these being now lost), had been removed from a frame which corresponded to that of the first. And this made the Florentine provenance of the artist still more certain.

Longhi goes on to give a stylistic analysis of the work in the Kress collection. However it is quite clear that the features which allow him to proceed to this are external: iconography, measurements, marginal engraving, streaked haloes. Moreover these same haloes appear again, in one of the Assisi frescoes that Longhi ascribes to the mysterious "Stefano", the *Crucifixion*:

It is not, I think, going into too much detail to point out how even the rays of haloes – which, in frescoes, were usually printed from a

block onto the limewash – fan out irregularly; for the same, obscurely impressionistic reasons that led the painter to trace the haloes uncertainly and by hand onto the gold of the Vatican diptych.¹⁸

VI

Such an essay as this, which is a veritable research diary, quite disproves Longhi's oft-repeated claim that in the reconstruction of artistic identities, non-stylistic aspects and features must have an intrinsically subordinate status. The iconography, measurements, marginal engravings, and streaked haloes which enabled Longhi to reconstitute the Vatican diptych also allowed the entry of its painter into Italian art history. In this case, unlike that of the Fra Bartolommeo tondo, there is no divergence between "the mode in which the critic arrives at the truth" and the mode in which he presents it; on the contrary, they are one and the same. There is no risk, here, that "nobody will understand or believe". Here, we are in the realm of demonstration – albeit with the limitations that historical demonstration necessarily has. Theoretically, the match between the measurements, marginal engravings, and so on might be a matter of so many coincidences; but only theoretically. In reality the convergence between these different sets of features virtually rules out such a possibility.

It is of course one thing to state that the two pictures form part of a single diptych, and another to claim that they are the work of a single painter. Should there be a discordance between their stylistic features, this would pose fresh difficulties. However, where showing and demonstrating tend to the same end (not always, alas, the case), the argument benefits from the stronger control that results. Not only that: such cases invalidate the extreme claim, made in Longhi's essay of 1920, that the "successive historical development" constituted by a series of art works bears only an "inessential" relation to "any kind of chronological succession". Longhi's own work, indeed, shows as much, for example his wonderful reconstruction of the dispersed Griffoni polyptych which Francesco del Cossa and (in minor part) Ercole de' Roberti painted for San Petronio. Let us follow the stages of the argument. First of all, Longhi invokes stylistic features to confirm the attribution to Cossa of the two Saints and the tondo depicting the Crucifixion, now in Washington, whose authenticity - in the case of the tondo - some scholars had doubted. The use here of perspective

"from below" is taken to show that the pictures formed the upper part of a polyptych. Iconographically, this is a plausible hypothesis, as such usage might be derived from Tuscan models. The two Washington Saints, when compared to the two Saints at Brera (already recognized as part of the polyptych), "speak of the unity of the work and of its expressive moment". And now, even proofs à la Morelli are adduced – really adduced, for once (with the inevitable note of sarcasm), rather than invoked only to be dismissed: "Morelli would have made a great fuss about the wrinkle on the back of the hands, at the base of the little fingers. So much for wrinkles." Finally, there are the dimensions:

Now if the style matches, how about the carpentry? No need for fear: it confirms my argument, and to a greater degree than I would have dared imagine. The paintings of St Liberale and St Lucia measure 555 millimetres across; the two Saints at Brera measure 550 millimetres across; the painting of St Vincent, in London, is 595 millimetres wide and the tondo of the Crucifixion is 592 millimetres wide. It would hardly have been humanly possible for the carpenter who prepared the Griffoni altarpiece for Cossa's painting to have worked to a closer specification.¹⁹

A triumphant conclusion, and one corroborated by the dating – inferred on stylistic grounds as 1470–75 (with work probably begun before 1474), and confirmed by a document that Longhi publishes which certifies that on 19 July 1473 payment was made "to the well-known inlay-worker Agostino de Marchi of Crema for the chest 'quam fecit circa tabulam altaris Floriani de Grifonibus'".²⁰

And so a crowd has gathered around the San Petronio polyptych: not just the two painters, Francesco del Cossa and Ercole de' Roberti, but also the patron, Floriano de' Griffoni, his wife (who was in all probability called Lucia),²¹ the inlay-worker Agostino de' Marchi, the anonymous carpenter. The work of art has broken out of the separate sphere to which Longhi had sought to relegate it in his youthful polemic based on "pure figurative criticism", to enter a realm at once more spacious and less pure. If it has been possible to bring the various types of evidence into intelligible relation with one another, this is thanks to the materiality of the object, on one hand, and to absolute datings on the other. There is just one calendrical series which contains both the date of the polyptych, and the date of the legal document; and it is their convergence which

opens up the way along which we can seek a theoretically limitless number of similarly converging pieces of evidence. This, it seems to me, is the way that must be taken by a social history of art which departs from and returns to the work in its concreteness, and avoids getting lost in vacuous generalities.

Notes

This essay is based on a seminar paper given at the Fondazione Longhi in January 1982; it was published in *Paragone*, 386 (April 1982), pp. 5–17.

- 1. R. Longhi, Scritti giovanili, Florence 1980 (3rd edn), vol. I, p. ix.
- 2. Ibid., pp. 455, 458 (and see C. Garboli, "Longhi lettore", in *Paragone*, 367 [1980], pp. 19–21, where there is also a condensed anticipation of the distinction between history and morphology which is discussed below).
- 3. See R. Longhi, "Precisioni nelle Gallerie italiane. La Galleria Borghese", in *Saggi e ricerche*, 1925–1928, Florence 1967, vol. I, pp. 279–82.
- 4. Longhi, "Un chiaroscuro e un disegno di Giovanni Bellini", in Saggi e ricerche, vol. I, p. 180.
 - 5. G.G. Droysen, Sommario di istorica, ed. D. Cantimori, Florence 1943, p. 15.
- 6. See G. Contini, "Sul metodo di Roberto Longhi", in *Altri esercizî (1942–1971)*, Turin 1972, p. 15 (on p. 117, in the essay "Longhi prosatore", Contini quotes in part the passage concerning the ascription of the Galleria Borghese tondo to Fra Bartolommeo which has just been discussed here).
 - 7. Garboli, "Longhi lettore", p. 21.
- 8. See V. Propp, Morphology of the Folktale, ed. L.A. Wagner, Indiana 1968 (the reference to Goethe, however, is found only in the Italian translation, where it occurs in the methodological exchange between Propp and Lévi-Strauss printed at the end of the book; see the American editors' Introduction, p. xii, and cf. Propp, Morfologia della fiaba, Turin 1966, p. 205); A. Jolles, Einfache Formen, Halle 1930: there is no English translation, but see p. 7 of the Italian edition (Forme semplici, Milan 1980); L. Wittgenstein, Notes on Frazer's Golden Bough, ed. R. Rees, Swansea 1979 (and on the latter, see J. Schulte, "Coro e legge. Il 'metodo morfologico' in Goethe e Wittgenstein", in Intersezioni, II [1982], pp. 99-124). G. Dolfini, in the Introduction to his Italian edition of Jolles's Einfache Formen, argues that to see Jolles and Propp as equally the followers of Goethe is mistaken so far as Propp is concerned. In an interview given in 1981, Michel Foucault suggested that it was possible to see the programme of research "carried out in the USSR and central Europe during the 1920s . . . in the fields of linguistics, mythology and folklore" as a precursor of the French structuralism of the 1960s, which was influenced by the earlier work "by way of more or less subterranean, or at any rate little-noted, channels" (see D. Trombadori, Colloqui con Foucault, Salerno 1981, p. 48). However, apart from the very wellknown role of Jakobson, whose interpretation of Trubetskoi's phonology was adopted by Lévi-Strauss (see G. Mounin, "Lévi-Strauss' use of linguistics", in L. Rossi, ed., The Unconscious in Culture, New York 1974, pp. 31-52), it seems that contrary to Foucault's claim, Propp influenced neither Dumézil nor Lévi-Strauss.

- 9. Ezio Raimondi gave a fine account of Longhi's reading of Riegl at the conference on Longhi held in Florence in September 1980. So far as I know, his paper remains unpublished.
 - 10. See R. Longhi, Saggi e ricerche, vol. I, p. 282.
- 11. D.W. Thompson's classic book *Growth and Form* appeared in 1917. There is an Italian version of the abridged text (*Crescita e forma*, Turin 1969).
 - 12. R. Longhi, Saggi e ricerche, vol. I, pp. 221-32.
- 13. See M. Bloch, *The Historian's Craft*, trans. P. Putnam, Manchester 1954, p. 123 (where he comments on an example from Delahaye), pp. 129f.
- 14. See R. Jakobson, "Two aspects of language and two types of aphasic disturbances", in *On Language*, ed. L.R. Waugh and M. Monille-Burston, Cambridge: (Mass.) 1990, p. 132; and see pp. 129–33 passim.
 - 15. Longhi, Saggi e ricerche, vol. I. p. 7.
 - 16. Longhi, "Lettera pittorica a Giuseppe Fiocco", in Saggi e ricerche, vol. I, p. 90.
- 17. Cf. the document discovered by G. Abate (Miscellanea Francescana, 1956, pp. 25–30) and subsequently discussed by P. Scarpellini in Giotto e i giotteschi in Assisi, Rome 1969, pp. 246ff.
 - 18. See R. Longhi, "Giudizio sul Duecento" e ricerche sul Trecento, Florence 1974, pp. 64-82.
 - 19. Longhi, Officina ferrarese, Florence 1968, pp. 32ff.
- 20. Ibid., pp. 128f. The Latin means "which he made for the altar table of Floriano de' Griffoni".
 - 21. Ibid., pp. 130f.

Index

Agnello, Tommaso dell' 52	Bacci, Giovanni xvii, 15-16, 18-22,
Agnoletti, Ercole, don 9, 10, 11	34-40, 62-3, 65, 71, 76-8, 81-2,
Agnolo 33	85-7, 102-3, 118-20, 126
Agosti, Giacomo 129	Bacci, Giovanni di Francesco di Baccio
Alberti, Leon Battista 6-7, 17-18, 22,	see Bacci, Giovanni
27, 34, 40, 53, 117	Bacci, Luigi 61
Alesso, ser 19	Bacci, Niccolò 34
Aliotti, Girolamo 17–19	Bacci, Nicolosa 62
Altissimo, Cristoforo 74	Baglioni, Malatesta 21
Amadi, Agostino 124-5	Baldovinetti, Alesso 112
Amadi, Daniele 124	Barbazza, Andrea 123
Amadi family 124-6	Bartolo, Taddeo di 65
Amadi, Francesco 123-4	Bartolommeo (Baccio) della Porta, Fra
Amadi, Girolamo 120, 123, 125	140-41, 143, 148
Amadi, Marco 125	Basil, St 72
Amadi, Nicolò 125	Battisti, Eugenio 120-21
Andrea, Giovanni d' 122	Baxandall, Michael xxvii, 125
Antal, Frederick 108	Beato Angelico (also Guido di Pietro) 65
Antonello da Messina 51, 131-2,	Bellini, Gentile 72-4, 89
134	Bellini, Giovanni 123, 132
Antonino, St see Pierozzi, Antonino	Bellosi, Luciano xxxii, xxxiii, 107-9,
Aretino, Carlo see Marsuppini, Carlo	110-13, 126
Aronberg Lavin, Marylin xxxii, 54-5,	Belo, Gregorio 65
61, 63, 66, 71, 117	Benedict XII, Pope (Jacques Fournier)
Asini, Roberto degli (Bishop of Arezzo)	124
16	Berenson, Bernard xxxiii, 110-11,
	129-37
Babelon, Jean 55	Berenson, Mary 132
Bacci, Agnolo 62	Bergognone (also Ambrogio da Fossano)
Bacci, Andrea 62	130
Bacci, Baccio 21	Berruguete, Pedro 51, 73, 82
Bacci family 17, 25, 28, 117	Berry, Jean de 39
Bacci, Francesco 21-2, 25, 32, 34, 37,	Bertelli, Carlo xxxiii
62	Bessarion, Cardinal xvii, 34-40, 55-6,

71-80, 82-4, 85-90, 102, 117-19, 122 - 3, 126Biagio, S. 112 Bicci di Lorenzo xxiii, 21-2, 25, 28, 32, 62 Biondo, Flavio 82-4 Black, Robert 119 Bloch, Marc 145 Boccioni, Umberto 132, 134 Boniface VII, Pope 124 Boniface VIII, Pope (Benedetto Caetani) Borgo, Francesco del 77 Borgo, Ludovico 50-51, 66, 71 Borgo, Pietro Dall' 48 Borso d'Este 21, 63 Bosch, Hieronymus 51 Botticelli (also Sandro Filipepi) xv-xvi, 130 Bracciolini, Poggio 17-18 Bramante (also Donato di Pascuccio di Antonio) 51 Bramantino (also Bartolomeo Suardi) 74 Branca, Vittore 88 Bregno, Andrea 73 Bruni, Leonardo 17-18, 22 Buonarroti, Michelangelo 123 Burckhardt, Jacob xiv

Callistus III, Pope (Alonso de Borja) 80
Canedoli, Battista 21
Cantimori, Delio xiv
Capanna, Puccio 147
Carda, Bernardino della 84
Carda, Ottaviano Ubaldini della 54
Carnevale, Fra 126
Carpaccio, Vittore 87–90
Carter, B.A.R. 69
Castagno, Andrea del 50, 109, 111–12
Castelnuovo, Enrico xiii
Cecchi, Emilio 135
Cenni di Francesco 28
Certini, Alessandro 76
Cervelliera, Giovanni di Francesco del

(also Giovanni di Francesco da Rovezzano) 108 Cesarini, Giuliano, Cardinal 17, 35 Cézanne, Paul xxxiii, 131-4 Charlemagne, Emperor 124 Chosroes 118 Cicogna, Emanuele Antonio 123 Clark, Kenneth 24-8, 33, 53-5, 57, 61, 63-4, 66, 68, 70, 107, 116-18Colonna, Prospero, Cardinal 20 Constantine, Emperor 25-40 passim, 67-8, 70, 77Contini, Francesco 68 Contini, Gianfranco 139 Contrario, Andrea 73 Cosimo, Piero di 103, 143 Cossa, Francesco del 113, 148-9 Courbet, Gustave 134 Covi, D.A. 65 Credi, Lorenzo di 140

Dati, Agostino 123
Degas, Edgar 49, 134
Diacono, Giovanni 69
Diosa di Ranaldo di Mazarino de
Mazzetti 9–11
Diosa di Romaldo di Mazarino di
Mazzetti see Diosa di Ranaldo di
Mazarino de Mazzetti
Domenico Veneziano xix, 3, 15, 111,
146
Droysen, Johann Gustav 140

Edward IV of England 73
Erasmus, Desiderius of Rotterdam
122–3
Este, Borso of 68
Euclid 89, 143
Eugenius IV, Pope (Gabriele
Condulmer) 12, 16, 18, 76

Febvre, Lucien xiv, xxvii Federico da Montefeltro (Count, later Duke) xxi, 21, 48, 51–5, 62–3, 73, 78–85 passim, 103, 118

Ferdinand of Aragon, King 73 Fernandez, Alejo 51 Fichet, Guillaume 73 Filarete (also Antonio Averulino) 3 Filetico, Martino da Filettino 82 Flavius Josephus 66 Floriani de Grifonibus see Griffoni, Floriano de Fontana, Domenico 66 Fosca, Paolo see Foscari, Paolo Foscari, Paolo 124 Francesco del Borgo 77 Francis, St 64 Frazer, James 142 Frederick III, Emperor 72 Fredericksen, Burton B. 110-11 Freud, Sigmund xiv, xviii Gaddi, Agnolo 28-30, 32 Galasso 72 Gamurrini, Eugenio 15-16 Garboli, Cesare xxxiii, 129, 131-2, 134 - 5, 142Gentile da Fabriano (also Gentile di Niccolò) 89 George of Trebizond 35 Ghiberti, Lorenzo 33-4 Giacomo della Marca, Fra (St) 80 Gilbert, Creighton xxiv, 15-16, 21, 26-8, 34, 40, 49-50, 56-7, 60-61, 65, 71, 107 Ginzburg, Carlo xiii-xviii, xxxi Giorgione (also Giorgio da Castelfranco) xv-xvii, 7, 123 Giotto da Bondone 64 Giovanni di Fidanza 9 Giovanni di Francesco xxxii-xxxiii, 107 - 15Giovanni di Francesco di Baccio see Bacci, Giovanni Giovanni Aretino see Bacci, Giovanni Giovanni di Girolamo 146 Giovanni di Piamonte 40, 107-8, 113 Giovio, Paolo 38, 74 Giustiniano, Pietro 124

Goethe, Johann Wolfgang 72, 142 Gombrich, Ernst xiii, xxv, 49 Gonzaga, Ludovico 54-5, 61 Gouma-Peterson, Thalia 55-7, 63, 71-2, 74-5, 80-81, 116-17 Gozzoli, Benozzo xxiii, 64 Gradenigo family 123 Graffione, il 109, 111 Graziani, Alberto 7 Graziani family 9 Graziano the Minorite 72, 74 Gregorio the Elder see Melissenus, Gregorio Griffoni, Floriano de' 149 Guarino Veronese 19 Guerriero da Gubbio 84 Guidantonio da Montefeltro 54 Guidiccioni, Angelo 124 Guid'Ubaldo da Montefeltro, Duke 48

Haftmann, W. 67 Hartt, Frederick 61 Heemskerck, Marten van 67 Hill, Christopher xvii Horne, Herbert, P. 109 Huizinga, Johan xiv

Intelminelli, Rainaldo 124 Isidore of Kiev (Cardinal Ruteno) 17, 37

Jakobson, Roman 146 Jerome, St 72 John VIII see Palaeologus Jolles, André 142 Jongh, E. de xv Joseph of Arimathea 61 Juan de Flandes 51 Justus of Ghent 73

Krautheimer, Richard 33 Kurz, Otto 132

Lapo da Castiglionchio the Younger 16 Lauer, Philippe 69

Leonardo da Vinci 143 Montefeltro, Buonconte da 81-6, 118-Limbourg, Pol de 39 Lippi, Filippino 67 Montefeltro family 63, 81, 89 Longhi, Roberto xv, xix-xxiii, Montefeltro, Federico da see Federico xxxii-xxxiii, 6, 10-8, 22-8, 37, 40, Montefeltro, Oddantonio da xx-xxii, 53, 62, 64, 68, 87, 110-11, 113, 85, 116 129-37, 138-51 Morelli, Giovanni xiv, xvii, 130, 142, Lorenzetti, Pietro 50, 147 146 - 7.149Lotto, Lorenzo 65, 130 Moschini Marconi, Sandra 121-2 Luther, Martin 131 Muraro, Michelangelo 90 Malatesta family 20 Neri, Filippo, St 144 Malatesta, Novello 21 Niccoli, Niccolò 17 Malatesta, Sigismondo xix, xxiii, 20-21, Niccoli Fiorentino 5, 8 83, 103, 120 Nicholas V, Pope (Tommaso Mammas, Gregory see Melissenus, Parentucelli) 12, 23, 68, 72 Gregory Mancini, Giulio xiv Manet, Edouard 134 Oddo Antonio, Duke 48 Maniacutia, Nicola (also Maniacuria) Offner, Richard 112-13 122 Mantegna, Andrea 20 Pacioli, Luca 69, 89-90 Marcanova, Giovanni 67 Palaeologus, Constantine 102 Marchi, Agostino de 149 Palaeologus, Emperor John VIII Marco, brother of Piero della Francesca xvi-xvii, 3, 17, 32-9, 54-5, 71, 76 - 8, 118Marcus, Aurelius, Emperor 67, 68 Palaeologus family 36 Marsuppini, Carlo 16-18, 20 Palaeologus, Irene 36 Matisse, Henri 131 Palaeologus, Manuel II 39 Matteo di Giovanni 6, 7 Palaeologus, Thomas 54, 79 Maxentius, Emperor 29, 32 Pandoni, Porcellio 83-4 Medici, Cosimo de' 16, 20 Panofsky, Erwin xv, xxvii, 119 Medici family 20, 81, 103 Pascasio, Abbot 12 Medici, Giovanni di Cosimo de' 16, Pascoli, Giovanni 129 19 - 21Passavant, Johann David 49 Medici, Lorenzo de' 21, 81, 103 Paul II, Pope (Pietro Barbo) 56, 81 Melissenus, Gregory (also Mammas) Pelliccioli, Mauro 121-2 36 - 8Perocco, Guido 88-9 Merisi, Michelangelo da Caravaggio (also Caravaggio) 144 Perotti, Niccolò 35, 72, 83 Michael IX, Emperor 36 Peruzzi, Angelo 10 Michelangelo di Borgo San Sepolcro 19 Petraccone, Enzo 138, 141 Milanesi, Gaetano 109 Picasso, Pablo xxxiii, 131-4 Montagnani, Cristina 129 Piccinino, Niccolò 20 Montefeltro, Antonio da 81 Piccolomini Enea Silvio see Pius II, Pope

Sforza, Galezzo 84 Pierozzi, Antonino, Bishop of Florence 123 Siebenhüner, Herbert 54 Pisanello (also Antonio Pisano) 3, 38-9 Silvester, Pope 67 Pius II, Pope (Enea Silvio Piccolomini) Sixtus IV, Pope (Francesco della 18, 23, 27-8, 37-8, 40, 54, 66, 68, Rovere) 56, 81 72-5, 79, 118Sixtus V, Pope (Francesco Peretti) 66, Platina (also Sacchi Bartolomeo) 124 69 Plato 17, 35, 83 Skopas 26 Poggi, Giovanni 109 Smith Russell, Alys 132 Poggio see Bracciolini, Poggio Sodoma (also Giovan Antonio Bazzi) Porcellio see Pandoni, Porcellio Pordenone (also Giovan Antonio de Stefano Fiorentino 147 Sacchis) 123 Stein, Gertrude xxxiii, 131, 134 Post, Chandler, R. 51 Stein, Leo 131 Preti, Mattia 138 Stieglitz, Alfred 131 Propp, Vladimir Ja. 142 Strozzi, Alessandro 144 Raphael of Urbino 74, 123 Tanner, Marie 5-9, 11, 86 Regoliosi, Mariangela 16 Thomas Aquinas, Saint 7 Ribot, Théodule 130 Tintoretto (also Jacopo Robusti) Rice, Eugene 122-3 Riegl, Alois 142 Titian (also Tiziano Vecellio) xxv, 119, Rizzo, Antonio 134 123 Roberti, Ercole de' 148-9 Toesca, Pietro xx, 49, 53, 109–10, Romano, Giovanni xxxii 112 Romano, Giulio 74 Tolnay, Charles de 5-6, 8 Romano, Paolo 73 Tortelli, Giovanni 16-20, 35-6, 76, Rubens, Pieter Paul 144-6 102, 126 Rucellai, Giovanni 67-8 Tosi, Ubaldo 48 Running, P.D. 49 Traversari, Ambrogio 11-12, 15-17, 18, 22, 33-4Salmi, Mario xxiv, 62 Trevisano, Ludovico, Cardinal 19-20, Sandström, Sven 63 Santi, Giovanni 84 Tura, Cosmè 135-6 Saxl, Fritz xiii Scarampi-Mezzarota, Ludovico see Ubaldini della Carda, Bernardino 83 Trevisano, Ludovico Ubaldini della Carda, Ottaviano 54-5, Schmarsow, August 108 63, 71, 83 Schneider, L. 33 Uccello, Paolo 25 Scotto, Daniele 16 Uguccione of Pisa 123 Settis, Salvatore xvi-xvii, 7, 119 Urban VI, Pope (Bartolomeo Prignano) Seurat, Georges 132-3 Severano, Giovanni 66 Urbino, Count Oddantonio 52-4, Sforza, Battista 21, 84 Sforza, Francesco 20, 22, 54, 84 Urbino, Duke of (Guidubaldo) 89

Valla, Lorenzo 102
Varazze, Jacopo da 28–30, 32–3, 123
Vasari, Giorgio 21, 23, 50, 61–2, 68, 70, 74, 87, 109, 111
Vast, H. 72
Vendramin, Gabriele xvii
Vermeer, Jan 131
Verrocchio (also Andrea di Francesco di Cione) 140
Visconti, Filippo Maria 54
Vivarini, Alvise 130, 132

Warburg, Aby xiii–xv, xvii, xxvii Weisbach, W. 108 Weiss, Roberto 39, 72, 75 Whistler, James Abbott McNeil 130 Wind, Edgar xv Wittgenstein, Ludwig 142 Witting, F. 108 Wittkower, Rudolf 69 Wölfflin, Heinrich 139

Zippel, Giuseppe xxiv